P9-DMG-519

# POP PAINTING

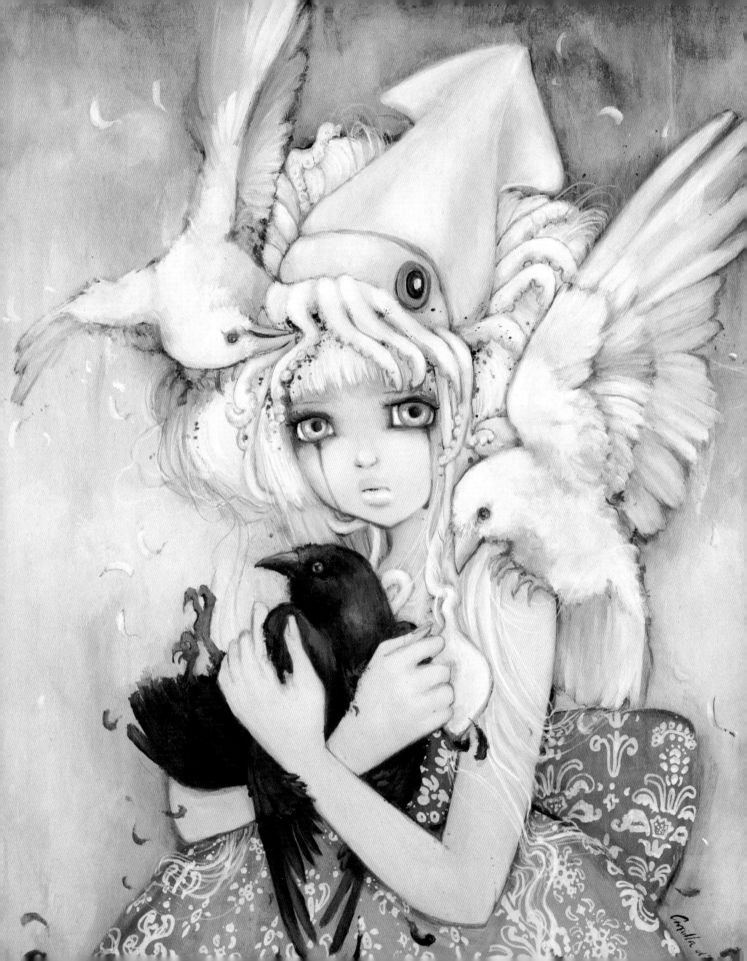

# POP PAINTING

## Inspiration and Techniques from the Pop Surrealism Art Phenomenon

### CAMILLA d'ERRICO

Watson-Guptill Publications
Berkeley

Copyright © 2016 by Camilla d'Errico

All rights reserved.
Published in the United States by Watson-Guptill Publications,
an imprint of the Crown Publishing Group, a division of
Penguin Random House LLC, New York.
www.crownpublishing.com
www.watsonguptill.com

WATSON-GUPTILL and the WG and Horse designs are
registered trademarks of Penguin Random House LLC.

ADDITIONAL ART: page viii © Greg Simkins; pages 6 and 11 (top)
© Travis Louie; page 10 (left) © Hikari Shimoda; page 10 (right)
© Tara McPherson; page 11 (bottom) © Audrey Kawasaki.

Library of Congress Cataloging-in-Publication Data

D'Errico, Camilla.
  Pop painting : inspiration and techniques from the pop
surrealism art phenomenon / Camilla D'Errico.
     pages cm
  Includes bibliographical references and index.
1.  Painting—Technique.
2.  D'Errico, Camilla—Themes, motives.
3.  Pop art—Themes, motives.  I. Title.
  ND1473.D47 2016
  751.4—dc23

                           2015026156

Trade Paperback ISBN: 978-1-60774-807-6
eBook ISBN: 978-1-60774-808-3

Printed in China

Design by Ashley Lima

10

First Edition

## DEDICATION

I hereby dedicate this book to those who have put up with all my crazy artistic habits. You know who you are!

It goes without saying that my life has been a culmination of ups and downs, sorrows and joys, frustrations and elations, and throughout the roller coaster that is my life, you have stuck by me, even when I may not have deserved it. If I could, I would write a chapter on how to train an artist, but then it would be the only fictional part of this book. Because as you all know, that is impossible. Even though I'm still not housebroken and I may throw a few tantrums, obsess way too much over vampires and zombies, and paint outside the lines, I know that I have the foundation of your love and strength to tether me to the real world and keep me from scattering to the winds.

So this is for you Poe-hulk, Llama, Frosted Flakes, Bean, Mammacia, Pappalino, and Loki. Yes, even the dog gets an acknowledgment, since he's the only one that will let me dress him up in silly outfits that make me giggle.

Camilla d'Errico

# CONTENTS

Foreword by Greg "Craola" Simkins ix
Introduction 1

PART 1 CREATING POP SURREALISM

CH 1 Pop Surrealism: What Is It? 5
The Evolution of Pop Surrealism 7
Pop Surrealism—Be Inspired! 10

CH 2 Originality, Inspiration,
and Intuition 13
What Inspires Me 14
Finding Inspiration 14
Using Intuition: Go with
Your Gut! 14
Choosing Colors Intuitively 17
Choosing Titles Intuitively 17
Becoming a Better Artist 17

CH 3 Tools of the Trade 19
Paint 20
Drawing Tools 23
Brushes 25
Painting Surfaces 26
Easels 26
Other Helpful Tools 29
Selecting Your Tools 29

CH 4 The Artist's Studio 31
Setup 32
Organization 35
Safety 35
Creative Space: What Is
Needed 35
Outside Studio vs. Home Studio 36

CH 5 Sketching, Studying, or Just
Doing It? 39
Sketching: Trials and Errors 39
Practice First 40
Do It! 40

CH 6 Composition 43
Juxtaposition 44
What to Do if You Run
Out of Room 44
What to Do When Something
Is Missing 47

CH 7 Pushing Boundaries 49
Paint with Your Gut,
Not Your Head 50
Dealing with Blocks and
Dry Spells 50
Don't Let Failure Get to
Your Heart: Move On! 53

CH 8 Evoking Emotions 55
Tapping into Emotions 56
Your Emotions While Painting 56
Getting in the Mood 56
Coloring Emotion 59
Subject Matter and Emotion 59
Expressing Your Emotional
Meaning 60
The Power of Emotions 60

CH 9 Blending 63
Blending Basics 64
Blend, Set, Go! 71
Light and Shadows 72
Depth: An In-Depth Look 74

PART 2 PAINTING POP SURREALISM

Top Ten Questions 78
Tips and Tricks 82

CH 10 Step-by-Step Examples 85
Humans 87
Eyes 89
Lips 99
Hair 109
Skin 117
Depth 125
Animals 133
Fur 135
Wings 143
Baby Animals 149
Rainbow Tigers 159
Melting Effects 167
Pools of Color 169
Melting Rainbow 175
Twisting Reality 183
Combining Cuteness 185
Tentacles 193
Cartoons and Caricatures 201
Butterfly Kisses 209

CH 11 Black and White:
Paint Drawing 217
Surface Preparation and
Underdrawing 218
The Paint Drawing Process 218
How to Paint Straight Lines 221
How to Paint over the
Canvas Edges 221

**CH 12** Passion to Profession 225

My Art Evolves 226
How I Learned to Love
   Painting 228
Finding My Creative Home
   in Pop Surrealism 228
On Being a Professional
   Artist 231
Approaching Galleries
   and Getting Started 231
Presenting Your Portfolio 232
Dealing with Rejection 232
Validate Yourself 234

Afterword 236
Art Credits 237
Index 238

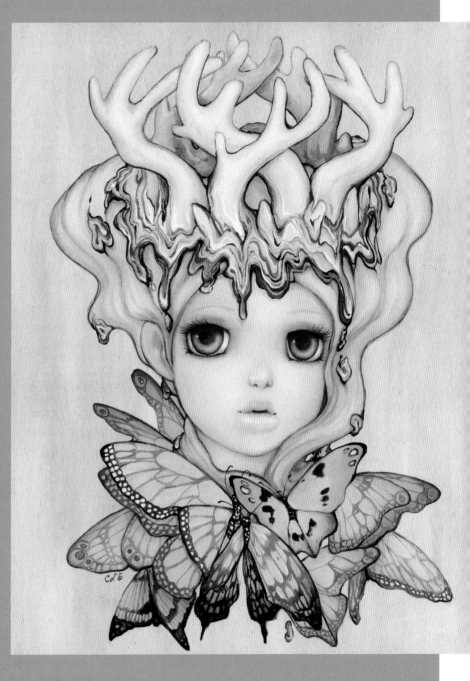

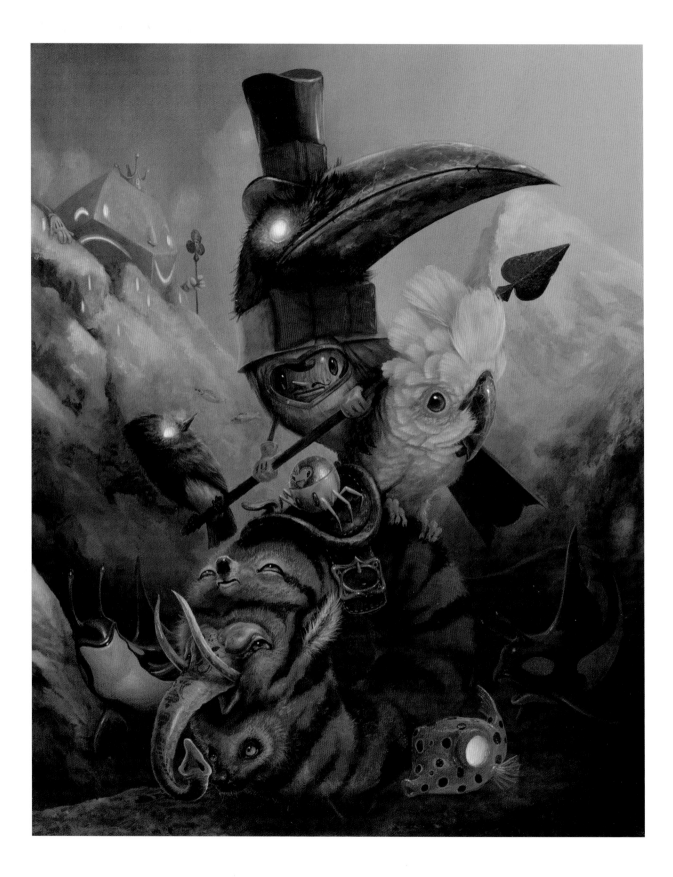

# FOREWORD

Where do I begin with Camilla? It wasn't so much of a battle or much of a fight. And no, it wasn't with her; it was with a couple ninjas who happened to be kicking it at the bar we were all going to meet up at. You might be saying "NINJAS!?!," but it isn't really that strange. The bar looked like the cantina at Mos Eisley, full of stormtroopers, Alf, a couple Smurfs, and Panthro from *Thundercats*. Yup, DragonCon was happening. It was my first time at the show (and to Atlanta as well), and I had no idea how into cosplay people got. I apparently wasn't welcome in my nifty blue jeans and plain white T-shirt. I am no stranger to a ninja fight and welcomed the exercise, but it was over before it began when Camilla came flying in with a jumping roundhouse kick that took not just one, but both of the dark assassins out. Amazed, I asked her if she was a superhero and she said, "Yes, obviously. I'm Camilla d'Errico."

I had been well aware of Camilla's work by the time we met. My good friend Alex Pardee had turned me on to her work many years previous, and Camilla had even participated in my curated exhibition *INLE*, contributing a very beautiful piece that I am still very fond of. I have always been amazed at how well-rounded Camilla's talents are and how her drawing skills enable her to freely express herself in her paintings. All the pencils for the beautiful comic books she has rendered have definitely burned there way into her muscle memory, making her storytelling that much more pleasing to the eye. The girls she paints invite you into their playful existence and dare you to weave crazy things into your hair as well. I have been an admirer of Camilla's work for some time and assume you are as well. Now we both can share some enjoyment in this book.

—GREG "CRAOLA" SIMKINS

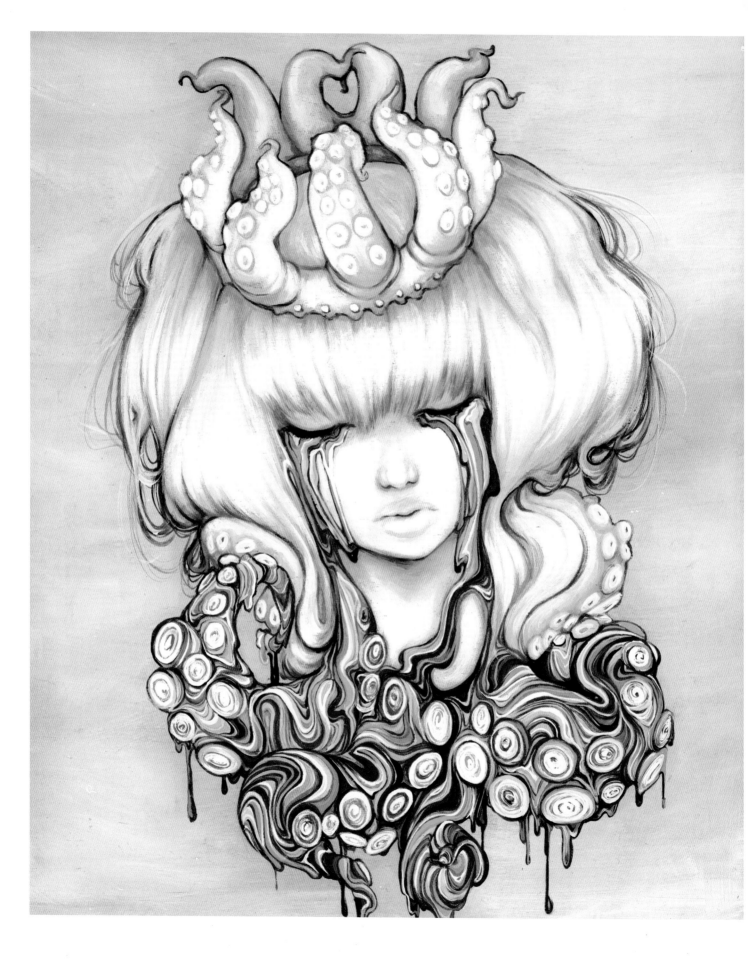

# INTRODUCTION

My mamma once told me that when I was born, one of the first things she noticed about me were my hands. She said that I had the hands of an artist. (Years later, she showed me a picture of myself as a baby and I realized that one of the first things she probably actually noticed about me was my radical troll mohawk!) Just like my hands showed my mamma my path, my heart told me that I was going to be an artist.

Since 2005 my paintings have been shown in galleries throughout the world—from New York to Tokyo, and a few places in between. I contribute to a movement the art world refers to as "Pop Surrealism."

As a Pop Surrealist, I've learned over the years that I have a lot to offer others even as I grow as artist. With this book, I'm super excited to answer all the questions that I've been asked about my painting techniques and

about what it's like to be a working professional artist. I'll do my darnedest to give you as many tips and tricks that I've learned along the way, to help guide you, and to show you how to have fun painting!

I'm ready to bare my soul to you, expose my secrets, and help you dive into the world of Pop Surrealism. I'll show you the techniques that have helped me define myself as an artist in this incredible movement. I can teach you my techniques and how to express emotions in your paintings, but never forget that painting is an expression of yourself. I want you to create paintings that mean something to you, using my lessons as your guide!

In the chapters ahead, I'll show you what I've learned, teach you some fun tricks, and give you a peek into my world.

Hey there, folks! I'm Zu. You may know my cousin, Inku from Pop Manga. He is my third cousin twice removed on my mother's great-uncle's side. We have a few things in common and poking fun at Camilla is one of them, ha ha. I'll help give you some tips and make things a little more fun, just like my cousin Inku did in Camilla's first book *Pop Manga*.

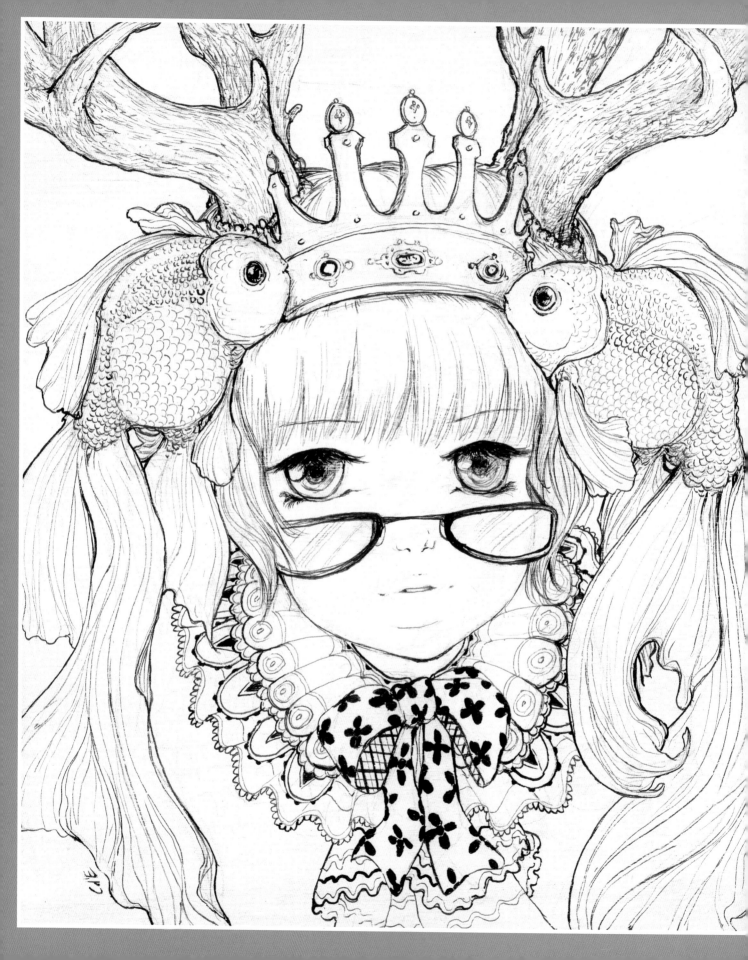

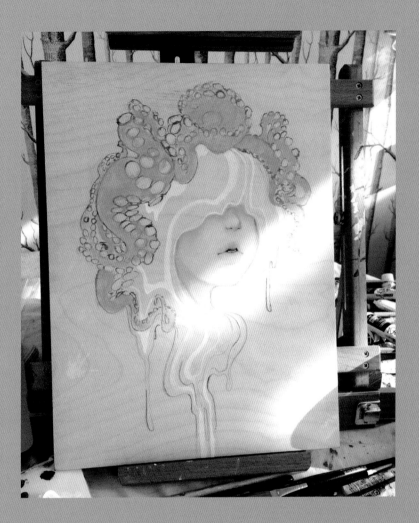

# CREATING POP SURREALISM

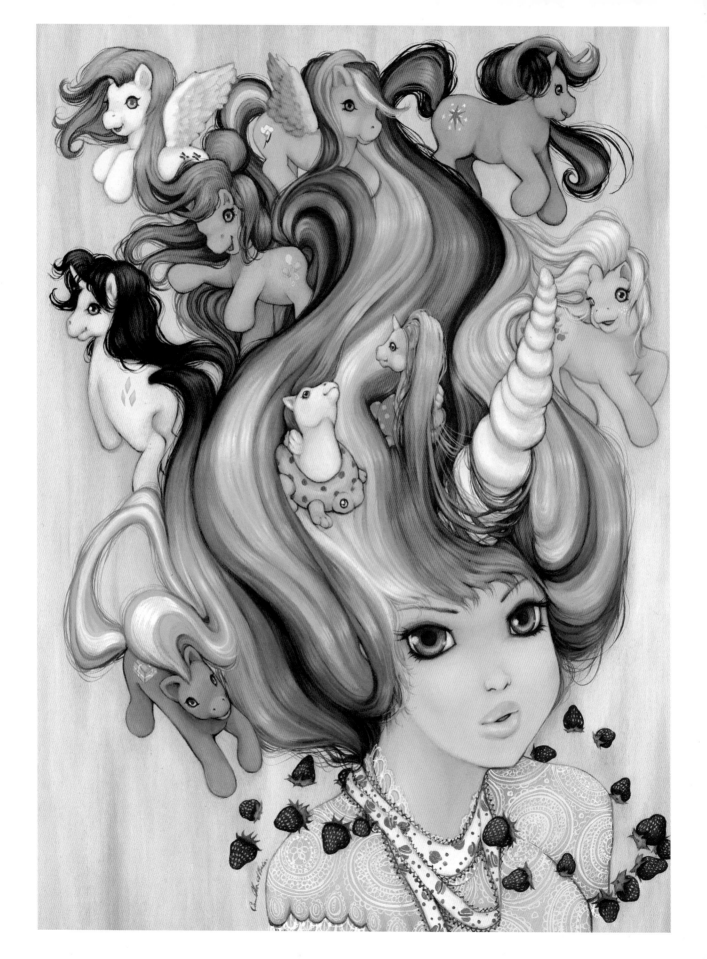

# ¹ POP SURREALISM: WHAT IS IT?

Art movements are created in hindsight—we reflect on what happened and that's how we are able to label and identify them. For those artists like myself, Mark Ryden, Audrey Kawasaki, James Jean, Camille Rose Garcia, and others, working within the movement, creating art before there was even a label, we didn't pattern our art after something that we saw, but rather created it on the precipice of defining the style, giving the movement its foundation. My fellow Pop Surrealists and I actively created the art without being consciously aware of what we had to do in order to be Pop Surrealists.

People ask me whether I like being labeled as a Pop Surrealist, whether I like being defined in such a way. I don't mind it at all, because I don't limit myself to it. I create art for myself; whether or not it fits within the confines of the definition of Pop Surrealism is up for interpretation. However, I believe that artists within the movement dictate what Pop Surrealism is, simply by breaking boundaries and continuously creating new and diverse art.

# THE EVOLUTION OF POP SURREALISM

Wikipedia would say that Pop Surrealism came from Low Brow art, and that it is an interchangeable label. However, I disagree. Although Low Brow art shares similarities with Pop Surrealism, there is a very distinct difference between the two for me. Low Brow artists began mixing comics characters and other pop culture elements into their paintings in the 1970s, creating artwork that featured low-end imagery that could be placed in high-end galleries. But where Low Brow moves in a dark and underground direction, Pop Surrealism has a brighter, more whimsical, and more playful nature, often containing elements of both humor and bizarreness. Yes, Pop Surrealism may have a connection to Low Brow; however, I believe that Pop Surrealism has taken on a life of its own and expanded beyond its Low Brow roots.

When I think of Pop Surrealism, I think of it in the following manner: *Pop* refers to pop culture and the *Surreal* part to the Daliesque nature of the imagery. In my paintings, gravity doesn't exist, animals blend into fruit, and time and space are not concerns. Pop Surrealism is about bending the rules of physics and mixing in characters viewers will recognize from cartoons, history, and fiction to create a whimsical, playful image. (That is my definition and I'm sticking with it!)

Got an idea? Great! Now imagine it defying physics, logic, and convention, and you've basically got yourself a recipe for Pop Surrealism.

You might look at my art and ask, "If it's based on pop culture, why don't all of your paintings have Hello Kitty or He-Man in them?" In truth, I don't always use characters from pop culture in my paintings, and not all the artwork in the movement contains this type of imagery. I and the other artists within Pop Surrealism have created a genre in which we can play with a variety of iconography and imagery, where we can create freely and wildly without having to continuously add in pop culture references.

The Pop Surrealism movement grew because of galleries that support the style. Galleries such as Corey Helford, The Ayden Gallery, Thinkspace, Merry Karnowsky, and Jonathan LeVine are just a few that have embraced and set the stage for Pop Surrealism's expansion. Additionally, magazines like *Juxtapoz* and *Hi-Fructose* are a huge part of what makes this sensational art movement widely accepted and represented in North America and internationally. Even celebrities have embraced it. Lady Gaga wore a meat dress so similar to Mark Ryden's painting *Incarnation* that there is no doubt in my mind that she was inspired by the godfather of Pop Surrealism.

There are so many artists in the movement. In addition to the ones I've already named, there's Ron English, Lola, Gary Baseman, Sylvia Ji, Charlie Immer, and so many more—all doing an incredible variety of paintings using lush and bizarre imagery. The only thing they have in common is the surreal nature of their subject matter.

## POP SURREALISM—BE INSPIRED!

I think it's important to see what kind of art is being created by some of the top Pop Surrealist artists in the industry. So have a look at these incredible paintings by Travis Louie, Tara McPherson, Hikari Shimoda, and Audrey Kawasaki. I hope you'll be inspired to try your own style, to let go of any preconceived notions of what you should paint, and just produce whatever comes into your mind.

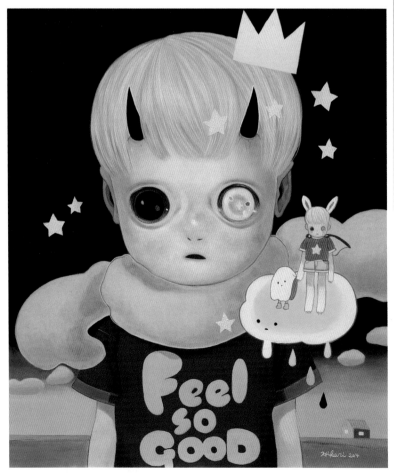

# 2 ORIGINALITY, INSPIRATION, AND INTUITION

You are born an original, so don't die a copy.

Part of being an artist is yourself, who you are and what inspires you, which is why it is so important for you to be original and follow your intuition. Taking someone else's ideas or style does nothing to show how you see the world. So even though other artists may inspire you, be true to yourself and never plagiarize someone else's artwork.

I know it can be hard to invent original ideas and put them out in the world without comparing yourself to others. In fact, comparisons will be something that you'll have to deal with often. Most people look at artwork and try to identify why they like it or dislike it based on something they've already seen, which is why I get a lot of people comparing me to artists like Audrey Kawasaki and Terada Katsuya. We may have things in common and vaguely similar styles, but when it comes down to it, my art is my own and I never look at other people's artwork as a source to base my own work on.

## WHAT INSPIRES ME

So where do my ideas come from? The question I'm most frequently asked is, "What's your inspiration?" It's a simple question with a complicated answer.

People are very curious to know where my ideas come from. Where do I get the idea to put a huge helmet on a girl's head or to mix octopuses with lovebirds, or why do I paint girls crying rainbows? I can't tell you where my ideas come from because it would be like my knowing why teal is my favorite color, or why I like apple pie so much, or why I dreamed that I was Spider-Man. I *do* know, however, the importance of the question and the significance of the answer, so I'll do my best to unlock the secret to my inspiration.

## FINDING INSPIRATION

So where does inspiration come from? In truth, I love many things, as a result much of the world inspires and feeds me creatively: nature, photography, fashion, literature, and art that ranges from the classical works by Raphael and Alfonse Mucha to Range Murata, James Jean, and Banksy. I'm inspired by the idea of breaking boundaries. One of the things that inspires me the most is trying to figure out people—the origin of emotions, human imagination, and how people view the world. I have grand inspirations, but small things inspire me, too. Textures, phrases, eyes, and the detail of a flower petal are a few of the little things that excite me. I love eyes the most, and I probably make a little more eye contact with people than I should, which is likely why I'm so obsessed with the actor that plays Damon Salvatore: his eyes are so bright and blue—they are hypnotic!

A big difference between artists and the rest of the population is that an artist will see the world and the subtext behind it. Being imaginative is being open to interpretations and exploring and expressing ideas

and emotions in ways that challenge the ordinary and present them in extraordinary ways.

Emotions and events in my life inspire me to express significant emotional milestones in my art. Experiencing heartbreak and loss, finding love, and being happy, angry, and lonely all provide fuel to the artistic flame that drives me creatively. The most inspiring of these emotions, of course, is sadness; however there is nothing quite as powerful as love. Being in love and losing love are equally inspiring.

## USING INTUITION: GO WITH YOUR GUT!

I've imagined so many paintings in my life that sometimes it's a little daunting to know just which idea I should paint. This is where intuition comes into play. If you have a sketchbook full of ideas and dozens upon dozens of drawings to choose from, go with your gut instinct! A lot of times I will draw a series of paintings, and then months will go by before I suddenly feel like painting one of them. As an artist, paint what you feel and go with your gut!

There are times, though, when I've begun a painting and halfway through lost my steam on it. I don't abandon it—I've very rarely left a painting unfinished—instead, I'll take a step back and leave it for a few days. If I come back to paint and I still don't like what's going on, I'll change some of the elements! Never paint against your intuition—your gut knows best.

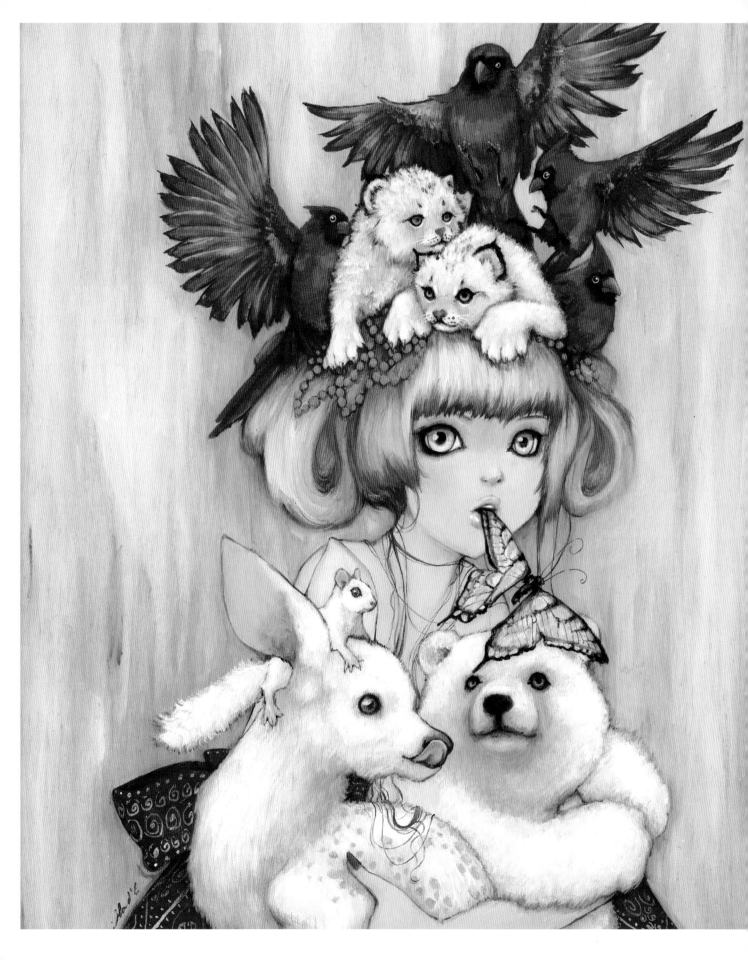

## CHOOSING COLORS INTUITIVELY

Choosing the colors in a painting is often the most time-consuming and difficult part for me. Since my sketches are all done in black and white, I don't see my ideas in color—well, sometimes I do, but more often than not, I decide the colors as I'm drawing on the wood panel. Occasionally I visualize the painting fully rendered—that's part of the intuition of choosing colors. You'll imagine them flowing together harmoniously. But if you have trouble deciding on colors, start with one element in the painting and work from there. Or you can decide on an overall color theme and work from that point. So if you say "I want my painting to be blue," then use blue and consider using complementary colors for balance.

Basic color theory can help you choose colors that go best together. Blue and orange, yellow and purple, and red and green are complementary colors because they are on opposite sides of the color spectrum and will give you the most contrast possible. Green and blue, yellow and orange, and red and purple are on the same side of the color spectrum and will work harmoniously together. Cold and warm tones give you good contrast as well, like blue and red, or yellow and blue. One of my favorite uses of contrast is with eye color. In *Canadian Tiger*, I used reds and whites throughout the entire painting, but then for contrast, I made the girl's eyes ice blue. This one element stood out but also focused the viewer's attention to the center of the painting and the surrounding elements. Intuition plays a big part not only in choosing colors and elements but also in choosing titles for my paintings.

## CHOOSING TITLES INTUITIVELY

The trickiest part of a painting for me is naming it! I've come up with hundreds of names over the years. Searching for them may seem like fishing in an infinite creative ocean, but finding the right name is like casting a reel into the water and hoping a fish bites. The best way to come up with a name is to just use your intuition: study the painting and what it means to you, and then decide on a name based on what you *feel* from the painting. Alternatively, put a bunch of words into a hat and pull some out and see what you get. My favorite title that I ever came up with was *A Tickle on a Dull Doomsday*, and I literally pulled the name out of a hat.

## BECOMING A BETTER ARTIST

Staying open to the seeds of inspiration and intuition, to new things and ideas, will allow your creativity to grow—although truthfully, sometimes it doesn't even feel like those seeds are germinating. That's okay! Don't wait for inspiration or intuition to punch you on the nose: get interested in things, ask questions, investigate, and be adventurous and original! All of these things will help you become a better artist.

Camilla will never admit it, but I know I'm her muse. Ha ha!

# ³ TOOLS OF THE TRADE

Creating a painting is like going to war. You need an arsenal of weapons and even some provisions to keep you sustained when going into battle. The same things are needed when you begin to paint.

# PAINT

What paint do I use? Here's my secret, I use Holbein Duo oils. These beautiful babies are oils that can mix with water! That's impossible right? "Oil doesn't mix with water," you say. Well, Holbein found a way to make it work. In fact, the Holbein Duo oils are the artist-grade water-soluble oils I prefer. I love to work with these paints because they are so flexible. I can use water, linseed oil, acrylic paints, and mediums to thin and blend them, allowing for a wide variety of painting techniques. As far as I know, I am the only Pop Surrealist artist who primarily uses water-soluble oils.

Why do I use the Duo oils instead of regular oil paints? While traditional oils are amazing, they come with some baggage. They take a long time to dry and you need to use chemical solvents to clean them. Because I have the attention span of a hamster, I have found that I don't have the patience to work with such requirements. Also, the fumes from the solvents were too strong for my tiny studio.

What makes these paints great? For one thing, you can achieve multiple looks with them. Since they blend with water, you can use them like watercolor paints and do washes on paper and on canvases. And since they have the consistency of oils, you can also use them as impasto paints, getting thick, luxurious textures from them. I love that they dry faster than regular oils. With them, I can create many different layers and use different blending techniques. The end result is a look that people don't really know how to place, and I find that very exciting.

Other paints I use are the Holbein Heavy Body Acrylics, Holbein Goauche, and Golden Liquid acrylics (which I mix with my Duo oils). I do this when I want to speed up the drying time of the oils or when I am doing underpainting or very thin linework. I'll walk you through these techniques in chapter 10.

What's the difference between Duo oils and acrylics? There are several: the texture, drying time, pigments, and blendability are all different. Oil paints have a higher pigment count than acrylics. That means there is more pigment in the oils, making them richer and more vibrant in color. Also, acrylics dry differently than oils. The color alters when acrylics dry, often becoming darker and duller than the wet paint. The color also changes when you varnish an acrylic painting. Varnish can sometimes darken acrylics or make them appear more vibrant depending on the brand of acrylics and type of varnish. I suggest you do small painting tests on canvases and then check the varnish on those tests to see which result you like best. It's best to play around with the paints, mediums, and varnishes to see which combination works best for you. Remember, I have spent years testing and painting to hone my painting preferences. What works for me may or may not work for you. But that's what makes painting so fun! You can experiment with gouache, watercolors, pencil crayons, oils, water-soluble oils, and so on. All artists have different ways of working and expressing themselves with art, so find what works best and is easiest for you and have fun.

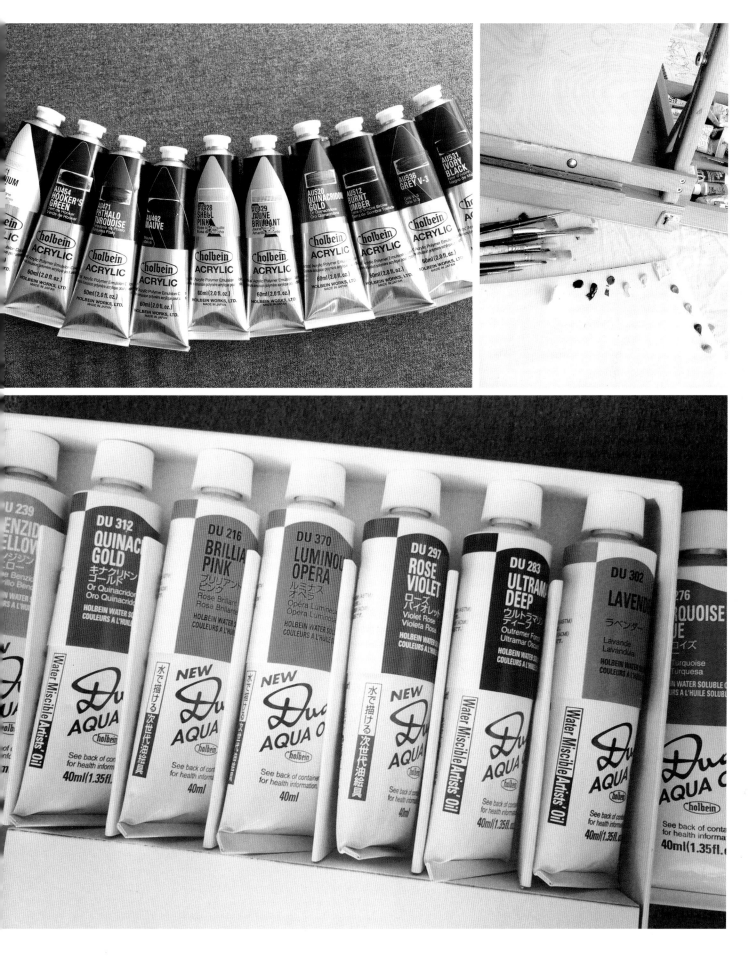

## QUALITY VERSUS COSTS

I often get asked if it's important to use quality paints, or if less expensive paints will provide the same results. Students and artists who are starting out have to be budget conscious, and I understand that. *I was a student!* I began painting using low-grade paints and brushes. You don't need the most expensive paints to start out; however, you will find that they make a huge difference when you begin to mature as an artist. Low-grade paints do not feel or look the same as high-grade ones. They do not have the same amount of pigments or textures. Often people who tell me they don't like painting say so because they are using the wrong paints.

Whatever you do, do not buy dollar store paints if you plan on keeping your pieces for a long time. Artist-grade paints are archival, which means they don't fade as quickly and they go onto the canvas much smoother and richer. If you don't have a lot of money to start out, don't worry—student-grade paints are fantastic and will help you find your stride as an artist. Once you have the budget for it, switch over to artist grade.

## MIXING PAINTS

To mix my paints and thin them out, I use tap water and Golden Acrylic Glazing Medium (AGM). I know AGM is for acrylic paints, but it is great for thinning out my paints without having them lose a lot of consistency. Water will unevenly distribute the color, and is better for washes. The AGM will thin out the paint, but gives you an even distribution of color while still maintaining a creamy consistency.

You'll also need a surface to mix your paints. I like to use disposable palettes. I know it goes against my inner Captain Planet, but I have found that these wax paper palettes allow me to mix my paints and clean up very easily. I've used all sorts of surfaces as palettes—plastic trays, glass surfaces, even old plates. Since I like to mix

a lot of different colors, I need a large surface area for spreading my paint around. Once I've used up all the room on the disposal palette, I rip the sheet away and start on a new one. You may find that you don't need as much area as I do; therefore, a reusable palette might just be perfect for you!

# DRAWING TOOLS

I use watercolor pencils to do all my underdrawings. These are amazing, because you can blend them with your paints. If you use regular graphite pencils, the lead will blend with but also muddy your colors, so invest in some watercolor pencils instead. Don't use crayons or pencil crayons either. The wax in their leads makes them difficult to paint over, and you'll have to add lots of layers to hide them. When you choose your watercolor pencils, try to select muted colors like sepias and light blue grays—colors that are not too dark. You don't want the drawings to show through your paints.

Along with your watercolor pencils, you'll also need an eraser—not just any eraser, but an artist-grade white eraser. Pink erasers will ruin your canvas. They leave color and streaks, and are pretty much terrible! If you need to erase your drawing or fix a mistake, lightly erase so that you don't damage the wood or surface.

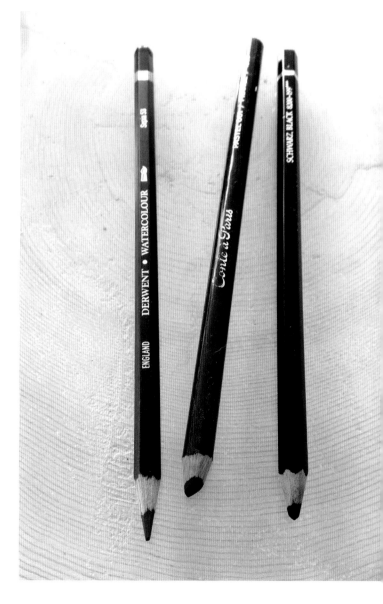

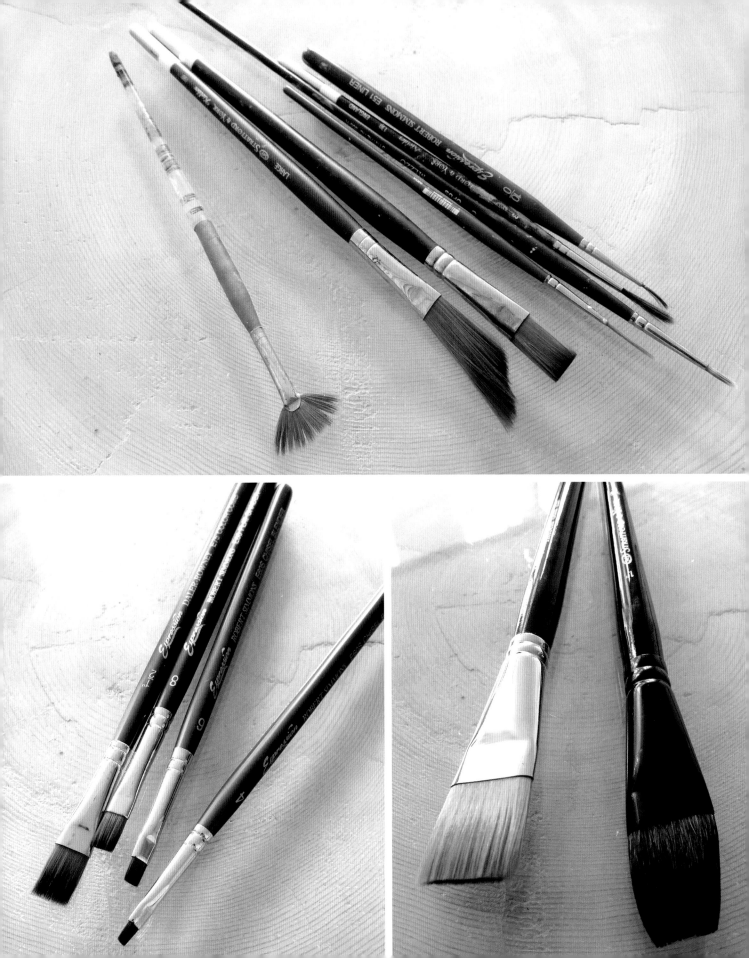

# BRUSHES

Once you have the Holbein Duo oils, you'll need the tools to work with them. Brushes come in many shapes, sizes, and lengths. I like to use short handle ones, because I paint on small canvases. To achieve the fine details of my paintings, I also use very thin brushes. For those reasons, I use synthetic short handle brushes. I love Robert Simmons, Opus Allegro, Holbein, and Trekell brushes the best.

Liner brushes are great for hair and long thin applications of color. Comb brushes are great for textures. I use angle brushes for edges. Chisel brushes and round, flat, blender brushes are nice for blending. Why do I prefer short handle to long? Long handle brushes are more commonly used for large paintings that you keep at a distance, so you have to grip the handle at the end to produce longer strokes. Short handle brushes add intimacy to my paintings. I work very closely to my canvas because my paintings' details are so small and thin. I grip my handle at the base of the brush head rather than at the end of the brush. I like the Robert Simmons brushes because they have thicker handles that are very nice to grip.

There are many, many companies that make brushes and a lot of options to choose from each one. I personally choose acrylic brushes because they blend really nicely and give a smooth finish to my Duo oils. I go into the store and select my brushes carefully by touching them and testing them with my fingertips and palm, making sure the tips are not too stiff and that the hairs won't fall out.

The lifespan of a paintbrush depends on how well you maintain it. You must never ever soak your paintbrushes in your water bucket. This will ruin the wood of the handle and also bend your brush tip, and no amount of soaking will clean it. The best way to clean your brushes is to use "The Masters" Brush Cleaner and Preserve. Place a little in the palm of your hand, and then slowly rub your brush tip into your palm until all the paint comes out. You can also use biodegradable dish soap if you don't have brush cleaner and use the same process to clean your brushes. Rinse the brushes and place them on a cotton rag to dry. Trekell actually makes a brush conditioner that revitalizes your brushes—it will bring your brushes back from the dead! Use this to lengthen the lifespan of your brushes.

These are a few of my favorite ones. The brushes depicted here are a mix of brushes from the Robert Simmons Expression Series, the Windsor & Newtown Cotman Series, the Stratford & York Kielder Series, and the Stratford & York Rulland Series.

## PAINTING SURFACES

Another huge part of my painting process is what I choose to paint on—wood. Specifically, I paint on birch plywood panels that are $\frac{1}{4}$- to $\frac{1}{2}$-inch thick. Many people ask me why I do this. Before making the switch, I used to work on canvas. Cotton canvases often come gessoed and stretched over a wood frame. They are flexible and white, so you start completely blank. You often have to be mindful of your hand pressure because you can easily dent the canvas. Pop Surrealists like Audrey Kawasaki and Amy Sol inspired my switch to wood. They were painting on wood and using the wood grain in their paintings, giving them a unique and fresh take. I was completely enthralled by their results, so I bought a piece of plywood, created my first painting on it, and fell in love! These panels can be purchased from multiple sources—online at Trekell.com, at Opus Art Supplies stores, and even at your local lumber store. In the beginning, I would go to my local hardware store and pick out huge sheets of birchwood. Birchwood is the lightest wood and takes paint really well. You don't want to choose a wood that has very dark wood grain or you'll find yourself using a lot of paint to cover it up. I spend lots of time looking at the grains on panels and picking just the right one. After that, I have it cut into many smaller pieces. Doing so saves money, but requires a few extra steps.

You can't paint on rough wood, so make sure to sand your wood canvases with sandpaper or an electric sander. Don't oversand them though. The more you sand, the more texture you remove. Wood that is too smooth will make it difficult for the paint to absorb into it. Trekell panels are already cut, sanded, and ready to go!

Painting on wood is very different than painting on stretched canvas. The wood is absorbent and stiff, so it forces you to do a lot of layering; however, it also allows you to work with the grain in interesting ways. Each wood grain is different and absorbs color differently. Some will take red really well, while others will blend really well with blues. It keeps you on your toes, but gives you a range that may even surprise you.

## EASELS

Easels are an important part of an artist's tool kit. Why do you need one? Why can't you just paint flat on a table?

The perspective you work in is very important. If you work flat, you see your painting at a very different angle than you will when it is mounted on the wall. Easels prop up your painting so that it faces you directly, thereby giving you the perfect perspective for painting.

There are many kinds of easels. I have two—one is a tabletop easel that I can use on my kitchen table and the other is a standing easel that I keep at my outside studio. The tabletop easel is great for smaller pieces and if you want to move around and switch locations with ease. My standing easel is perfect for larger paintings. When I want to sit and paint, I will adjust the height of my chair and easel.

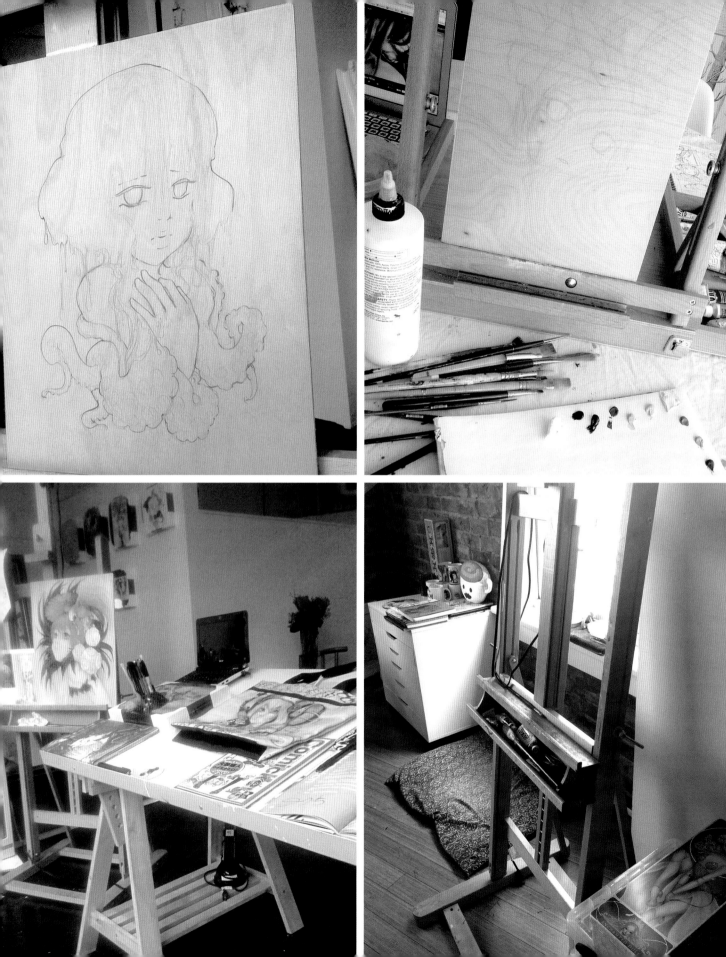

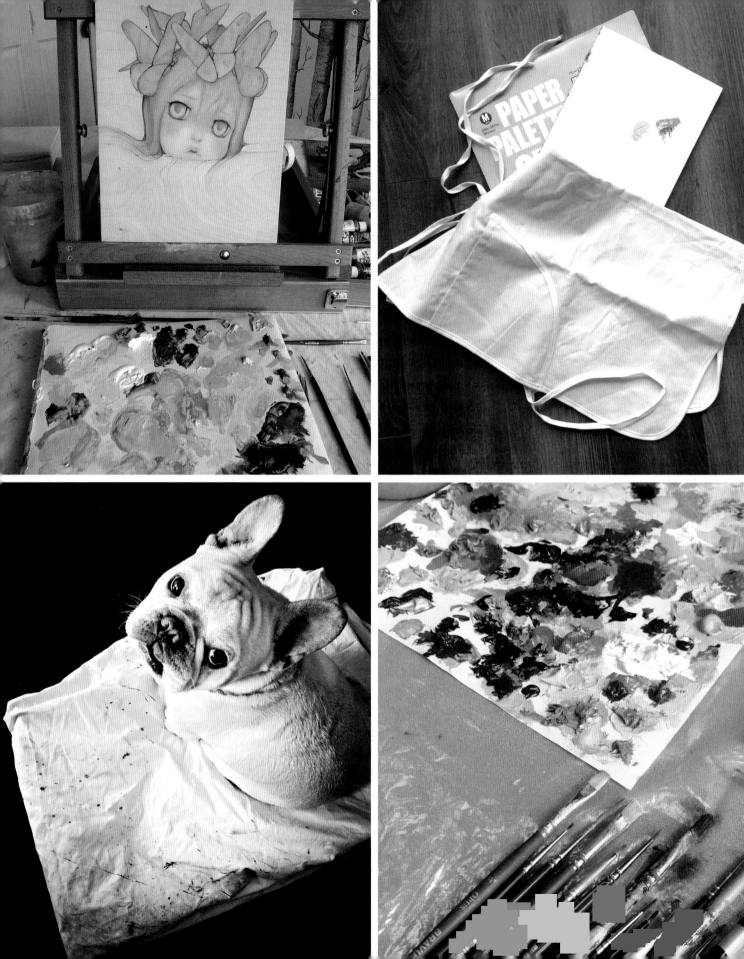

## OTHER HELPFUL TOOLS

**Drop sheet** You'll need to make sure that when you paint, you protect your space from paint splatters and other messes. Use a drop sheet to avoid any damage. It can be a plastic sheet, a tarp, a large piece of thick fabric—any large covering. I use an old bedsheet that would have been thrown out, but I repurposed it. Reuse and recycle!

**Container** You'll need a container for your mixing water. You'll use it when you need to clean your brushes, when switching colors, and also when you need to thin out your paint. Infact, try to have two containers so that the water dish you use for mixing is clean and untainted. I use an old porcelain pitcher or an old yogurt container for my water dish. It's great finding uses for objects you'd otherwise just throw away. We need to be mindful of our planet, so before you throw a container or dishcloth away, think about how you could use that for your studio!

**Dishcloth** I also use an old dishcloth or cloth napkin to clean my brushes while I work. Using cotton rags is great, because they don't have any fibers that stick to your paintbrushes (unlike paper towels, which will leave bits of debris in your brushes).

**Apron** I wear an apron while painting so I stay as clean as possible, not that it keeps my hands from getting filthy.

**Daylight lamp** One of the best items you can have in your tool kit is a daylight lamp that you can use when working in a dark studio or at night. Buy a regular lamp and replace the bulb with a daylight bulb available at an art supply store. This is how I work at night!

**Projector** Another neat tool I use is a projector. This little baby is perfect for those times when you don't want to redraw your sketch on canvas and you'd rather use the drawing you've created. A projector will enlarge your drawing, and project it on the canvas. Then you can slowly trace your projected sketch onto the canvas, using your watercolor pencil. Voilà! Your sketch is now on your canvas.

## SELECTING YOUR TOOLS

I've had a lot of years to learn which materials work best for me—it's important that you take your time to find the right paints and surfaces that work for you. When I first started painting I worked with acrylics, traditional oils, and gouache, and found that I could achieve the style I wanted. It was through trial and error that I discovered the Holbein Duo oils worked best for me. So don't let just one type of paint get you down. Try and try again until you find your favourite medium and rock it!

As you can see on the opposite page, Loki is a big fan of my drop sheet!

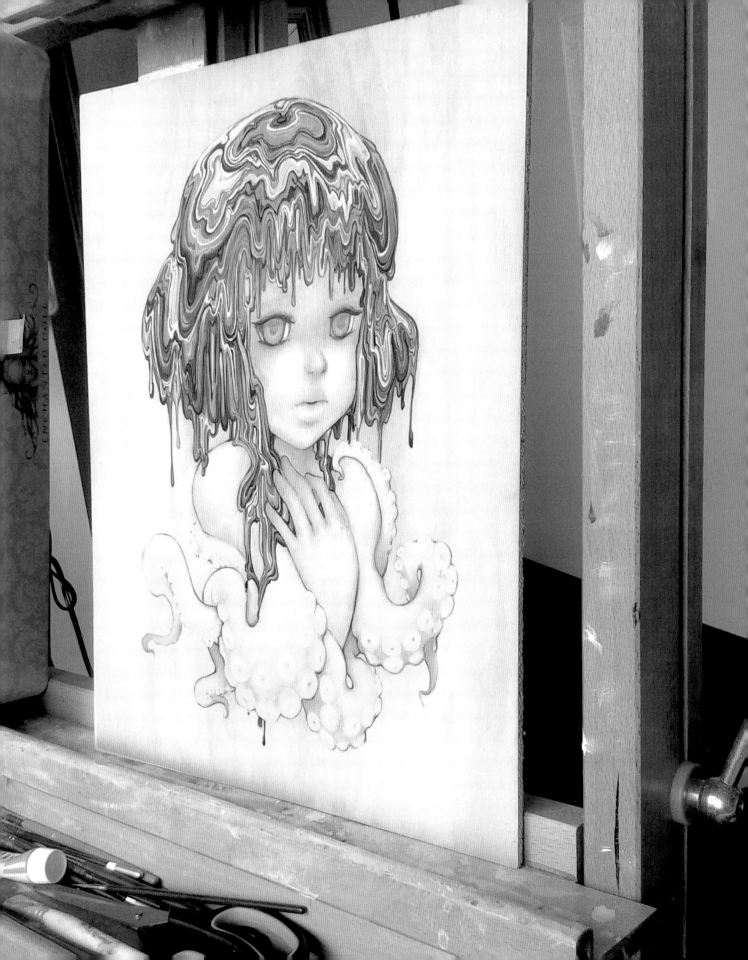

# 4  THE ARTIST'S STUDIO

My studio is my personal Fortress of Solitude, minus the muscled man in a cape and all the ice. Every artist needs a studio. Whether it's at home, in a shed, or in an office, the studio is a place that is sacred ground for all artists. Mine is my sanctuary, my isolation chamber. The only exception is my little French bulldog Loki—he's my little studio buddy and follows me around like my shadow. Plus he's cute and squishy and wears outfits that make me giggle.

I am the kind of artist that needs absolutely zero human interaction and outside noise in order for me to focus and create. I know how that sounds, like I'm a cranky old woman shooing kids off her lawn; however, I'm just particular in the way I set things up—I can't help it if my inner artist is a hermit!

There are many kinds of artist's studios, collectives, and shared spaces. Some are controlled spaces that have no windows and use regulated lighting. There are also home offices. Then there are those studios that are forged in whatever space the artist could find (for example, the kitchen table, the walk-in closet, or a corner of the living room). Whatever space you find yourself creating art in, that is your art bubble, your happy place.

Set up your studio for maximum creativity. I fill my studio with all sorts of artwork. In fact, I have a library of art books and manga that help to jump-start my creativity. I'll post whatever images I think are amazing and inspiring around my space, along with anime figures, vinyl toys, and chibi characters that I've collected. There's nothing quite as adorable as a chibi Sasuke plush staring at you while you paint and draw!

# SETUP

There are a few things that you need to consider when setting up your studio. It's important to get the feeling of the space to match the organization of it. You can be as comfortable as a pig in a blanket, but if you can't find what you're looking for you'll get frustrated really quickly. So make sure that you put a lot of thought into your space so that it becomes your den of creativity and maximizes your productivity.

## LIGHTING

Let's touch on lighting first, as it is one of the biggest challenges for an artist. I love natural light; however, it creates a challenge because the light changes throughout the day. I'm forced to shift around my space to catch the right amount of light for working. Still, I love windows, open spaces, and watching the birds fly by— they're a part of my creative process. Nature inspires me; I can't close myself off in a space that is just four walls, so even if I have to move around in my space to capture the correct natural light, it is worth it for me.

There are sealed artist studios that have track lighting and fixtures that perfectly light the space. These are great, as you never have to worry about getting the right kind of light. They also help when working at night. But they do take time to set up.

A lot of people ask me how I can paint at night. I use lamps with daylight bulbs, which can be purchased at art supply stores. They are a great advantage for the night-owl artist because they create artificial daylight, which helps for rendering accurate colors that match up in the daytime. It's amazing how technology has advanced and made it possible for artists to create anytime, anywhere.

It's important to remember what happens to artwork outside of the studio—it will look different in each place you put it. Gallery lighting, natural light in a home, or the relative absence of light in a darkened hallway are all different, so be prepared to see your piece change. Remember that no matter how you light your space, ultimately your painting will find a home in a totally different lighted area.

Loki and I love terrorizing Camilla in the studio—she keeps it clean and we make it messy! After all, he's not named after the god of mischief for nothing!

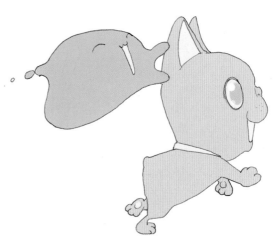

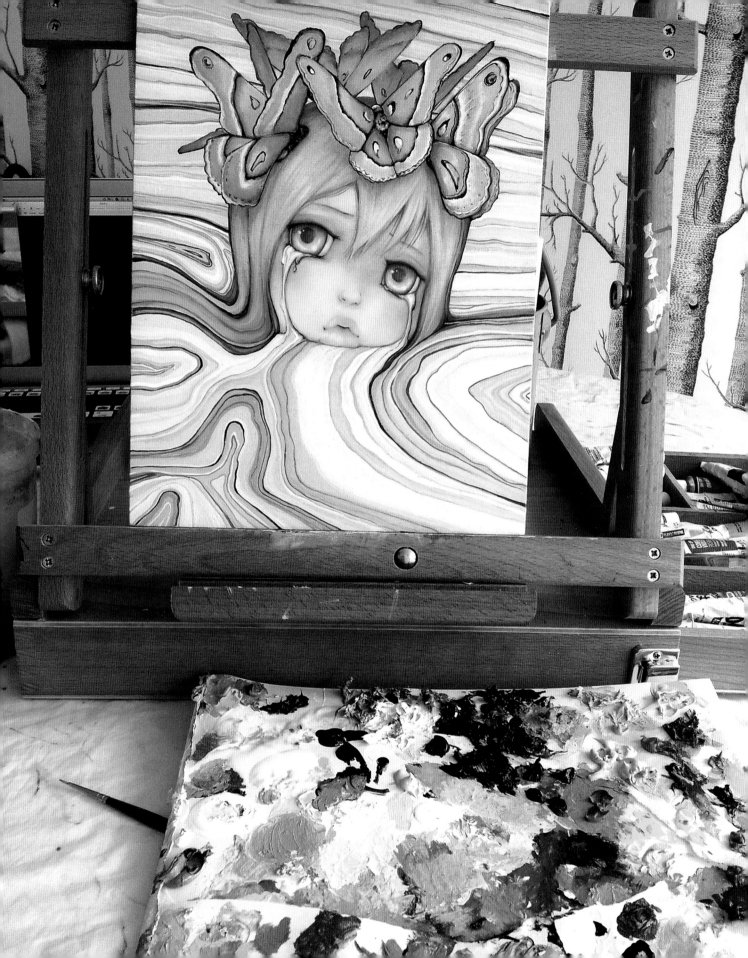

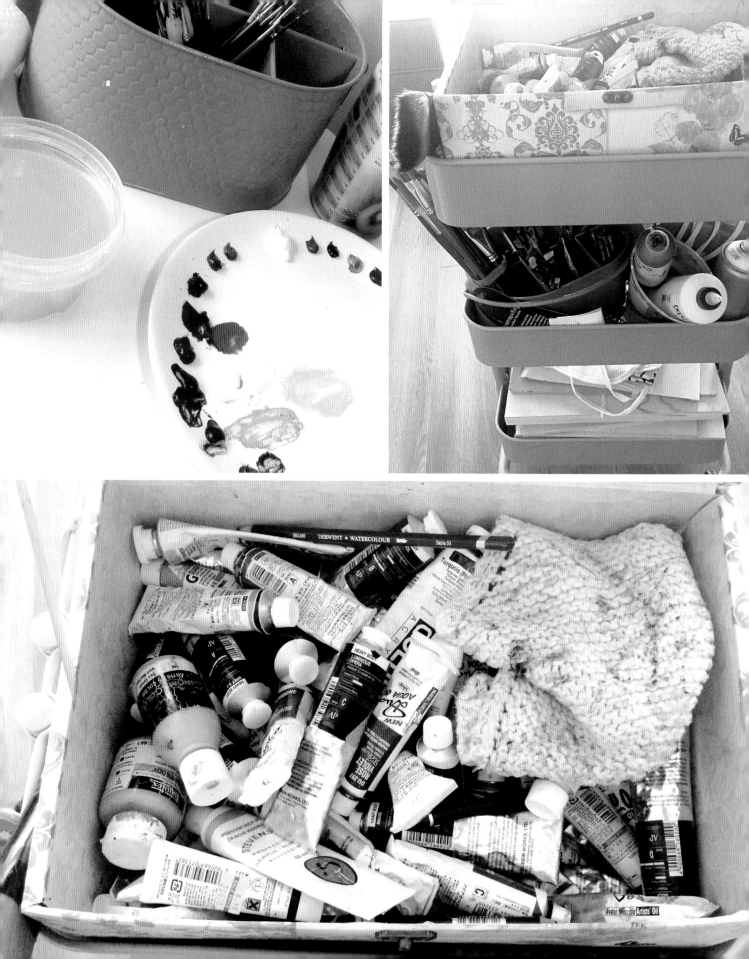

### DRYING TIME

One important factor to keep in mind when you're blending is the drying time, which will vary depending on the paint you use. For example, Holbein Duo oils dry faster than regular oils, but slower than acrylics. Paints' drying times depend on how thick they are. Usually, I wouldn't take more than ten minutes before I start applying the next layer if the previous one is thin. However, there are definitely times when I've put a thick amount on the canvas, and it's taken about three days before it was completely dry. Remember: the thicker the layer, the more time it will take to dry.

### FIXING PAINT THAT'S TOO LIGHT OR TOO DARK

What happens when you paint something too dark or too light? That's a job for *superblending!*

The best way to blend in lighter colors and darker colors is to dab your paint on the area. Doing so will give you a good sense of whether the color works in that area. If it doesn't, you can immediately swipe it off either with your finger or with a cloth. If the color works, then you can use a brush with acrylic glazing medium (AGM) and pull the colors into the next layer. Now if you paint your shadows too dark and want to lighten them up, it's not a problem. You'll just mix in the darkest color you used and add an opaque lighter color and blend them over top.

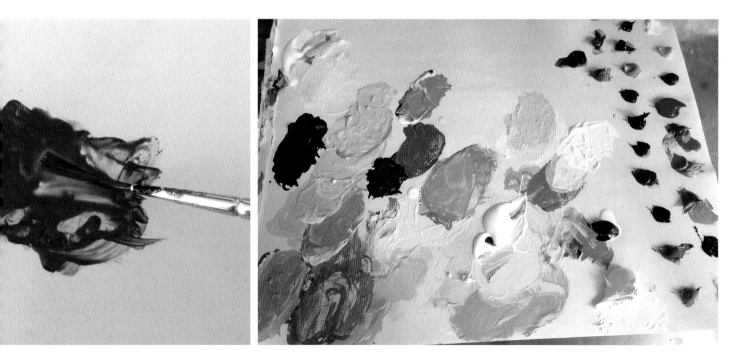

## SMOOTHING LAYERS OF BRUSHSTROKES

I use two methods to smooth out the layers of brushstrokes. The first is to apply the color with my paintbrush, and then gently pull the paint along until there is no more color. Then I will go back to the thickest part of the color and pull it along again until there is no more paint to thin out. The second is to use a clean, dry brush to pull the paint out and blend it into the layer. You can either load it with acrylic glazing medium (AGM) or leave it dry. It all depends on the thickness of your color. Believe it or not, I will use my fingers occasionally to blend the paint. Sometimes when I make a mistake, I'll scoop the paint away with my index finger. Other times, it's more like applying makeup—I just dab my finger along the paint until I smooth it out.

## SMOOTH COLOR TRANSITIONS

Blending completely different colors together in a smooth gradient/transition is all about layering! To blend two colors together and seamlessly transition from one to the other, you need to have a starting point and an ending point. Start with one color that you like and apply it to your painting, then add in a little bit of the second color, and mix the two together on your palette. Apply a small amount of the mixed color on top of the one you just used on your painting. Then, with gentle strokes, pull the paint away from the bottom layer and along the surface of the canvas. Then mix your colors again, repeating the process of mixing a little bit of the second color to the mixed one. Next, apply another thin layer over what you painted. Continue this technique until you get to the point where your color is undiluted.

Another way to blend layers is to apply one of the colors first, starting with a thick amount of paint, and then pulling the color along your canvas, thinning it out with acrylic glazing medium (AGM) or water. Then, you can clean off your brush and apply the second color on the opposite end of the area, again starting with a thick layer that you pull out and thin with AGM or water. The transparency of the layers will help blend them together.

## BLENDING IN SHADOWS

Blending in shadows can get tricky. The most important thing to remember when blending in your darker colors to your lighter areas is that transparency of the paint is essential. There are paint colors that are opaque and others that are transparent. Opaque colors are ones that you can't see through and that hide the colors underneath them. I've found that using transparent colors works beautifully for painting in shadows, because they still reveal the texture and a small amount of color from the layer underneath them.

I love when Camilla blends me with acrylic glazing medium. I feel so smooth and thin—and it tickles!

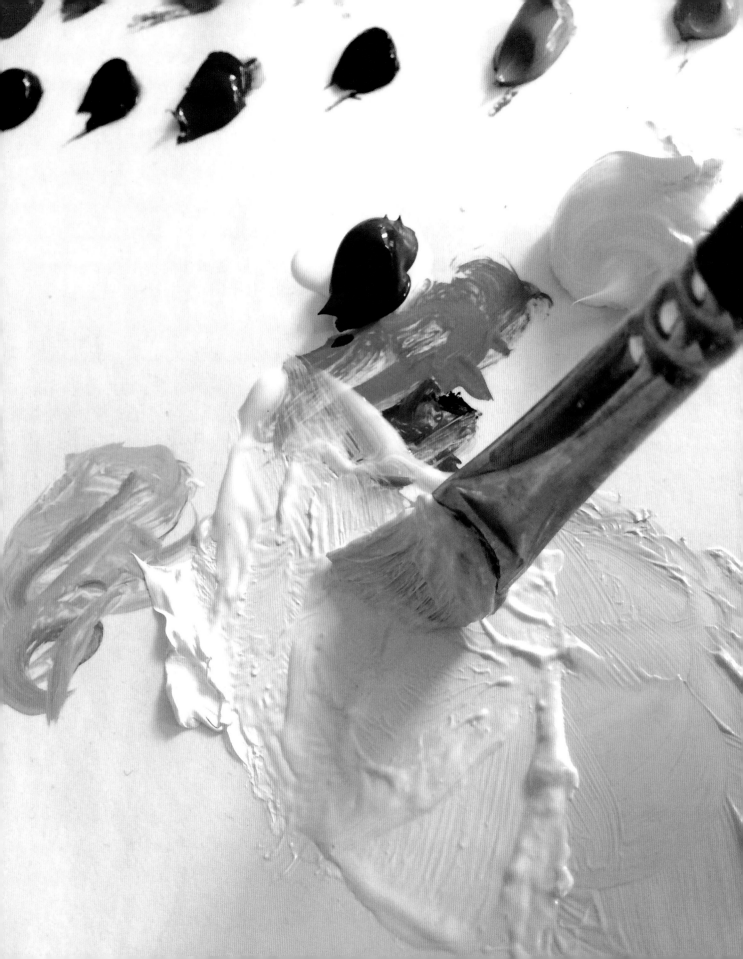

## USING WET-ON-WET AND DRY BRUSH TECHNIQUES

I'm a big fan of trying all sorts of techniques when I paint. I use various blending methods to achieve the best looks for my paintings. Each one will give a different look. *Wet-on-wet technique* is commonly used with oils—it's what I mostly use for my paintings. With this technique, I paint a new layer over a wet layer of paint. This application helps create a smooth transition from the bottom layer to the new one. I use this technique in many different ways. I use it to layer smooth textures, and also for creating fur. If I want to create an impasto look, then wet-on-wet is the way to go. (*Impasto* means adding very thick paint strokes.)

On the other hand, dry brushing will give you a different look altogether. Dry brushing is great for creating rougher textures. For this technique, your paintbrush must be dry and free of any solvents or liquids. Load up your bristles with paint and then brush thick coats onto your canvas, spreading the paint around. The bristles will leave a rough texture and the paint will pick up on the texture of the canvas, whether it's wood or cotton.

## BLENDING BACKGROUNDS

The way that I paint in my backgrounds is by using a technique called *washing*. This results in background colors that are soft and floaty. It lets me show the wood grain through the paint (without showing the brushstrokes), which I like doing because the wood grain adds a nice texture and organic feel to my pieces.

If I want to have a very soft and unified look, I take clean water and a large fan brush, then I wet the wood in the areas that will be the background. You don't want to soak the wood because it will warp; however, you'll have to be fast because the wood will dry out quickly! Once I've wet the background area, I work quickly to apply my washes. You can take a tiny little container, fill it

with water, and then add a bit of color. I mix the color in roughly, so that there are still some small globs of paint on the brush. Starting from the top of the panel, I use broad strokes to apply the wash. I go top to bottom, because the water will run downward. You'll see that the colors will mix in with the damp wood and spread. Remember: you don't want to soak the wood, so add in your backgrounds in stages.

## BLEND, SET, GO!

Blending is a true art unto itself. Remember, just take your time. Blending is all about patience and training your hand. Even the greatest masters had difficulty blending. If you're having a discouraging blending day, just try and imagine Leonardo da Vinci flipping out over the neck shading of the *Mona Lisa*. That should help get you back on track!

# LIGHT AND SHADOWS

I want to give you a basic idea of how to deal with lighting. Light is an essential weapon in your painting arsenal. Light = drama! Intensities of light and its effects are used in many different ways by artists. I'm in the soft and indirect light camp. Generally, I don't add a strong light source. That is part of my soft, ambiguous style— the girls I paint exist in a well-lit environment. Even though I don't have strong light casting huge shadows on my girls, I do understand shadows, highlights, and low lights and how to manipulate the lighting to achieve the kind of emotion and drama that I seek.

## LIGHTS, CAMERA, AND ACTION!

Let's shine some light on lighting, shall we? First, you should know that you will need more white paint than any other tube of paint. White paint will be your best friend, trust me! There are different kinds of white paint to choose from, but I stick with titanium white as my go-to for mixing. It's bright and opaque, and I love how it mixes.

Creating lighting in your painting is all about source, direction, and intensity. There are all kinds of light: ambient light, sunlight, direct light, spotlight, and so on. Each one gives your painting a totally different look. I generally paint with ambient light. I prefer it because it's a softer light that doesn't cast strong or dark shadows. I also suggest you choose a direction that the light is coming from. I'll switch from top left in one painting to top right in another, based on my composition. If your light source comes from below, it will create an eerie look.

## HIGHLIGHTS

Highlights are another big part of lighting and shadow. They help define the intensity of the light, reflectiveness of the surface, and depth of the shadows. Painting solid white in your highlights is okay.

## REFLECTIVE LIGHT

Another thing to consider is reflective light. Reflective light is a secondary source of color that you can paint on your elements. The colors come from surrounding objects or the background. If your character is wearing pink, then the reflected light on your character will be pinkish or reddish. Reflected light can come from multiple sources. Not only objects reflect light—backgrounds do, too. So, if you have a green background, it will reflect green light on your elements.

## LIGHT SOURCES

The first thing you need to ask yourself is, *Where is the light coming from? Why?* Where the light is coming from will change the direction and intensity of your shadows. The stronger the light source, the bigger the shadows. The closer the light source, the brighter the highlights and the darker the shadows.

## SHADOWS

Shadows are multifaceted. They can be barely there to almost black. Note that you want to be careful with the intensity of the shadows. Paint large areas too dark and you might create a black hole—an area that will suck the viewer into an abyss. This isn't *Star Trek*, so let's avoid black holes and leave them for Kirk and Spock to explore. Shadowed areas that have too much contrast when compared to the rest of the image, or that are too large and black, create dead space in your piece. That's a bad thing.

A misconception about shadows is that they are black. However, when you stop and examine a shadow in real life, it is full of color (albeit it darker color)! I never, ever mix black into my paintings, unless it's for a black-and-white painting. The darkest color that I use is Payne's gray, which is a mixture of black and ultramarine blue. Shadows capture a wide variety of rich colors—a whole bunch more than you might believe. Painting a natural

shadow is all about mixing colors that complement your elements, and taking the opportunity to mix even more color into your painting. Use blues, purples, reds, and greens, instead of black, and you'll see how much more intense and enriched your image becomes.

## STUDY PHOTOGRAPHY AND ART

I've found that a great way to learn about lighting and shadows is to study photography. You'll be able to see how light affects objects that are solid, semitransparent, and those that are metallic and glossy. Shadows are superdynamic and change colors depending on the light as well. So, make sure you study the kind of lighting you want to use and make notes. The best way to learn is to study and apply!

Some of my favorite shadows are the ones cast on sand or snow. There is something so magical about seeing a blue shadow over white tundra and purple shadows spread over sandy beaches.

I don't work with heavy shadows or intense lighting, but there are many artists who do, including some of my favorites from the Renaissance. Raphael and Leonardo da Vinci are amazing examples of artists who captured rich, intense lighting in their portraits. Pop Surrealists like Lori Earley, Mark Ryden, and Greg Simkins rock shadows and dramatic light like no one's business! Check out their work if you want to sink your teeth into some dramatic portraits.

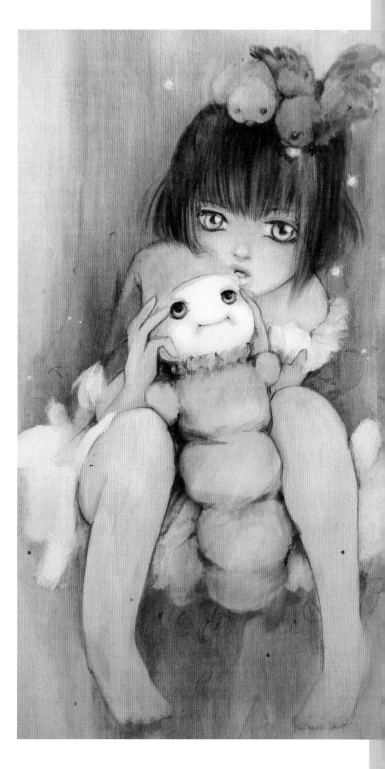

# DEPTH: AN IN-DEPTH LOOK

Making a two-dimensional painting look 3D is all about depth and rendering the elements in a way that makes them feel as if they are layered on top of each other. To make something look like it has mass and occupies space, you need to create that depth by playing with the shadows and light source, as well as with edges.

## OVERLAPPING OBJECTS

It's tricky to make a 2D image look 3D, because it lacks that third dimension. However, there are techniques for tricking the eye into seeing a flat painting as 3D. Overlapping objects is one of the most basic ways to show depth. Having things in front and behind others will show distance in your painting.

## COLORS

Colors can also show depth. There are cool and warm colors. Warm colors are hues from red to yellow, tan, and brown. Just think of colors you associate with heat, the sun, fire, and deserts. Cool colors are the opposite—blues, greens, and purples. Think about ice and water and starry nights.

The farther away the object, the cooler its colors become. If you look at a photo of mountains, you'll see that the farther the hills are, the bluer they become. Warmer colors always seem closer and cooler colors seem farther away.

## SATURATION AND VIBRANCE

It's important to understand the elements of hues and tones. Saturated colors are pure colors that don't have any white in them. So, the more saturated a color, the less white it has mixed in it. Vibrant colors are bright colors that are intense and stand out against other colors and hues. So, you can have a saturated blue that is dark versus a vibrant blue that is brighter.

## SHARPNESS

Sharpness is another qualifying way of painting depth. Objects in front will be in focus, while those that are farther away will be blurry and less in focus. So, if you paint elements that are in the distance, you don't want to paint them with a thick outline but rather with a faint outline that will make them look blurred.

## SHADOWS

Shadows are another excellent way of showing depth. When you cast a shadow, it shows distance between one object and the next. So, if I want to show an element that is behind another, I paint in a shadow and—boom!—the eye is tricked into believing that the element is separated from the object in front of it.

## HIGHLIGHTS

Highlights also play a role. Just as shadows show that objects are behind others, highlights show what is in front. Light will be brightest on the object that is closest to the light source.

Choosing a light source can be fun or it can be scary. You know what's *really* scary? The time Camilla painted *The Melting Mind* with no pants on!

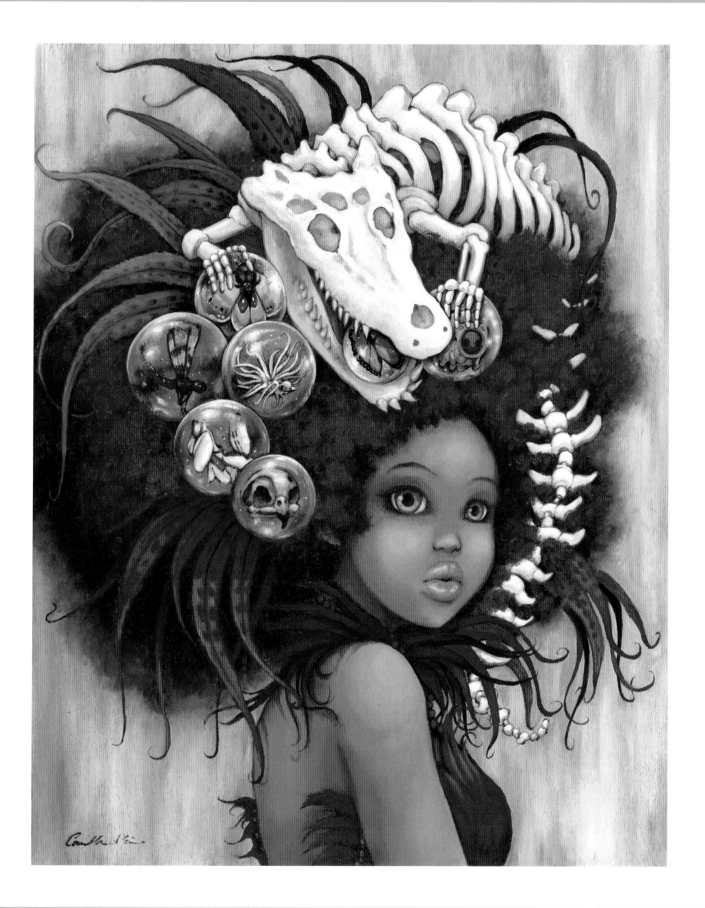

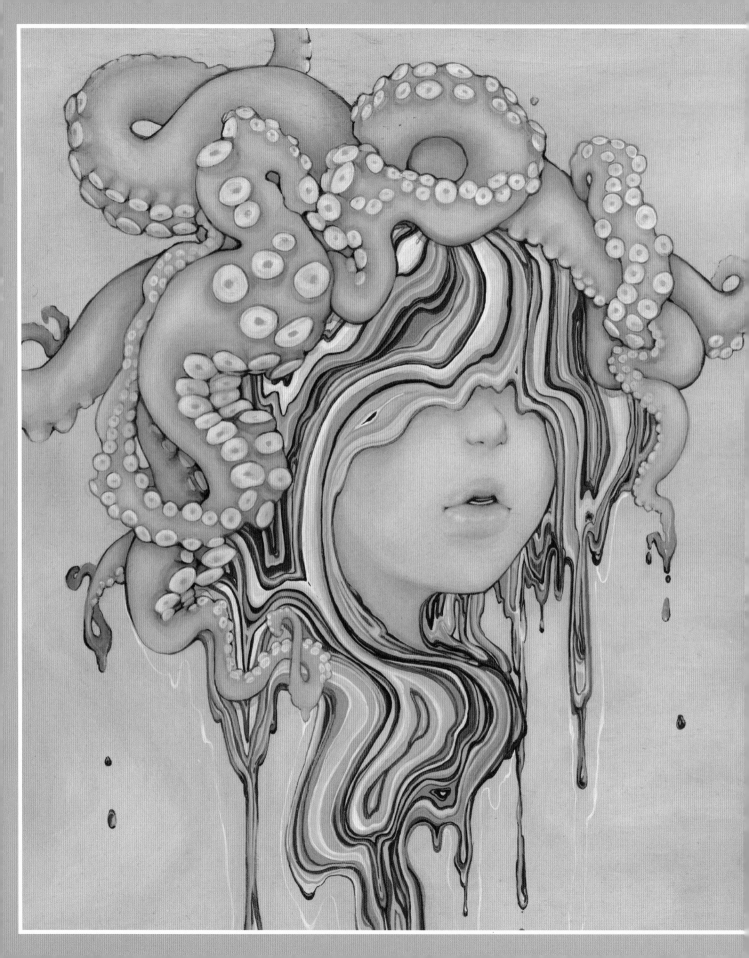

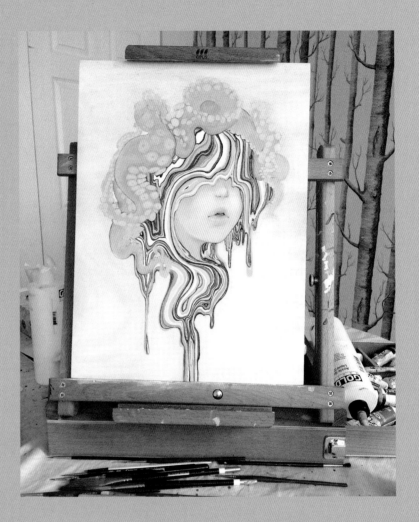

**PART 2**

# PAINTING POP SURREALISM

# TOP TEN QUESTIONS

1 **Do you lay down thicker layers of paint as a foundation, or build up slowly?** I always build my layers up slowly. The beauty of the water-soluble oils is that you can thin layers if needed, so I will work with washes of color first and then slowly add in more layers. When I add in thick layers of paint, it will be specifically for the element that I am working on and most likely one of the top layers.

2 **Do you do underpainting? How?** An *underpainting* is a preliminary layer of paint, usually just one solid color, that coats the surface of your canvas. Artists use underpainting as a base from which to build; the color they use also helps set the tone for the painting. I actually don't use an underpainting for the simple reason that I like to see the wood grain show through on my paintings. Because the wood grain already has a color, I want to work with the tones in the wood. I do paint in a light wash of color in the background sometimes. That definitely helps me set the tone for my painting.

3 **How do you decide which parts will have darker outlines?** The two darkest parts of the painting are usually the points where the shadows are the strongest and the eyes, because those elements will always be the focal points of my painting. Using dark lines definitely helps to focus the eye of the viewer, so keep that in mind; the eye will automatically go to the lightest or darkest point in a painting, so it's like you are telling the viewer where to look.

4 **How long does it take for layers to dry? What happens if I don't wait long enough and try to paint over wet parts?** With Holbein Duo oils the drying time is a lot faster than regular oils, but slower than acrylics. They'll dry slower depending on how thick you make your layers. I love painting with the Duos because they allow me to add in a thicker layer and then leave it for a day. I can then come back to it and blend it with a new layer. The thing you want to avoid is to paint a thin layer over top of a thick layer that hasn't fully dried. When paint dries, it shrinks. So when the bottom wet layer dries and shrinks, the top layer (which has solidified) will break because it's no longer flexible. Your paint is only going to crack if you use a really thick layer and paint a thin layer over the top. So be patient and wait for your layers to dry, before applying any thin layer over top.

5 **How do you decide which parts to paint first?** Deciding which part to paint first is totally up to your intuition! I have no rule for deciding where I start. It's really up to what I decide on in the moment. Sometimes, I know exactly what color I want the eyes to be, so I'll start there. Other times, I'm dead set on having a blushing girl, so I'll start with the rosy cheeks. There are even times when I have no idea what color I want the background to be, so I leave it until last. Other times, I want to get that background color established first. The best thing to do is to go with your gut! No rules here!

6 **What if you want to add or remove a big element halfway through the painting process?** Because of the nature of painting on wood, removing paint is much harder than adding paint. Wood soaks up paint, and some colors will stain the wood grain. No matter what you do, you can never fully erase it. If you want to try to remove the element, start by putting the painting flat on the table (you don't want any drips ruining the rest of your painting). With a flat-tipped paintbrush, start to blend water into the area you don't like. (It's kind of like reverse blending.) With some pressure, circle your brush around, and when you see the paint starting to blur, take a cloth and dab it in the area, gently lifting off the paint. Keep adding a little bit of

water and swirling your brush and taking away the excess paint with the cloth. Eventually, you should be able to get down to the wood grain. Keep in mind that whenever you add water to wood, it breaks up the softness of the grain. Therefore, the affected area will be a little rough now. Hopefully, you've been able to remove enough paint that you can start over.

On the other hand, adding things is much easier! Duo oils are opaque, which means that you can add layers of one on top of other colors and you won't be able to see underneath it. I don't suggest you put a big, thick layer down, but instead slowly build up your layers. The beautiful thing about painting is that you can never add too much paint! In fact, there have been a lot of cases of painters painting an entirely new image over the top of a finished painting. Believe me, there are times when I've repainted a girl's face five times before I got it right.

**7** **The surface of my canvas got scratched. What do I do?** Scratches are tricky, since they are cuts that completely damage the painting. There is no easy fix here, so you have one of two options to consider. (1) Repaint the area. It sucks, I know. However, it will be almost impossible for you to remix the exact colors that you used in the painting. (2) Add in a new element in the scratch. Use it to your advantage. Someone once said, "There are no accidents, just new opportunities." So, make lemonade out of those lemons. A scratch can turn into a strand of hair, a feather, or a tear—anything is possible!

**8** **How long does it take to create a finished painting?** One thing you need to know about painting is that it takes time—lots of time. I know the lessons in this book will make it seem like I painted each of the step-by-steps in an hour; however, all the

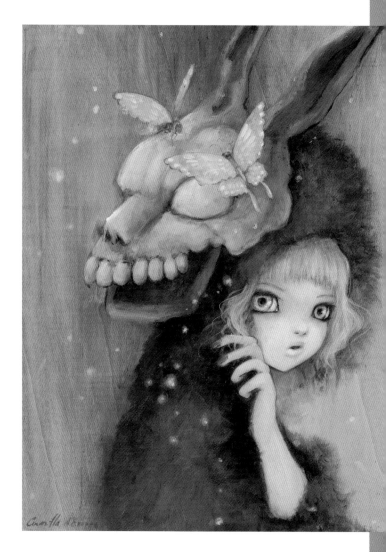

paintings in this book were done over many hours and many days. A typical painting typically takes me a couple of weeks to complete. I usually spend about six hours per session. The first layers of your painting will always be rough, but don't get discouraged. If you don't like the rough stage—what I call the ugly duckling phase—remember that it'll take a few more painting sessions to get through it. Once you are past the midway phase, I find the painting goes faster. I gain more confidence once the elements are in place and I've chosen the colors. Give yourself time to complete your painting and expect to spend several days, weeks, maybe even a month, on it. Patience is a virtue!

9 **How do you seal/protect the surface after you finish painting?** Once you have finished your painting, you will need to protect it from dust and UV light. Over time, light will fade the colors, and dust and debris will collect on the surface of a painting, eventually ruining your masterpiece. There are a lot of varnishes on the market. There are ones that you can spray on and ones you can brush on. Matte, gloss, and even semigloss varnishes are some of the options for finishing your paintings.

I prefer a semigloss finish, and I also prefer brushing the varnish on rather than spraying it. For me, it's about getting an even coat. The liquid varnishes are thicker, so I only use one coat rather than the two or three needed with a spray varnish. I use Golden Polymer Varnish with UVLS. I love how it gives a nice sheen to the painting without altering the colors.

One very important thing to know about sealing your painting is that it first needs to set before you varnish it. Acrylics need a twenty-four hour period from your last brushstroke until you varnish it. If you use Duos, then you need to wait at least seventy-two hours from the point the paint has dried. Since the water-soluble oils take longer to dry, you want to make sure that they have set completely before you seal them. Otherwise the paint will crack, and you don't want that.

If you use a spray varnish, then make sure to do it in a very well-ventilated area and wear a dust mask so you don't breathe the varnish in. Meanwhile, brushing on varnish has some requirements that spraying doesn't. First, lay a plastic sheet underneath your painting. (The last thing you want to do is ruin your floor!) Use a wide-tipped brush and follow the varnish instructions, mixing the varnish with the right amount of water. Again, make sure that your room is well ventilated and as clean as possible. Human hair, animal hair, dust, and little bits of fibers will stick to your varnish like flypaper, and you'll never be able to remove them. Dip your brush in the varnish mixture and, with a smooth and unbroken stroke, run the varnish down your painting in sections. You do *not* want to spread the mixture on your painting and mix it with your brush. You want to use the least amount of strokes; otherwise, the varnish will bubble and that's not good. If you do get bits of dust or lint or even your own hair in the varnish when it's wet, you have very little time to take it out. Use a clean brush to pluck the bits out. Believe me, all the effort is totally worth it! The varnish will add a beautiful sheen to your painting, protecting it from the sun and from time itself!

10 **How do you take your photos/scans afterward? What kind of scanner is best?** Properly documenting your artwork is superimportant! When I first started as a gallery artist, I didn't have my paintings scanned or photographed. So, there are actually a lot of my works that I can't share with anyone; it's a real shame. Eventually, I got on board the archiving boat! What you need to do is find a professional scanning company that specializes in documenting artwork. Trust me, it will be worth the cost to make sure that you have a color-corrected digital file of your painting. Make sure that when you have a file, it is a high resolution dpi (dots per inch)—300 to 600 dpi will be best.

The most important question of all: What's Camilla's favorite color? Me, baby! Zu is short for *azzuro*, which is Italian for teal. Booya!

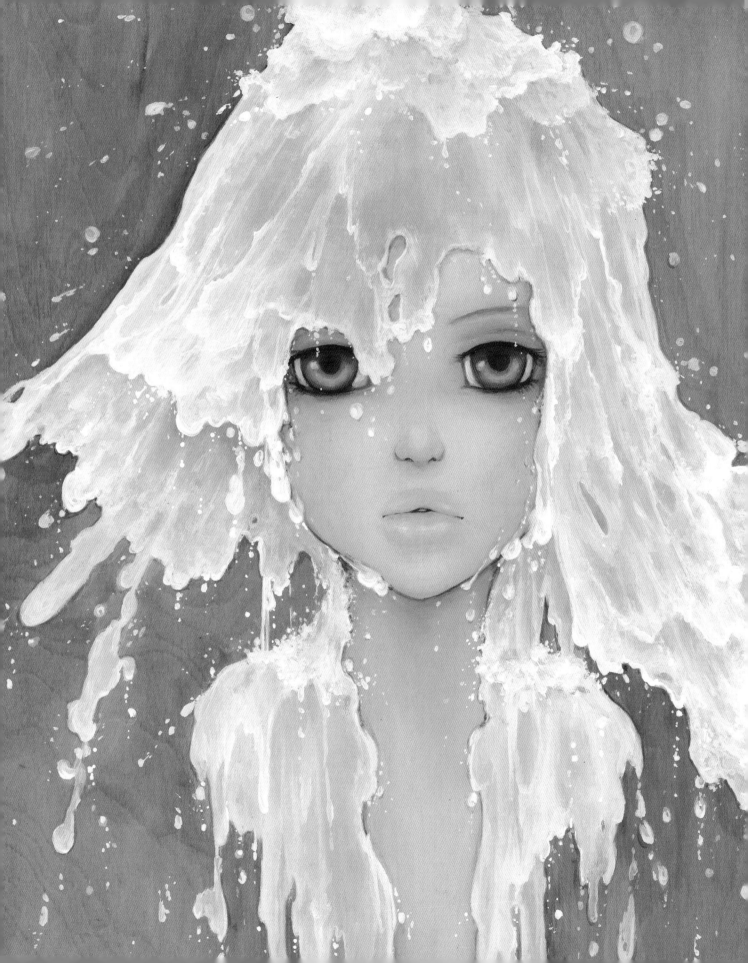

# TIPS AND TRICKS

### MAKE ART AND COLOR YOU LIFE

Does anyone else out there love color so much they wish they could eat it? Well, I sure do! I have always imagined that teal would taste the weirdest and pink the best—omigosh, imagine the sweet candied ambrosia that it would be! But let me tell you, pink does *not* taste like candy. I would know, since I tried to eat some when I was eight!

I've loved colors and art for as long as I can remember. However, my love for pop culture started the second my mother turned on the TV one fateful Saturday morning. *My Little Pony*, *Rainbow Brite*, along with *Strawberry Shortcake* and her motley crew of colorful tots, each mesmerized me and transported me into a world that I never wanted to leave. And in fact, I have never left that world. I'm immersed in pop culture. From childhood to adolescence to adulthood, I've stayed young at heart because of it!

I surround myself with all kinds of art—from the works of Renaissance masters to the sea of manga and anime produced in the Far East to the paintings of present-day artists in the Pop Surrealism movement in North America and Europe. Art is my life and it is a fun one!

### EAT! DRINK! STAY ALIVE!

Remember to eat and drink when you are painting. If you're like my husband, who often forgets to eat, you'll wither away and look like a dried prune or a zombie after about ten hours of painting. I love my hubby, but it's not an attractive look! Those bags under the eyes are nasty. Don't neglect your body while being creative. Make sure to stay hydrated. If you can't break for lunch or dinner, have healthy snacks to munch on so you can keep your energy up. Cherry tomatoes, grapes, and raw almonds are some of my favs! They are chock-full of nutrients, and don't leave a mess (unlike, say, eating lasagna).

### NO DISTRACTIONS

Don't distract yourself! Stay off YouTube and Facebook when you paint or you'll get sucked into the abyss that is the Interweb, where one minute can easily turn into two hours. It's bad news bears, I'm telling ya! Trust me—I know from experience. And actually I'm still guilty of it sometimes.

The lure of the sun can also pull you away from painting. It's hard to tell yourself that you can't go outside when you make your own hours. But stay focused, especially if this is your career. Distractions will only cut into your painting time and that means you'll have to sacrifice other hours and days to make up for it.

### AUDIO ENTERTAINMENT

I like to listen to music while I paint. If I feel bored of listening to songs I've heard before, I'll switch to an audiobook. Audio entertainment is a fantastic way to engage your brain, while your eyes stay focused on the work. Granted, a really good audiobook can captivate you and you might pause to enjoy a minute or two, but ultimately it's much better than putting on an anime or your favorite TV show. Then all you'll do is watch and take your eyes away from what you're painting.

### WHAT TO WEAR

What should you wear while painting? Well, anything and even nothing, if you dare! Just make sure that what you wear is comfortable and that it is nothing that you plan on keeping clean. Even the most meticulous and fastidious painter will inevitably get paint on herself. When I paint, I like to use an apron and some cruddy clothes I don't mind getting dirty.

## STAY ACTIVE

Make sure to get exercise so your body doesn't suffer from the countless hours of being hunched over and immobile! Remember to stretch. Put your hands behind your back and intertwine your fingers and touch your palms together like you're holding a pencil. This exercise will pull your shoulders back and strengthen your spine!

## THE WITCHING HOUR

You've probably heard the saying "Artists are night owls." Well, it's true. But don't let that stop you from painting in the morning. I work at the oddest hours. I'll jump up wide awake at 7 a.m. and paint for hours, and other times I'll paint so late that I hear the sounds of birds chirping, and then realize the light coming in my studio is from the sunrise.

When creativity strikes, seize that moment and paint— no matter what time it is. Unless, of course, you have to go to school or a job or have commitments the next day. Recovering from an all-nighter is no picnic!

## FOCUS, DANG IT!

Find something to focus on—whether it's your deadline, the audiobook you are listening to that you really, *really* want to hear the end of, or the progress you are making on your painting. It's almost impossible to paint when your mind is cluttered with things you have to do. A good way to focus is to get everything out of the way first—e-mails, chores, exercise, and so on. That way, when you sit down to paint there is nothing pulling your mind away from you and the beautiful canvas in front of you.

## GIVE YOURSELF A BREAK

One of the most important rules for an artist is *TAKE A BREAK!* I know how all-consuming art can be. Boy, when I get on a roll, it's like the world just disappears and time ceases to exist. It's not healthy to work for too many hours straight. You need to recharge, stretch your legs, and step away from your painting. Not only is it good for your health to take a break, but it's also important for the creative process. Sometimes artists get tunnel vision when we paint for too long. So while being on a roll is usually a good thing, it can also blind us to mistakes that we might be making. I've been there and done that! Trust me, even though you might think you are creating magic, you may actually be making a mess! Every couple hours, set aside the paintbrush, take off the apron, and step away from your painting. You'll thank me for it!

Want a tip? Hold your painting up to a mirror: the reflection will reveal anything that's distorted. So will turning the canvas upside down. Don't ask me how or why, I'm just a temp.

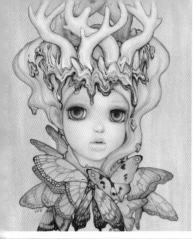 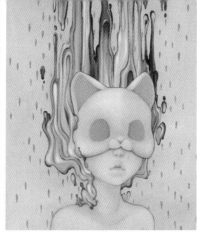  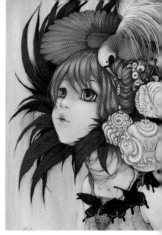

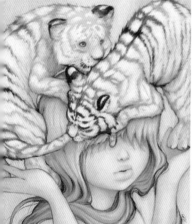 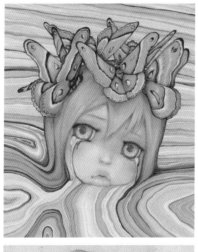  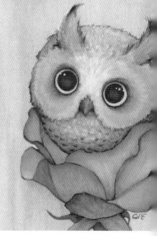

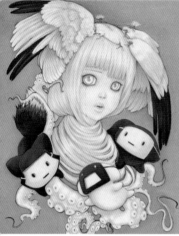 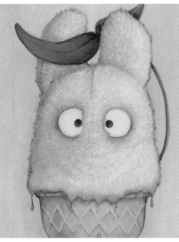  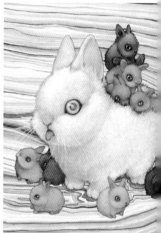

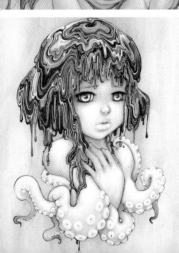 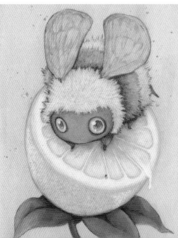  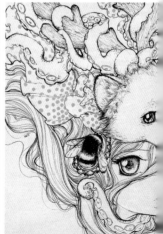

# 10 STEP-BY-STEP EXAMPLES

So are you guys ready to learn how I create my paintings now? Well, I hope so, because I'm ready to put paint to canvas! I've broken down these examples into a few sections: Humans, Animals, Melting Effects, and Twisting Reality.

Remember that paintings are not like drawings. They take much longer to create—days and weeks even—so don't rush. Take each step and focus on it until you are ready to move on to the next one. These featured paintings each took me a long time to create. So remember, guys: patience is a virtue! I'll be here to help and so will Zu!

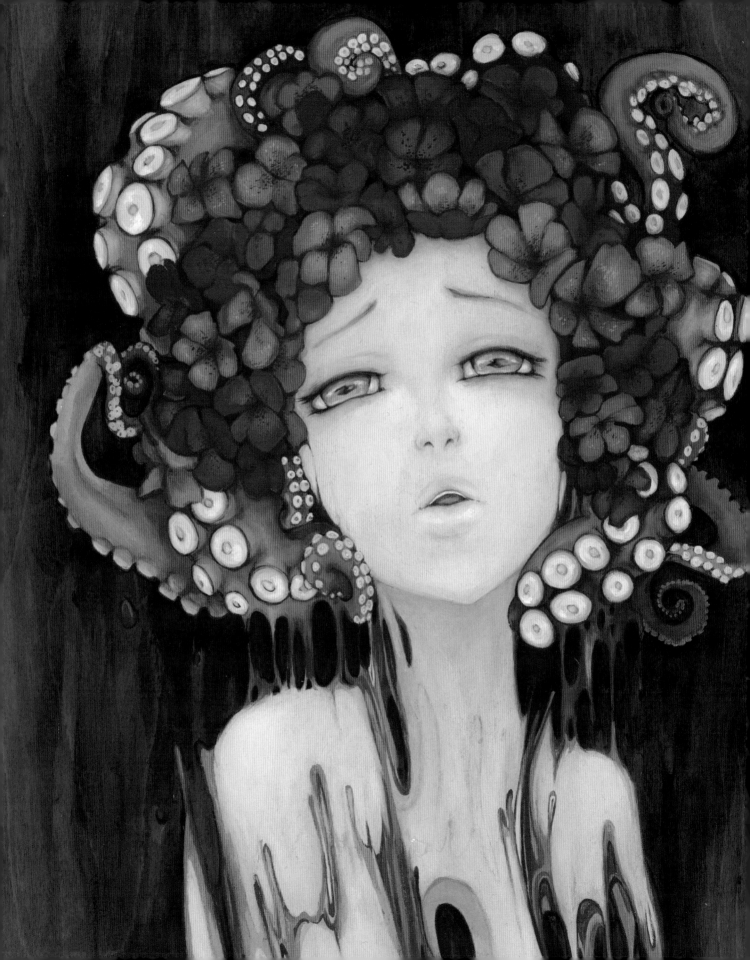

# HUMANS

One of my teachers in college once told me that I couldn't paint people very well. He said the man I painted looked like "he was a man under the sea" . . . I still don't know what that means. So trust me when I tell you that it takes time and practice to render a portrait. The secret is to take apart the various facets of the character you are painting. In this section, I'll show you how to do that! Start small. Learn how to paint specific areas, like the eyes, lips, and so on. I'll also show you how I paint skin tones, which I know are a big issue for a lot of artists. The colors I use aren't as important as the techniques. You can choose any color you want for eyes, hair, or skin; however, I'll show you one color theme for each lesson and then once you've mastered the techniques behind the lesson, go wild! Paint a purple girl with silver hair if you want . . . hmm, that's a good idea . . . I might just do that. Come on, Zu, we're going painting!

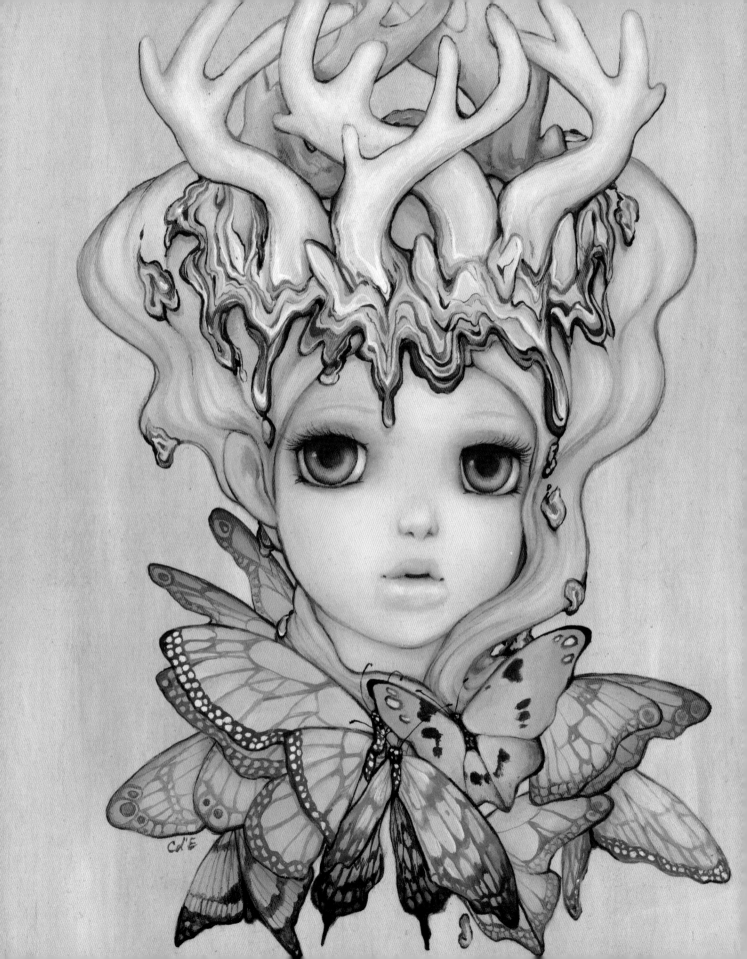

# EYES

Some say that eyes are the windows to the soul. That principle holds true for paintings as well. What connects you and me to the essence of a painting is often that longing stare, that wistful look, or that penetrating gaze of the subject. Painting round-, big-eyed girls is what I am best known for—blending the classic doe-eyed manga girl with a Renaissance portrait painting style. I think that my girls span the edges of the Japanese and European styles, resulting in a unique look. I try creating things that don't necessarily exist in nature, like orange and pink eyes. This is a style that I have developed over a decade of painting. When you create *your* paintings, keep in mind that they come from your heart and soul, so take your time to create a look and style that is unique to you.

Painting eyes is a process that takes patience—lots of patience. It is the part of my girls that I spend most of my time on, because it is the part of the painting that I want to pop, to catch the attention of viewers and make them fall in love with the girl they are seeing. Pop Surrealism is all about twisting the normal—like the eyes—into something fantastical. So, let's jump in!

### Tips

A good way to understand eyes is to have photographic reference while you paint. Gather imagery of eyes and study the colors in them. You'll see that a lot of eyes have multiple colors in them, so don't be afraid to add in little bits of other colors!

Use muted and vibrant colors when painting your eyes. The contrast in the colors will really make the eyes pop!

Most people tend to use a little too much paint, so try to mix your Duo oils with acrylic glazing medium (AGM) to thin the paints out. Also, add in as little paint as possible with each new layer. It'll help you with your blending and saves you money, too!

STEP 1 I start with the underdrawing, done with a watercolor pencil. You want to choose a color that will complement the overall tone of your painting. Don't worry if you change your mind about what colors to use—the underdrawing will be covered up eventually. I choose a brown color for my underdrawing.

STEP 2 Next, I outline the shape of the eyes. I mix acrylic paint with water to thin it out so that it creates a smooth stroke. It can be hard to hold the brush steady (with my old, shaky hands over here), so I recommend holding the brush near the very tip. This helps you maintain a solid grip and steadies your stroke.

STEP 3 To outline the eyes, I use a very fine paintbrush, usually a liner brush. The thinner the line you can get, the better. Add water until you achieve the right consistency. I use Holbein quinacridone gold and burnt sienna at this step.

STEP 4 Focusing on the eye only, I want to contour the shape now. I do so by adding in the whites of the eye. This gives the viewer a sense of which direction the character is looking. For this piece, I want her to look slightly to the left, so I add in my white to the right side of the eye with a small sliver on the left.

The bigger and rounder the eyes, the more innocent your character will look. See? Aren't I adorable now?

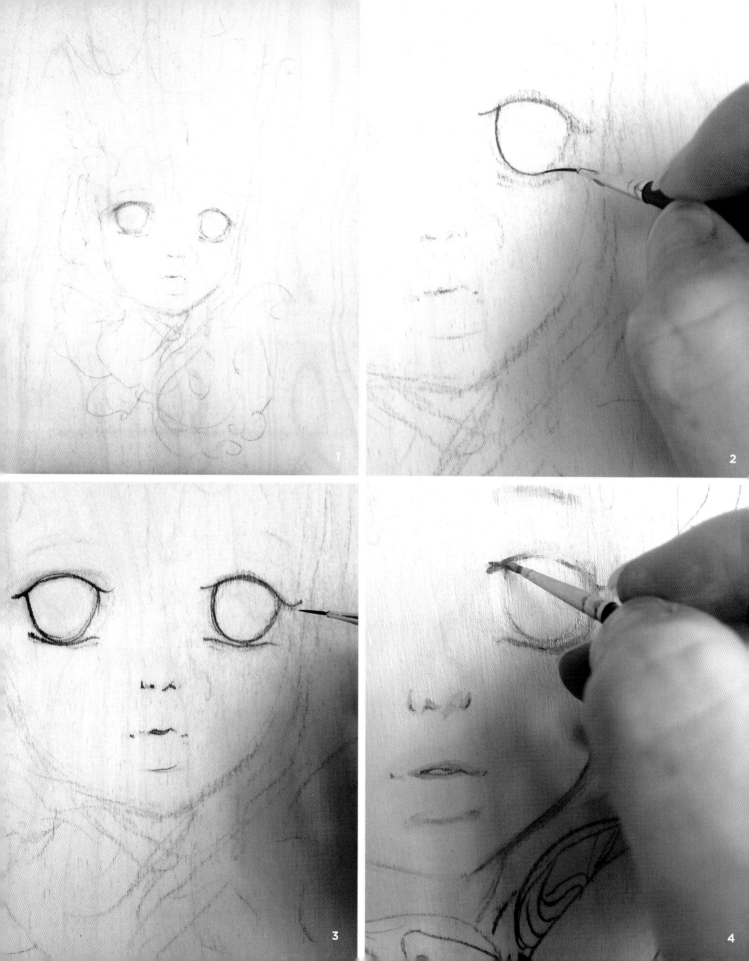

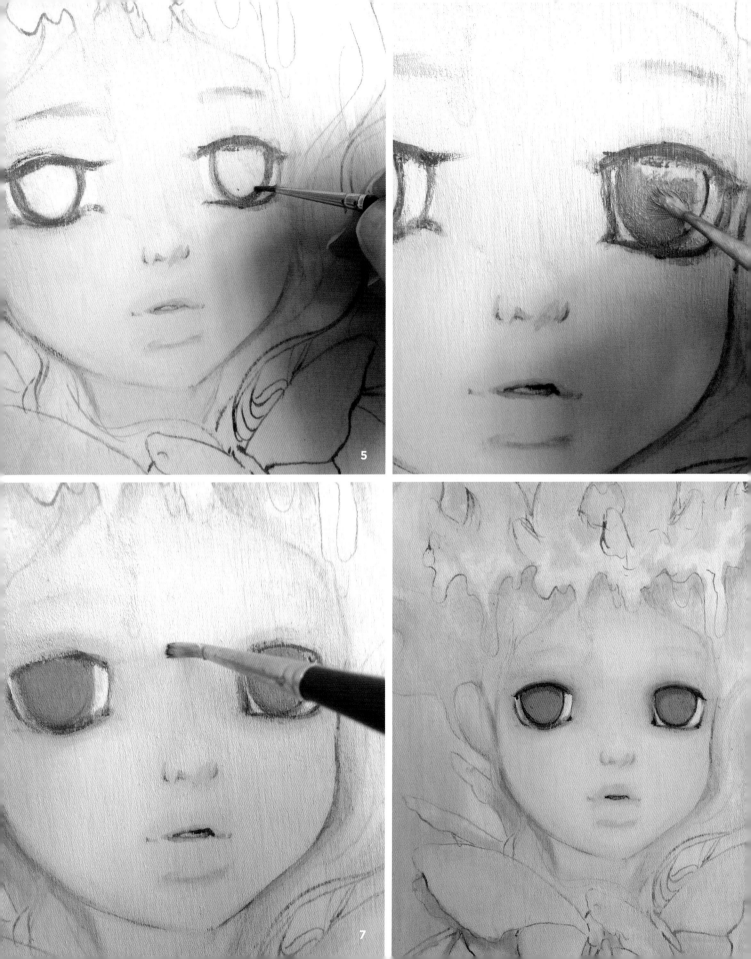

STEP 5 What's a girl without a little bit of eyeliner? I find the best way to define the eyes is to add a thick layer of dark paint along the top eyeline and then trace the iris with that same darker paint. It may seem like a dramatic look, but it's only the starting point. It will be covered up eventually.

STEP 6 Eyes are all about layering and more layering. You have to combine neutral and vivid colors to create a lush eye that looks alive. I start out with a neutral color as a base and then fill in the total iris. For this stage, I'm mindful not to use a vibrant tone but rather a more pastel, neutral color. You should choose a neutral color that will be the halfway point between the darkest and the lightest color. Sometimes I'll go through a few colors before I land on the one that feels right!

STEP 7 As the painting develops, I know that it's okay to switch from the eye to the skin and vice versa. At this point, I want to soften those lines that were painted over. Using skin tones, I add a thin layer over the dark lines. This blends the lash line with the eyelid, and looks supersexy!

STEP 8 It's time to start filling in the eye! I mix a darker shade of my base color. Starting from the top of the iris, I work thin layers downward, gradating the darker color gradually, to the iris.

**STEP 9** Now it's time to get that pupil painted! The pupil is generally in the center of the iris. I find where the center should be and make my mark! Painting the pupil subtly gives a soft look to the eye, so don't just put down one big dark dot. The pupil is a tricky part of the eye, and the one I find the most difficult. I use a light stroke and paint half of the pupil in first. Remember to use a dark color (but not black) for the pupil.

**STEP 10** I blend the colors while they are still wet, and continue to darken the upper part of the iris. This is a time when you can use more vibrant and saturated colors. I recommend blending the paint over the pupil, as you fill in the iris. It makes it looks cohesive. Don't be afraid to blend in the colors in the eye. The more layers, the more depth there will be.

**STEP 11** I now outline the iris with a color similar to the one I used for the pupil. I add in a bit of definition on the upper eyebrow and the corners of the eye. It's a good time to add in some shadows to the white of the eye. Don't just mix black and white to make gray. Add in a bit of blue or yellow for the shadow. This tiny addition of color produces a more natural shadow.

**STEP 12** It's important to remember what's on the outside (of the eye). Painting around the eye is as important as painting the iris. I like to give a bit of coloring to my girls, so I blend small amounts of color with the skin tones, and then gently blend them around the eye. This requires a few layers of painting over the outlines. The part of the eye that I want to pop is the colorful iris, so I make sure it is strongly outlined with a darker shade—never black, but always the darkest shade of the iris color.

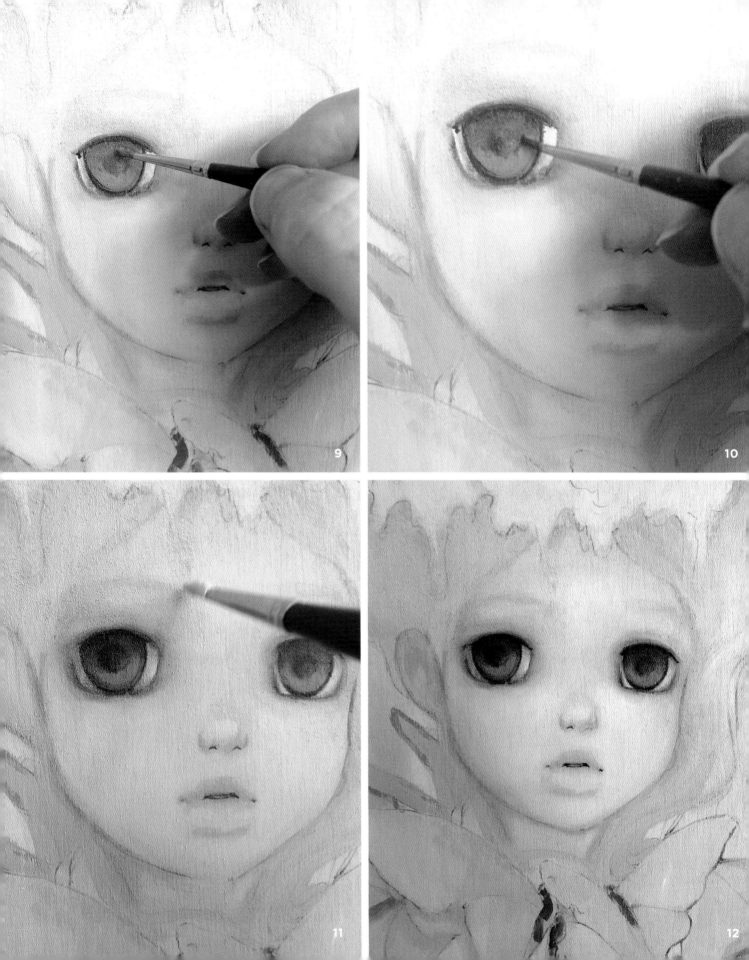

9

10

11

12

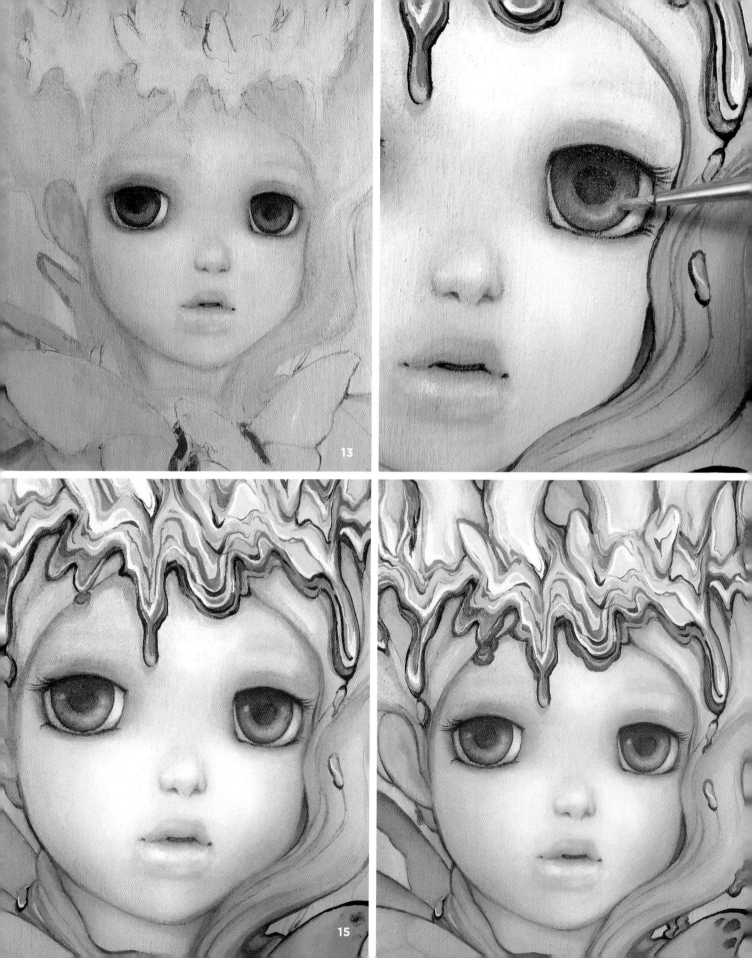

13

15

STEP 13 At this stage, it's good to establish more of the outside details of the eye. I blend in what one could describe as eye shadow. I suggest you choose colors that will complement the tone of your eyes.

STEP 14 It's time to add in some highlights to the eye. Here is where you can choose a light color, perhaps a lighter version of the base color or a more vibrant, lighter shade of a contrasting color. I choose a salmon pink. I dab the color on with a shorter bristled paintbrush, and make sure to stay between the pupil and the edge of the iris. I build up the lightness in the eye by blending the light color with the base color. I continue by adding even lighter tones to that area of the eye. I like to mix slightly different shades to add depth to the lighter part of the eye. You can use more vibrant shades, including both cooler and warmer tones, at this step.

STEP 15 I add in one small highlight to the corner of the eye. This highlight is both the brightest color in the eye, but also the smallest. Don't just add a pure white dot. You want to mix the white with a little bit of the color from the iris. This helps blend it and makes it appear less out of place. I also add more color to the highlights of the eyes here.

STEP 16 The pupil has many layers to it as well. As you can see, I choose to give a dark edge on one side and a lighter edge on the other. For more depth, I also add the most saturated colors in the pupil, while blending the highlights so they look smooth.

When finishing the eye, you want to paint in the eyelashes and contour the eye as well as the iris. And then, voilà! You're all done! Don't be fooled by the steps here, painting the eyes takes hours, many layers, and patience. Don't rush it. Remember: the eyes are the windows to the soul, so take your time.

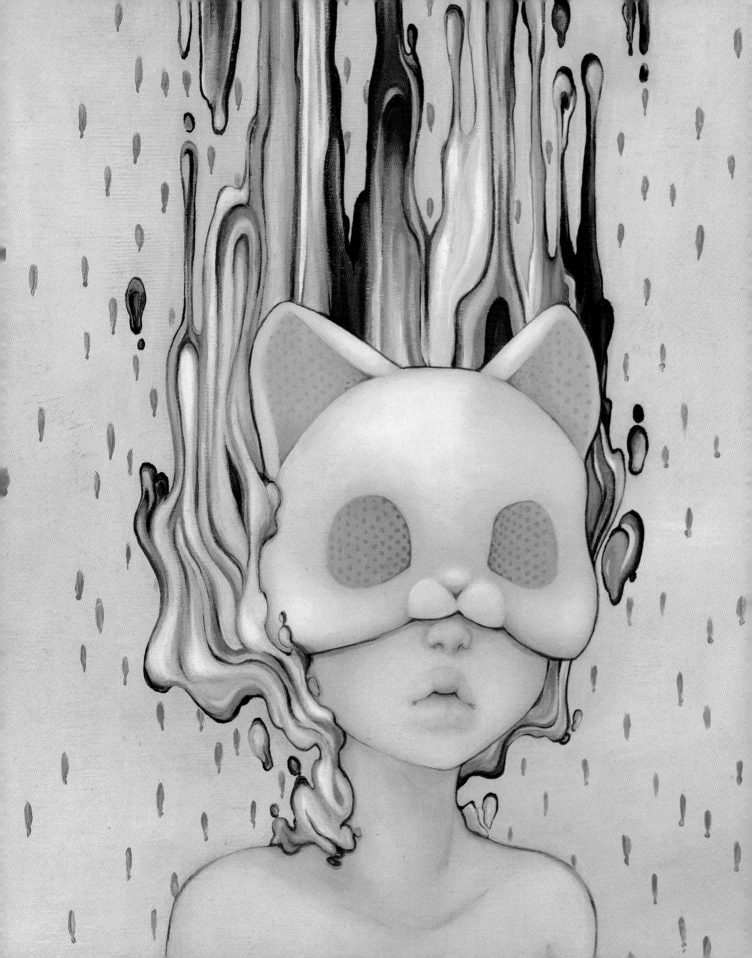

# LIPS

Plump, juicy, and delicious—no, I'm not talking about food. I'm talking about lips, baby! Eyes express the soul, but lips express emotions. A subtle smile, a little pout, a frown—all of these details bring to life a person's emotion.

Manga aesthetics simplify facial features, especially the lips. Mostly manga artists just draw the opening of the mouths. By simply painting in lips, I blend genres and define my own style. I just can't help it. With so many kinds of lips, it was too tempting not to fall in love with painting plump lips that even Angelina Jolie would envy!

So, how does one paint a pouty COVERGIRL-style mouth? Follow along with this step-by-step example and you'll see that it's not as daunting as you might think. While this particular example is for painting big, pouty lips, remember that these steps can apply to any size lips!

---

**Tip**

Lips should be a different shade of pink than the skin tone, so add in cooler or warmer tones of pink to the lips and do not use those in the rest of the skin.

---

**STEP 1** First, I draw in my figure and her lips with a watercolor pencil. Then I trace the drawing with a very thin line of paint using a liner brush. The trick to full, pouty lips is to start off with the line of the mouth. You should draw the mouth wider than the upper and bottom lip line. I make the corners of the mouth curve slightly down. Keep in mind that the more you curve the line down, the more upset the expression will look; the more you curve upward, the happier the expression will be.

**STEP 2** When painting a pouty mouth, you want to leave a small gap so it looks like the girl's mouth is slightly open. Doing so gives a bit of life and movement to the expression. It also shows that she is breathing. (You can even add in a thin line for teeth if you want.) Once I've finished outlining my figure, I erase the watercolor lines with a cotton rag. A white eraser will also work.

**STEP 3** I can't just paint the lips and then fill in the face later. I have to paint everything at once so that it all blends together. I use very thin layers of skin tone, thinning it out with either water or acrylic glazing medium (AGM) and brushing the paint lightly over the entire face. I add in lighter layers of skin tone on the cheeks and use that same lighter color for the lips. I start at the center of the lips and pull outward to the corner of the mouth.

**STEP 4** As I add in my darker shades of pink, I make the center of the lips the darkest color and lighten the tone at the top of the lip. I also paint in a shadow under the bottom lip, which is a darker shade of pink. This helps to give some real depth to those juicy lips!

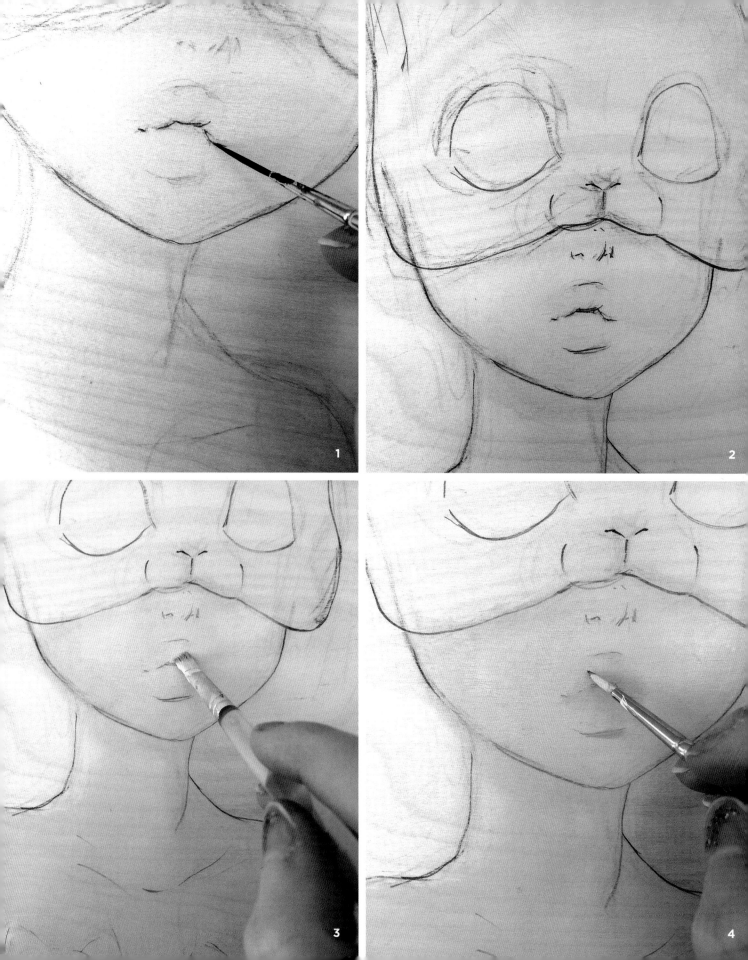

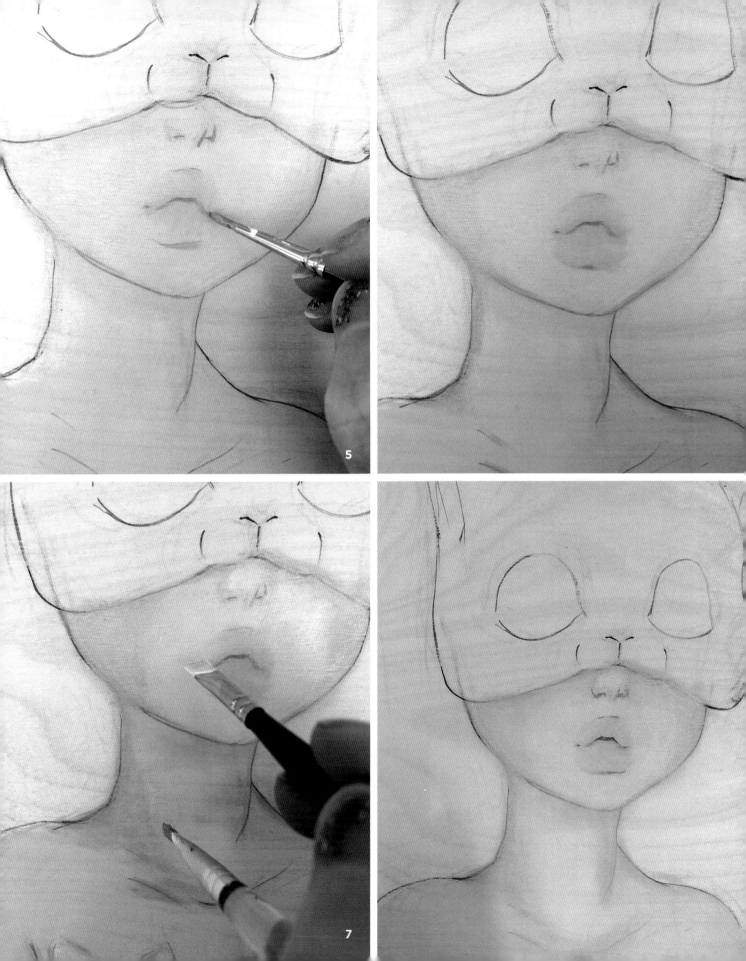

# Table of Contents

*Introduction* ......................................................... *1*

About This Book........................................................1
Conventions Used in This Book......................................2
What You Don't Have to Read........................................3
Foolish Assumptions..................................................3
How This Book Is Organized.........................................3
    Part I: Dealing with the Diagnosis of Celiac Disease.........4
    Part II: How Celiac Disease Can Make You Feel ..............4
    Part III: Treating Celiac Disease ................................4
    Part IV: The Long Term: Living and Thriving with Celiac Disease.....4
    Part V: The Part of Tens .........................................5
    Part VI: Appendixes .............................................5
Icons Used in This Book ..............................................5
Where to Go from Here................................................6

*Part 1: Dealing with the Diagnosis of Celiac Disease* ....... *7*

**Chapter 1: Finding Out You Have Celiac Disease**...................9

Getting to Know Celiac Disease .....................................9
Dealing with the Diagnosis of Celiac Disease.....................10
Knowing How Having Celiac Disease Feels ........................12
Treating Celiac Disease..............................................12
Living and Thriving with Celiac Disease...........................13
Handling the News...................................................14
    Experiencing denial .............................................14
    Being angry.....................................................14
    Feeling sad .....................................................16
    Taking the next step ............................................16
Finding Information and Support on the Internet .................17
    Knowing whether an Internet site is reputable..............17
    Finding a celiac disease support group on the Web ........18
Looking at "Real" (Non-Virtual) Support Groups .................21

**Chapter 2: Celiac Disease and You**...............................23

Knowing What Causes Celiac Disease..............................24
    Genetic influences..............................................25
    The immune system ...........................................26
    Increased uptake of gluten by the small intestine..........29
    Environmental factors..........................................30
Examining Gluten.....................................................32
    Knowing where gluten is found...............................33
    Getting a handle on grains.....................................33

Comparing Celiac Disease, Food Allergy, and Food Intolerance.............36
Understanding How the Normal Digestive Process Works.....................37
    Getting down the gastrointestinal tract.......................................39
    Understanding what the pancreas and liver do.............................42
Knowing What Goes Wrong When You Have Celiac Disease...................43
    Changes to the structure of the small intestine...........................43
    Changes to the function of the small intestine ............................44

**Chapter 3: Diagnosing Celiac Disease.......................45**

Figuring Out Whether You Have Celiac Disease...................................46
Understanding the Importance of Symptoms.....................................46
Knowing What to Expect from the Physical Examination .....................47
Getting Blood Tests......................................................................48
    Antibody tests .......................................................................49
    Genetic testing ......................................................................53
    Other blood tests ...................................................................55
Outside Looking In: How an Endoscopy Works...................................56
    Preparing for your endoscopy ..................................................57
    Undergoing the procedure .......................................................58
    Knowing what to expect after your endoscopy .............................59
Examining What the Doctor Looks for During Your Endoscopy..............59
    Exploring your esophagus ........................................................59
    Surveying your stomach ..........................................................60
    Delving into your duodenum.....................................................60
Taking a Little Piece: Small Intestinal Biopsy ...................................61
    Interpreting a biopsy...............................................................62
    Knowing when the biopsy may potentially be wrong.....................62
    Having another small intestinal biopsy ......................................63
Diagnosing Celiac Disease When You Already Live Gluten-Free.............64
    Confirming a diagnosis of celiac disease when
      you live gluten-free.............................................................65
    The role of a gluten challenge...................................................66
Questioning Your Diagnosis............................................................67
    Second-guessing celiac disease ................................................67
    Looking for suspected celiac disease when it can't be found........68

**Chapter 4: Screening for Celiac Disease.......................71**

Knowing When to Screen Someone for Celiac Disease..........................71
Determining Who Should Be Screened for Celiac Disease .....................72
    Screening and genetic ancestry ................................................73
    Screening and symptoms.........................................................74
    Screening, personal choices, and one's stage in life .....................75
Understanding How Screening for Celiac Disease Works ......................76
    Genetic testing ......................................................................76
    Antibody testing.....................................................................77
    Knowing which test method is best for you:
      Genetic testing or antibody testing?.......................................77
Asymptomatic Celiac Disease Detected by Screening...........................77

**Chapter 5: What Type Am I? Looking at the Forms of Celiac Disease** . . . . . . . . . . . . . . . . . . . . . . . . . . . . . . . . . .**79**

What's in a Name: The Different Types of Celiac Disease . . . . . . . . . . . . . . . 79
Textbook Disease: Looking at Classical Celiac Disease . . . . . . . . . . . . . . . . . 80
Symptoms of classical celiac disease . . . . . . . . . . . . . . . . . . . . . . . . . . . . 80
Diagnosing classical celiac disease . . . . . . . . . . . . . . . . . . . . . . . . . . . . . 81
Treating classical celiac disease . . . . . . . . . . . . . . . . . . . . . . . . . . . . . . . . 81
When Symptoms Suggest Something Else:
Looking at Atypical Celiac Disease . . . . . . . . . . . . . . . . . . . . . . . . . . . . . 82
Looking at GI symptoms of atypical celiac disease . . . . . . . . . . . . . . . 83
Examining non-GI symptoms of atypical celiac disease . . . . . . . . . . . 83
Hushed but Not Forgotten: Silent Celiac Disease . . . . . . . . . . . . . . . . . . . . 87
Uncovering silent celiac disease . . . . . . . . . . . . . . . . . . . . . . . . . . . . . . . 88
Treating silent celiac disease: Should you or shouldn't you? . . . . . . . . 88
Lurking in the Background: Latent Celiac Disease . . . . . . . . . . . . . . . . . . . . 89
Deciding whether latent celiac disease should be treated . . . . . . . . . . . 90

**Part II: How Celiac Disease Can Make You Feel . . . . . . . . . . . . 91**

**Chapter 6: Symptoms of Celiac Disease** . . . . . . . . . . . . . . . . . . . . . . .**93**

Symptoms 101: Looking at the Big Picture . . . . . . . . . . . . . . . . . . . . . . . . . . 94
Gut Feelings: Gastrointestinal Symptoms . . . . . . . . . . . . . . . . . . . . . . . . . . 94
The gut stops here: Diarrhea, celiac disease, and you . . . . . . . . . . . . . 95
Olfactory challenges: Sniffing out the importance of flatulence . . . . 97
Abdominal symptoms: Belly pain, bloating, and beyond . . . . . . . . . . . 98
Reflux and heartburn . . . . . . . . . . . . . . . . . . . . . . . . . . . . . . . . . . . . . . . . 99
Indigestion . . . . . . . . . . . . . . . . . . . . . . . . . . . . . . . . . . . . . . . . . . . . . . . . 101
Weight Loss . . . . . . . . . . . . . . . . . . . . . . . . . . . . . . . . . . . . . . . . . . . . . . . . . . 102
Weight loss due to active celiac disease . . . . . . . . . . . . . . . . . . . . . . . 102
Weight loss due to the gluten-free diet . . . . . . . . . . . . . . . . . . . . . . . . 103
Weight loss due to a co-existing condition . . . . . . . . . . . . . . . . . . . . . 103
Weight loss due to a complication of celiac disease . . . . . . . . . . . . . . 103
Failure to Thrive in Children . . . . . . . . . . . . . . . . . . . . . . . . . . . . . . . . . . . . 104
Non-Gastrointestinal Symptoms and Celiac Disease . . . . . . . . . . . . . . . . 105
Rash decisions . . . . . . . . . . . . . . . . . . . . . . . . . . . . . . . . . . . . . . . . . . . . 106
Mulling over mood, thinking, and neurological issues . . . . . . . . . . . 106
Feeling fatigued . . . . . . . . . . . . . . . . . . . . . . . . . . . . . . . . . . . . . . . . . . . 107
Hormonal (endocrine) problems . . . . . . . . . . . . . . . . . . . . . . . . . . . . . 108
Musculoskeletal problems . . . . . . . . . . . . . . . . . . . . . . . . . . . . . . . . . . 108
Cancer . . . . . . . . . . . . . . . . . . . . . . . . . . . . . . . . . . . . . . . . . . . . . . . . . . . 109
Gynecological and obstetrical problems . . . . . . . . . . . . . . . . . . . . . . . 109
Other problems . . . . . . . . . . . . . . . . . . . . . . . . . . . . . . . . . . . . . . . . . . . 109

**Chapter 7: Conditions Caused by Celiac Disease** . . . . . . . . . . . . . .**111**

Vanishing Vitamins . . . . . . . . . . . . . . . . . . . . . . . . . . . . . . . . . . . . . . . . . . . . 111
Considerations about taking vitamin supplements . . . . . . . . . . . . . . 112
Vitamin A . . . . . . . . . . . . . . . . . . . . . . . . . . . . . . . . . . . . . . . . . . . . . . . . . 112

Vitamin B$_9$ (folate or folic acid)......................................................113
Vitamin B$_{12}$...............................................................................114
Vitamin D ...................................................................................115
Vitamin E....................................................................................116
Vitamin K....................................................................................116
Missing Minerals...............................................................................117
Calcium deficiency........................................................................117
Iron deficiency.............................................................................118
Other mineral deficiencies.............................................................121
Low Blood: Anemia............................................................................121
Anemia due to low iron ("iron-deficiency anemia")......................121
Anemia due to low levels of folic acid...........................................124
Anemia due to low levels of vitamin B$_{12}$ .............................124
Skeleton Isn't Just An Olympic Sport: Celiac Disease and Your Bones ......125
Osteoporosis ...............................................................................125
Rickets.......................................................................................126
Osteomalacia...............................................................................127
Oral Health ....................................................................................128
Dental health ..............................................................................128
The rest of the mouth....................................................................129
Infertility and Complications of Pregnancy.........................................129
Hyposplenism and Increased Risk of Infection.....................................130

**Chapter 8: Conditions Associated with Celiac Disease . . . . . . . . . . .131**
Understanding What "Associated" Means .............................................132
Skin Deep: Dermatological Conditions ................................................132
Dermatitis herpetiformis ..............................................................133
Vitiligo .......................................................................................136
Psoriasis.....................................................................................137
Eczema .......................................................................................137
Feeling Down in the Dumps: Depression..............................................138
Getting a Head Start: Neurological Manifestations ...............................139
Migraine headache .......................................................................139
Peripheral neuropathy ..................................................................140
Ataxia.........................................................................................140
Epilepsy (seizures) .......................................................................141
Attention-Deficit/Hyperactivity Disorder (ADHD).......................141
Autism ........................................................................................142
Hormonal Health: Endocrine Disorders and Celiac Disease....................143
Type 1 diabetes............................................................................143
Thyroid disease............................................................................145
Adrenal insufficiency (Addison's disease) .......................................147
Disjointed: Rheumatologic Disorders .................................................148
Connective tissue disorders...........................................................149
Fibromyalgia ...............................................................................152
Raynaud's phenomenon .................................................................153
Liver and Bile Duct Conditions ..........................................................153
Abnormal liver enzyme levels.........................................................154
Primary biliary cirrhosis................................................................154

Autoimmune hepatitis................................................155
Primary sclerosing cholangitis............................155
Chromosomal Disorders...............................................156
Down syndrome..............................................................156
Turner syndrome.............................................................157
IgA Deficiency.......................................................................157

**Chapter 9: Celiac Disease and Cancer...........................159**
Assessing How Great the Increased Risk Is............................160
Factors influencing your risk of cancer.........................161
Possible reasons for an increased risk of cancer...........162
Looking at the Types of Cancer for Which You Are at Increased Risk....162
Enteropathy-associated T cell lymphoma....................163
Other lymphomas..........................................................165
Small intestine adenocarcinoma..................................166
Oropharyngeal cancer....................................................166
Esophageal cancer...........................................................167
Other cancers and celiac disease..................................167
Screening for Cancer...................................................................168
Preventing Cancer.......................................................................169

**Part III: Treating Celiac Disease ............................... 171**

**Chapter 10: Treating Celiac Disease with a Gluten-Free Diet.......173**
Going Gluten-Free.........................................................................174
Knowing what "gluten-free" means................................174
Knowing whether you need to eliminate
    other things besides gluten.......................................175
Examining the reasons for a gluten-free diet................176
Understanding the downsides of a gluten-free diet......177
Getting help.....................................................................178
Shopping Successfully for Gluten-Free Foods..........................180
Cooking Gluten-Free Food.........................................................182
Baking your own gluten-free food.................................183
Planning meals for the newly diagnosed.....................184
Eating Out Gluten-Free...............................................................185
Eating in restaurants .....................................................185
Traveling with celiac disease.........................................187
Visiting friends and family............................................188
Planning for Emergencies...........................................................189
Dealing with Cross-Contamination...........................................190
Sticking with a Gluten-Free Diet................................................191
Tracking Down Hidden Sources of Gluten................................192
Checking the ingredients of prescription medications......192
Verifying the ingredients of over-the-counter medications.....192
Knowing other sources of gluten ..................................193

**Chapter 11: Exploring Other Nutritional Considerations** . . . . . . . . . .**195**

Understanding Nutritional Deficiencies in Celiac Disease . . . . . . . . . . . . . . . . . . . . 195
Malnutrition in celiac disease . . . . . . . . . . . . . . . . . . . . . . . . . . . . . . . . . . . . 196
Looking at common nutritional challenges . . . . . . . . . . . . . . . . . . . . . . . 197
Being Overweight and Having Celiac Disease . . . . . . . . . . . . . . . . . . . . . . . . . . . 203
Celiac Disease and Lactose Intolerance . . . . . . . . . . . . . . . . . . . . . . . . . . . . . . . 203
Who gets lactose intolerance? . . . . . . . . . . . . . . . . . . . . . . . . . . . . . . . . . 204
How lactose intolerance makes you feel . . . . . . . . . . . . . . . . . . . . . . . . . 204
Celiac disease and your lactase levels . . . . . . . . . . . . . . . . . . . . . . . . . . 204
Diagnosing lactose intolerance . . . . . . . . . . . . . . . . . . . . . . . . . . . . . . . . 205
Treating lactose intolerance . . . . . . . . . . . . . . . . . . . . . . . . . . . . . . . . . . . 206
Living Gluten-Free as a Vegetarian . . . . . . . . . . . . . . . . . . . . . . . . . . . . . . . . . . 207

**Chapter 12: Are You Responding to Your Gluten-Free
Diet? (And What to Do If You Aren't)** . . . . . . . . . . . . . . . . . . . . . . . . . .**209**

Knowing Whether Your Gluten-Free Diet Is Working . . . . . . . . . . . . . . . . . . . . . 209
Surveying your symptoms . . . . . . . . . . . . . . . . . . . . . . . . . . . . . . . . . . . . 210
Antibody blood tests . . . . . . . . . . . . . . . . . . . . . . . . . . . . . . . . . . . . . . . . . 211
Other blood tests . . . . . . . . . . . . . . . . . . . . . . . . . . . . . . . . . . . . . . . . . . . 211
Another intestinal biopsy? . . . . . . . . . . . . . . . . . . . . . . . . . . . . . . . . . . . . 212
The persistently abnormal small intestine biopsy . . . . . . . . . . . . . . . . 212
Exploring Why Your Gluten-Free Diet May Not Be Working . . . . . . . . . . . . . . . . 213
Continued gluten exposure . . . . . . . . . . . . . . . . . . . . . . . . . . . . . . . . . . . 214
Conditions complicating celiac disease . . . . . . . . . . . . . . . . . . . . . . . . . 215
Conditions coexisting with celiac disease . . . . . . . . . . . . . . . . . . . . . . . 219
Wrong diagnosis . . . . . . . . . . . . . . . . . . . . . . . . . . . . . . . . . . . . . . . . . . . 220
The overall approach if you are not responding
to your gluten-free diet . . . . . . . . . . . . . . . . . . . . . . . . . . . . . . . . . . . . . 221
When Your Celiac Disease Won't Settle Down . . . . . . . . . . . . . . . . . . . . . . . . . . 222
Refractory celiac disease . . . . . . . . . . . . . . . . . . . . . . . . . . . . . . . . . . . . . 222
Enteropathy-associated T cell lymphoma (EATCL) . . . . . . . . . . . . . . . . . 224

*Part IV: The Long-Term: Living and
Thriving with Celiac Disease* . . . . . . . . . . . . . . . . . . . . . . . . . . . . . . . . . . . . **225**

**Chapter 13: Alternate and Complementary Therapies.** . . . . . . . . . . . .**227**

Important Safety Info about Complementary and
Alternative Medicines . . . . . . . . . . . . . . . . . . . . . . . . . . . . . . . . . . . . . . . 228
Prebiotics and Probiotics . . . . . . . . . . . . . . . . . . . . . . . . . . . . . . . . . . . . . . . . . 229
Herbal Supplements . . . . . . . . . . . . . . . . . . . . . . . . . . . . . . . . . . . . . . . . . . . . 230
Vitamin Supplements . . . . . . . . . . . . . . . . . . . . . . . . . . . . . . . . . . . . . . . . . . . 230
Digestive Enzymes . . . . . . . . . . . . . . . . . . . . . . . . . . . . . . . . . . . . . . . . . . . . . 231
Following the Specific Carbohydrate Diet . . . . . . . . . . . . . . . . . . . . . . . . . . . . . 231

Treating Celiac Disease by Avoiding Foods Other Than Gluten ........... 232
    Removing a limited number of foods from your diet ................... 233
    Trying an elimination diet ................................................................ 233
    Removing certain sugars from the diet ........................................... 234
Going Gluten-Free to Treat Disorders Other Than Celiac Disease ........ 235
    Gluten sensitivity .............................................................................. 235
    Going gluten-free to treat neurological and mood disorders ....... 237

## Chapter 14: Celiac Disease and Pregnancy, Children, and Beyond . . .239

Pregnancy and Celiac Disease ................................................................. 240
    Infertility and celiac disease ............................................................ 240
    Complications of pregnancy .............................................................. 242
Timing of Gluten Introduction in Infancy ............................................... 245
Detecting Celiac Disease in Children ...................................................... 245
    Diagnosing children with celiac disease ......................................... 246
    Screening children for celiac disease .............................................. 249
Starting Your Child on a Gluten-free Diet .............................................. 251
Shopping and Cooking with Your Child Who Has Celiac Disease ......... 252
Growing Up Gluten-Free ........................................................................... 252
    Dealing with the preschool years .................................................... 252
    Helping your child through the elementary school years ............. 253
    Grasping teenage challenges ........................................................... 253
    Sending your child off to college ..................................................... 255

## Chapter 15: Ongoing Care of Celiac Disease . . . . . . . . . . . . . . . . . . . .257

Monitoring Your Celiac Disease .............................................................. 257
    Determining how often you should see your
       health care providers ................................................................. 258
    Knowing who does the monitoring .................................................. 259
    Knowing what is discussed during a monitoring visit ................. 260
    Monitoring you through testing ....................................................... 262
Managing Ongoing Nutrition Issues ....................................................... 266
    Weighty issues ................................................................................... 266
    Becoming constipated ....................................................................... 269
Falling Off the Diet .................................................................................. 273
Taking Charge of Your Celiac Health ...................................................... 274
    Preparing for your appointment with your
       celiac disease specialist ............................................................. 274
    Knowing what to ask your doctor ................................................... 275
    Becoming an expert on your condition .......................................... 276
Being an Advocate for Your Celiac Health ............................................. 276
    Dealing with insurance companies ................................................. 277
    Having your doctor help you advocate for yourself ...................... 278
    Handling hospitalizations ................................................................ 278
    Selecting a nursing home .................................................................. 279

**Chapter 16: What the Future May Hold**..........................**281**

Devising Better Ways of Determining Your Risk
of Getting Celiac Disease....................................................282
Finding Out Why Genetically Susceptible People Get Celiac Disease .....282
Improving Ways to Diagnose and Monitor Celiac Disease....................284
Better ways to diagnose celiac disease ...........................284
Better ways to monitor celiac disease that
isn't responding to a gluten-free diet..............................284
Developing New Treatments for Celiac Disease....................285
Reducing intestinal exposure to gluten ...........................285
Decreasing gluten uptake by the intestinal wall..............286
Preventing Celiac Disease: When to Introduce Gluten in a Child's Diet .....288
Increasing Public Awareness ..............................................288
Public awareness and public policy....................................288
Public awareness, information, and misinformation ...................289
Making sense of new information .....................................290
Identifying Areas for Further Investigation ........................291
Discovering more about who gets celiac disease and why..........292
Preventing and screening for celiac disease.....................292
Finding better ways to make the diagnosis of celiac disease ......293
Finding out what happens to people with
celiac disease as time goes by..........................................294
Improving treatment ........................................................294
Finding better ways of managing refractory celiac disease .........295
Discovering more about gluten sensitivity.........................295
Knowing whether tolerance to gluten occurs ...................295
Increasing public awareness of celiac disease....................296

**Part V: The Part of Tens** ................................................. **297**

**Chapter 17: Ten Frequently Asked Questions** ...................**299**

Do I Need to Have a Small Intestine Biopsy
to Diagnose Celiac Disease? ..............................................299
Can I Protect My Child from Getting Celiac Disease? .............301
Should I Have My Child Tested for Celiac Disease? ................301
Can You Outgrow Celiac Disease?......................................302
If I Have Celiac Disease, Will My Child or Sibling Also Have It?.............303
How Much Gluten Can I Safely Consume If I Have Celiac Disease? .......304
Can I Skip the Diet and Just Take an Iron
Supplement to Treat My Low Iron? .................................304
Should My Whole Family Eat Gluten-free If
Only One Member Has Celiac Disease?.............................305
Is It All Right for Me to Eat Oats?.......................................306
Does Avoiding Gluten Protect Me from Getting
Other Autoimmune Diseases? ..........................................307

**Chapter 18: Ten Tips for Living Successfully
with Celiac Disease**...................................**309**

Strive to Be Healthy.................................................309
Keep Informed about Your Disease .........................310
Discover How Avoiding Gluten Is Sexy ....................311
Prepare for Your Child's Visit to Friends .................312
Learn How to Eat Out without Standing Out.............413
Figure Out How to Save On Your Food Purchases.....314
Be Prepared for Blank Looks (Or Worse)..................315
Have a Good Answer to the Inevitable Question —
   "What Happens When You Eat Wheat?" ................316
Pack Your Bags, We're Going To . . . .......................317
Deal with the Slipups ..............................................317

**Chapter 19: Ten Myths, Misperceptions, and
Falsehoods about Celiac Disease**.....................**319**

Heavy People Can't Have Celiac Disease..................319
Eat Gluten and You Feel Immediately Ill...................320
You Can Have Borderline Celiac Disease .................321
You Cannot Eat Buckwheat......................................322
You Must Avoid All Products with Gluten..................322
Vinegar Is Forbidden...............................................323
Feeling Fine Means No Celiac Disease .....................323
You Are More Likely to Have Food Allergies and Food Intolerance .....324
You Can't Share Cooking Implements.......................325
If Your Old Symptoms Return, It's Likely Due to Celiac Disease...........325

**Part VI: Appendixes** .................................. **327**

**Appendix A: Web Sites Worth Visiting** ......................**329**

General Celiac Disease Web Sites..............................330
   The National Institutes of Health (NIH)
      Celiac Disease Awareness Campaign.................330
   Children's Digestive Health and Nutrition Foundation (CDHNF)...331
Determining Whether Your Child Is Growing Properly..........331
Determining Whether You or Your Child Are at a Healthy Weight.......331
General Nutrition, Vitamins, and Minerals.................332
   The Center for Nutrition Policy of the United States
      Department of Agriculture................................332
   The National Institutes of Health Office of Dietary Supplements......332
   Health Canada ................................................332
   The National Dairy Council................................332
Gluten-Free Cooking and Eating...............................333
Ordering Gluten-Free Foods Online .........................334
Where to Buy Pure Oats .........................................334
Choosing a Gluten-Free Beer ..................................334
Eating Out Gluten-Free............................................335

Dietary Restrictions Apart from Living Gluten-Free................................336
Lactose intolerance ..........................................................................336
Following a vegetarian diet..............................................................336
Food allergies ...................................................................................337
Gluten-free medications...................................................................337
Advocating for those on gluten-free diets .....................................337
Other Gastrointestinal Conditions ............................................................338
Inflammatory bowel disease.............................................................338
Functional gastrointestinal disorders .............................................338

**Appendix B: Organizations for People with Celiac Disease .......339**

Celiac Disease Societies and Support Groups .........................................339
The Canadian Celiac Association (CCA) ........................................340
The Celiac Sprue Association (CSA)................................................340
The Gluten Intolerance Group of North America (GIG)...............340
La Fondation Québécoise de la Maladie Coeliaque ......................340
Foundations and Organizations.................................................................341
The American Celiac Disease Alliance ...........................................341
The Celiac Disease Foundation .......................................................341
The National Foundation for Celiac Awareness ...........................341
Celiac Disease Centers at University-based Medical Institutions .........342
Eastern U.S.........................................................................................342
Central U.S. .......................................................................................342
West Coast U.S. .................................................................................343

*Index*..................................................................... *345*

# Introduction

· · · · · · · · · · · · · · · · · · · · · · · · · · · · · · · · · · · · · · · · · · · · · · · · · · ·

*W*hat a difference a few years make! It was only a short time ago that few people had ever heard of celiac disease. And, when it *was* a subject of discussion, the conversation was typically rife with misconceptions, misapprehensions, and misinformation. Compounding this unfortunate scenario was the fact that celiac disease was little taught in medical schools, and, outside of select health care disciplines, was off the medical radar. Heck, it wasn't just off the radar; it was somewhere south of Alpha Centauri. Well, that was then and this is now. How topical is celiac disease these days? How much importance is now properly placed on this common condition? Well, let's put it this way: You have in your hands an entire book devoted to the subject!

There's not much to love about having celiac disease. Celiac disease can make you feel crummy. It can lead to damage to your body. It requires constant treatment and vigilance. And it's a lifelong condition. So if you think that being dealt a celiac disease diagnosis is patently and profoundly unfair, we won't disagree because you're right; it *is* unfair. But here's the thing: Although having celiac disease is no piece of cake, the wonderful thing — the *absolutely . . . wonderful . . . thing* — is that you can be entirely healthy with your celiac disease. You can live a full, active, long and productive life with your celiac disease. You can explore the ocean depths or climb the Himalayas. You can work on the city subway or have a top-floor office in the nearest skyscraper. You can play in the NFL or play in the backyard sandbox (age permitting!). And, as for celiac disease not being a piece of cake, well, actually you can have a piece of cake . . . so long as it doesn't contain a nutrient called gluten. As we look at in detail in this book, avoiding gluten is the key to successfully living with celiac disease. The world can be your oyster (hey, oysters are gluten-free so have as many as you want) and in this book we show you how.

## About This Book

We've written this book for people living with celiac disease, and in case you think this phrase is ambiguous, this is by intention because if *one* member of a family has celiac disease, *everyone* in the family is very much living with celiac disease. Which is all to say that we hope *Celiac Disease For Dummies* is helpful whether you are the one who has celiac disease or you are reading this book because someone you care about — a child, another family member, or another loved one — has the condition.

Throughout this book, when we discuss celiac disease as causing one or another problem, we are typically talking about untreated or insufficiently treated celiac disease. Celiac disease that is properly treated (by, as you will discover, meticulously following a diet free of a nutrient called gluten) typically causes . . . nothing! Also, whenever we use the term *active* celiac disease, we are again referring to celiac disease that is untreated or insufficiently treated, in which case there is still active inflammation in the small intestine (something which we explain in detail in Chapter 2).

We hope you find this book helpful, interesting, informative, and even entertaining. We'd truly love to get your feedback. You can reach us by e-mail at celiacdisease@ianblumer.com. (We apologize in advance, however, for our being unable to provide responses for medical advice.)

# Conventions Used in This Book

This book is co-written by Sheila (*hi*) and Ian (*hello*). Sheila lives in Charlottesville, Virginia, and Ian lives in Toronto, Ontario. Being equal partners in the writing of *Celiac Disease For Dummies*, we would have loved to have been equal opportunity employers of American and Canadian spelling, but we had a pretty strong feeling that were we to keep alternating from "o" to "ou" (color versus colour, flavor versus flavour, and so on), we would drive both readers and — egads — our proofreader, around the bend. So, begging the indulgence of our Canadian readers, we've elected to use U.S. spelling since that is what most of our readers use.

Most people living in Canada and the United States receive the bulk of their health care from a physician, but increasingly people are also (or, instead) seeing physician assistants, nurse practitioners, and other important allied health care professionals. Because it would be onerous to repeatedly write out (and, we suspect, boring for you to read) each of these titles, we hope you will indulge us and, when we write that we recommend you "see your physician" or "see your primary care provider," that you will read this to mean we are advocating that you contact whichever health care professional acts as your main health care provider.

And speaking of health care providers, throughout this book we discuss the terribly important role of *registered* dietitians in assisting people living with celiac disease to take charge of their condition by healthy, gluten-free eating. *Registered* dietitians have passed stringent academic requirements and are part of an officially certified health care profession. Again, because it gets awfully repetitious to add the word "registered" before each use of the word "dietitian," whenever we use the word "dietitian" we are specifically (*and only*) referring to *registered* dietitians. Similarly, when we use the word *nutritionist* we are once again using this term interchangeably with *registered dietitian*.

Following are a few other standard conventions you'll see in this book:

- ✔ *Italic* type is used for emphasis and to introduce new terms.
- ✔ **Bold** indicates the action parts in numbered steps. It also emphasizes the keywords in a bulleted list.
- ✔ Web addresses show up in `monofont`.

# What You Don't Have to Read

We hope that you'll find everything in this book to be both interesting and helpful; however, there are a couple of things that, should you wish, you can take a pass on without missing out on any essential information.

- ✔ *Sidebars* are shaded areas that contain additional, often scientifically-based detail on selected topics.
- ✔ Paragraphs that follow a *Technical Stuff* icon (we explain what icons are all about later in this Introduction) are, as you might surmise, comprised of, well, technical stuff.

Reading these materials can be deferred indefinitely (unless you're married to us in which case — Peter and Heather take note — we'll be mortally offended and deeply hurt if you don't read every single word we've written!).

# Foolish Assumptions

We have written this book based on the assumption that whatever your knowledge of celiac disease, you want to learn more. Period. If you know nothing about celiac disease you will find this book allows you to readily discover the basics, and if you're already acquainted with the condition, you'll discover additional details to meet your needs.

# How This Book Is Organized

This book is divided into six parts to help you readily find the information you're seeking.

## Part I: Dealing with the Diagnosis of Celiac Disease

In this part, we define the condition and look at how it can impact you emotionally and psychologically. We also take a journey down the gastrointestinal tract and look at how it functions both normally and when injured by celiac disease. You'll discover possible causes for celiac disease (gluten triggers the condition, but why this happens to some people and not others is largely a mystery), the way in which celiac disease is diagnosed, who should be tested for it, and the different types of celiac disease.

## Part II: How Celiac Disease Can Make You Feel

Some people with undiagnosed celiac disease have nary a symptom while others feel like they've been hit by a train. In this part, we look at the many different symptoms that can be caused by celiac disease and we point out symptoms that might otherwise be potentially passed off as being unrelated. We also look at conditions, like anemia, that can be caused by celiac disease, and other conditions, like type 1 diabetes with which celiac disease can be associated.

## Part III: Treating Celiac Disease

The key to successfully managing celiac disease is the complete elimination of gluten from your diet. We explore this essential nutritional consideration in detail in this part. We also provide helpful tips for shopping and cooking gluten-free and what to do should your diet seem not to be working. Also, we explore alternative and complementary treatments.

## Part IV: The Long Term: Living and Thriving with Celiac Disease

Until a cure is found, if you have celiac disease today, you're going to have it tomorrow, the next day, and for the foreseeable future. Therefore, it's helpful to know how to deal with celiac disease at various stages of life. In this part, we look at how celiac disease can be managed from childhood to adulthood. We also look at how you and your health care team can monitor your celiac disease both when it's under control and when it seems not to be. Lastly, we explore some potentially exciting future therapies that may make living with celiac disease a lot simpler.

## *Part V: The Part of Tens*

The Part of Tens presents key information that you won't want to miss. Here you discover ten frequently asked questions (likely including those you may have asked yourself), ten tips for living normally, and ten myths, misperceptions, and falsehoods you may have heard about celiac disease.

## *Part VI: Appendixes*

The Internet is an invaluable, but sometimes intimidating (or, even worse, misleading) resource. In this part, we provide a handy-dandy list of helpful celiac disease Web sites worth visiting and a listing of organizations for people living with celiac disease.

# *Icons Used in This Book*

There exist political, intellectual, social, and goodness knows how many other icons in society. Well, we don't discuss those here! No, the icons we mention here are those that serve as little flags or identifiers — bookmarks if you will — that let you know what information you're going to find in the paragraph that follows.

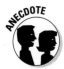

This icon signifies that we're sharing a story about a patient. These stories have been specifically selected because they contain elements that you may well relate to. (The names and other identifiers have been changed to maintain confidentiality.)

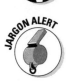

This icon lets you know that we're about to drop some medical jargon on you. Don't be alarmed; we then define or explain the term before we move on.

This icon indicates we're providing information of a technical nature. You may find this interesting to read, but it is not fundamental to your understanding of celiac disease.

When you see this icon, it means the information is essential and you would be well served to pay special attention.

Many — indeed most — aspects of living with celiac disease you can manage quite nicely on your own, thank you very much. But there are times when you need to seek medical attention. This icon lets you know we're discussing something that will require you to see your primary care provider (be it your family physician, physician assistant, nurse practitioner, and so forth), your celiac disease specialist physician, your dietitian or another member of your health care team in order to get help.

This icon indicates that we're sharing a practical piece of information that will arm you with a time-saving or grief-avoiding measure.

This icon means we're discussing critical issues and that immediate or imminent harm could come to you if the information is overlooked or not heeded.

# *Where to Go from Here*

*Celiac Disease For Dummies* is written in modular format, which is basically a fancy way of saying that this book is structured so that you can open it to whatever topic interests you at a particular time rather than having it to read it from front to back. Having said that, if you have no familiarity with celiac disease, you may find that reading it in just that way works best for you.

Not sure where to start? Well, recognizing there isn't a bad place to begin your journey of discovery, if you've just been diagnosed and are finding the whole notion of having celiac disease overwhelming, have a look at Chapter 1 to discover the emotional impact of being told you have celiac disease. Alternatively, you may want to flip to Chapter 2 and delve right into an exploration of the human gut, how it works, and what happens to the gut if you have celiac disease. Or you may want to do what Ian does whenever he takes a *For Dummies* book home (other than the ones he's written!) and start by reading the Part of Tens chapters. Sure, some of it won't make sense until you've read other parts of the book, but you may still find it the most interesting section of all to read.

# Part I
# Dealing with the Diagnosis of Celiac Disease

The 5th Wave                    By Rich Tennant

"We're not sure what causes celiac disease, but we can rule out playing around grain silos as a kid or eating too much celery..."

## In this part . . .

Being diagnosed with celiac disease is, for many people, both a shock (who wants to be told you have a disease for which there is no cure?) and a relief (knowing that with a change to your diet you can maintain good health). In this part, you find out how the diagnosis of celiac disease is made, the psychological and physical impact of the condition, and the various types of celiac disease.

# Chapter 1

# Finding Out You Have Celiac Disease

*In This Chapter*

▶ Understanding celiac disease

▶ Coming to terms with the diagnosis of celiac disease

▶ Considering how celiac disease can make you feel

▶ Treating celiac disease

▶ Living well with celiac disease

▶ Coping with a celiac disease diagnosis

▶ Looking at celiac disease support groups

*W*hen you first find out that you or your loved one has celiac disease, you may be shocked. No one likes to hear bad news, and, as so often happens in this type of situation, you may recall little other than the words *celiac disease* from the conversation you have with your doctor that day.

Over the next few days and weeks, your mind may race non-stop as you mull over your new diagnosis and try to come to grips with it. Or, if the diagnosis is brand new to you, perhaps you are right now in the process of trying to deal with the news.

*Celiac Disease For Dummies* provides you not just with the *facts* about celiac disease, but the tools to help you *master* it. In this chapter, our goal is to help you understand and come to terms with your diagnosis.

## Getting to Know Celiac Disease

*Celiac disease,* also known as *celiac sprue, non-tropical sprue,* and *gluten-sensitive enteropathy,* is a condition in which consuming *gluten* — a protein found in wheat, rye, barley, and some other grains — leads, in susceptible people, to damage to the lining of the small intestine, resulting in the inability to

properly absorb nutrients into the body. This can lead to many different symptoms, including fatigue, *malaise* (feeling generally poorly), bloating, and diarrhea. Left untreated or insufficiently treated, celiac disease can lead to damage to other organs. If properly treated, celiac disease typically leads to . . . nothing!

In your travels, you may see the word *celiac* spelled as *coeliac.* Both terms refer to the same condition. *Celiac* is the spelling far more commonly used in North America and, hence, the spelling we use throughout this book. Incidentally, the term *celiac* (or *coeliac*) comes from the Greek word *Koila*, which refers to the abdomen.

Doctors have known about celiac disease for a long time. Articles describing individuals suffering from diarrhea (most likely due to what we now call celiac disease) first appeared over two thousand years ago. It was, however, Dr. Samuel Gee who, in London, England in 1887, first described the condition in detail and even presciently observed that successful therapy was to be found in changing a patient's diet.

# Dealing with the Diagnosis of Celiac Disease

Perhaps you are already aware (and if you're not, you soon will be as it is a recurring theme in this book) of the key role that a nutrient called *gluten* plays in triggering celiac disease. As we discuss in Chapter 2, however, although gluten *triggers* the condition, that's not quite the same as saying it *causes* the condition.

By way of analogy, if ever you were working on your computer and you routinely pressed a key only to suddenly have your computer crash, one could appropriately say that pressing the key *triggered* the crash, but an underlying software glitch *caused* the problem in the first place.

What, then, causes celiac disease? The quick answer is we don't know. The more complicated answer is a combination of having a susceptibility to the condition by virtue of one's genetic make-up in conjunction with some as yet unknown environmental factor. Chapter 2 contains the full story on the cause, as best we understand it, of celiac disease.

Unless people are ill with some sort of gastrointestinal (GI) ailment, they understandably generally think little, if at all, about the incredibly complex processes involved in extracting the good from the food we eat and ridding our bodies of the stuff we don't need. That makes sense. When celiac disease enters your life (either directly or by virtue of a family member now being affected by it), however, having some familiarity with your GI system proves beneficial. Chapter 2 explains how your GI system works when you're healthy and how it malfunctions when you have celiac disease.

## Discovering celiac disease

The first definitive report of celiac disease was made by Dr. Samuel Gee in London, England in 1887 in his seminal study "On the Coeliac Affection." Dr. Gee astutely observed that "if the patient can be cured at all, it must be by means of diet."

He experimented with various diets and noted that "A child, who was fed upon a quart of the best Dutch mussels daily, throve wonderfully, but relapsed when the season for mussels was over." It is, perhaps no surprise to any parent that Dr. Gee also reported, "Next season (the child) could not be prevailed upon to take them."

In 1950, the link between celiac disease and wheat was finally established. In that year, Dr. Willem-Karel Dicke, a Dutch pediatrician, reported that children with symptoms of celiac disease got better when wheat was removed from their diet.

His discovery was based on observations that during World War II — during which wheat products were in short supply in Holland — previously unwell children, now deprived of wheat-based products, had relief from their symptoms with them only to return upon the reintroduction of wheat into their diet after the end of the war.

With the realization that the absence of wheat relieved symptoms and the availability of wheat resulted in symptoms, Dr. Dicke joined that pantheon of clever people who, by using just their keen powers of observation, had made discoveries that were to improve the lives of millions of people.

Some diseases are easy to diagnose. Tell a doctor you have spells where you see flashing lights followed by a throbbing headache, and, dollars to donuts, the doctor will quickly inform you that you may be suffering from migraine headaches.

Diagnosing celiac disease is never that simple. It involves an interview and examination by a physician, and necessitates investigations typically including blood tests and *always* having a fiberoptic scope passed through your mouth, down your esophagus, through your stomach and into your small intestine where a biopsy is then taken. Okay, we admit, that may not sound particularly pleasant, but as you see in Chapter 3, it ain't so bad at all.

If you are diagnosed with celiac disease, or if a close relative has it, you may be wondering whether other family members are similarly affected. In Chapter 4, we look at who should be *screened* (tested) for celiac disease and how the screening should be done. In Chapter 5, we discuss the different types of celiac disease, including those forms typically found at the time of screening.

# *Knowing How Having Celiac Disease Feels*

It could well be that you were diagnosed with celiac disease after having been unwell for quite some time. If so, then when you read this section's heading ("Knowing How Having Celiac Disease Feels"), you may have said to yourself, "Hey, I can tell you how it feels. It feels crummy. I had belly pain and I had indigestion and I had . . . " Yup, those things sure can happen. But so too can many other symptoms or, on the other side of the spectrum, few or even no symptoms at all.

In Chapter 6, we look at the whole panoply of symptoms one can experience if one has celiac disease. Some of these may lead you to nod your head in recognition (such as the symptoms we just mentioned), and some may take you by surprise (such as discovering the link between celiac disease and conditions as varied as skin rash and infertility).

As we mentioned earlier in this chapter, if left untreated or insufficiently treated, celiac disease can not only make you feel unwell, but it can lead to serious damage to your body (including causing complications like osteoporosis, anemia, and more).

In Chapter 7, we take a detailed look at these potential complications and how to avoid them. In Chapter 8, we look at the many ailments that are not directly caused by celiac disease, but are *associated* with it. We describe the kinds of symptoms these ailments cause and the symptoms to which you should pay the most heed.

For many people, the most feared complication of celiac disease is cancer. Thankfully, celiac disease seldom leads to this, but it can. In Chapter 9, we make you aware of the types of cancer that are linked to celiac disease and, most important, early warning signs on which you should keep a close watch.

# *Treating Celiac Disease*

Celiac disease can make you feel unwell. It can be a hassle to live with. It can cause complications, including damage to your body. *Oh joy.* So now the good news: *You* have ultimate power over this condition. Even better, this power is derived not from taking a truckload of pills — or, indeed, any pills at all; no, this power is derived from you modifying your diet to eliminate any and all gluten.

Modifying your diet to eliminate gluten intake, however, isn't simple and requires lots of work and, like they say about the price of freedom, eternal vigilance. In Chapter 10, we look in detail at what constitutes a gluten-free diet and provide all sorts of tips to help you make the necessary changes to the way you eat and how you eat. And, speaking of vigilance, we also look at hidden sources of gluten for which you should be on the lookout.

When it comes to celiac disease, gluten is the most important nutrient that affects the health of your GI system, but it's not the only one. As you see in Chapter 11, celiac disease can lead to low iron levels and difficulty digesting certain milk products (a condition called *lactose intolerance*).

Infrequently, but sometimes, despite carefully following a gluten-free diet, a person continues to feel unwell. Could it be that gluten is sneaking its way into your diet? Or could it be, perhaps, that you either don't have celiac disease (doctors do make mistakes, including mistaken diagnoses) or that you have an additional ailment that's causing your symptoms. In Chapter 12 we explore these possibilities.

Chapter 13 looks at alternative and complementary therapies that some people with celiac disease sometimes consider employing.

# Living and Thriving with Celiac Disease

Although people living with celiac disease share many similar challenges, differences exist for some people based on age, living condition (home or in a college dorm for instance), and special circumstances such as attempting to conceive, or being pregnant. Chapters 14 and 15 cover living — and thriving — with celiac disease in these situations.

Perhaps it's been some time since you were diagnosed with celiac disease and you are nicely on track with your gluten-free existence. What then? Do you need to be monitored for celiac disease-related health issues? If so, how should the monitoring be done? Chapter 15 describes the ongoing care of celiac disease and ways that you can continue to empower yourself.

Better ways of managing celiac disease may emerge in the future. Indeed, there may come a time when you may not need to follow a gluten-free diet. In Chapter 16, we explore these and other possible options for dealing with celiac disease that may come about someday.

# Handling the News

From the time you were first told you (or your loved one) had celiac disease until the time you picked up and started reading this book, you probably have experienced many different feelings and conflicting emotions.

If you were feeling poorly — especially if this had been going on for a long time — with typical symptoms of celiac disease (we discuss these in Chapter 6), you likely felt relief that the cause of your troubles was identified and that treatment would make you feel better. At the same time, you may have been understandably upset that you had been saddled with a diagnosis for which there is no cure. All these feelings are perfectly normal.

In this section, we look at a few of the different types of feelings that people experience after being diagnosed with celiac disease.

## Experiencing denial

Your first reaction upon being told that you had celiac disease may have been surprise; indeed, you may have been stunned. And it could be that, as the impact of being told you had this life-changing disease sunk in, you doubted it could be the case.

"Me? Celiac disease? No way," you may have said to yourself or others.

You may have then looked up information on the Internet and found that your symptoms didn't match all of those listed on some Web sites; this may have provided additional justification to your feelings of denial.

But you still weren't feeling as well as you should or your lab tests showed you were deficient in certain nutrients, or your bone density was low (as seen with osteoporosis), or you had some other feature of celiac disease which, try as you might, wasn't going to disappear. Eventually, you likely came — perhaps grudgingly — to accept that you had the condition. Or perhaps as you read this book, you have only recently been diagnosed and you still can't believe it. Either way, these feelings are perfectly natural.

## Being angry

If you felt angry after you were told you had celiac disease, rest assured, this is normal and perfectly understandable. You've got enough going on in your life without being told there is another issue you have to contend with.

ANECDOTE

# "Celiac disease? Me? It can't be."

A long, long time ago, when Ian was a naïve young thing in second year medical school, he was asked by the attending physician in the teaching hospital clinic to inform a 45 year-old patient that his test results had come back showing that he had celiac disease. Ian recalls sitting down beside the man and telling him the news and then explaining in great detail — and over considerable time — the rationale leading to the diagnosis, how the patient's symptoms fit, how the blood tests were abnormal, and how a small intestine biopsy showed irrefutable evidence.

Finishing his lengthy monologue, Ian prepared to answer the patient's first question which surely was going to be "Okay, so how do we treat this?" or, perhaps, "What caused this?"

or some such thing. Instead, the man looked Ian square in the eyes and said, "I don't believe it." And added, "I don't mean to sound rude, but your tests must be wrong; there's been some mistake. There's no way I have celiac disease."

With that, the man stood up, thanked Ian for his time, and left. Ian recalls feeling stunned that, despite incontrovertible evidence to the contrary, the patient was convinced that he didn't have celiac disease. As it turned out, the gentleman returned to the clinic a few months later after having continued to feel unwell and having come — with reluctance — to accept the diagnosis and begin treatment. (And Ian came to learn that denial is a normal part of the process of coming to terms with unwelcome news.)

Having celiac disease isn't like having a strep throat or bladder infection that will quickly go away after a few days of antibiotics; if you have celiac disease today, you will have it tomorrow and next week and next month and next year, too. And who wants that? Nobody.

It's also perfectly understandable to be angered by the "work" of having celiac disease. All of a sudden, you need to spend far greater effort when shopping and cooking, not to mention the additional expense of buying food that is gluten-free. Also, in addition to the usual considerations regarding fat content, calories, sodium, and so forth, you now also need to scrutinize everything you eat to ensure that it doesn't have gluten.

The diagnosis of celiac disease may not be what led to anger. You may be angry that the diagnosis wasn't made earlier. Many people go months or even years, feeling unwell all the time, before their celiac disease is discovered. During this time, other, incorrect diagnoses may have been made or people may have been told that their problem was "all in your head" or "due to nerves." No wonder a person in this situation feels frustrated or angry.

Another source of anger arises when a person with a delayed diagnosis reflects on the lost opportunity to have prevented complications from celiac disease (such as, for example, osteoporosis).

By the way, we are not casting stones here. Celiac disease is an ailment that can both mimic and masquerade as many other diseases and a delayed or

missed diagnosis is not uncommon; indeed, many an excellent physician has overlooked this diagnosis.

Regardless of the source of your anger, the thing is, feeling angry isn't useful treatment. Eventually, anger has to be left behind so that you can get on with your life and get back to and maintain a state of good health.

## Feeling sad

Feeling sad upon hearing bad news is perfectly understandable and normal. You may find, however, that if you've been feeling unwell (especially if it's been for quite some time), your sadness will be mixed with relief now that treatment will get you feeling better in short order. You should realize, however, that even after your celiac disease symptoms are controlled, you may at times feel sad that you have celiac disease. With time, that too will pass.

## Taking the next step

Upon finding out that you have celiac disease, you experienced times when you felt angry or sad, and perhaps you even denied that you had celiac disease. None of these feelings have gotten your symptoms to go away or your blood tests to normalize, and now you're ready to take the bull by the horns (speaking of which, if you choose, you can take more than the bull's horns because unprocessed meat doesn't contain gluten!) and deal with your diagnosis. Wonderful. As you learn the ins and outs of living a gluten-free existence, don't get mad at yourself if, from time to time, some of your old angst shows up. That is normal and will pass.

When you're feeling down or frustrated or simply upset at having celiac disease, you may find the following coping strategies helpful:

✔ **Be a positive thinker.** Focus on how much better you will feel once you're following a gluten-free diet or, if you're already on treatment, how much better you already feel. Unlike so many other diseases, you have the power to control things without requiring medication.

✔ **Know that you're not alone.** Recognize that there are health care professionals — most importantly, dietitians — who are there to help you learn what you need to know. You're not on your own!

✔ **Involve your family.** As you learn about living gluten-free, you can share your newfound knowledge about nutrition with your partner and your children. You will find that you are — or will shortly become — a true nutrition resource! Also, involving your family allows them to provide you with the support and encouragement you may need and want from time to time.

✔ **Seek out a celiac disease support group**. Find a support group, either one that meets in your community or an online one. We discuss online support groups in the next section.

# Finding Information and Support on the Internet

We certainly hope that you will find this book a helpful tool to assist you in your quest to find out more about your celiac disease, but we also recognize that a vast amount of additional information is available in Cyberspace. (How vast? Last time we checked, using our favorite search engine on the term *celiac disease,* we got 4.6 million hits. Wow!)

Some of the information you find online is good, and some is, to put it charitably, not quite as good (or downright awful to be quite frank). In this section, we look at how you can use the Web to find more information about celiac disease and how you can seek out Internet support groups to lend you a cyber-hand when you need it.

## Knowing whether an Internet site is reputable

Okay, sure, sometimes it's obvious when an Internet site is not to be trusted, like if you were to come across a site called *www.wesellusedcarsand wealsocureceliacdisease.com* But most of the time, it's not nearly so easy to tell whether you've reached a cutting edge, state-of-the-art site, or one that is far less reputable.

A Web site that is credible and provides reliable information and advice (recognizing that, of course, none of these criteria guarantees the site will be sound) generally does the following:

✔ **Reports facts objectively.** The site provides information in an even-handed way and avoids sensationalism.

✔ **Relies on science.** The site doesn't rely on testimonials to the exclusion of science. An unusual or unique treatment that appeared to help a person with celiac disease isn't proof that it worked; perhaps the person got better for an unrelated reason.

✔ **Uses ads responsibly.** The site doesn't have advertising or, if it does, the ads, like the site, are not over-the-top declarations encouraging you to buy "instant cure" miracle-type products.

✔ **Aims primarily to inform, not to sell.** If the site is run by a scientific organization, hospital, health care clinic, or recognized expert on celiac disease, the site is likely very reputable. If the site is owned and run by a company that is marketing a product, question whether the information on the site is appropriately dispassionate and even-handed. Such company-owned sites may be perfectly reasonable and good sources of information; it's just necessary to question it, that's all.

One clue that a site is run by a scientific or academic — rather than a commercial — institution is the appearance of ".org" or ".edu" rather than ".com" in its Web address. You can find many exceptions to this general rule, but it represents a good starting point.

✔ **Identifies its author.** The author or authors of the site are identified and, ideally, the site provides background information regarding important details such as their professional qualifications and academic affiliations (if any).

Use a search engine, such as Google or Yahoo, to search the Internet for the names of a Web site's authors. You may discover an author has written hundreds of scientific articles, which is good, or you may discover that they've just lost their medical license because of incompetence — which, ahem, is bad.

✔ **Uses verifiable facts.** Information on the site is referenced or at least supported by verifiable facts rather than just being "stream of consciousness" opinion. Also, if the site quotes scientific studies, check to see whether they were published in obscure-sounding journals; they may be obscure for good reason. (Although, of course, some excellent scientific journals have unusual names.)

✔ **Does *not* engage in conspiracy thinking.** If the site talks about conspiracies amongst the medical community or "big business" or government or some other organization said to be participant in some Machiavellian scheme to "hide the cure" to celiac disease, then not only should you take a pass on the site, we would recommend you use your imagination to conjure up a cyber-toilet and flush away this offensive and disreputable site.

In Appendix A, we list some helpful and reputable Web sites where you can find useful information on celiac disease.

## Finding a celiac disease support group on the Web

An *Internet-based support group* (which, depending on the specific nature of the group, may also be referred to as a *discussion group, discussion forum,* or *chat group*) is a place where people affected by a condition, either directly because they have it or indirectly because a loved one has it, can exchange thoughts, ideas, facts, and suggestions.

Although forums may require you to join (done by filling out an electronic form on their site) before you can post comments, most groups allow you to see any already posted material without having to sign up.

Support groups are designed to provide support. That is, however, just the tip of the iceberg. Indeed, support groups provide myriad other functions above and beyond this. They can also have their downsides, however. In the sections that follow, we look at these issues.

### Understanding how a online support group can help you

An Internet-based support group can help you by providing the following:

- **Other people's stories.** If you don't know other people with celiac disease and as a result are feeling isolated, reading other peoples' stories about how they have been affected by celiac disease can help you realize that you're not the only person out there battling the condition.

- **Patient-provided tips.** You can find many tips that others with celiac disease have posted regarding helpful shopping, cooking, and other "living with celiac disease" topics. For example, a person may have discovered a great place to buy gluten-free foods (either online or at a bricks-and-mortar store) and may be keen to share this information.

- **Opportunities to share your story.** You may find it cathartic or stress-relieving to share with others your own trials and tribulations with celiac disease.

- **Encouragement.** Support groups are designed to provide support! Having a bad day? Feeling fed-up with living gluten-free? Let the group know and you'll likely find members quickly commiserate and encourage you to keep up your efforts.

- **Opportunities to help others.** You can gain satisfaction by helping others if you share your own how-to tips with the cyber-community.

- **Success stories.** If celiac disease is new to you, you may find it reassuring to read postings from people who have successfully lived with celiac disease for many years.

- **Substitute for a "real" support group.** If you don't have a local, "real" (as opposed to online) support group, or if you do but are unable to attend (out of shyness or scheduling conflicts or lack of time or whatever), online forums allow you to still participate in group discussion and to do so at times that are convenient for you.

- **Worldwide support.** The Web is, by its very nature, a worldwide entity. You can use the Web to discover how people are living with their celiac disease not only in other cities, but other continents. You may even become friends (virtual or otherwise) with people you "meet" in the discussion group.

- ✔ **Multi-language support.** You may be able to find discussion groups that converse in the language in which you are most comfortable.

- ✔ **Resource to take to your doctor.** If you're having symptoms of one sort or another, you may find postings describing similar issues and what was eventually found to be their cause. You could then ask your health care provider if your symptoms, too, might be attributable to this.

### Recognizing the downsides of online support groups

Like the Internet in general, online support groups have both upsides (see the immediately preceding section) and downsides. Here are some of these downsides and what you can do to avoid these pitfalls:

- ✔ **Question your sources.** Anyone can post to a discussion forum. *Anyone.* You could be reading a posting that has been written by a well-informed, knowledgeable, well-meaning individual who has something important to share . . . or you could be reading a posting by someone who is ill-informed and is sharing nothing more than misinformation.

- ✔ **Avoid endless complainers.** Some people participate in a support group for no other reason than because they've got an axe to grind. Although sometimes reading about someone else's complaints can be helpful in its own way, to read complaint after complaint after complaint can get to be a real downer.

- ✔ **Scrutinize sales pitches.** Online support groups may contain postings by people whose main goal is to try to sell you something, whether or not the product is of proven value or benefit.

- ✔ **Turn away sites dominated by a few individuals.** Online support groups may have posting after posting after posting by a single or small group of individuals who dominate, take over, and hijack discussions.

- ✔ **Leave mean-spirited groups.** Support group postings sometimes degenerate into nothing more than name calling, insults, and other derogatory rants. Not a pretty sight (or site!).

**TIP**

Look for support groups that are moderated; that is, they have someone (typically a well-meaning, reasoned, and knowledgeable person) who supervises the postings and removes those that fall below or outside an appropriate minimum standard.

### Finding an Internet support group

You can begin your search for an online celiac disease support group by typing, in quotes, "celiac disease support group" or "celiac support groups" or some other similar phrase into your preferred search engine. You can even start your own online celiac disease support group. One way to do this is through Yahoo!Groups (`http://groups.yahoo.com`).

Some Internet support groups cater specifically to a certain geographic region, such as a particular state.

# Looking at "Real" (Non-Virtual) Support Groups

Whether or not you elect to participate in an Internet-based support group, we recommend you consider joining a local, non-virtual-world group. By participating in such a group, you can do the following:

- **Get to know real people.** You get to meet in the flesh other people living with celiac disease. Getting to know snippets of someone's life by reading postings on the Internet is one thing; spending time with a "real" person is quite another.

- **Expand your conversations.** Spending time with others allows you to have expanded conversations not constrained by the limitations of interacting exclusively online. Online postings are, by their very nature, typically a few sentences long and necessarily limited in scope.

- **Meet people who know your locale.** Local people live locally! The great benefit of meeting local people is that your neighbors likely know the best places in your community to buy gluten-free foods, the most knowledgeable and helpful dietitians and doctors, and so much more.

- **Mobilize the group to work together.** There is strength in numbers. The group can order food items in bulk to minimize shipping charges and can then divide up the goods amongst the people that ordered the product; that way, you (and the others) can help avoid storing large amounts of a product that you may use only occasionally. The power of a group can also be helpful in persuading a local heath food or specialty food store to stock their shop with gluten-free products that the group identifies as tasty and worth having available locally.

- **Participate in organized activities.** Participating in such group activities allows you to learn the "gluten-free" ropes of shopping, cooking, and eating out while making new friends and acquaintances. Local support groups often organize helpful events such as:

  - Cooking demonstrations

  - Food tastings

  - Restaurant outings

  - Seasonal parties

✔ **Attend presentations.** Support groups often invite speakers to talk with the group. A speaker may be a celiac disease specialist, dermatologist (skin specialist), rheumatologist (arthritis specialist), dietitian, or a nurse who specializes in celiac disease. The possibilities are virtually limitless.

✔ **Join a well-managed support group.** People participating in a real support group are less likely to dominate and take over conversations than what you find on some online forums. Mind you, we've sure seen situations where a person has taken over the conversation, but it happens less often in real support groups than online support groups.

✔ **Get real, live human support.** Sometimes, in moments when you're feeling down, a real hug can feel a heck of a lot better than a cyber-hug. (*Cyber-hug.* Geesh.)

Here are a few ways you can find a local support group:

✔ **Ask your health care provider.** Ask your dietitian or celiac disease specialist.

✔ **Look up the listings.** If you live in the United States, have a look at the state-by-state listings at www.celiac.com or on the Celiac Disease Foundation Web site: www.celiac.org/connections.php. You also can call them directly (818-990-2354). Other suggestions are listed in Appendices A and B.

If you live in Canada, have a look at the Canadian Celiac Association listing of affiliated chapters: www.celiac.ca/EnglishCCA/echptr.html.

✔ **Use an Internet search engine.** Use your Internet search engine in the same way as would be done if you were looking for a virtual group (see the section "Finding an Internet support group," earlier in this section), but add the name of your community to the search request. If you lived in, say, Indianapolis, you'd type in "celiac disease support group" and "Indianapolis."

# Chapter 2

# Celiac Disease and You

*In This Chapter*

▶ Recognizing what causes celiac disease

▶ Checking out gluten

▶ Digesting how the gut works

▶ Discovering how celiac disease affects your gut

As many as 3.3 million people in the U.S. and Canada have celiac disease. Unfortunately, many people living with celiac disease don't know they have it. They may not have obvious symptoms (we discuss symptoms of celiac disease in Chapter 6), or they may have symptoms for a long time and simply become accustomed to living with them. Or sometimes, a doctor hasn't thought of the diagnosis. The list of possibilities is far-reaching.

When celiac disease goes undetected and untreated, it can damage the body and even increase the risk of some cancers (see Chapter 9). We hope this book helps people recognize when celiac disease may be present so that they will know when to speak to their health care provider about the possibility of celiac disease — even if it means bringing up the potential diagnosis with your doctor. (No doctor is perfect, including ourselves, and no doctor would disagree with our stating this as fact.)

Being diagnosed with celiac disease is, in many ways, the start of a journey — and a sometimes arduous one at that. In this chapter, we look at questions that typically arise after someone has been given the news. Questions like "What *is* celiac disease?" And "What causes it?" And "Why did I get it?" We also answer — with apologies to Tina Turner — "What's gluten got to do with it?" Last, we have a look at how your gut works both normally and when celiac disease makes it go awry.

# Knowing What Causes Celiac Disease

In order for you to develop celiac disease, several factors must be present. (We illustrate these in Figure 2-1 and discuss them in detail in the sections that follow this one.) Some of these factors are present from the time of conception and several play a role later on in the process. Here are those key factors:

- ✔ **Genes that put you at risk.** In order for you to develop celiac disease, you must have something in your genes that puts you at risk of celiac disease. Without these "at risk" genes, your risk of getting celiac disease is almost nonexistent.

- ✔ **A problem with your immune system.** To get celiac disease, a specific problem within the immune system has to develop in which, after you ingest certain types of grain proteins (*glutens*), your body's immune system behaves abnormally, including making antibodies against some of your own tissues. For this reason, celiac disease is classified as an *autoimmune* disease, meaning that the immune system attacks one's own body.

- ✔ **Ingestion of gluten.** Only the glutens found in some types of grains (including wheat, rye, and barley), when ingested, trigger the abnormal immune response present in celiac disease. If a person has never eaten gluten, they could never get celiac disease. This connection between gluten and celiac disease is why celiac disease is treated with a diet that does not contain gluten, the so-called *gluten-free diet*.

- ✔ **Increased uptake of gluten by the small intestine.** If you have celiac disease, a larger amount than normal of gluten gets taken up by the small intestine and absorbed into the body. This extra amount of gluten *amplifies* (increases) the abnormal immune response to gluten that we mention previously in this list.

- ✔ **A damaged small intestine.** This results from the abnormal immune response to gluten and is the characteristic underlying feature of celiac disease.

Medical science doesn't allow us to change our genes (well, not yet anyhow), but free will does allow us to change what we eat. And that is the basic tenet of treating celiac disease. By eliminating gluten from your diet, you interrupt the processes that we just listed so that the antibodies diminish, the inflammation gradually goes away, and your health is restored. We discuss the treatment of celiac disease in detail in Chapter 10.

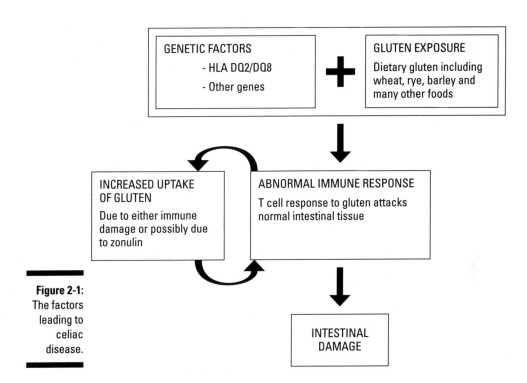

**Figure 2-1:**
The factors
leading to
celiac
disease.

# Genetic influences

Genes are those things found in our cells' DNA that serve as a blueprint from which our body is built and develops. Our genes determine whether we are short or tall, blue-eyed or brown-eyed, and so on. Well before medical science knew about the specific genes that are associated with celiac disease, it was, nevertheless, recognized that celiac disease runs in families. And even within families there was additional evidence for a genetic influence because, doctors observed, both members within a set of identical twins (who, therefore, had the identical genes) were much more likely to have celiac disease than were members of a set of non-identical twins (who share only half the same genes).

Thanks to advances in medicine, a lot is now known about the genetics of celiac disease and, in particular, the important role of *human leukocyte associated* (HLA) genes. There are many different types of HLA genes with, depending on the type, widely varying roles in how the body functions (or, malfunctions, as the case may be). The specific HLA genes involved with celiac disease are the DQ genes. (Despite their name, so far as we are aware, these genes don't make one long for soft ice cream; mind you, now that we think of it. . . .)

Virtually all people with celiac disease have either HLA DQ2 and/or DQ8 genes. Indeed, this association is so strong that if you have neither of these genes, you have almost no risk of ever developing celiac disease. Knowing this, doctors now use a test to detect HLA DQ2 and DQ8 genes to exclude the possibility of celiac disease in certain special situations. We discuss genetic testing further in Chapters 3 and 4.

The flip side, however, is not true: since 30 to 40 percent of the North American population has these genes, yet only a very small (2 to 3) percent of this group develops celiac disease, other factors (including other as yet undetermined genetic factors) must be responsible in determining who gets celiac disease. We discuss this further in Chapter 16.

## The immune system

The *immune system* is a complex set of cells and organs that protect the body from various types of illnesses. A major purpose of the immune system is to help fight off bacteria, viruses, parasites, and other infections. The immune system also helps get rid of dying cells and cancerous cells within our bodies. It seems like every day there emerge a slew of new research findings on the incredibly important roles of the immune system in maintaining good health.

However wonderful the immune system is, sometimes, in fact, it does the wrong thing and turns against you by attacking your own normal, healthy cells. Illnesses in which this behavior is a feature are called *autoimmune diseases*. Examples of autoimmune diseases are systemic lupus erythematosis (SLE), rheumatoid arthritis (RA), type 1 diabetes mellitus (all of which we discuss in Chapter 8), and most germane to this book, celiac disease.

Because celiac disease is an immune disease, in this section we look in detail at the immune system. Knowing the basics of how the immune system works helps you understand what happens when, as with celiac disease, it doesn't function properly. This information can be tough slogging, so we provide some handy dandy figures to help illustrate the key points we discuss.

### The components of the immune system

The immune system consists of many types of cells and a number of different organs. It is made up of two branches:

- ✔ **Systemic immune system.** Includes organs such as the thymus and the spleen, and a variety of types of white blood cells that reside in the circulatory system of blood vessels, lymph glands (also known as *lymph nodes*), and lymph channels (that is, the pathways through which lymph fluid flows). This system is very important in protecting us against infections of the blood and also plays a role in autoimmune diseases.

✓ **Mucosal immune system.** Consists of the immune cells present in the *mucosal surfaces* of the body. Mucosal surfaces are the linings of the respiratory tract, eyes, nose and sinuses, digestive tract, urinary tract, and the reproductive system. The mucosal immune system contains immune cells that are important in protecting us from infections of these parts of the body.

The immune system has a variety of different types of white blood cells, each with their own special function. Here we list some of these and in the next section, we discuss what goes wrong when you have celiac disease:

✓ **T cell lymphocytes (or just T cells for short).** Involved in recognizing and responding to sick cells, such as cells infected with a virus or cancerous cells.

✓ **B cell lymphocytes.** Produce proteins called *antibodies.* Antibodies can attach to tiny molecules called *antigens* which are present on the surface of germs and other substances and allow the body to eliminate them.

✓ **Neutrophils.** Help kill bacteria by releasing enzymes and toxins.

✓ **Macrophages.** Eat (in a manner of speaking) other cells including germs. They also act as a delivery service by taking certain proteins (*antigens*) that line the surface of various molecules and bringing them to T cells where these lymphocytes can then act on them. (Sort of like an underworld boss's henchmen apprehending someone and bringing them to the boss to be worked over.) This is called *antigen presentation.*

✓ **Eosinophils.** Involved in immune responses to parasites and are also important players in controlling the body's mechanisms associated with allergies.

✓ **Basophils** and **mast cells.** Found either in the blood (basophils) or certain body organs including the intestines (mast cells). Their main role is in generating an immune response to allergens and to certain parasites.

Now that you are armed with this information, we can show you what happens with your immune system if you have celiac disease.

### The immune response

The *immune response* is the way in which the immune system reacts when exposed to tiny molecules called *antigens.* It is a wayward immune response to antigens that leads to diseases such as allergies and autoimmune diseases like celiac disease.

### The role of the T cell

In celiac disease, T cells play the greatest role in the abnormal immune response. In the case of celiac disease, *glutens* are the specific protein to which the immune system abnormally responds and thus it is gluten that triggers celiac disease. Glutens, which are present in certain foods, enter into the mucosal lining of the small intestine where they are then taken up by macrophages. Through antigen presentation (see the preceding section, "The components of the immune system"), the macrophages "present" these foreign proteins to the T cells. The T cells generate an immune response to gluten that involves production of inflammatory substances called *cytokines* which damage the intestine.

### The role of tissue transglutaminase (TTG)

With celiac disease, excess amounts of gluten enter into the lining of the intestine. The gluten then encounters an enzyme called *tissue transglutaminase (TTG)* that has been released from intestinal cells that have already been damaged (see the preceding, "The role of the T cell"). When the gluten meets up with TTG, a very small piece of the gluten protein is broken off in a process known as *deamidation*. The deamidated gluten tenaciously attaches to and stimulates the T cells much more so than regular gluten would. This is the last thing in the world you want to happen since it's the T cells that are already causing your gut to get damaged in the first place.

A vicious circle is now created (see Figure 2-2) in which gluten enters the lining of your intestine, T cells respond and release cytokines which cause damage, this damage leads to more gluten uptake which in turn leads to deamidation which stimulates the T cells which causes more cytokines to be released which causes more damage which . . . The net result is that the lining of your gut comes to resemble a war zone. At present, the only good way to bring the war to a halt is removing gluten from the diet. We discuss the gluten-free diet in detail in Chapter 10.

---

# Zonulin and celiac disease

Various things in our bodies control how well the tight junctions work. Scientists have discovered that one such protein, *zonulin*, plays a role in increasing the intestinal permeability in celiac disease. It seems that in patients with celiac disease, gluten increases the release of zonulin from the intestinal cells, thereby allowing increased uptake of gluten, which is too big to get across the tight junction under normal circumstances. This condition is another example of how the whole process of events leading to intestinal damage in celiac disease can get amplified. As we discuss in Chapter 16, researchers are developing new therapies that inhibit zonulin so that increased gluten exposure and the resulting immune stimulation are quieted down; currently the only available therapy is to follow a gluten-free diet (which we discuss in Chapter 10).

Gluten

Gluten Particles

SigA

TTG

Deamidated
gluten

TTG IgA

T cell

* * * *
* * * *

Cytokines

**Figure 2-2:**
The inflam-
matory
changes in
celiac
disease.

# Increased uptake of gluten by the small intestine

The *epithelial* cells that form the outer-most layer of the small intestine are rather brilliant, at least when functioning normally. Like a good parent, they know when to hold the line and when to allow things to get by. (Oh, heavens, at least we parents *try*, oh how we try.) In terms of digestion, these cells keep germs and other foreigners *out of* the body while at the same time allowing absorption of nutrients *into* the body.

Many substances are not absorbed into the body through *the cells* per se, but, rather, the miniscule spaces *in between the cells*. These spaces are known as *tight junctions* (see Figure 2-3). A variety of factors including viral infections of the gut, anti-inflammatory medications, and intestinal diseases such as celiac disease can cause these tight junctions to be, well, less tight, thereby allowing excess amounts and types of substances to gain entry into the body. This condition is referred to as *leakiness*. The increased leakiness (also known as increased *intestinal permeability*) seen with celiac disease is one way by which gluten may get a chance to start triggering the abnormal immune response which leads to the severe gut inflammation that we described in the preceding section.

**Figure 2-3:**
Tight
junctions.

# *Environmental factors*

Anything apart from factors within our body that may cause illness is referred to as an *external* or *environmental factor*. As we mention earlier in this chapter, many people, although being genetically at risk for getting celiac disease, never develop it, which tells doctors that other, environmental factors must be responsible for celiac disease. Here are some additional clues that environmental factors are involved in celiac disease:

✓ **Geography.** Celiac disease is increasing in frequency in many different regions of the world (even though there has not been a surge in the number of people in those regions with the HLA DQ2 or DQ8 genes).

✓ **Age.** Celiac disease is showing up less often in children and more often in adults. (The average age that people are now being diagnosed with celiac disease is over the age of 40, and some people only develop problems leading to the diagnosis when into their 80s!)

✓ **Various forms.** Until recently, the great majority of people diagnosed with celiac disease had the classical form whereas nowadays most people with celiac disease have one of the other forms. (We discuss the various forms of celiac disease in Chapter 5.)

Although consuming gluten leads to the inflammation found in the small intestine of people with celiac disease and results in the symptoms and other problems that are present, gluten in and of itself does *not* cause celiac disease. Gluten *triggers* or *causes flares* of celiac disease in people who are already predisposed to the condition.

So then, what is the environmental factor (or factors) that triggers celiac disease (in genetically susceptible people)? Alas, the answer is unknown. Also unknown are answers to other important questions such as:

- ✔ Why is celiac disease so much more prevalent now compared with 40 years ago?
- ✔ Whatever the factors responsible, why do they lead to different ages when celiac disease shows up?
- ✔ Why do these factors result in such varied ways in which celiac disease causes problems?

Although medical science doesn't have the answers to these questions, there's no shortage of theories. These are potential factors that may play a role in why gluten triggers celiac disease:

- ✔ **Timing of gluten exposure in infancy.** It could be that the timing of when babies are first fed gluten-containing foods is an important environmental factor leading to celiac disease. Indeed, medical researchers consider dietary factors to likely be the most important environmental influences. We discuss this in detail in Chapter 14.

- ✔ **More gluten in diets.** Nowadays people consume more gluten than did previous generations. (Through generations of cultivation of grains by cross-breeding, agriculture has selected for wheat strains with a higher gluten content compared to ancient grains.) It could be that this increased gluten exposure to the gut may overwhelm the body's natural defense mechanisms.

- ✔ **Excess hygiene.** The "hygiene hypothesis" proposes that the increasing number of people in industrialized societies with allergic and autoimmune diseases (such as celiac disease) are due in part to a relatively sterile environment (compared to other or previous societies). People in well-off societies have less exposure to germs and have fewer infections; the hygiene hypothesis suggests that this factor increases the chances of reacting to foods and other proteins in the environment and also to one's own antigens. This situation in turn can increase the chance of getting allergies, celiac disease, and other autoimmune diseases.

- ✔ **Infections.** It could be that during an episode of gastroenteritis (that is, an intestinal infection) the inflamed lining of the gut absorbs excess quantities of gluten leading to an abnormal immune response which, in turn, causes celiac disease. (Although infections remain a possible factor in developing celiac disease, this does not seem to explain most cases.)

✔ **Stomach (gastric) surgery.** Sometimes celiac disease shows up after patients have part of their stomach removed to treat an ulcer or to help severely overweight people lose weight ("bariatric surgery"). Why celiac disease shows up in these instances is unknown. Given the relative rarity of stomach surgery in people who later develop celiac disease, clearly this would be a factor in only a tiny proportion of cases.

✔ **Stress.** Various kinds of stress can influence many diseases, but typically by making a condition (such as high blood pressure) worse, rather than actually causing the condition to develop in the first place. Current medical research does not support previously held notions that stress is a cause of celiac disease; however, stress can make symptoms worse.

# *Examining Gluten*

Almost everything humans eat is made from various types of proteins, carbohydrates, and fats. When considering celiac disease, the most important of these nutrients to know about is a protein called *gluten*. Gluten is a general name for the various *storage proteins* (also known as *prolamins*) found in grains. (Storage proteins are those proteins in grains available to provide nutrients for their future growth in the field.) Ingesting gluten triggers celiac disease and thus, gluten needs to be avoided if you have this condition.

When we were in medical school, way back when, we learned an acronym to remember the four major grains that were thought to trigger celiac disease: BROW, which stood for barley, rye, oats, and wheat. Things have changed a bit since then, and, as we discuss in the following sections, oats are no longer considered a trigger for most patients — which means, now that we've lost a vowel, we're looking for a new acronym to use to teach to our own students!

As we discuss in Chapter 1, a Dutch physician observed that during World War II, when wheat was not available, previously ill children became healthier (and became ill again after wheat's reappearance after the end of the war). This keen observation led to the eventual determination that celiac disease is triggered by exposure to gluten, which is a component of wheat and certain other grains.

Because the term "gluten" refers to a variety of different proteins, you may see it written in its plural form: *glutens.* However, most commonly it is used in the singular form.

# Knowing where gluten is found

Gluten is present in many different types of foods and is also found in many commercial products (even including some medicines!). Until not too long ago it was very difficult to know if something did or did not contain gluten, but today, food and product labels typically reveal this information. Food labels don't always indicate whether a food or product contains gluten, however. We discuss this and other gluten-free food and product issues in detail in Chapter 10. In this section, we list some commonly consumed foods and whether or not they contain gluten.

These foods (unless specially prepared to be gluten-free) typically *contain gluten*:

| | |
|---|---|
| Breads and other baked products | Prepared soups |
| Cereals | Salad dressings |
| Pastas | Snack foods and chocolate bars |
| Prepared meats (such as hot dogs, hamburgers, deli meats) | |

These foods in their native state *do not contain gluten* (and can be referred to as naturally gluten-free):

| | |
|---|---|
| Cheese | Nuts |
| Eggs | Seeds |
| Fish | Unprocessed meat |
| Fruits | Vegetables |
| Legumes | Wine and spirits |
| Milk | Yogurt |

# Getting a handle on grains

Grains (cereals) are a major food staple in the human diet throughout the world. Not only are grains a key component of what we eat, grains have helped dictate how society has evolved. The ability to grow various foodstuffs — particularly grains — allowed and promoted the transition from hunter-gatherer societies to increasingly large and communal agricultural-based societies.

### Wheat, barley, and rye

Wheat is the major cereal grain consumed in many parts of the world, including North America and, because wheat contains gluten, wheat is most responsible for triggering celiac disease in people living in these regions. Gluten found in wheat has two main components:

- ✔ **Gliadins.** Responsible for dough's viscosity (thickness) and ability to be stretched. More important, in terms of celiac disease, it is the gliadins within gluten that are the specific trigger for celiac disease.
- ✔ **Glutenins.** Responsible for dough's cohesiveness (tendency to stick together), strength, and elasticity.

The attributes of the gluten found in wheat (as we note in the preceding list) make wheat useful for making bread and also explains why making bread with gluten-free flours is difficult. We discuss the difficulty of gluten-free bread-making further in Chapter 10.

Barley contains a specific form of gluten known as *hordein*. Because barley contains gluten, it must be avoided by people with celiac disease.

Rye contains a specific form of gluten known as *secalin*. Because rye contains gluten, it, too, must be avoided by people with celiac disease.

*Triticale* is a blend of wheat and rye and is also to be avoided if you have celiac disease.

### What about oats?

At one time, the consensus was that oats could trigger celiac disease, but a large number of studies in adults and children have now demonstrated that oats can, in fact, be safely consumed by people with celiac disease. There is, however, a *but*. Only *pure* oats are safe to eat if you have celiac disease and, until recently, food manufacturers seldom made products comprised only of oats. (The plants mill oats in the same facility as gluten-containing grains.) Fortunately, things have changed in some mills and pure oat-containing food products are now carried in many specialty food stores and even larger grocery store chains. We include a list of brands of pure oats in Appendix A, as well as information on how to order these products.

We do need to add one caveat to our 'pure oats are okay to eat' comment. Some research suggests that a very small number of people with celiac disease do, in fact, react to even pure oats.

The current consensus among celiac disease experts (bas
very good scientific studies as well as clinical experience
well tolerated by both adults and children living with celia
you have treated celiac disease and uneventfully eat pure
foods, well, enjoy them. On the other hand, if you're havir
pure oats, it may be best to discontinue consuming any a
and consult your dietitian and physician for further advice.

## Getting a grip on other grains

Most people are familiar with barley, rye, and wheat, however there are a
number of other, less well known grains. Some of these contain gluten and
therefore need to be avoided; others do not contain gluten and therefore can
be safely consumed.

These are grains that contain gluten and must be avoided:

| | |
|---|---|
| Bulgur | Farro |
| Couscous | Kamut |
| Durum | Semolina |
| Einkorn | Spelt (Dinkel) |
| Emmer | Triticale |
| Farina | |

These are grains that do not contain gluten and are safe to eat:

| | |
|---|---|
| Amaranth | Nut flours (almond, hazelnut, pecan) |
| Arrowroot | Quinoa |
| Buckwheat (kasha) | Potato flour, potato starch |
| Corn | Rice flour, rice bran |
| Flax | Sorghum |
| Indian ricegrass (Montina) | Soybean |
| Legume flours (bean, garbanzo bean, lentil, pea) | Sweet potato flour |
| Mesquite flour | Tapioca (cassava, manioc) |
| Millet | Teff |

# Comparing Celiac Disease, Food Allergy, and Food Intolerance

In order to explain why they are on a special diet, many people with celiac disease understandably (and perfectly reasonably) try to make things easier for their friends, coworkers, and restaurant staff by just saying they are "allergic to wheat" rather than describing in detail what their condition is all about. Although saying you are allergic to wheat is perfectly fine (and indeed, this is what Sheila's husband — who lives with celiac disease and has a PhD in immunology — often says), the statement is not perfectly accurate.

As we mention earlier in this chapter, celiac disease is an autoimmune disease, meaning that your immune system has turned against — and is attacking — your own, healthy tissues. Autoimmune diseases, including celiac disease, typically cause chronic problems, not sudden, life-threatening crises. Food allergies are caused by a different problem with the immune system and can indeed lead to immediate catastrophic situations. A food intolerance (such as lactose intolerance, which we discuss in detail in Chapter 11), on the other hand, is not related to the immune system and, although it leads at times to unpleasant symptoms, is not life-threatening in nature. We illustrate the key differences between these three conditions in Table 2-1.

| Table 2-1 | Comparing Celiac Disease, Food Allergy, and Food Intolerance | | |
|---|---|---|---|
| | *Celiac Disease* | *Food Allergy* (e.g. Peanut allergy) | *Food Intolerance* (e.g. Lactose intolerance) |
| **Time to Onset after Consuming the Triggering Food** | Days, months to years | Seconds to minutes | Minutes to hours |
| **Common Symptoms** | Variable but often includes abdominal cramping, diarrhea | Shortness of breath, swelling of the lips and tongue, hives | Abdominal cramps, diarrhea |
| **Immune Problem** | T cell mediated disease | Immediate hypersensitivity reaction | None |

Technically speaking, a *food allergy* is a special type of immune reaction (called an *immediate hypersensitivity reaction*) that involves immune system cells called *basophils* and *mast cells* (these are special types of white blood cells involved with the body's allergic response and certain other conditions). An immediate hypersensitivity reaction results, upon exposure to a certain stimulus, in the immediate release into the bloodstream of a substance called *histamine,* which causes instantaneous — and sometimes life-threatening — symptoms such as shortness of breath, a swollen tongue, and a skin rash (hives). Perhaps you know people who are allergic to peanuts. They have this type of food allergy. People can also be allergic to wheat, which is different from celiac disease because the reactions to wheat are immediate and cause problems with breathing, hives, and swelling of the mouth and lips. Unlike in celiac disease, wheat does not cause intestinal damage in people with wheat allergy.

As you know from your own experiences living with celiac disease (or living with someone who has celiac disease), this is entirely different from what happens if a person with celiac disease consumes a gluten-containing food (such as wheat) in which case, such instantaneous, life-threatening symptoms don't occur. Although, as we discuss elsewhere in this chapter (see "What goes wrong when you have celiac disease"), the immune system plays a role in celiac disease, it is of an entirely different nature.

The one exception to celiac disease and food intolerance being unrelated is if you have newly diagnosed and therefore untreated celiac disease in which case you may have *temporary* lactose intolerance. We discuss lactose intolerance in greater detail in Chapter 11.

# Understanding How the Normal Digestive Process Works

*Digestion* is the process of breaking down foods and then absorbing their nutrients into our bodies. The digestive process involves a variety of organs (see Figure 2-4), each with their own special roles in helping transform the foods and liquids you consume into nutrients that are absorbed *into* the body and waste products that you excrete *from* your body. The organs involved with digestion are the

- Gastrointestinal (GI) tract
- Liver
- Pancreas

In this section we look at how each of these organs assists with digestion.

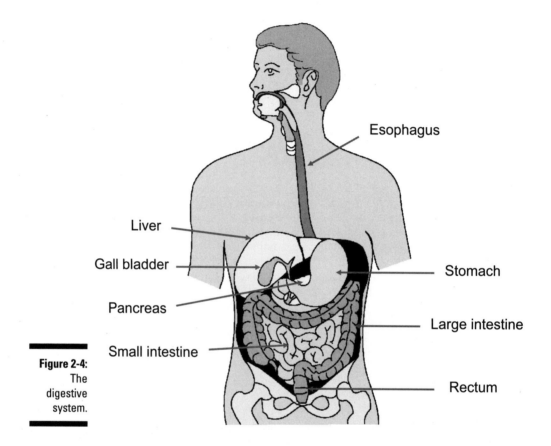

**Figure 2-4:**
The digestive system.

---

# What a piece of work is man (and woman)

Like many people, we marvel at the incredibly complex functioning of the most sophisticated computer in existence, the human brain. And, like many others, we also marvel at how, over a lifetime, the human heart will pump 3 billion times and a person's kidneys will filter 1 million gallons of blood. Mind boggling numbers indeed. But, equally incredible, although not getting nearly so much glory, is the work that our digestive system does as, over a lifetime, it looks after over 100 tons (200,000 pounds; about 91,000 kg) of food and liquid you've swallowed! (In case you're wondering — and we suspect you aren't — that's equivalent to eating 20 elephants or, less tasty we presume, 10 city buses, not, ahem, including passengers.)

# Getting down the gastrointestinal tract

Since digestion starts — and finishes — in the gastrointestinal tract (the "gut") let's begin our journey here.

## Normal anatomy of the gastrointestinal tract

The GI tract starts with the mouth where food and liquids enter the body and ends at the anus where the wastes of what we eat — along with other things like dead bacteria and cells that line the gut — exit as stool. (*Stool* is the medical term for a bowel movement. Last time we checked — clearly we had too much time on our hands — there were well over 50 non-medical synonyms for stool, many of which you may have some familiarity with, but of course we wouldn't know.)

For the purposes of discussion, the GI tract can be divided into three sections:

- Mouth
- Esophagus and stomach
- Small intestine and large intestine (including the rectum)

In the following sections, we look — figuratively speaking — into each of these parts of your anatomy.

## Looking at what the mouth, esophagus, and stomach do

The main job of the mouth is to chew food so it can then be swallowed. The mouth accomplishes this feat by using the teeth, tongue, and saliva (produced by the salivary glands):

- **Teeth.** Help you chew food down into small pieces that are more easily swallowed.
- **Tongue.** Allows you to taste the food you eat; if something tastes good you are, of course, more likely to ingest it (and thus, derive nourishment from it).
- **Saliva.** Aids in the digestive process, both by moistening food (which makes it easier to swallow) and by initiating breakdown of food through the action of saliva's digestive enzymes. We further discuss the role of digestive enzymes in the section, "What the pancreas and liver do."

When you swallow, food moves from your mouth into your esophagus. The esophagus is a flexible, muscular tube (conduit) through which the food passes as it travels from your mouth into your stomach.

The stomach is a workhorse. This muscular organ helps digest food in two ways:

- ✓ **Churning food.** Repeated, forceful, contractions, which turns food into smaller pieces.
- ✓ **Producing acid.** Helps break down proteins and other food components.

It takes up to several hours for the contents of the stomach to empty (into the small intestine) after a regular meal.

### Recognizing the importance of the small intestine

Since celiac disease causes most of its havoc by damaging the small intestine, we look at this organ in detail. In this section, we discuss the features of a healthy small intestine and later in this chapter (see "Knowing What Goes Wrong When You Have Celiac Disease"), we look at abnormalities that can develop.

The small intestine (also known as the *small bowel*) is a long, coiled tube that, if stretched end to end, would measure 21 feet. (Please don't try this at home!) The small intestine is the most vital part of the digestive process because this is where virtually all nutrients are extracted from food. The small intestine also helps regulate the body's fluid balance since it is responsible for absorbing most of the fluids we drink along with those produced by the digestive tract, totaling about 6 to 8 liters a day. You cannot survive without your small intestine, and if this part of the digestive tract is damaged or partially removed, then you are at risk of malnutrition and dehydration depending how much small intestine function you are missing.

The small intestine consists of three sections (see Figure 2-5):

- ✓ **Duodenum.** The first part of the small intestine, the duodenum measures just under 1 foot in length (the jejunum and ileum are each considerably longer). The very first part of the duodenum is called the duodenal bulb. The stomach empties its contents into the duodenum. Digestive enzymes made in the pancreas and bile made in the liver empty through a duct into the duodenum. Iron and calcium are some of the few nutrients that are absorbed into the body from this part of the small intestine.

- ✓ **Jejunum.** The jejunum is the second part. The jejunum absorbs the major food components including proteins (in the form of small molecules like *peptides* and *amino acids*), carbohydrates (as small sugars such as *glucose*), fats (as *triglycerides*), and a variety of vitamins and minerals.

- ✓ **Ileum.** The third part of the small intestine, the ileum plays a role in absorbing vitamin B-12 and bile salts, which are important in fat absorption. The very last part of the ileum is, unfortunately, called the "terminal ileum." Why unfortunate? Because we know of at least one patient who — egads — took this term to mean they had a terminal illness of their ileum! (Terminal, in the case of the ileum, simply means "the end" as in train terminal, or bus terminal.)

Duodenal bulb

Duodendum

Jejunum

Ileum

**Figure 2-5:**
The parts
of the small
intestine.

The small intestine has millions of small, finger-like projections called *villi* that extend inward from the lining of the small intestine and greatly increase the amount of surface area available to interact with food and extract nutrients (see Figure 2-6). (Villi increase surface area of the small intestine in much the same way that the many branches on a tree increase the amount of a tree's surface area compared to having one long trunk.)

The villi, in turn, are lined by even smaller projections called *microvilli* (also shown in Figure 2-6). Microvilli help with digestion because they further increase the surface area in the small intestine and also, they contain many digestive enzymes. Because microvilli are numerous and are packed closely together like a hair brush with many densely packed bristles, the microvilli form what is called a brush-border.

Microvilli

Villi

Small
intestine

**Figure 2-6:**
The villi and
microvilli of
the small
intestine.

The villi and microvilli increase the absorptive surface of the small intestine to the equivalent size of a tennis court! Gotta *love* that.

### Knowing what the large intestine and rectum do

The large intestine (also known as the colon) is the wide, 5 foot long part of the gastrointestinal tract that connects the small intestine to the anus. The colon turns about 1 to 2 quarts of very liquid bowel contents it receives from the ileum into about one-third of a quart of solid stool each day. Prior to defecation (having a bowel movement), stool is stored toward the end of the large intestine, an area called the *sigmoid* (sigmoid means "s shaped") *colon.* Just prior to defecating, stool passes from the sigmoid colon into the very last part of the large intestine: the rectum. It is the presence of stool in the rectum that gives one the urge to go to the bathroom. The very last part of the process is the subsequent passage of stool from the rectum through the anus into the toilet (latrine, diaper . . .).

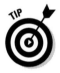

Although lots of people think the only normal pattern is passing a stool once a day, the normal range is actually anywhere from two or three a day down to three times a week.

# Understanding what the pancreas and liver do

The pancreas is a 10-inch long organ located in the upper part of the abdomen and behind the stomach. The pancreas produces digestive enzymes that travel down a duct from the pancreas and empty into the duodenum. These enzymes break down foods into microscopic sizes which then allows them to be absorbed into the body across the lining of the small intestine (primarily the jejunum). The other essential function of the pancreas is to produce hormones such as insulin that help to control metabolism. These hormones are released from the pancreas directly into the blood. (In the case of insulin, this hormone helps regulate blood glucose; having insufficient insulin causes diabetes.)

The liver produces bile which is transported through the bile ducts into the small intestine where it helps digest fats. Bile can be stored in the gallbladder which acts as a reservoir of bile between meals.

# Knowing What Goes Wrong When You Have Celiac Disease

In the previous sections, we look in detail at the *normal* anatomy and functioning of the digestive system. In the following sections, we look at the small intestinal *abnormalities* that are present in celiac disease. (The remainder of the digestive system is typically unaffected.) We can group these into two categories: abnormalities of structure and abnormalities of function.

## Changes to the structure of the small intestine

The beautifully intricate and elegant structure of the small intestine (sure, we know it's only your bowel, but hey, bowels can be beautiful, in their own special way) is the very first thing to be injured if you have celiac disease. With celiac disease, the duodenum and jejunum are always damaged; the ileum, however, is not usually affected. These are the stages in which damage to the small intestine happens after gluten exposure:

1. White blood cells, called *lymphocytes* (these are part of the immune system), accumulate in abnormal numbers in the tips of the small intestine's villi. Because of their location in the surface layer (*epithelial layer*) of the small intestine, these lymphocytes are called *intra-epithelial lymphocytes* or *IELs*.

2. The spaces (*crypts*) below the villi become proportionately longer (something called *crypt hyperplasia*).

3. The villi become shorter, or blunted, which is known as *partial villous atrophy*. (*Partial* because the blunting is not complete. Atrophy means "wasting away" or shrinking.)

4. The villi become so severely damaged that they are completely flattened; this condition is called *total villous atrophy*.

Figure 2-7 illustrates the various stages of intestinal damage in celiac disease.

**Figure 2-7:**
The stages
of intestinal
damage in
celiac
disease.

Normal    1    2    3    4

# Changes to the function of the small intestine

In the section, "Recognizing the importance of the small intestine" we discuss the importance to digestion of the huge surface area provided to the small intestine by the millions of villi (and microvilli). As you might expect, because celiac disease causes these villi to shrink — sometimes to the point of not even being identifiable — and because significant inflammation is now present in the small intestine, this organ's ability to function is severely compromised. Problems with small intestine function may include:

- ✔ Reduced ability to absorb fluids (and increased fluid production by the small intestine), which, if sufficiently severe, results in diarrhea.

- ✔ Malabsorption of important minerals (such as iron and calcium) and vitamins (such as vitamin D, vitamin K, and folic acid). Malabsorption can lead to anemia, osteoporosis, and other ailments.

- ✔ Malabsorption of nutrients such as protein, which in turn may lead to progressive weight loss.

We discuss these and other potential complications from celiac disease in Chapters 6, 7, 8, and 9. Now, lest you feel overwhelmed and discouraged by the problems we've pointed out in this chapter, be sure to read Part III of this book because that's where you'll find out what you need to know to correct these problems or avoid them in the first place.

# Chapter 3

# Diagnosing Celiac Disease

· · · · · · · · · · · · · · · · · · · · · · · · · · · · · · · · · · · · · · · · · · · · · · · · ·

*In This Chapter*

▶ Determining whether you have celiac disease

▶ Recognizing the importance of symptoms

▶ Getting a physical examination

▶ Understanding blood tests

▶ Knowing what to expect the day of your endoscopy

▶ Discovering what an endoscopy does

▶ Interpreting intestinal biopsies

▶ Diagnosing celiac disease if you already follow a gluten-free diet

▶ Wondering whether your diagnosis is accurate — and what to do about it

· · · · · · · · · · · · · · · · · · · · · · · · · · · · · · · · · · · · · · · · · · · · · · · · ·

**C**eliac disease affects about one percent of the North American population, although only a small fraction of this group has actually been diagnosed with celiac disease. Indeed, about 90 percent of people with celiac disease either don't know they have it or, in some cases, , are suspected to have it (and are treated for it) without first having objective confirmation of the diagnosis with appropriate testing. (As we discuss later in this chapter, we recommend against treating celiac disease unless the diagnosis is first proven.)

A key reason that so many people with celiac disease are undiagnosed is that, as we discuss in Chapter 6, the symptoms of celiac disease frequently occur with other, more common ailments and, common things being common, are attributed (by patients and doctors alike) to one or more of these other conditions. Fortunately, both health care providers and people in general are becoming more aware of celiac disease and, as a result, celiac disease is now being looked for more often.

In this chapter we discuss what should be done once the suspicion first arises that you have celiac disease. In particular, we look at the tests that should be done to determine whether you do or do not have it.

# Figuring Out Whether You Have Celiac Disease

In order to figure out whether you have celiac disease, your doctor typically follows four steps:

1. **Learns about your symptoms.**

   If you've been diagnosed with celiac disease, you probably recall having had symptoms of one sort or another that ultimately led you to see your doctor who then interviewed you to learn more about how you were feeling. "Taking a history" is always the first step that doctors follow in figuring out what may be the cause of a patient's symptoms.

2. **Examines you.**

   The second step in determining whether you have celiac disease is a physical examination in which the doctor measures your weight, looks at your skin, feels your abdomen, and looks for other physical abnormalities that can be seen with this ailment.

3. **Orders blood tests.**

   We hope that you notice that we discuss blood tests only all the way down in Step 3. Medical tests are always complementary to the essential information that a doctor learns from talking to you and examining you.

4. **Sends you for an endoscopy and small intestinal biopsy.**

   Although the preceding steps are essential, ultimately a doctor can only diagnose you as having celiac disease if you first have an endoscopy and small intestinal biopsy with the latter being interpreted by the pathologist as showing the appropriate features of the condition.

The rest of this chapter discusses each of these steps in detail.

# Understanding the Importance of Symptoms

If the retail business world is all about "location, location, location," the world of medicine is all about "history, history, history." By medical history, we don't mean the balms and salves of ancient Rome, but rather, history in the sense of what a patient tells a doctor. Ninety percent of a diagnosis is based not on a physical examination or laboratory testing but on the story you relate when you meet with your physician. (That's why medical students are taught to pay great attention to listening to patients; in medical circles, this practice is called "taking a good history.")

A key part of the history is reviewing what symptoms you are experiencing. As we discuss in Chapter 6, some symptoms are considered classical of celiac disease. These include complaints like diarrhea, weight loss, abdominal discomfort, and really smelly gas and bowel movements (worse than other people's, if that's possible!), and, in children, failure to grow normally.

Your doctor doesn't need to be the dean of Harvard Medical School to think of celiac disease when these are the complaints; however, as we review in Chapter 6, many people with celiac disease instead have other, more subtle GI symptoms that point less obviously toward this condition as their cause. Other people who are eventually found to have celiac disease may have few or even no GI symptoms, but rather, have seemingly unrelated (to celiac disease) complaints like fatigue, depression, or muscle and joint aches and pains.

Until the past 5 to 10 years, the classical form of celiac disease (see Chapter 5) was largely what led patients, families, friends, and doctors to think of celiac disease, but today, people increasingly recognize that these other, less obvious symptoms can be due to celiac disease. For this reason, doctors and other health care providers have to be alert to the possibility that a person's symptoms may be due to celiac disease.

If you are not yet diagnosed with celiac disease but are experiencing the symptoms we discuss here and in Chapter 6, ask your health care provider if these might be due to celiac disease. Who knows; you may be the one that first sets the wheels in motion leading to discovering your own as yet undiscovered diagnosis.

# Knowing What to Expect from the Physical Examination

Although the history is a very important part of a medical visit, an examination of your body (a *physical examination*) is also necessary to help make a diagnosis. Here are some of the things your doctor will check and what your doctor is trying to find:

✔ **Weight and height:** By knowing your weight and height, your doctor can calculate your body mass index (BMI), which indicates whether you are underweight, of normal weight, or overweight.

A normal BMI is between 18.5 and 24.9. If you are underweight this may be a sign that you are not absorbing nutrients from your food properly as is often the case if you have celiac disease. (On the other hand, as we discuss in Chapter 6, many people with celiac disease aren't underweight or losing weight; in fact you can have celiac disease and, like most North Americans, be overweight, even considerably so.) You

can determine your own BMI by using an online tool such as the one available at www.cdc.gov/healthyweight/assessing/bmi.

Measuring a child's height is especially important because if a child is shorter than his or her peer group or has stopped growing normally, these may be clues that the child also has a nutrient absorption problem like celiac disease.

✓ **Blood pressure and heart rate:** Having low blood pressure and a rapid heart beat can signify a number of different ailments, including dehydration (as you may experience if your celiac disease has resulted in profound diarrhea). A rapid heart beat (without low blood pressure) can also be seen with celiac disease complications or associated conditions such as anemia (see Chapter 7) or hyperthyroidism (Chapter 8).

✓ **Skin:** Celiac disease can be associated with a skin condition called *dermatitis herpetiformis* (see Chapter 8). Also, paleness may indicate you are anemic (Chapter 7).

✓ **Mouth:** As we discuss in Chapter 7, celiac disease can be associated with oral health issues such as mouth ulcers.

✓ **Abdomen:** When your doctor examines your abdomen, this is to determine if it causes you discomfort, if your belly is soft or firm, if it is distended, and if there is evidence of enlargement of your internal organs.

✓ **Arms and legs:** Because celiac disease can affect the muscles and nerves in your extremities, your doctor will examine your arms and legs. Also, dermatitis herpetiformis (see the previous bullet about skin abnormalities) can cause skin changes on your extremities.

✓ **Rectal exam:** We saved this for the, ahem, end. A rectal exam is not done all the time but is part of a complete examination for many digestive conditions.

# Getting Blood Tests

Although the history and physical examination are invaluable tools in figuring out whether you have celiac disease, in and of themselves they are not sufficient to establish a diagnosis, and you will need to have certain tests done. In most medical conditions, including celiac disease, the first tests to be done are blood tests.

You will be sent for blood tests for two main reasons:

✔ **To help determine if you may have celiac disease.** The two main types of blood tests that can help diagnose celiac disease are:

- **Antibody tests** (also called *serologic tests* or *serology*). These are virtually always done.

- **Genetic tests.** These are not done routinely but are now being more commonly ordered than in the past, partly because such tests are now more readily available. (Until relatively recently, only special laboratories performed these tests.)

✔ **To look for evidence of complications from or associated with celiac disease.** For example, blood tests may reveal that you are anemic, malnourished, dehydrated, or have evidence of liver injury. See Chapters 7 and 8 for more information on the complications from or associated with celiac disease.

In the remainder of this section, we look in detail at the various blood tests that are performed to help figure out whether you have celiac disease.

## Antibody tests

*JARGON ALERT*

*Antibodies* (abbreviated as Abs if plural, Ab if discussing just one) are special proteins called *immunoglobulins* (abbreviated as Ig) produced by certain white blood cells in our body. The body forms antibodies most commonly in response to — and to fight off — infections caused by germs like viruses and bacteria. (To discover more about the immune system, have a look at Chapter 2.)

Having antibodies to help us battle an infection is essential, but sometimes the immune system makes antibodies that are not only unhelpful, but are actually harmful. Conditions in which the body makes antibodies that attack a person's own tissues are called *autoimmune* diseases. Rheumatoid arthritis is an example of an autoimmune disease. In this condition, antibodies attack the joints.

Celiac disease is also an autoimmune disease, but in addition to making antibodies against one's own tissues, people with celiac disease also make antibodies to *gluten* which is a protein found in wheat and some other grains.

Medical scientists don't really know why celiac disease is associated with the various antibodies that are found with this condition, but knowing *if* they are present remains very helpful in making (or excluding) the diagnosis, as we look at next. In the next few sections, we look at the antibody tests that are used to diagnose celiac disease; following that discussion, we summarize how your health care provider can then use this information to help determine whether you may have celiac disease.

### Tissue transglutaminase antibody

*Tissue transglutaminase* is a protein found in nearly all the body's tissues. If you have celiac disease, you form *tissues transglutaminase* (TTG) *antibodies* against this protein. (Two types of TTG antibody are formed: TTG IgA and TTG IgG. Most laboratories test for TTG IgA; only select laboratories have the ability to test for TTG IgG; see the later section "The issue of IgA deficiency" for information on when TTG IgG test is recommended.)

The TTG IgA test is the single most important blood test you should have done if your doctor suspects you have celiac disease. As we discuss in Chapter 2, in celiac disease, gluten ingestion activates the immune system and leads to damage to the lining of the small intestine. Because TTG IgA is present in most people with celiac disease, doctors routinely look for TTG IgA if they suspect a patient has celiac disease.

Even though TTG IgA is a particularly important test in diagnosing celiac disease, because it can also be present in some other conditions (such as liver disease, congestive heart failure, and other autoimmune diseases), its presence does not guarantee you have celiac disease and does not preclude the need for a small intestinal biopsy.

In addition to helping doctors *diagnose* celiac disease, measuring your TTG IgA is also helpful in *monitoring* your condition. As we discuss in Chapter 15, as you remain on track with your gluten-free diet, your TTG IgA level will return to normal. If, on the other hand, it remains elevated, this indicates that most likely your gut is still being exposed to gluten, and your diet needs to be reviewed to determine how this is happening.

Different laboratories have different methods and, as a result, different normal ranges for many tests including TTG IgA levels. For this reason, in order to ensure apples are being compared to apples, if you need your TTG IgA test redone, it is best to go back to the same lab that did your earlier TTG IgA test.

### Endomysial antibody

*Endomysial antibody* (EMA) is an antibody that, like TTG antibodies, targets the protein, tissue transglutaminase.

EMA testing used to be commonly performed, but because TTG antibody testing tells us similar information, is (a bit) more accurate, is more readily available, and is less expensive to perform, EMA studies are now ordered much less often.

One additional problem with the EMA test is that sometimes it can be normal *even in people who have celiac disease;* a situation doctors refer to as a "false negative" test result. As you can imagine, this can be very misleading as it could cause your celiac disease diagnosis to be overlooked. (Although the TTG antibody test — covered in the preceding section — can also be falsely negative, this false result occurs less often.)

*TECHNICAL STUFF*

# Deamidated gliadin peptide antibodies

Recently, researchers have discovered that patients with active celiac disease have antibodies to a form of gliadin that has been modified by the tissue transglutaminase enzyme. This form of gliadin is referred to as *deamidated gliadin peptide* (DGP). Studies thus far show that IgA and IgG antibodies to DGP are very good at detecting celiac disease, but more studies need to be done, and these blood tests are not as yet widely used.

The endomysial antibody is, however, very helpful in one significant way: If your result is positive (that is, if you have this antibody present in your blood), it virtually guarantees that you do, in fact, have celiac disease.

## Gliadin antibody

As we discuss in Chapter 2, *gliadin* is the component of gluten that is the major trigger of celiac disease. Antibodies to gliadin are called *antigliadin antibodies* (AGA).

Because AGA testing is not nearly as accurate as the TTG antibody test in diagnosing celiac disease — it has both frequent *false positive* (meaning that the test is abnormal but the person being tested doesn't have celiac disease) and false negative results — the test is now seldom ordered. The exception to this is in young children where AGA IgA testing is sometimes helpful for diagnosis and monitoring the response to a gluten-free diet as we discuss in Chapter 15.

## Other antibody tests

Until a few years ago, some laboratories included another antibody test as part of their testing for celiac disease. That test detected antibodies to *reticulin*, a protein found in many body tissues, including the intestine. The reason that this test is no longer recommended is that it was not very accurate, having both high false positive and false negative rates.

Medical researchers are trying to find new antibody tests or combinations of antibody tests that may be more accurate than the currently available tests to both diagnose celiac disease and to rule out a diagnosis of celiac disease. In your Internet travels, you may come across one such test: antibodies to a protein called *actin*. Unfortunately, so far, anti-actin antibodies have not proven to be as helpful as initially thought.

### The issue of IgA deficiency

People make five types of antibodies (immunoglobulins): IgA, IgD, IgE, IgG and IgM. IgA is the major type of antibody made by the immune cells in the lining of the digestive tract. About 1 in 500 to 700 otherwise healthy people do not make IgA; this condition is known as *IgA deficiency*. As we discuss in Chapter 8, patients with IgA deficiency are at increased risk of infections of their respiratory and digestive tracts.

For some reason, patients with celiac disease are more likely to have IgA deficiency. This fact is important because if you are IgA deficient, some of the key tests that doctors order to figure out whether you have celiac disease (such as the tests we discuss in the previous few sections) may be normal even if, in fact, you *do* have celiac disease. This is because if you do not have the ability to make IgA, you will make neither normal, healthy IgA antibodies (such as those to fight off infections of the respiratory and digestive tracts) nor the abnormal IgA antibodies (such as TTG antibodies) that are seen with celiac disease.

To get around the problem of diagnosing celiac disease when you have IgA deficiency you can have a type of TTG antibody test other than the one typically used. The usual TTG test is for TTG *IgA,* which you will not have if you are IgA deficient. The TTG antibody test your doctor may order if you are IgA deficient is the TTG *IgG* test. This test is not available in all laboratories, however. Another option is to check your DGP IgG level (see the accompanying sidebar "Deamidated gliadin peptide antibodies").

### A stepwise approach to using antibody tests to help diagnose (or rule out) celiac disease

If your physician suspects that you have celiac disease, in the majority of cases, antibody tests will be ordered. In some instances, as discussed in the next section, genetic testing may also be requested. Because of its accuracy, the preferred antibody test is the TTG antibody. (Most laboratories, as we mention in the preceding section, "Tissue transglutaminase antibody," perform the TTG *IgA* antibody.)

Looking specifically at your TTG IgA result:

- ✔ **If your TTG IgA result comes back positive (that is, you *have* the TTG IgA antibody).** This result indicates a sufficiently strong probability of celiac disease that the next step is typically to proceed directly to a biopsy of your small intestine (as we discuss later in this chapter).

- ✔ **If your TTG IgA result comes back negative (that is, you *do not* have the TTG IgA antibody).** Your doctor needs to ensure the negative result isn't because you have IgA deficiency and, therefore, will send you for an IgA level if this was not already checked. What happens next depends on whether your IgA level is normal or low:

- **Normal.** IgA deficiency is excluded, your negative TTG IgA result is in keeping with a very low likelihood of celiac disease, and further testing for celiac disease is usually unnecessary *unless* your particular situation is so very suspicious for celiac disease that, despite these negative test results, you still require additional tests — such as an endoscopy and small intestine biopsy — to be as definitive as possible whether you do or do not have celiac disease. (An example of this situation might be a man or a post-menopausal woman who is iron deficient and for whom there is no evidence of bleeding.)

- **Low.** You likely have IgA deficiency, and your negative TTG IgA result may be on this basis rather than the absence of celiac disease. Therefore, additional testing is required. If available, the next step is usually to measure your TTG IgG level or your DGP IgG level. If either of these are positive (or if neither are available), the next step is typically to proceed with a small intestine biopsy. If this is *negative* then the probability of you having celiac disease is very low and further testing for celiac disease is typically unnecessary.

*TIP*

To spare patients extra trips to the lab, a doctor may order an IgA level at the same time as ordering a TTG IgA level. The downside to doing both tests at the same time is the extra cost involved.

In Figure 3-1, we illustrate schematically the usual diagnostic steps that are performed when your doctor suspects you have celiac disease. You will notice that the final common pathway in order to make a diagnosis of celiac disease is an endoscopy and small intestine biopsy. At present, as helpful as blood tests are, none exists that is sufficiently accurate, in and of themselves, to diagnose celiac disease.

## Genetic testing

As we discuss in Chapter 2, you need to have the right (or, perhaps one could say, the wrong) genes in order for celiac disease to develop. Because virtually all people with celiac disease have the HLA DQ2 or DQ8 genes, if tests show you do *not* have either of these genes, the likelihood that you will ever develop celiac disease is remote. In contrast, having one or even both of these genes does not mean you have or will later develop celiac disease. In fact, most (97 to 98 percent) people with these genes do not have celiac disease.

Medical scientists estimate that having the HLA DQ2 or DQ8 genes accounts for about 40 percent of the risk of getting celiac disease, which means many other factors exist that lead to celiac disease as we discussed in Chapter 2. Scientists are working to discover other genes that are necessary for developing celiac disease. We discuss the work that scientists are doing in this field in Chapter 16.

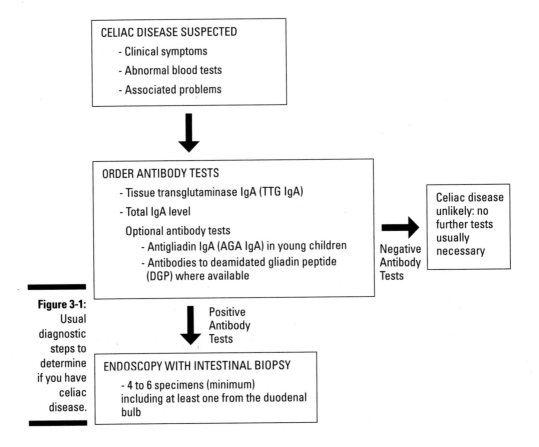

**Figure 3-1:**
Usual diagnostic steps to determine if you have celiac disease.

HLA DQ2 and DQ8 genetic testing can be of value in several situations. Common to all of these situations is that the presence of these genes indicates a person may or may not have celiac disease, and the absence of these genes indicates a person almost certainly cannot have celiac disease.

Here are the situations in which genetic testing is of value:

> ✔ **If your doctor suspects you have celiac disease, but your other test results do not fit with the diagnosis.** In this situation, the fact that you have the HLA DQ2 and/or DQ8 genes means that despite the other test results, you still may have celiac disease. This may prompt a more concerted effort to find other evidence of celiac disease.

✔ **If you have started yourself on a gluten-free diet prior to a diagnosis of celiac disease having been made.** In this case, a small intestine biopsy may be normal either because you have celiac disease and are successfully treating it or, on the other hand, because you didn't have celiac disease in the first place. We discuss this scenario further in the section, "Diagnosing celiac disease if you are already living gluten-free."

✔ **When a person within a family becomes unwell and is discovered to have celiac disease, raising concerns that other family members may be at risk.** This is the most common reason that genetic testing for celiac disease is performed. If these family members don't have the HLA DQ2 or DQ8 genes, they can be reassured they are highly unlikely to have or to later develop celiac disease. Doing such tests on undiagnosed — and asymptomatic — relatives is called *screening*. We discuss screening in detail in Chapter 4.

## Other blood tests

In the preceding sections, we look at blood tests performed to help determine whether you might have celiac disease. In this section, we look at blood tests that your doctor will most likely order to see whether you have either complications from celiac disease or some other ailment associated with it. (We discuss these different conditions in detail in Chapters 7 and 8.)

These are other blood tests you may have:

✔ **Hemoglobin level:** *Hemoglobin* is the molecule that carries oxygen in your blood stream. Your doctor will order your hemoglobin level to determine whether you are anemic.

✔ **Electrolytes (sodium, potassium) and other blood chemistry:** These tests are done to determine whether you are dehydrated or have low levels of body minerals such as potassium, calcium, and magnesium.

✔ **Thyroid function:** Thyroid disease can occur with celiac disease and can also cause gastrointestinal symptoms.

✔ **Liver tests:** Celiac disease can cause liver test abnormalities and may be associated with (autoimmune) liver and bile duct diseases.

✔ **Nutritional tests:** Because celiac disease causes malabsorption, your doctor will most likely test your blood to look for evidence of deficiencies of vitamins and other nutrients.

# Outside Looking In: How an Endoscopy Works

To determine whether you have celiac disease, your doctor must hear about your symptoms, examine you, and, almost always, order appropriate blood tests. At that point, if suspicion remains that you have celiac disease, you will need a simple and safe outpatient procedure called an *endoscopy* and small intestine biopsy. We discuss the endoscopy procedure in this section. (We discuss biopsies further in the next section; "Take a Little Piece: Small Intestinal Biopsy.")

You may be wondering, as some of our patients do, why a doctor wouldn't forego preliminary steps and go directly to an endoscopy and biopsy if a diagnosis of celiac disease is being considered. Although these procedures are the only definitive ones, and although they are straightforward and safe, they are still much more involved than a blood test, require a patient to give up time from work or other commitments, are much more expensive than a blood test, and do carry an element of risk — however slight. For these reasons and others, doctors seldom subject a patient to endoscopy and biopsy without first doing a preliminary evaluation to be certain that these procedures are truly necessary.

When you have an endoscopy, a specially trained physician places a narrow, flexible, fiberoptic tube (called an *endoscope*) into your body to look at one or another different parts of your gastrointestinal tract. Different endoscopes are used, depending on which part of your gut needs to be looked at. Figure 3-2 shows what a typical endoscope used to examine your small intestine looks like.

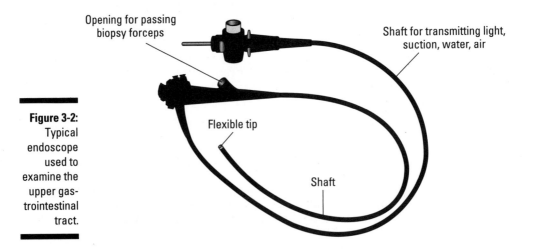

**Figure 3-2:** Typical endoscope used to examine the upper gastrointestinal tract.

Opening for passing biopsy forceps

Shaft for transmitting light, suction, water, air

Flexible tip

Shaft

Although *endoscopy* is a general term for this method of examining any part of your digestive tract, doctors typically reserve the term for those procedures done on the *upper* digestive tract (the esophagus, stomach, and duodenum), not the lower digestive tract. (When the lower part of the digestive tract — that is, the colon — is being examined, the procedure is called a *colonoscopy*.) Since the full name for endoscopy is *esophagogastroduodenoscopy* (EGD), you can see why it is easier to simply call it an endoscopy or an EGD.

## Preparing for your endoscopy

Not much preparation is required prior to your endoscopy; however, there are a few helpful and important measures for you to follow:

✔ **Plan to bring someone with you to your endoscopy appointment.** This serves two important functions because that person can:

- **Provide an extra set of ears.** Bring someone to listen in when the doctor (or nurse) tells you the endoscopy results. Having someone there is especially important if you've received sedation because you'll be prone to forgetting what you were told. (We have had conversations with an unaccompanied patient after an endoscopy only to get a call a few hours later with the patient saying "I can't remember what you told me about the results." Far better to have that extra person with you at the time of your scope so that you don't have to later play telephone tag with your physician and, more important, so that you don't have to worry needlessly.)

- **Drive you home after the procedure.** This is especially important if you've received sedation because driving after being sedated is dangerous.

✔ **Fast before the procedure.** You should not eat or drink for a number of hours prior to your test. (See the next section for the details on this requirement.)

✔ **Check with your doctor about medicines.** Speak to your doctor to find out what, if any, changes to your usual medicines will need to be made. For example:

- **Diabetes medications.** May need to be changed in dose or not taken the day of (or a portion of the day of) your procedure because you won't eat be eating fully that day.

- **Anticoagulants ("blood-thinners").** Anticoagulants, including medicines such as warfarin (Coumadin) or potent platelet-inhibiting drugs such as clopidogrel (Plavix), are typically not taken for about 5 days prior to an endoscopy. Most endoscopy units do not require you to stop over-the-counter doses of aspirin

(ASA) or anti-inflammatory drugs like ibuprofen or naproxen. Check with both the doctor who prescribes these medications for you and also the physician who will be doing the procedure to see what their recommendations are for you.

- **Medicine to be taken during the day of the procedure.** For those medicines that your doctor says you may continue to take the day of the procedure and that you customarily take first thing in the morning, ask the doctor who will be performing the endoscopy whether you can take them with a sip of water (even though you are fasting).

## Undergoing the procedure

Physicians performing endoscopies are assisted by endoscopy nurses and technicians in an endoscopy unit of a hospital or a specialized endoscopy center. An endoscopy (and small intestinal biopsy) is a fast procedure; start to finish, it typically takes no more than 10 to 15 minutes or so (a bit longer if one includes the time that you rest after it's done). These are the steps involved with an endoscopy:

1. If you are having your endoscopy in the morning, you should not eat or drink anything after midnight the night before the test (therefore, if your test is, say, at 8am, you will have been fasting for 8 hours). If your test is in the afternoon, your doctor will probably tell you that you can drink a small amount of clear liquids early that morning.

   Fasting is important as your stomach needs to be empty both to allow the doctor to see properly and also, so that you don't vomit (and, potentially, choke).

2. You are brought into the endoscopy suite where you are asked to lie on your side on a special table. A small needle is placed in a vein (an "intravenous") in your arm.

3. To make swallowing the endoscope easier for you, the doctor or nurse numbs the back of your throat by either spraying it or by having you gargle with a local anesthetic medicine. To make it more comfortable for you to undergo the procedure, you may be given an intravenous injection of a small dose of sedative. Both the sedative and the spray will wear off within a few hours.

4. You are given a protective piece of plastic (a mouth guard) to place between your teeth. The scope is then inserted through the opening in the mouth guard into your mouth and then passed down into your stomach and subsequently into your duodenum. The doctor examines the lining of your duodenum where, sometimes, highly characteristic changes (such as small notches and fissures) may be seen. Then, as we discuss in detail in the very next section, the doctor uses long forceps to painlessly take biopsies of your duodenum.

5. The scope is withdrawn and, within minutes, the sedation (if you were given any) starts to wear off, and you awaken. The doctor (or nurse) discusses the findings with you and soon thereafter you're on your way home.

An endoscopy test is usually very well tolerated and, especially if you've been given a sedative, you'll almost certainly be surprised when the doctor tells you the test is all done. Often, people don't know the test had even started!

## Knowing what to expect after your endoscopy

As we mention in the preceding section, "Undergoing the procedure," you'll probably be surprised at how fast and easy the whole procedure goes. Here are a few things to be aware of after the endoscopy has been completed:

- ✔ You may notice a bit of a sore throat after the local anesthetic mouth spray or gargle wears off.

- ✔ You can return to normal eating and drinking within a few hours.

- ✔ If you had sedation, you cannot drive, operate heavy machinery, or perform other such activities for the rest of the day. For that reason, it's necessary to have someone drive you home after your endoscopy.

# Examining What the Doctor Looks for During Your Endoscopy

As the doctor performs your endoscopy, he will examine each part of your upper gastrointestinal tract. He'll look at the general health of the lining of the different organs and, in particular, will look for evidence of the abnormalities that can be seen with celiac disease. Equally important, the *endoscopist* (that is, the doctor performing your endoscopy), will look for abnormalities *unrelated* to celiac disease that could also explain any symptoms you've been having.

## Exploring your esophagus

As we discuss in Chapter 2, the esophagus is the tube that connects the mouth to the stomach. The most important abnormality that your doctor examines your esophagus for is evidence of inflammation related to gastro-esophageal reflux and, in rare cases, a narrowing (stricture). We discuss these conditions in Chapter 6.

# Surveying your stomach

After examining your esophagus, the doctor will push the scope further down into your gastrointestinal tract, now reaching your stomach. The endoscopist will examine your stomach to look for ulcers, *gastritis* (stomach inflammation), and other abnormalities that may explain any symptoms — such as upper abdominal pain — that you may have been having.

# Delving into your duodenum

After the endoscopist examines the stomach, he passes the scope through the small channel (the *pylorus*) that leads from the stomach into the duodenum and then, voila, the duodenum, the very first part of the small intestine, is reached. Although examining the other parts of your gastrointestinal tract is important, when it comes to celiac disease, the duodenum is where the money is.

Typically, the endoscope is advanced as far down the small intestine as possible. This can range from just beyond the first part of the duodenum (known as the *duodenal bulb*) to the first part of the jejunum. (The *jejunum* is the part of the small intestine just beyond the duodenum.)

Your doctor will carefully examine your duodenum for changes of celiac disease and will also take biopsies. (We discuss biopsies in the very next section, "Taking a Little Piece: Small Intestinal Biopsy.") If an abnormal area is identified, the endoscopist will make a point of specifically biopsying this region.

The specific abnormalities in the duodenum that the doctor is looking for are:

- ✔ Scalloping or notching of the duodenal *folds*. Normally, the duodenum is smooth and free of scalloping or notching.
- ✔ Fissuring or cracking of the mucosal lining between the folds.
- ✔ Absence of the duodenal folds. This can happen in very severe celiac disease.

Some newer methods to enhance the ability to detect abnormalities of the lining of the small intestine are now available. These include *chromendoscopy* in which a dye or a different wavelength of light is used, and also, there are now new, high definition endoscopes available which can help detect abnormalities that would have been less likely to be seen with earlier generation scopes.

 A person can have celiac disease yet have a *completely normal* endoscopic appearance of the duodenum (or the entire upper gastrointestinal tract for that matter). Therefore, having an endoscopy is not sufficient to make (or rule out) a diagnosis of celiac disease. In all suspected cases, biopsies must be taken of the small intestine. It is only biopsy confirmation of celiac disease that establishes the diagnosis.

# Taking a Little Piece: Small Intestinal Biopsy

As we mention in the preceding section, the diagnosis of celiac disease can only be made based on the results of a biopsy (that is, a tissue sample) of your small intestine. In a sense, everything else we discuss earlier in this chapter can be considered one long opening act and the small intestinal biopsy result the climax of your diagnostic journey.

As we discover in Chapter 2, the small intestine is over 20 feet long and virtually any part of it can be damaged by celiac disease. Fortunately, the part of the small intestine that is easiest to reach with an endoscope — the first part, called the duodenum — is abnormal if you have celiac disease and hence is ideally suited for obtaining a biopsy. A biopsy of the small intestine is performed at the same time as the endoscopy. After the doctor has passed the endoscope into your duodenum, a long forceps is inserted through a channel in the endoscope allowing it to emerge into the intestine where the forceps can be opened and then closed, painlessly pinching off a tiny sample of the lining of the small intestine called the *mucosa*. The biopsy sample is very small indeed, about the size of grain of rice.

It is important to take at least 4 to 6 biopsy samples of the duodenum including at least one biopsy from the duodenal bulb. Taking fewer samples may miss affected areas of the intestine. (Sometimes celiac disease is "patchy," meaning that not every single area of a portion of the small intestine is equally affected.) Using the special techniques of chromendoscopy or using a high definition endoscope as described in the preceding section can be helpful in targeting abnormal looking areas where biopsies are to be taken; this increases the likelihood that, if you have celiac disease, the biopsy pieces will show the abnormalities of celiac disease.

## Interpreting a biopsy

To the naked eye, the biopsy sample that your doctor takes at the time of your endoscopy doesn't look particularly impressive; basically it is a tiny fragment of pinkish tissue. But put that same biopsy under the microscope and, if changes of celiac disease are present, whoa, is that ever a whole different story! As we describe in Chapter 2, a biopsy taken from someone with active celiac disease can show dramatic changes (well, okay, dramatic to the trained observer in any event) resembling a microscopic war zone. However, because not everyone with celiac disease has this full-blown microscopic picture, the pathologist who looks at the biopsy will also look for milder forms of damage that are also consistent with the diagnosis of celiac disease.

Of the microscopic changes seen on a small intestinal biopsy taken from someone with active celiac disease, the most important abnormalities are signs of inflammation, and shrinking (*atrophy*) of the finger-like projections (*villi*) that are key components in allowing absorption of nutrients into the body.

## Knowing when the biopsy may potentially be wrong

Even though the small intestinal biopsy is considered the gold standard for making the diagnosis of celiac disease, there are some potential pitfalls:

- ✔ A pathologist may misinterpret the biopsy findings and incorrectly attribute the observed abnormalities to some other condition even though, in fact, they are due to celiac disease.

- ✔ A pathologist may overlook abnormalities altogether and report a specimen to be normal even though there are, in fact, features of celiac disease present.

Fortunately, in the great majority of cases, if you have a biopsy that has celiac disease findings present, the pathologist will find them and report them correctly. Also, as we mention previously in the section, "Take a Little Piece: Small Intestinal Biopsy," it is important that the doctor performing the endoscopy provide a sufficient number of biopsy samples to the pathologist.

If you have symptoms and physical examination findings and blood tests that all point toward celiac disease, but your biopsy report comes back stating otherwise, your doctor should consider having the biopsy slides reviewed again. A second opinion can't hurt. If the biopsies turn out to be truly normal, then genetic testing should be performed if not already done. If these are positive for the HLA DQ2 and/or DQ8 genes, then additional testing to get biopsies from further down in the small intestine is often recommended. We discuss this uncommon situation at the end of this chapter.

# *Having another small intestinal biopsy*

Some people require a second endoscopy and small intestinal biopsy, and some do not.

If you have been diagnosed with celiac disease, gotten on track with a gluten-free diet, and had resolution of your symptoms and laboratory abnormalities (including antibody levels), then typically you do not need a repeat biopsy.

On the other hand, if you are not responding to treatment the way you should (for example, you continue to have abdominal pain and diarrhea despite months of appropriate dietary therapy), then your doctor will probably recommend your endoscopy and small intestine biopsy be repeated. If the repeat procedure reveals ongoing abnormalities, you and your doctor will then need to play Sherlock Holmes (and Watson) and figure out why. Typically, the problem is that you are inadvertently still ingesting gluten. We discuss this situation further in Chapter 12.

Some celiac specialists recommend a repeat EGD and biopsy in *all* their patients within 1 to 2 years of starting the gluten-free diet, but other specialists, including us, do not routinely recommend this course of action. We consider the ongoing care of celiac disease in more detail in Chapter 15.

## Exploring other diagnostic tests

In your travels — especially of the Internet kind — you may come across other tests that doctors may order to determine whether you have celiac disease. Which tests are available, and who pays for them, varies depending on where you live and what insurance coverage you have. These tests are:

✔ **The blood dot test:** This test involves obtaining a tiny sample of blood from your fingertip and then placing the specimen on a card which is impregnated with chemicals (*reagents*) which will change colour to reveal if tissue transglutaminase (TTG) or antigliadin antibodies are present. The blood dot test available for home use in Canada is marketed under the trade name "Biocard" and costs approximately $50.00 CDN. (The blood dot test is not approved for use in the U.S.) It is important to be aware

that when it comes to screening family members for celiac disease, the more appropriate test is to do genetic testing, not measuring antibody levels (either with home testing or laboratory testing). It is also important to note that how the blood dot test should be used in clinical care remains to be established.

✔ **Fecal tests:** These tests involve analyzing a stool specimen for the presence of celiac disease antibodies.

✔ **Saliva tests:** These tests involve analyzing a saliva specimen for the presence of celiac disease antibodies.

The fecal (stool) and saliva tests have not been very well studied or validated so they neither replace standard testing nor should they be used routinely.

# Diagnosing Celiac Disease When You Already Live Gluten-Free

More and more people are going on a gluten-free diet without having a confirmed diagnosis of celiac disease.

Sometimes, a gluten-free diet is started without any testing because a person believes that he or she is having symptoms that are so typical of celiac disease (see Chapter 6) that, in that person's opinion, the diagnosis seems overwhelmingly likely and doing tests seems unnecessary. Other times, a well-meaning doctor gets antibody tests that come back positive and instructs the patient to start a gluten-free diet without getting an intestinal biopsy.

Celiac disease specialists do not advocate starting a gluten-free diet without first having had a definitive, biopsy-proven diagnosis. Here's why:

- **Risks treating wrong condition.** As we discuss in Chapter 11, other conditions can have similar symptoms to celiac disease, so you may end up treating the wrong disease with the wrong treatment.

- **Potentially delays proper treatment.** Antibody results, although helpful in establishing a diagnosis of celiac disease, are still not as reliable as a small intestinal biopsy, so, once again, treating yourself without biopsy confirmation of celiac disease may end up delaying your receiving proper treatment for the condition that is actually present.

- **Alters test results.** If you are on a gluten-free diet but are not feeling better, it makes it more difficult to figure out if you do or do not actually have celiac disease. This is because antibody tests and biopsy specimens become less accurate once someone is on a gluten-free diet. We discuss this further in the next section, "Confirming a diagnosis of celiac disease when you live gluten-free."

- **Causes unnecessary screening of relatives.** If you are the first person in your family to be diagnosed with celiac disease, you may have relatives that then want to be (or need to be) screened for the condition. Imagine the confusion and hassles to your relatives if they seek out screening tests for a condition which, as it turns out, they didn't need to be screened for because you, in fact, never had it to begin with.

See Chapter 13 for a further discussion on this topic.

## Confirming a diagnosis of celiac disease when you live gluten-free

If you have *not* been biopsy-proven to have celiac disease, but have been following a gluten-free diet, determining if you do or don't have celiac disease can be a challenge.

The fact that your symptoms may have improved on a gluten-free diet should *not* be taken as proof that you have celiac disease. There may be many other reasons for the improvement. For example, people with *irritable bowel syndrome* (see Chapter 12) sometimes feel better on a gluten-free diet even if they don't have celiac disease. One study showed that a good result from being on a gluten-free diet correctly predicted that celiac disease was the underlying problem 36 percent of the time. This means that the other 64 percent of patients had other problems that in some cases should have been treated differently.

If you have undiagnosed celiac disease and you've been on a gluten-free diet for *less than* a year and, especially, if you've not been meticulously gluten-free, then the odds are good that one or more of your antibody tests will still be abnormal and a small intestinal biopsy would also be abnormal (thus confirming the diagnosis). Therefore, in this situation, your specialist will probably send you for these tests.

If, however, you've been living gluten-free for a year or more, your antibody tests and your small intestinal biopsy will most likely be normal. The challenge is to figure out if they are normal because you have celiac disease and it's under excellent control or, conversely, if they are normal because you don't have the disease to begin with. To sort this out is a challenge, but the first step is to do genetic testing (see Chapter 4) and only if you have the DQ2 or DQ8 genes would further tests, such as a gluten challenge (see the next section), be warranted.

Kelly, a 30 year-old nutritionist came to see Sheila for possible celiac disease. She had suffered from bloating and loose bowel movements for several years and, concerned that she had celiac disease, she had earlier placed herself on a gluten-free diet with subsequent improvement in her symptoms. Sheila checked Kelly's TTG IgA which was normal but she also ordered a HLA DQ2 and DQ8 test which showed that Kelly did not have these genes. When Kelly returned to discuss the results of her tests, Sheila informed Kelly that she was very unlikely to have celiac disease and that most likely the reason she got better was that the gluten-free diet was helping an underlying irritable bowel syndrome or that Kelly could have gluten sensitivity (see Chapter 13) or that some other factor may have been responsible. Kelly gradually incorporated gluten back into her diet and she continued to feel well thereafter.

# The role of a gluten challenge

As we mention in the preceding section, if you are following a self-imposed gluten-free diet on speculation that you have celiac disease, and you then have a normal biopsy of the small intestine, this doesn't prove much. It could be that you have celiac disease and it has responded to your diet or it could mean that you don't have celiac disease to begin with.

This conundrum can sometimes be resolved by having you perform a *gluten challenge* meaning that you abandon your gluten-free diet and then, under your doctor's close supervision, wait and see if you redevelop your previous symptoms or develop positive antibodies. If this happens, an endoscopy with small intestinal biopsy can then be performed. There are, however, some problems with the gluten challenge, including these:

- **Becoming ill.** Some patients may become very ill soon after beginning it. The one good thing about this is that with the return of their symptoms, the affected person's blood tests and small intestinal biopsy equally quickly become abnormal if they have celiac disease, so the diagnosis can be readily made.

- **Delayed onset of symptoms or antibodies.** Some patients, even if they have celiac disease, may not develop symptoms or antibodies for months in which case the diagnosis remains unclear. In this circumstance, most celiac experts recommend endoscopy and biopsy at the end of 6 months of a gluten challenge.

- **Significantly delayed onset.** If you are an adult and you've been on a gluten-free diet since infancy, it could be *years* before a gluten challenge causes antibodies or intestinal damage to develop. For this reason, if you're an adult who was, as an infant, diagnosed with celiac disease without biopsy confirmation and you've been on a gluten-free diet ever since, rather than having a gluten challenge, you are better off first having genetic testing done. If you don't have the HLA DQ2 or DQ8 genes, you can be quite sure you don't have celiac disease, no further testing is necessary, and you need no longer follow a gluten-free diet. If you have the genes and you have been doing well on the diet then most celiac disease specialists recommend you stick with the diet.

Great variation exists among celiac specialists on how the challenge is conducted (amount of gluten, duration of challenge, frequency of TTG Ab testing during the challenge, timing of the EGD). This depends on the age of the patient, how long the patient has been gluten-free, and other factors.

If your doctor advises you to reintroduce gluten into your diet, be sure to do so only gradually. This applies regardless whether this is being done as part of a gluten challenge to detect celiac disease or if you have gluten-sensitive irritable bowel syndrome (see Chapter 12) and have been avoiding gluten. In these situations, consuming too much gluten too soon can potentially lead to marked gastrointestinal symptoms.

# *Questioning Your Diagnosis*

No symptom, no physical examination finding, no blood test and, on rare occasion, not even a biopsy result provide perfect accuracy in determining whether someone has celiac disease. So, if no perfect way of diagnosing celiac disease exists, it could be that you have either been told you have it and you wonder whether you don't or, conversely, you might have been told you don't have it, yet you wonder if, in fact, you do. We look at these two issues in this section. We also examine the rare situation when everything points to celiac disease but the standard tests aren't enough to make the diagnosis.

## *Second-guessing celiac disease*

If you've been diagnosed with celiac disease and are being treated with a gluten-free diet yet you continue to feel unwell, this should raise a red flag that perhaps something else is amiss. One possibility is that, despite your best efforts, you are inadvertently continuing to ingest gluten. (We discuss hidden sources of gluten in Chapter 12.) Another possibility is that the diagnosis is wrong and you don't actually have celiac disease.

Bill Mason was a 48 year-old veterinarian, who, after having had longstanding problems with heartburn, constipation, and bloating, was referred to a gastroenterologist. The gastroenterologist performed an EGD with small intestinal biopsy, which a pathologist concluded showed features of celiac disease. Bill was, therefore, treated with a gluten-free diet, but despite dutifully following the diet, his symptoms didn't go away. Because of the lack of improvement, his gastroenterologist decided to treat Bill with a potent anti-inflammatory medication called prednisone. Alas, not only did this not help, but, in fact, Bill started to feel even worse. He therefore went back to see his family doctor who then sent Bill to see Sheila for a second opinion. Sheila arranged for her own hospital's pathologist, who specializes in gastrointestinal diseases, to review the previous biopsies and, lo and behold, the pathologist's conclusion was that the specimens did not, in fact, show celiac disease, but, rather, revealed changes typical of excess acidity (*peptic duodenitis*). The patient was taken off prednisone, was started on anti-acid medication, and discontinued his gluten-free diet. Within a few weeks, his symptoms were almost gone and he felt like a new person.

If you suspect that you do not have celiac disease, even though you've been diagnosed with the condition, speak to your doctor about your concerns. Your doctor can review the different factors that led to the diagnosis having been made and the two of you can decide if further investigations or getting a second opinion (either from a gastroenterologist who has a special interest in celiac disease or by your doctor arranging to have your biopsy slides read by a different pathologist) is appropriate.

In some situations, your doctor may conclude that you don't have celiac disease, but you are unconvinced. Sheila encountered just such a circumstance.

Ingrid, a 20 year-old woman with diarrhea, troublesome flatulence, and abdominal bloating, was referred by her family doctor to a gastroenterologist. Ingrid's sister had been previously diagnosed with celiac disease, and the GI specialist was quite certain that Ingrid also had it. Ingrid's TTG Ab result came back positive, but, to the doctor's surprise, the small intestinal biopsy result was normal. The doctor reassured Ingrid that she did not have celiac disease. Ingrid, however, still wondered if she did. Her family doctor, therefore, sought a second opinion and referred her to Sheila. Sheila was quite convinced that Ingrid had celiac disease, so she had the biopsy specimens sent to a different pathologist (one whom she knew to be excellent and very interested in celiac disease) and, lo and behold, in fact, typical features of celiac disease were present. Ingrid's doubts had been completely justified; she had celiac disease after all.

## *Looking for suspected celiac disease when it can't be found*

As we mention earlier in this chapter, on occasion a person who has both clinical features (that is, symptoms and physical examination findings) and laboratory test abnormalities (including antibodies) strongly suggesting celiac disease nonetheless has a normal endoscopy and small intestine biopsy. This can be quite a conundrum. Does the person have celiac disease and it's being overlooked? Or, in fact, is celiac disease not present?

If you are in this situation, these are next set of measures your celiac disease specialist can then undertake to sort things out:

- ✔ Have another pathologist look at the small intestine biopsy slides to make sure some subtle changes of celiac disease were not overlooked.

- ✔ Test your blood to see whether you have the HLA DQ2 or HLA DQ8 genes that place you at risk for celiac disease. If you have neither of these genes, then you are highly unlikely to have celiac disease.

- ✔ Check to see whether you have some other reason for having antibodies most commonly seen with celiac disease. Other, non-celiac disease causes include other autoimmune diseases, liver disease, and congestive heart failure.

If despite these measures, it is still unclear whether you do or do not have celiac disease, the next step is to look for small intestine abnormalities of celiac disease further down the small intestine, that is, in areas beyond the reach of a conventional endoscope. (The regular endoscope can only reach the duodenum and the very beginning of the jejunum.)

The following sections explain the ways your doctor can try to assess areas of your small intestine that cannot be reached with a regular endoscope.

## Colonoscopy

With this, the goal is to pass the scope beyond the colon and into the terminal ileum (this is the end part of the small intestine). This is called an *ileoscopy*. When the scope is in the terminal ileum, biopsies of this area can then be obtained. (Though rare, sometimes the only portion of the small intestine that is affected by celiac disease is the terminal ileum.) While the endoscopist is performing the colonoscopy, she will take biopsies of the colon to look for microscopic colitis since, as we discuss in Chapter 7, this condition can sometimes mimic celiac disease and not infrequently occurs with celiac disease.

## Capsule endoscopy

A *capsule endoscopy* (CE) is a procedure that allows video images to be taken of the intestine beyond the reach of an endoscope. During a CE procedure, you swallow an oversize "pill" which in fact is a miniature video camera (see Figure 3-3). The pill takes high resolution movies of the lining of the gut as it makes its merry way through the intestine, moved along not by a tiny propeller but by the bowel's own natural contractions (something called *peristalsis*). As it journeys through your gut, the camera beams its video images to a specially designed recorder (attached to a belt) you wear for eight hours, at which time the recorder (and belt) are removed and the captured images of the small intestine are downloaded onto a computer where a doctor analyzes them for evidence of signs of complications of celiac disease such as lumps, bumps, ulcers, and other abnormalities.

If you're wondering what happens to that high tech capsule, well, eventually, you pass it out of your body with your stool, retrieve it from the stool, and then simply dispose of it.

In addition to its role in monitoring celiac disease, capsule endoscopy can also be used to help diagnose elusive cases. Specifically, there are occasional situations where a doctor strongly suspects a person has celiac disease, but a regular endoscopy and biopsies don't detect it. In this situation, it could be that celiac disease is indeed present, but only located further down the small intestine where a regular endoscope can't reach. In this situation, a capsule endoscopy can be performed, and if the images it captures are compatible with celiac disease in this more distant region of the small intestine, then a longer type of endoscope (a *push enteroscope* or a *double balloon enteroscope*) can be used to try to confirm the diagnosis by obtaining biopsies of this portion of the intestine. The following section has more details on this procedure.

**Figure 3-3:**
Capsule
endoscope.

### Enteroscopy

Enteroscopy is the same as endoscopy, but using a long scope (an *enteroscope*) that, because of its length, can reach beyond where an endoscope is able. Since these techniques are time consuming and require specific expertise, referral to a specialized center will often be needed to have such testing done.

Before you undergo an ileoscopy or enteroscopy, your specialist may ask you to eat more gluten than you normally do in the hopes that this will enhance the small intestinal damage. (Making your small intestine damage worse is helpful only insofar as it helps establish the diagnosis; it is certainly *not* a long term goal!)

If — egads — after all this, a biopsy confirmation of celiac disease has *still* not been made, then further recommendations are made based on your individual clinical situation. Often, a trial of a gluten-free diet is undertaken to see whether this causes relief of symptoms and resolution of abnormal celiac disease antibodies. Alternatively, if you're not feeling particularly unwell in the first place, your doctor may recommend you continue with your regular diet and have certain of your tests redone after 6 to 12 months to see whether they've become more definitive. (In particular, with the passage of time, if you have celiac disease your small intestine biopsies will likely become more clearly abnormal.)

Fortunately, it is very rare that diagnosing celiac disease is as complicated as this!

# Chapter 4

# Screening for Celiac Disease

. . . . . . . . . . . . . . . . . . . . . . . . . . . . . . . . . . . . . . . . . . . . . .

## In This Chapter

▶ Knowing who's at risk of developing celiac disease

▶ Looking at who should be screened for celiac disease

▶ Understanding how screening works

▶ Detecting celiac disease before it makes you unwell

. . . . . . . . . . . . . . . . . . . . . . . . . . . . . . . . . . . . . . . . . . . . . .

*I*f celiac disease caused every person with the condition to develop a shiny green foot, figuring out who did and who did not have the condition would be a piece of cake and as simple as having you take off your shoe. No diagnostic uncertainty. No tests necessary. Yes, well, as we all know, things are seldom that simple. As we discuss in Chapter 6, there is no symptom (or group of symptoms) that is unique to celiac disease. For that reason, when someone has suspicious symptoms — such as unexplained diarrhea and weight loss — further investigations, such as those described in Chapter 3, are required.

But what if you have no symptoms at all? Should you still be tested to see whether you have celiac disease? The quick answer is "it depends." The longer answer is, well, the entirety of this chapter. So read on . . .

## Knowing When to Screen Someone for Celiac Disease

*Screening* for a disease is the term used when a doctor tests someone who doesn't have evidence of a disease to see if, nonetheless, they do in fact have it. In other words, *screening* is looking for a condition before it turns into a problem.

You may be surprised to learn that throughout your life, you've been screened for various diseases. Screening begins at birth when all infants are tested for hypothyroidism (thyroid underfunctioning). As the years roll by, doctors perform other screening tests, including, depending on a person's age and gender, those for diabetes, high cholesterol, high blood pressure, breast cancer, colon cancer, cervical cancer, and prostate cancer to name but a few.

Two main criteria must be met in order to justify screening someone for celiac disease:

- ✔ **A reasonable probability exists that testing will show you do indeed have celiac disease.** If the odds of your having celiac disease are close to zero, performing testing for this disease is, as you may expect, rarely going to be helpful.

- ✔ **Determining that you have celiac disease is meaningful.** In other words, justification to test you for celiac disease only exists if, upon finding out you do indeed have the condition, the institution of a gluten-free diet occurs. Also, the diet would need to be of health benefit to you.

We discuss controversies surrounding celiac disease screening in the sidebar, "To screen or not to screen, that is the question."

# Determining Who Should Be Screened for Celiac Disease

A number of factors put you at increased risk of having celiac disease and, therefore, may make screening you for celiac disease more appropriate.

These factors are the most important *general* situations that may make screening you for celiac disease appropriate (we discuss specific situations in a moment):

- ✔ **If you have a close relative with celiac disease.** A close relative is considered a *first degree relative,* that is, a parent, sibling, or child with celiac disease.

- ✔ **If you have a disease that often occurs together with celiac disease.** An example of such a so-called *associated disorder* is having another autoimmune disease such as type 1 diabetes. We discuss this and other associated conditions in Chapter 8.

- ✔ **If you have a disease that can be caused by celiac disease, such as osteoporosis or iron deficiency.** We discuss these conditions further in Chapter 7.

## To screen or not to screen, that is the question

In North America people are screened for celiac disease only if it is thought they are at significant risk of having the condition. Several reasons exist for doing this *selective screening* rather than screening everybody (so-called *universal screening*), including:

- ✔ The significant costs of the screening tests.

- ✔ Concerns about diagnosing a condition that may never cause clinical problems. (In other words, "if it ain't broke, don't fix it.")

- ✔ Identifying a problem for which the affected person is, perhaps, not interested in being treated.

Screening for diseases is important when the disease is contagious or if having the condition diagnosed and treated helps prevent deterioration in one's health, reduced quality of life, premature death, or any combination of the preceding. Because celiac disease is not contagious, because it does not usually shorten lifespan significantly, because people with celiac disease who are symptom-free and only diagnosed by screening might never get sick from it, and because screening tests are costly, screening everyone for the condition is generally thought by health authorities to be inappropriate. However, this remains a controversial area among experts in the field of celiac disease and, understandably, is also sometimes a point of contention among many individuals and their family members who have suffered from a delayed diagnosis of celiac disease.

Bill, a 25 year-old patient of Ian's, had been having problems with abdominal cramping and heartburn. Tests were run and a diagnosis of celiac disease was made. His perfectly healthy sister, Tara, having heard about her brother's diagnosis, saw her own physician who tested her for celiac disease by sending her for appropriate investigations which, as it turned out, showed that she, too had celiac disease. Both Bill and Tara had celiac disease, but it was Tara who, being free of symptoms or other evidence of celiac disease, had been *screened* for the condition.

The debate continues as to whether screening for celiac disease is justified on a widespread basis in the general population. Conversely, determining whether screening an individual on a case-by-case basis is a different matter because, for a specific individual, a doctor can generally estimate whether or not there is a sufficient probability of celiac disease that testing the person for it is appropriate.

## *Screening and genetic ancestry*

Because of their genetic ancestry, some people (such as those from the Far East or sub-Saharan Africa) are at low risk of having celiac disease. Nonetheless, because North America has a long history of immigration from all corners of the world and of interracial mating, determining which North

ıns are genetically at risk is not easy. For this reason, people who,
urely on their ancestry, might be considered to be at low risk for
sease are sometimes screened for this condition anyhow.

## Screening and symptoms

We recommend you discuss with your doctor whether you should be
screened for celiac disease if you have any of the following (all of which we
discuss in Chapters 7 and 8), *particularly when other known causes of these
conditions or symptoms cannot be identified*:

- Alopecia (loss of hair)
- Dry eyes and mouth
- Aphthous ulcers ("chancre sores") of the mouth
- Erosions of dental enamel
- Thyroid disorders
- Indigestion or heartburn
- Type 1 diabetes mellitus
- Liver and biliary tract problems (such as abnormal liver enzyme tests or autoimmune liver disease)
- Anemia
- Irritable bowel syndrome symptoms (bloating, cramps, altered bowel habits)
- Gynecological problems, such as not having begun having periods despite reaching an appropriate age, having periods stop before reaching menopausal age, early menopause
- Obstetrical problems, such as the inability to get pregnant, frequent miscarriages, delivering premature babies
- Osteoporosis, unexpected broken bones
- Neurological problems, such as neuropathies, difficulties with balance, migraine headaches
- Behavioral disorders, including hyperactivity, difficulty concentrating
- Mood and thinking problems such as depression, irritability, or forgetfulness
- Growth and development problems in infants and young children including lack of growth, insufficient growth, unexplained weight loss
- Fatigue, if chronic
- Down syndrome or Turner syndrome

One could consider looking for celiac disease in such instances as *case finding* rather than screening, since many, if not most, of the disorders listed above can be associated with celiac disease and since, by definition, screening is typically considered to be testing for a condition in the absence of any evidence that it is present. But hey, we don't want to get overly nitpicky here.

The preceding list is long and admittedly somewhat intimidating: What person, after all, hasn't had at least some of the features that we noted? Indeed, the number of situations in which celiac disease could be considered is rather mind-boggling. Turning things on their ear, one could reasonably ask, "Who should *not* be tested for celiac disease?" The truth of the matter is that the answers to the questions who to screen and who not to screen simply aren't known. We think a reasonable compromise is for you to be screened if you have features in the preceding list *and* they are persisting or unexplained by other, more obvious causes.

## Screening, personal choices, and one's stage in life

That the person being screened should want to be screened goes without saying. Undergoing screening tests may not be a huge ordeal, but some people would rather not undergo these tests, thank you very much. Also, some people don't want to be treated for the condition being searched for, in which case there's no point searching for the condition in the first place. Some benefit must be derived from finding out that you have celiac disease, and some value obtained by being treated with a gluten free diet.

Sheila was hosting a meeting of her local celiac disease support group, and the topic of screening relatives came up. One woman (who, herself, had celiac disease) wanted to have her 86 year-old father screened for the condition. He was healthy as an ox and had never had any problems that raised concerns that he could have celiac disease, but the woman was worried about her father nonetheless. Sheila advised the daughter that it would be best to let her father live the rest of his life without undergoing screening. At such a late stage of life, the treatment would most likely not benefit him and rather, would likely decrease his enjoyment and quality of life. On the other hand, the woman's children were appropriate candidates for screening, because they had many, many years of life ahead of them and ample time for celiac disease, if left untreated, to harm them.

# Understanding How Screening for Celiac Disease Works

Screening for celiac disease is performed in two ways:

- ✔ **Genetic testing** is performed on either a blood sample or on cells obtained from the inside of the cheek (obtained by a painless "scraping" of the inside of the cheek). If the test is positive, further investigations are then undertaken. We discuss this further in the section "Genetic testing."

- ✔ **Antibody testing** is performed on a blood sample obtained from the person being screened. If the test is negative (that is, the antibody is not present), the test is repeated again every few years. Lifelong re-screening applies primarily to first degree relatives of celiac disease patients, although if celiac disease has not developed by later in life, a case could be made that enough is enough and screening may then be discontinued. (Having said that, because celiac disease can present in every decade of life, experts don't really know when screening should stop in someone who has the HLA DQ2 and/or DQ8 genes that make them at risk of developing celiac disease.)

Ideally, the antibody test is performed only after a positive genetic test. That way, you will not be sent for needless antibody tests if your genetic test has already revealed that you have virtually no risk of having celiac disease.

## Genetic testing

Your genes lay out your body's blueprint. Your genes determine whether you have dark hair or blond hair, or are short or tall, and so forth. As we discuss in Chapter 2, the genes most associated with celiac disease are called HLA DQ2 and DQ8.

If you have the HLA DQ2 and/or DQ8 genes, this does *not* mean that you are certain to have celiac disease, but it does mean that you are at increased risk. Therefore, if you have these genes, additional tests (including antibody testing, and, if positive, endoscopy with small intestine biopsy) are needed to determine whether celiac disease is present. The main benefit of having genetic screening is that if you don't have the HLA DQ2 or DQ8 genes, you are almost without risk for ever getting celiac disease.

## Antibody testing

As we discuss in Chapter 3, several blood tests are available that check whether you have antibodies to various proteins that are associated with celiac disease. Of these, the most accurate one to help diagnose (or, if absent, exclude) celiac disease is the IgA antibody to tissue transglutaminase (TTG IgA).

## Knowing which test method is best for you: Genetic testing or antibody testing?

Just like the expression "different strokes for different folks," so, too, when it comes to deciding which screening test is preferred for different individuals:

- ✔ **Genetic screening** is preferred if you are being screened because you are at increased risk of having celiac disease since you have a close (first degree) relative with celiac disease. This test is particularly help-ful if the result shows you do not have the HLA DQ2 or DQ8 genes, as the lack of these genes means your risk of having or later developing celiac disease is so remote that, in fact, you will not need any further screening.

- ✔ **Antibody screening** is preferred if you are being screened because you are at increased risk since you have an autoimmune condition. (Genetic screening is typically not done in this situation because medical stud-ies have shown that if someone has an autoimmune disease, they likely have the HLA DQ2 and/or DQ8 genes so testing for these is not helpful.)

The TTG antibody can be falsely elevated in autoimmune diseases, congestive heart failure, and liver diseases. Therefore, if you have one of these diseases and your TTG Ab result is positive, this result is *not* a reliable indicator for celiac disease and, depending on your particular situation, you may need a biopsy of your small intestine performed.

# Asymptomatic Celiac Disease Detected by Screening

When an *asymptomatic* individual (that is, someone who has no symptoms) undergoes screening and is found to have celiac disease, they have either the *silent* or *latent* forms of celiac disease. We discuss these and the other types of celiac disease in Chapter 5.

The long-term outlook for people diagnosed with silent or latent celiac disease is unknown, and some controversy exists as to whether such individuals should be treated with a gluten-free diet. On the one hand, some studies demonstrate an improved quality of life after asymptomatic celiac disease is detected by screening and treated by a gluten-free diet. On the other hand — and diametrically opposed! — some studies report a *reduced* quality of life in screen-detected celiac disease patients who go on a gluten-free diet.

Given this conflicting information, doctors are often understandably hesitant to screen everyone at risk of celiac disease, seeing as when these asymptomatic forms of celiac disease are discovered, what should be done, if anything, remains unclear.

# Chapter 5

# What Type Am I? Looking at the Forms of Celiac Disease

## In This Chapter

▶ Looking at the types of celiac disease

▶ Exploring classical celiac disease

▶ Learning about atypical celiac disease

▶ Discovering latent celiac disease

▶ Finding out about silent celiac disease

Although most people — including many health care professionals — think of celiac disease as being one condition, there are, in fact, several different forms. In this chapter, we look at the various forms of celiac disease, what they have in common, and how they differ. Most importantly, we discuss why this is important for you to know.

## What's in a Name: The Different Types of Celiac Disease

In its *classical* — and best known — form, celiac disease is associated with abdominal cramping, diarrhea, and malnutrition. And as you may expect, if there is a classical form, there is bound to be one or more non-classical forms. Non-classical forms of celiac disease are the *atypical* form, the *silent* form, and the *latent* form. It is now known that the majority of people with celiac disease do not have the classical variety; rather, they have one of these other types. Table 5-1 illustrates the key features of the different forms of celiac disease; you may find it helpful to refer back to this table as you read the chapter.

| Table 5-1 | The Main Features of the Different Types of Celiac Disease | | | |
|---|---|---|---|---|
| **Type of Celiac Disease** | **Classical** | **Atypical** | **Silent** | **Latent** |
| **Typical Age of Onset** | Childhood | Adulthood | Adulthood | Adulthood |
| **Symptoms** | Primarily gastrointestinal | Primarily non-gastrointestinal | None | None |
| **Complications** | Usually absent | Often present | None | None |
| **Celiac Disease Antibodies** | Present | Present | Present | Present |
| **Small Intestine Biopsy** | Abnormal | Abnormal | Abnormal | Normal |
| **Treatment** | Gluten-free diet | Gluten-free diet | Gluten-free diet | Uncertain |
|  | Treatment of complications | Treatment of complications | | |

# Textbook Disease: Looking at Classical Celiac Disease

For two thousand years, when doctors described what we now call celiac disease, they were discussing the classical form of celiac disease. Similarly, when celiac disease has been discussed in the press or at the dinner table or at the office water cooler, it has been this variety of the condition that typically was being considered. The following sections discuss the symptoms, diagnosis, and treatment of this form of celiac disease.

## Symptoms of classical celiac disease

Classical celiac disease can occur in adults but more typically begins in early childhood. It is characterized by symptoms that arise directly from damage to the small intestine. The affected person has abdominal bloating and

discomfort, and diarrhea. Also, because the damaged bowel becomes unable to properly absorb nutrients into the body (a condition called *malabsorption*), the individual with classical celiac disease starts to break down some of his or her own tissues to provide nutrients to supply energy for the body's normal functioning. This leads to loss of muscle mass and weight loss.

In children, the malabsorption that is present means there are insufficient nutrients present to allow for proper weight gain, growth and physical maturation (a condition called *failure to thrive*). In particularly severe cases, a child's bones may not develop properly, leading to bowing of their legs (called *rickets*; see Chapter 7). We discuss celiac disease in childhood in detail in Chapter 14.

## Diagnosing classical celiac disease

As with the other forms of celiac disease, a person with classical celiac disease has abnormal blood tests; most importantly, he or she typically has the presence of tissue transglutaminase IgA antibody (TTG IgA). We discuss this test in detail in Chapter 3.

The TTG IgA test will not be reliable if a person has a deficiency of the IgA antibody. Therefore, if you have the symptoms we discuss in this section yet after doing some blood tests, the doctor determines that celiac disease is not, in fact, present, we recommend you ask the doctor whether the IgA level was tested. If it wasn't, it needs to be. We discuss the issue of IgA deficiency in detail in Chapter 3.

Classical celiac disease cannot be diagnosed unless a small intestine biopsy is obtained and found to be abnormal. We discuss this test in detail in Chapter 3.

## Treating classical celiac disease

The mainstay of treating classical celiac disease is following a gluten-free diet. Meticulously. Conscientiously. Strictly. Ah, we think you get the point. The speed with which a person responds depends, in part, on how long he or she has been unwell, how severely damaged is the small intestine, and how ill he or she is, but in general, once treatment is underway, the person with classical celiac disease will soon start to improve with progressive resolution of the abdominal symptoms and diarrhea. If a child has had stunted growth and development, he or she will usually have a spurt and, depending on when the diagnosis was made and how severe is this complication, may eventually catch up to his or her peer group in size and maturation.

Jane was on the verge of tears when she brought Brittany, her four year-old daughter, to see the pediatrician. Sick with worry, Jane told the doctor how Brittany would sometimes cry in pain, would have such bad diarrhea that she was sometimes not making it to the bathroom in time, and had stopped growing. The doctor took one look at the clearly malnourished child and recognized why Jane would be so worried. The doctor carefully examined Brittany and then said to her mom, "Jane, your daughter has textbook findings of celiac disease. We should be able to quickly confirm this and get treatment under way." Sure enough, subsequent tests established that Brittany had classical celiac disease. Shortly after starting a gluten-free diet, Brittany quickly began to regain her health and once again became a vibrant and growing child.

# When Symptoms Suggest Something Else: Looking at Atypical Celiac Disease

*Atypical celiac disease* is the form of celiac disease characterized by the absence of or, at most, only a very small number of small intestinal symptoms with the predominant complaints being related to some other organ. This is in distinct contrast to classical celiac disease wherein symptoms are primarily or, often exclusively, related to the small intestine and the associated malabsorption. Also, atypical celiac disease is most commonly diagnosed in adults and relatively less often in children. However, even in children, the atypical form is being seen more often, especially in older children.

Despite the lack of gastrointestinal (GI) symptoms, the small intestine *is* damaged if you have atypical celiac disease.

Atypical celiac disease is much more common in society than is classical celiac disease. (Hmm . . . if something that is called "atypical" is much more common than is something that is called classical — reasonably a synonym for "typical" — we think a case could be made for reversing the names. But, oh my, imagine the confusion that would lead to. "Mr. Smith, you have classical celiac disease, no wait, you have atypical celiac disease, no wait, you have . . ." Guess, we'll just stick with the existing classification!)

Because atypical celiac disease is, well, atypical, it is a diagnosis that is often not considered by doctors. For that reason, if you think you may have it (based on the features we discuss in the next section), feel free to mention the possible diagnosis to your physician. As always, we'll be happy to take the blame should your doctor — perish the thought! — take offense at your raising the issue.

## Looking at GI symptoms of atypical celiac disease

When present, GI symptoms may include mild indigestion, heartburn, abdominal cramps and bloating, diarrhea, and/or constipation. Because these GI symptoms are mild and because they are so commonly seen in otherwise healthy individuals or people with any of a whole slew of different ailments, most physicians wouldn't — perfectly understandably by the way — readily consider celiac disease as the culprit. More likely, if you were having these GI symptoms, a doctor would entertain diagnoses such as:

- ✔ **Irritable bowel syndrome,** a condition characterized by abdominal discomfort and altered bowel habits (frequently involving both constipation and diarrhea). (We discuss this condition in Chapter 12.)
- ✔ **Gastro-esophageal reflux,** an ailment in which acid from the stomach goes back up into the esophagus. (We discuss this condition in Chapter 12.)

## Examining non-GI symptoms of atypical celiac disease

As we mentioned earlier in this section, atypical celiac disease is characterized by a paucity or complete absence of gastrointestinal symptoms. Many different circumstances lead to the ultimate diagnosis of atypical celiac disease. What they have in common is someone (be it a physician, a nurse, a dietitian, another health care provider or, importantly, a patient) thinking of the possibility.

*Many* different scenarios may lead — sometimes sooner, sometimes later — to a diagnosis of atypical celiac disease, including when a person is discovered to have otherwise unexplained

- ✔ Anemia
- ✔ Osteoporosis or low impact fracture (we define these terms in the section "Osteoporosis due to atypical celiac disease") in adults; rickets in a child
- ✔ Infertility
- ✔ Erratic blood glucose levels in the setting of type 1 diabetes
- ✔ Skin rash
- ✔ Nerve damage
- ✔ Bleeding

- ✔ Calcium deficiency
- ✔ Vitamin deficiency
- ✔ Tooth (enamel) defects in a child

We discuss the first four of the listed items in detail in the following sections. We discuss the other listed items (and many of the other possible health issues that can lead to a diagnosis of atypical celiac disease) in Chapters 7 and 8.

### Anemia

The small intestine is damaged if you have atypical celiac disease just as it is with the classical form. When the small intestine is damaged, it loses its ability to absorb into the body essential nutrients required to make red blood cells. The three most common types of anemia that are seen are those due to low levels of

- ✔ Iron (anemia due to low iron is called *iron deficiency anemia*)
- ✔ Folic acid (or *folate*)
- ✔ Vitamin $B_{12}$

You can have a deficiency of iron, folic acid, or vitamin $B_{12}$ without necessarily being anemic. In this case, it is only when these specific nutrients are measured on a blood test that the deficiency is identified.

Deficiency of iron, folic acid, or vitamin $B_{12}$, whether or not associated with anemia, does not necessarily cause symptoms.

Bill was a perfectly healthy 40 year-old man who, after seeing a notice in the local newspaper asking for blood donors, headed down to the local clinic. To his shock, as he went through the screening process done prior to giving a donation, he was told he would not be allowed to give blood as he was anemic. He had felt completely well. Following the clinic's advice, he went to see his family physician, who discovered that Bill was low in iron. Tests to rule out bleeding were normal (low iron can be caused by blood loss), so further testing was undertaken and, lo and behold, it was determined that Bill had low iron due to iron malabsorption due to celiac disease. He was treated with a gluten-free diet and, for a time, iron supplements, and his iron level gradually returned to normal. After his anemia had corrected, he returned to the blood donor clinic and was able to donate.

We discuss the subject of anemia and celiac disease in more detail in Chapter 7.

### Osteoporosis

Osteoporosis is a condition where loss of bone strength and mass (amount) occurs. Having osteoporosis increases your risk of a fracture. As we discuss in Chapter 7, to have healthy bones, you must have not only sufficient

amounts of calcium and vitamin D in your diet, but you must also have a healthy small intestine that can absorb these nutrients from the gut into your body. If you have celiac disease, you may not be able to properly absorb calcium and vitamin D and as a result you can develop osteoporosis.

Because osteoporosis causes — and this is a surprise to most people — *no symptoms at all*, it is typically undetected until it either is found when a person is sent by their doctor for a routine osteoporosis screening (bone mineral density) test or when an individual sustains a low impact fracture. In medical parlance, a *low impact fracture* is defined as a fracture of a bone (excluding the small bones of the hands or feet) that occurs despite only minor trauma such as a seemingly harmless fall.

When celiac disease is the cause of osteoporosis and fractures, this is the usual chain of events leading to the diagnosis of celiac disease:

1. An apparently healthy person has a seemingly harmless fall.

2. Despite the person having had only a minor fall, he or she sustains a low impact bone fracture.

3. Surprised that such minor trauma lead to a fracture in a healthy person, a doctor questions whether the person has some underlying bone disorder, such as osteoporosis, that made that person susceptible to a fracture.

4. The doctor orders a bone mineral density (BMD) test to evaluate the patient's bones and it comes back showing osteoporosis.

5. The physician questions why this healthy person would have osteoporosis and, aware that osteoporosis can be caused by malabsorption, orders tests looking for this condition.

6. Blood tests confirm evidence of malabsorption, and the doctor then runs further tests, including those for celiac disease, to determine why malabsorption is present. Lo and behold, celiac disease is found. (Sometimes, a doctor may order celiac blood tests during Step 5.)

As you might imagine, the poor person who, until the fracture, had thought themselves to be perfectly well is typically stunned to find out he or she has not just one, but *two* underlying conditions: osteoporosis *and* celiac disease. There is, however, one silver lining to this. Unlike other people with osteoporosis, a person in this situation has one additional, highly potent therapeutic weapon available to help rebuild bone strength; use of a gluten-free diet. The gluten-free diet heals the intestine which will then allow for the resumption of normal absorption of calcium and vitamin D.

You may perhaps have noticed that in the preceding numbered list we twice referred to a doctor questioning the unanticipated occurrence of a problem and then doing further tests which subsequently led to an unexpected discovery. Alas, not all physicians are so questioning and for this reason many people with fractures don't have their osteoporosis discovered and, if the osteoporosis was due to celiac disease, don't have this discovered either.

You can be your best advocate and you can help your doctor help you and others in the following ways:

- ✔ If you *have* celiac disease and you ever sustain a low impact fracture, ask your doctor to test your bone density to determine if you have osteoporosis.

- ✔ If you are *not* known to have celiac disease and you sustain a low impact fracture, ask your doctor to test you for osteoporosis. If osteoporosis is found, ask your doctor to also test you for celiac disease.

- ✔ Whether you have celiac disease or not, feel free to share with others the information discussed in this section. If you know someone that has had a fracture despite only minor trauma, mention to that person that you read how osteoporosis (and celiac disease) can cause this.

### *Infertility*

Although it remains a controversial topic and although the link is not considered fully proven, there appears to be an association between infertility and celiac disease.

Jill was a 34 year-old woman who, despite years of trying to start a family, had been unable to conceive. She had had repeated meetings with her gynecologist and had been poked, prodded, and tested more than she could have dreamt possible, yet no cause for her infertility had been discovered. Her husband, too, had been tested, but nothing untoward showed up. Jill decided to do her own research and, turning to the Internet, she discovered that there were cases where similarly infertile women had been found to have celiac disease and once placed on a gluten-free diet had successfully conceived. She approached her gynecologist with this information and was tested for celiac disease. Despite having not a single other symptom of the disease, her results came back positive. Jill met with a dietitian, began a gluten-free diet, and a few months later was back in the doctor's office. Before the doctor said a word, he knew that his patient was pregnant: Jill's ear-to-ear smile told the story. Indeed, the story continued as, over the next few years, Jill ended up having two further, successful pregnancies. She was so overwhelmed by both her joy and how she had discovered her own celiac disease that she ended up starting a local community celiac disease support group.

Jill, in the preceding anecdote, had atypical celiac disease; that is, in her case, her celiac disease had not caused gastrointestinal symptoms — or any other symptoms for that matter — with one exception: she had infertility. Was Jill infertile because of her (atypical) celiac disease? And was she able to conceive because she was then treated with a gluten-free diet? It's impossible to know for certain, but medical research suggests this could be the case.

It pays to be your own advocate. If you have infertility and routine tests don't reveal a cause, ask your doctor to consider the diagnosis of celiac disease. It could well be that this is something they'd already considered and had previously excluded. Or it could be that because you hadn't had any of the symptoms of celiac disease that are most familiar to doctors (that is, gastrointestinal symptoms), the diagnosis of celiac disease hadn't been considered.

We further discuss the relationship of infertility and celiac disease in Chapter 14.

### Erratic blood glucose control (in people with type 1 diabetes)

Type 1 diabetes is the form of diabetes that most commonly onsets in children or young adults and requires the immediate introduction of — and ongoing use of — insulin therapy. Controlling blood glucose levels in type 1 diabetes is a fine balance between many factors, including, most importantly, food intake, exercise, and the amount of insulin given. If these are out of sync, then blood glucose control can become erratic.

As we discuss in Chapter 8, because celiac disease causes malabsorption, it can lead to unstable blood glucose control in a person with type 1 diabetes. Fortunately, nowadays, diabetes specialists are usually familiar with this and routinely test for celiac disease in this situation. If celiac disease is discovered, following a gluten-free diet usually quickly improves the blood glucose control. Because celiac disease presenting this way is unassociated with other symptoms of celiac disease, it is said to be the atypical form of celiac disease that is present.

In the preceding paragraph we mentioned that diabetes specialists are *usually* familiar with the relationship between type 1 diabetes and celiac disease, which is to say that not all such specialists are especially aware of this connection. Also, not every person with type 1 diabetes is being followed by a diabetes specialist. For these reasons, if you have type 1 diabetes and your blood glucose control has become unexpectedly erratic, we recommend that you ask your health care provider if you've been tested for celiac disease. If you haven't been tested for celiac disease, and if no other apparent explanation exists for your problem, you should have this testing undertaken.

# Hushed but Not Forgotten: Silent Celiac Disease

Silent celiac disease (also sometimes called *subclinical celiac disease*) has three key features. The affected person:

✔ Does not have symptoms (gastrointestinal or otherwise) of celiac disease and does not have other diseases or health problems that would provide clues they have celiac disease.

✔ Has typical blood test abnormalities of celiac disease (and, like the other forms of celiac disease, is associated with certain HLA genes as we describe in Chapter 4).

✔ Has small intestine biopsy findings of celiac disease.

## Uncovering silent celiac disease

As you may expect, because silent celiac disease is, by definition, not associated with symptoms, it is most likely to be discovered as an incidental and unexpected finding, such as when a person has a small intestine biopsy done during an endoscopy being performed for an entirely unrelated condition (such as having an ulcer) or is tested for possible celiac disease as part of a research study being done on close relatives of someone who is known to have celiac disease. (We discuss screening in detail in Chapter 4).

## Treating silent celiac disease: Should you or shouldn't you?

Arguments can be made both for and against treating silent celiac disease (with a gluten-free diet). In support of *not* treating it, one could point out that:

✔ The person with silent celiac disease feels perfectly well; why, therefore, ask that person to initiate therapy for something that isn't bothering him or her? (That is, "if it ain't broke why fix it?")

✔ Following a gluten-free diet is not an easy thing to do; indeed, it is not only inconvenient, but it can also be frankly difficult. Why, therefore, recommend that a perfectly healthy person take on this burden?

✔ Doctors don't have any long-term scientific data to show that treating silent celiac disease is of value in protecting and preserving health, so in the absence of this data, isn't it inappropriate to advocate treating it?

On the flip side of the argument, in support of *treating* silent celiac disease, one could point out that:

✔ A person with silent celiac disease may feel completely well, but that isn't a reason not to treat them. Rather, this simply means that they were fortunate to be discovered before celiac disease had had time to make them sick. Treating them now will help keep them from later getting sick.

✔ It's not rare that a person who had no awareness of having symptoms only recognizes with the benefit of hindsight, once they've been following a gluten-free diet for a time, that in fact *they had* been having symptoms. In other words, it was only after symptoms they'd had chronically (and therefore didn't even notice them anymore) went away that they realized they'd ever been there in the first place.

✔ Following a gluten-free is not easy, but getting sick and running into complications from untreated celiac disease is far worse.

We wish harder scientific evidence were available to tell us what advice we should give patients, but, well, it isn't. In the absence of this evidence, doctors — including us — need to rely on our best clinical judgment. We know how much damage can be done by celiac disease; indeed, we see it all the time. So even though we don't have foolproof evidence that patients with the silent form of celiac disease benefit from following a gluten-free diet, we prefer to err on the side of caution. For that reason we advocate that if you have silent celiac disease, you follow a gluten-free diet. Most of our colleagues, by the way, offer similar advice to their patients.

# Lurking in the Background: Latent Celiac Disease

Latent celiac disease (also sometimes called *potential celiac disease*) has three key features. The affected person:

✔ Does not have symptoms due to their celiac disease.

✔ Has typical blood test abnormalities of celiac disease (and, like the other forms of celiac disease, is associated with certain HLA genes as we describe in Chapter 4).

✔ Does *not* have small intestine biopsy findings of celiac disease.

The most important difference between silent celiac disease and latent celiac disease is that with the former the small intestine biopsy is abnormal and with the latter it is normal. Latent celiac disease is most likely to be discovered when someone has an abnormal blood test found as part of a celiac disease screening program and then goes on to have a normal small intestine biopsy.

Celiac disease is, by definition, a condition in which the small intestine has certain characteristic abnormalities. Latent celiac disease, by definition is associated with a normal small intestine biopsy. This contradiction has led to controversy amongst celiac disease experts with some contending that latent celiac disease shouldn't be considered a form of the disease.

## *Deciding whether latent celiac disease should be treated*

There is controversy over whether or not a person with latent celiac disease should be treated. The arguments pro and con are much the same as we outline in the preceding section where we discuss silent celiac disease, but with one major difference. If you have silent celiac disease, by definition you have an *ab*normal small intestine biopsy. In other words, there is clear evidence that your celiac disease is causing damage to your body. Latent celiac disease is different. If you have latent celiac disease, by definition you have a *normal* small intestine biopsy and thus no evidence that celiac disease is damaging your body.

Because latent celiac disease is not associated with damage to the body — and because there is currently no scientific proof that damage would develop in the future — justifying treatment for it is harder than justifying treatment for silent celiac disease (where, by definition, there is already evidence of damage). Nonetheless, some well-respected celiac disease experts believe latent celiac disease would eventually lead to damage and that it is better to treat it sooner than later. Other celiac disease experts believe that latent celiac disease may remain latent indefinitely and, as such, placing someone on lifelong treatment (even one not involving medication) is *in*appropriate in the absence of hard scientific evidence that this is beneficial for this particular group of individuals.

An additional argument in favor of treating latent celiac disease is the possibility that the normal small intestine biopsies that were taken simply missed the abnormal intestine due to patchy disease or disease that could not be reached because it was further down the small intestine. In other words, the person labeled as having *latent* celiac disease actually had *silent* celiac disease. (Although we see the rationale for this argument, we believe that it is important to find damaged intestine — such as by using additional tests as we discuss in Chapter 3 — before labeling someone as having latent celiac disease.)

Our opinion, based on the current literature and our own experience, is that there is, at this point in time, insufficient justification to routinely treat people with latent celiac disease. We also feel, however, that it is imperative that a person diagnosed with latent celiac disease be monitored for the development of more overt disease (that is, one of the types discussed earlier in this chapter). The majority of our colleagues follow a similar approach. (We discuss monitoring of celiac disease in Chapter 15.)

# Part II
# How Celiac Disease Can Make You Feel

The 5th Wave          By Rich Tennant

"Wait a minute — you properly feed 2 exotic parrots, 3 iguanas, and a tank full of rare fish, but now you're concerned you won't be able to stick to a special diet?"

## In this part . . .

Celiac disease doesn't always cause symptoms, but when it does, the symptoms can range from mild indigestion all the way to severe diarrhea and malnutrition. In this part, you discover how celiac disease can make you feel. You also find out about those conditions that are either caused by, or associated with, celiac disease.

# Chapter 6

# Symptoms of Celiac Disease

. . . . . . . . . . . . . . . . . . . . . . . . . . . . . . . . . . . . . . . . . . . . . . . . . .

## In This Chapter

▶ Exploring gastrointestinal symptoms of celiac disease

▶ Finding out how celiac disease can lead to weight loss

▶ Looking at skin rashes

▶ Assessing mood, thinking, and neurological symptoms

▶ Evaluating endocrine (hormonal) problems

▶ Discovering aches and pains caused by musculoskeletal conditions

▶ Considering symptoms caused by other organs

. . . . . . . . . . . . . . . . . . . . . . . . . . . . . . . . . . . . . . . . . . . . . . . . . .

*W*hen we speak to celiac disease support groups, we are struck by the fact that the label — celiac disease — is often the only thing that the roomful of people has in common. Indeed, all people with celiac disease have their own stories, their own journeys with celiac disease and, in the case of symptoms, their own personal ways in which the condition has affected them.

As you read through this chapter, you may recognize symptoms you've been experiencing. In that case, take heart; if you've not yet begun your gluten-free diet or if you've only very recently started it, once you're on track with your new diet, you will likely find your symptoms soon start to ease. In other words, throughout this chapter when we say that celiac disease causes this or the other symptom, we are — unless we specifically state otherwise — invariably talking about *untreated* or *insufficiently treated* celiac disease.

Many people with celiac disease recognize just how bad and just how long they've been feeling unwell only *after* they've been diagnosed and treated and their symptoms have started to ease. That is, their symptoms had been present for so long, they had simply become "part of the wallpaper." (Sort of like after your car has had a tune up and you only then notice, conspicuous by its absence, that a longstanding rattle has suddenly disappeared.)

Some of our patients tell us this makes them feel guilty — as if they did something wrong by having ignored their symptoms and that if only they had mentioned them earlier to their doctor they would have been diagnosed — and therefore, felt better — sooner.

If you feel this way, we hope your guilt quickly falls by the wayside. First, perhaps you're just stoic. Second, it's perfectly reasonable that you might have attributed such everyday symptoms as stomach upset or abdominal cramps that *everyone* (whether one has celiac disease or not) gets from time to time to something else. Third, guilt isn't going to make you feel any better, so there's no point on dwelling on the past anyhow.

# Symptoms 101: Looking at the Big Picture

Because celiac disease can be such a many-headed hydra, referring to "typical" symptoms of celiac disease is seldom appropriate. Indeed, for most people, the only thing that's "typical" about their symptoms is that they're atypical! Indeed, this is even reflected by the fact that the substantial majority of people with celiac disease have what is called the atypical form of the disease. We discuss the classification of celiac disease in detail in Chapter 5, but with regard to symptoms, here are the key attributes of these types:

- ✔ **Classical celiac disease** is associated with gastrointestinal symptoms such as abdominal bloating and discomfort, diarrhea, and weight loss.

- ✔ **Atypical celiac disease** has few, if any, gastrointestinal (GI) symptoms, with non-GI symptoms or symptoms present due to complications from celiac disease being the predominant features.

- ✔ **Silent celiac disease** and **latent celiac disease** do not cause symptoms.

As this list indicates, it is only the classical and atypical forms of celiac disease that cause symptoms.

# Gut Feelings: Gastrointestinal Symptoms

If you've been experiencing gastrointestinal symptoms, but, out of embarrassment, have been hesitant to see your doctor about them, you're certainly not alone. Indeed, lots of people find themselves in this same boat. Doctors, however, are *never* embarrassed discussing GI symptoms and your doctor's comfort with this will soon put you at ease, too. (In fact, GI specialists have been known to say: "It may be poop to you, but it's bread and butter to me!" Well, actually, they word it somewhat less, ahem, tastefully, but we've edited the saying as this is a family-oriented book.)

Jerry was a 25 year-old man who hadn't been feeling well for quite some time. He was feeling constantly bloated and he was spending lots of the time in the bathroom with diarrhea. He had put off seeing a doctor, initially because he had hoped things would go away on their own and, when they didn't, because he thought he'd be embarrassed talking about his bowel habits. As it turned out, it took less than 30 seconds for him to realize he'd had no reason to fear; the discussion with his family doctor was no more embarrassing than had they been talking about the weather. Jerry's physician astutely concluded that Jerry's symptoms were not to be passed off and referred Jerry to Sheila for further investigation. Sheila discovered Jerry was also having problems with excess burping, heartburn, and flatulence (*farting* in non-medical speak). Quickly putting two and two together, Sheila surmised he may have celiac disease and performed an endoscopy and small intestine biopsy (we discuss these procedures in Chapter 3), which confirmed the diagnosis. Jerry was placed on a gluten-free diet and within a short period of time, he felt like new.

## The gut stops here: Diarrhea, celiac disease, and you

*Diarrhea* is the frequent passage of watery or semi-formed stools. Pretty well everyone — whether having celiac disease or not — gets diarrhea from time to time, often from relatively harmless (but decidedly unpleasant) conditions such as viral gastroenteritis ("stomach flu").

### Loosely speaking: Diarrhea due to celiac disease

Diarrhea is the symptom of celiac disease that is best known to the world at large and it comes as a surprise to most people — including many doctors, by the way — to learn that, in fact, upwards of 50 percent of people with celiac disease *have no diarrhea at all*; indeed, for some people living with celiac disease, the main bowel problem is that of constipation! Contrary to popular belief, diarrhea should no longer be considered a hallmark of this disease.

Of those people with celiac disease who do get diarrhea, its nature can vary to a great extent; both between people and even for a given person. If you have diarrhea, it could be that you've noticed that you have some days where you feel that you're spending the entire day on the toilet and other days where you could be a hundred miles from the nearest bathroom and care not a whit (well, passing urine aside).

If you have not been diagnosed with celiac disease and you see your doctor to report that you are having alternating constipation and diarrhea, the odds are high that your doctor will not have celiac disease high up on his radar as a possible cause for your problem and instead will be more likely to consider irritable bowel syndrome (or IBS; which we discuss in Chapter 12). This is perfectly understandable as IBS is a very common cause of these kinds of

symptoms. Nonetheless, it cannot hurt for you to mention — especially if you're not responding sufficiently well to treatment for IBS — that you've read (here) that celiac disease can also cause these symptoms. Who knows; perhaps you will end up being responsible for figuring out your own diagnosis?

Celiac disease does *not* cause blood to appear in or on the stool. If you see blood with your stool, you should let your doctor know. It may be that there's nothing going on beyond some minor problems with hemorrhoids, but much more serious causes exist, including bowel cancer. Blood in the stool is not a symptom to be ignored.

### An absorbing discussion about malabsorption

Some people, especially those with the classical form of celiac disease, have severe, unremitting diarrhea. This can be evidence of *malabsorption*. Malabsorption is a condition in which one is unable to properly absorb nutrients from food. If you malabsorb fat, the fat you eat stays in your intestine and — it's got to go somewhere — becomes part of your stool. Having stool that contains fat is called *steatorrhea*. If you have steatorrhea, your family will know you have this problem almost as quickly as you do. Why? Well, everyone's stool smells, shall we delicately say, *unpleasant*, but steatorrhea smells dreadful. Horrible. "Call in the fumigators" awful. Also, these fatty stools tend to stick to the bowl so you may find yourself needing to get a brush to scrape off the remnants of your trip to the bathroom, lest the next visitor have an eyeful. Other features of steatorrhea are that the stools are bulky and tend to float.

Eating when you're suffering from severe malabsorption is like filling your car's gas tank only to find the fuel gauge showing you're nearly empty because you've got a hole in your tank. The gas goes in, but gets drained out without being used; your food goes in but also does not get used, the nutrients instead being passed out of your body with your stool.

Malabsorption isn't an "all or none" phenomenon. Some people with celiac disease — especially children with the classic form — have severe malabsorption and, as a result, lose a great deal of ingested nutrients from the body. This can result in loss of muscle mass, fat stores, fatigue, lethargy, and weight loss. Much more commonly, however, malabsorption is selective with only a limited variety and amount of nutrients (particularly iron) being lost from the body and with virtually no symptoms being present. This is seen in many people with the atypical form of celiac disease and, because of the frequent absence of symptoms, it is often only after a routine blood test done at an annual check-up or for some other, coincidental reason comes back abnormal that the diagnosis of celiac disease eventually gets made.

### Treating diarrhea due to celiac disease

The mainstay of treating diarrhea (and other bowel complaints) due to celiac disease is to follow a gluten-free diet. Within a few weeks of getting on track with your diet, you will likely notice an improvement in your bowel troubles. It may, however, take months before things are back to normal. If your symptoms don't settle, then you and your health care providers will need to determine whether some other problem is going on. Considerations, which we discuss in detail in Chapter 12, include:

- Having some other, co-existing intestinal problem (such as irritable bowel syndrome)
- Having a complication from your celiac disease (such as lactose intolerance)
- An incorrect diagnosis of celiac disease
- Ongoing, typically inadvertent, ingestion of gluten

## Olfactory challenges: Sniffing out the importance of flatulence

One of our favourite pieces of trivia is the fact that the average adult farts thirteen times per day. Although everyone (yup, *everyone* — even Presidents, Prime Ministers, and Princes; not that we would know first hand mind you) routinely passes gas, people with celiac disease can be particularly prone to flatulence.

When it comes to celiac disease there is no classical or typical pattern of flatulence. Indeed, although if you're passing more wind than the last Nor'easter it's likely you have a problem with your gut (celiac disease or otherwise), the absence of lots of flatus doesn't necessarily mean that all is well and, in particular, doesn't rule out the possibility you've got celiac disease.

Flatus is caused by bacteria in the large intestine acting on undigested or incompletely digested food (specifically, carbohydrates) that's made its way down to the colon after having not been absorbed into the body by the small intestine. As the large intestinal bacteria munch on the nutrients that have come their way, they produce gasses including the infamous hydrogen sulphide which is the main cause of flatus's malodour.

If you have steatorrhea (see the preceding section), your gas may be particularly malodorous. This can be an important clue for your doctor, so share this — so to speak — with him or her; and don't feel embarrassed (see the preceding anecdote to find out why).

# Abdominal symptoms: Belly pain, bloating, and beyond

As with flatus (see the preceding section), every person on the planet experiences abdominal symptoms of one sort of another from time to time. When it comes to celiac disease, however, abdominal symptoms are often much more of a problem and indeed, may be part and parcel of one's existence.

When we consider abdominal symptoms, in addition to well known and well understood terms (like cramps), there are a few other, sometimes misconstrued terms worth looking at:

- **Abdomen.** The part of your body between your chest and your pelvis (see Chapter 2). We mention this so as to differentiate it from your stomach which, of course, is the organ connecting the esophagus and the (small) intestine.

  Why mention this at all? For this reason: If you were to mention to a health care provider that you are having "stomach pain," how your words are interpreted may be very different than if you were to mention you were having "abdominal pain." Many people use these two terms interchangeably and most health care providers recognize this. Nonetheless, to avoid confusion its best to just use the word "abdomen" unless you are very certain your symptom really is coming specifically from your stomach (which, by the way is often exceptionally difficult to know).

- **Bloating.** The symptom of feeling that one's abdomen is overly full. Typically if someone says they feel bloated they are referring to a feeling of fullness as if they have too much gas in the intestine, but the term is also used by people to describe a similar feeling due to other causes such as feeling overly full with food, or even feeling constipated.

- **Abdominal distension.** The physical equivalent to the symptom of bloating. In other words, it is something that a doctor observes when she examines you. Having said that, the word *distension* is also often (and perfectly legitimately) used synonymously and interchangeably with the term bloating.

Bloating (and, therefore, abdominal distension) due to celiac disease is typically most bothersome after a meal, but can also be present even if you haven't recently eaten. Although bloating is not a serious or life-threatening symptom, it can be very unpleasant. Marked and persisting abdominal distension used to be seen quite often in very young children affected by severe celiac disease, but thankfully this seldom happens nowadays as children with celiac disease are typically diagnosed (and treated) much earlier in the process than used to be the case.

## Abdominal symptoms and the misdiagnosis of celiac disease

Abdominal symptoms from celiac disease don't have features that are specific to this particular illness, which is part of the reason that celiac disease so often gets overlooked. Perhaps you had the experience, before your celiac disease was diagnosed, of telling your health care provider that you were having abdominal discomfort, bloating, and so on, and you were then misdiagnosed with some other ailment like, for example, irritable bowel syndrome (IBS). If so, you're in good company because this happens all the time. All we can say is that we hope that as both health care providers and health care recipients become more aware that celiac disease is so common, and how often celiac disease presents with atypical features (see Chapter 5 for a discussion of the different types of celiac disease), that they will have a heightened level of alertness to look out for this condition, and the condition will be more quickly diagnosed.

Abdominal cramps are sharp, often piercing, pains which can be felt in a variety of places. They are typically fleeting, lasting from seconds to minutes. Cramps are usually caused by contractions of the intestine and as the contraction relaxes the discomfort eases. Passing flatus sometimes also helps ease a cramp, which you probably know from personal experience.

## *Reflux and heartburn*

Reflux is a condition in which acid from within the stomach passes back up into the esophagus (as shown in Chapter 2, the esophagus is the swallowing tube that connects the mouth to the stomach) giving rise to a burning feeling behind the breastbone (sternum).

Reflux is the short form for *gastroesophageal reflux*. If someone has chronic problems with reflux, the condition is called *gastroesophageal reflux disease* (or GERD).

As we discuss in Chapter 2, the stomach produces acid, which helps to digest food. How much acid is in the stomach? Well, the stomach produces so much hydrochloric acid that stomach fluid is, brace for this fact, 1,000,000 times more acidic than water.

The stomach has special protective mechanisms so that all this acid doesn't normally damage the stomach lining. (When this mechanism fails, people are susceptible to stomach ulcers.) The esophagus, however, doesn't have these same protective features and as a result is susceptible to damage from acid.

To protect the esophagus from being exposed to the stomach's acid, the part of the esophagus that attaches to the stomach has a valve-like feature (called the *lower esophageal sphincter*) that blocks the stomach acid from entering. When this valve is weak, acid travels up from the stomach into the esophagus and damages it, giving rise to the symptom of heartburn.

Most people, whether or not they have celiac disease, experience reflux and heartburn from time to time — particularly after a large meal or drinking more than their fair share of coffee. Heartburn is more likely to be a problem as a person enters middle age. Heartburn is also particularly common during pregnancy and, especially, labor. (Note to all pregnant women, whether or not you have celiac disease: If your husband offers you a slice of pizza when you are in labor — as an unnamed author of this book did to his wife in this situation many, many moons ago — decline it!)

### Non-drug therapy

If you have celiac disease, you may be more prone to reflux and, therefore, heartburn. The reflux (and heartburn) may be present both more often and more persistently. Following a gluten-free diet can help lessen your reflux, but often is insufficient. Here are some non-drug therapies that may help ease your symptoms:

- Avoid ingesting — or, at the least, limit the consumption of — those things (such as coffee, tea, spicy foods) that trigger your symptoms.

- Avoid overeating — especially in the late evening before going to bed. (When you are lying down, you are especially prone to reflux because you don't have gravity helping to keep acid in the stomach and out of your esophagus.)

- Avoid excessive liquid intake for a few hours before going to bed.

- Try to lose weight if you are overweight. (Being overweight is a contributory factor leading to reflux.)

### Drug therapy

Despite the measures we just discussed, many people still have problematic symptoms. In this case, a variety of medications are available to help you, including:

- **Antacids.** Include Maalox, Mylanta, and many others. Antacids can be obtained without a prescription and are often an excellent treatment choice if you get heartburn just occasionally.

- **$H_2$ blockers.** Go by a variety of names, including, in alphabetical order, cimetidine (Tagamet), famotidine (Pepcid), nizatidine (Axid), and ranitidine (Zantac). Many $H_2$ blockers are available over-the-counter and have various other trade names. These drugs can be used on an "as needed basis" to treat an episode of heartburn or, under a doctor's supervision, on a routine basis to prevent heartburn.

> ✔ **Proton pump inhibitors.** Go by a variety of names including, in alpha-
> betical order, dexlansoprazole (Kapidex), esomeprazole (Nexium),
> lansoprazole (Prevacid), omeprazole (Losec, Prilosec, Zegerid), pan-
> toprazole (Pariet, Protonix), and rabeprazole (Aciphex). Proton pump
> inhibitors are especially potent at suppressing acid production from the
> stomach and have become very popular therapies.

We recommend that if you get just occasional heartburn, simply take an
antacid or an H$_2$ blocker when you need to. If your problem is occurring
regularly, follow the non-drug preventative strategies we outline previously.
If, however, your heartburn is occurring frequently or is particularly bother-
some for you, then speak to your doctor about whether or not you might
benefit from taking a proton pump inhibitor.

Rarely, celiac disease causes such severe and intractable reflux that the
recurring presence of stomach acid in your esophagus leads to scarring and,
eventually, narrowing of the esophagus (a *stricture*). If this happens, you will
have difficulty swallowing solid foods such as bread or steak with the food
getting stuck in your esophagus. This is typically felt as a sudden pain behind
the lower part of your sternum which comes on as you are eating and even-
tually eases as the food finally passes through the obstruction. If you are
experiencing this symptom be sure to mention it to your doctor so that he or
she can determine if you have a stricture. Whether you have a stricture is typi-
cally determined by performing an endoscopy (we discuss this procedure in
Chapter 3).

## Indigestion

Indigestion (*dyspepsia*) is a common gastrointestinal symptom of celiac dis-
ease. Though indigestion can be defined in many different ways, most com-
monly it refers to an aching, uncomfortably full, or burning discomfort which
typically occurs after eating and is felt in the upper part of the abdomen
(as opposed to GERD where the main symptom is a burning behind the
breastbone).

Pretty well everyone, whether having celiac disease or not, experiences indi-
gestion from time to time (think third helping of Christmas turkey, or beer
and pizza when out with "the boys"). If you have celiac disease, however, you
are more prone to indigestion, and it may occur without any obvious food
overindulgence.

Many people with celiac disease have put up with years of bothersome indi-
gestion only to have it nearly vanish within a few months of starting a gluten-
free diet. Indeed, eliminating gluten from your diet will likely be the only
therapy you require (apart, that is, from possibly needing to avoid that third
helping of turkey, but, hey, if it's Christmas, what the heck . . . ).

# Weight Loss

Until recent years, when much has been learned about celiac disease, it had been thought that celiac disease was primarily a childhood ailment and was pretty well always associated with weight loss. Although this is true of what is called *classical celiac disease*, it is, in fact, not true of the majority of people with celiac disease, most of whom have *atypical celiac disease* (see Chapter 5 for a discussion on the classification of celiac disease) and do not experience weight loss. Having said all this, weight loss in adults with celiac disease can and does occur and, if it happens to you, it's important that you are aware of the possible causes.

When you lose weight due to celiac disease, you typically lose no more than a few pounds and have no cause for alarm. If, however, you are losing substantial amounts of weight, you should seek very prompt medical attention.

Looking at the issue of weight loss in four different settings is helpful. Weight loss due can be caused by:

- ✔ Active celiac disease
- ✔ Dietary change once a person starts following a gluten-free diet
- ✔ A co-existing condition
- ✔ Complications from celiac disease

In the next few sections, we look at each of these scenarios.

## Weight loss due to active celiac disease

Having active celiac disease — that is, ongoing damage to the small intestine — can lead to weight loss from two main causes.

- ✔ **Loss of appetite:** Celiac disease can make you feel generally crummy and if you feel that way you may not have much of an appetite which, in turn, will lead you to eat less. This reduced intake of calories will result in loss of weight.

- ✔ **Malabsorption:** As we discuss earlier in this chapter in the section, "An absorbing discussion about malabsorption," celiac disease damages the small intestine, which is the place that nutrients are absorbed into the body. If you have a reduced ability to absorb these nutrients *into* your body, they — and the calories they contain — are then lost *from* the body with your stool. This is called *malabsorption*. Lost calories causes lost weight.

## Weight loss due to the gluten-free diet

People with celiac disease may find that they lose some weight once they start on a gluten-free diet. As we discuss in detail in Chapter 15, following a gluten-free diet entails giving up certain calorie-rich gluten-containing foods such as is found in junk foods or restaurant buffets. As a result of ingesting fewer calories, you may find yourself losing weight after you've started your gluten-free diet.

## Weight loss due to a co-existing condition

As we discuss in detail in Chapter 8, a number of different diseases are not caused by celiac disease but occur with greater frequency if you have celiac disease. Several of these can result in weight loss *unrelated* to your celiac disease.

If you have celiac disease, have gotten on track with your gluten-free diet, and are ingesting sufficient calories, but are still losing weight, then you and your doctor should consider the possibility you have one of these co-existing conditions:

- **Addison's disease.** The adrenal glands are under-functioning.
- **Depression.** People who feel depressed often lose their appetite.
- **Diabetes.** Having high blood glucose levels (as is a hallmark feature of diabetes) causes weight loss.
- **Hyperthyroidism.** The thyroid is over-functioning.

## Weight loss due to a complication of celiac disease

As we discuss in Chapter 12, celiac disease can cause complications which, in turn, can cause weight loss. These are *not* common occurrences, but if other causes of weight loss have not been found, they should be considered. Here are the most important ones to be aware of:

- **Pancreatic insufficiency.** This is a condition in which the pancreas is unable to make sufficient quantities of digestive enzymes, and as a result, you get malabsorption.

✔ **Small intestinal bacterial overgrowth (SIBO).** This is a condition in which there are excess numbers of bacteria in the small intestine; these excess bacteria consume some ingested dietary nutrients and also damage the small bowel, and as a result, digestion is impaired and malabsorption develops.

✔ **Intestinal cancer.** Cancer of the small intestine, which we discuss in depth in Chapter 9, is a rare complication of celiac disease and is most likely to develop if you've had many years of severe, uncontrolled celiac disease.

Save yourself untold grief: Before you and your health care providers start an extensive search for one or more of the conditions we mention in the preceding list, make sure you have eliminated all gluten from your diet. What a shame it would be if you went through all sorts of tests to look for why you were unexpectedly losing weight if, in fact, the cause was nothing more than the fact that you were still (inadvertently) ingesting gluten.

Bill, a 35 year-old man, came to see Ian for a routine celiac disease visit. Ian asked him how he was feeling, to which the man replied that everything was fine. "You sure you haven't lost any weight?" Ian asked, noticing the patient's belt to have a few worn — and now unused — notches. "Well, now that you ask, I guess I have lost some weight." And, following Ian's gaze to his belt, he added, "Yeah, my wife pointed that out to me, too." With further discussion, the patient realized he had recently been having some palpitations (heart pounding) and his hands had been shaky (tremor). As it turned out, he had hyperthyroidism; a condition known to be associated with celiac disease. Ian treated his patient's hyperthyroidism and the gentleman quickly regained the weight he had lost.

# Failure to Thrive in Children

As we discuss in detail in Chapter 14, although children with celiac disease can have similar symptoms (like abdominal discomfort and diarrhea) as adults, youngsters may also have one unique group of symptoms, which are collectively called *failure to thrive*.

A child who is failing to thrive will have stopped growing and developing at the rate of his or her siblings or peers. The child may also be less energetic, less able to concentrate (and therefore, his or her schoolwork may suffer), and less socially engaged. These symptoms improve when your child is on track with a gluten-free diet . . . in which case if they still don't feel like doing their homework, they'll have joined the ranks of many other healthy kids!

# *Non-Gastrointestinal Symptoms and Celiac Disease*

When most people think "celiac disease" — when they think of it at all — they think "gut." And indeed, the gut is the root of the condition and the place that many people experience symptoms. Nonetheless, if you have celiac disease, you are at increased risk of other of your organs malfunctioning.

Your other organs may malfunction

- ✔ **As a *direct result* or your celiac disease**. An example of this direct effect would be celiac disease damaging your intestine and as a result impairing your ability to absorb vitamin D into your body with this, in turn, leading to osteoporosis.

- ✔ ***In association* with celiac disease**. If you have blond hair, you are more likely to have blue eyes but, of course, your blond hair did not cause you to have blue eyes. This is an *association*, not cause and effect. In the same vein, celiac disease affecting the gut may be associated with other bodily ailments without directly causing them. Sometimes, this is because if you have one type of immune disorder (like celiac disease), you are at increased risk of having other immune disorders (like type 1 diabetes). More often, however, the reason for this association is either only partly known or is simply obscure.

In the following sections, we look at non-gastrointestinal symptoms that you may experience if you have celiac disease. Depending on the symptom in question, it may be present as a direct result of your celiac disease or, alternatively, may be present because you have an associated condition. In either case, we'll let you know. For a detailed discussion on the diseases we mention in this section, have a look at Chapters 7 and 8.

As you read in this section of the many ailments that are associated with celiac disease, please do us — and, more importantly, *yourself* — a favor and bear in mind that most people with celiac disease *never* experience *any* of the problems we discuss here. Having said that, they can and thus we feel it's important that you be aware of them.

With some important exceptions (such as the skin rash called *dermatitis herpetiformis,* which we discuss in a moment), each of the conditions we discuss in this section requires their own specific treatment. In other words, the gluten-free diet you need to follow to help control your celiac disease does not generally help you manage these other ailments.

## Rash decisions

If you have celiac disease, you are at increased risk of having one of several different types of skin rash. We discuss these conditions in detail in Chapter 8. In this section, we note the visual changes seen with some of the skin diseases most commonly linked to celiac disease.

- ✔ **Dermatitis herpetiformis:** If you develop small, intensely itchy, pinkish blisters on the elbows, knees, or buttocks (less often on the shoulders, scalp, face, and back), you may have dermatitis herpetiformis (DH). The link between DH and celiac disease is so strong that DH is sometimes referred to as "celiac disease of the skin." Both conditions are triggered by exposure to gluten, have the same antibodies present, and respond to the elimination of gluten from the diet.

- ✔ **Psoriasis:** Should you have red, scaly sores affecting your skin — particularly the scalp, elbows, knees and back, this may indicate you have psoriasis.

- ✔ **Vitiligo:** If you develop patches of pale (to the point of being white) skin, you may have vitiligo.

## Mulling over mood, thinking, and neurological issues

People with celiac disease are at increased risk of having certain mood, thinking, and neurological disorders. It is far from clear why this association exists, and it is always worth bearing in mind that an association isn't the same thing as cause and effect. These are the related conditions to be aware of (and which we discuss in detail in Chapter 8):

- ✔ **Ataxia** is a condition in which the balance is affected, causing one to walk unsteadily.

- ✔ **Epilepsy** ("seizures") is a condition in which episodes of abnormal electrical discharge occur in the brain leading, depending on the area involved, to abnormal movements or behaviors.

- ✔ **Migraine headaches** are intense, typically throbbing headaches, which are often preceded by visual warning symptoms.

- ✔ **Peripheral neuropathy** is a condition in which the nerves in the feet (far less often, the hands) are damaged, typically causing numbness.

- ✔ **Attention-Deficit/Hyperactivity Disorder (ADHD)** is a condition in which the affected person has difficulty paying attention, tends to be overly active, and often acts impulsively.

✔ **Autism** is a condition in which the affected person has difficulties communicating and interacting socially.

✔ **Depression** and other psychiatric disorders.

# Feeling fatigued

In the previous section, we list various mood, thinking, and neurological issues. But what if your problem is simply that you feel tired? Run down. Exhausted. Worn out. Could this be due to your celiac disease? The quick answer is, well, there is no quick answer. In this section, we look at the possibilities.

You might imagine that, if you have chronic abdominal pain, are getting recurring bouts of diarrhea, and are malnourished because you're not sufficiently absorbing important nutrients into your body, that you'd feel tired. You bet! So yes, if you have these symptoms, it would likely be no surprise to you that fatigue is part and parcel of the process. Fortunately, soon after you start your gluten-free diet, these symptoms start to ease (though, if you're very malnourished, your tiredness may take longer to improve than the other symptoms we just mentioned).

Some people with celiac disease, however, feel fatigued even in the absence of gastrointestinal symptoms (and, as we discuss in detail in Chapter 5, most people with celiac disease have the so-called "atypical" type in which GI symptoms are minimal or non-existent). Although the cause may be unrelated and coincidental (literally thousands of different ailments can cause fatigue), there are a few celiac-related/associated conditions that can lead to fatigue and, therefore, should be considered by you and your doctor:

✔ **Anemia.** As we discuss in Chapter 7, there are several types of anemia that may occur if you have celiac disease. Of these, the most common one, and also the one most likely to lead to tiredness, is *iron-deficiency anemia*. This is typically readily determined by performing a simple blood test.

✔ **Depression.** Tiredness is a common symptom experienced by people who are depressed. It is, however, not the only symptom seen with depression; rather, it occurs in the context of a number of other features including difficulty sleeping, and feeling helpless and hopeless. We discuss depression in detail in Chapter 8.

✔ **Fibromyalgia.** Fibromyalgia is a musculoskeletal condition in which tiredness is a very common feature. We look in detail at fibromyalgia in Chapter 8.

✔ **Thyroid disease.** The thyroid gland is a small hormone-secreting gland located in the front of the neck just above the breastbone (sternum). As we discuss in detail in Chapter 8, the thyroid helps regulate a great many different processes in the body. If the thyroid is under-functioning (a condition called *hypothyroidism*), fatigue commonly results. What is far less widely known is that if the thyroid is *over*-functioning (a condition called *hyperthyroidism*), fatigue is also very frequently experienced. If you have celiac disease and you have unexplained fatigue, be sure to ask your health care provider if your thyroid function has been checked. Your thyroid function is readily tested by performing a simple blood test. (The most commonly used test to screen for thyroid malfunction is called a TSH, which stands for *thyroid stimulating hormone*.)

If your celiac disease is well-controlled yet you feel fatigued on an ongoing basis, you are doing yourself a disservice if you simply attribute your tiredness to the fact of your celiac disease. Instead, you should discuss your symptom with your doctor to determine what else might be causing it.

## Hormonal (endocrine) problems

If you have celiac disease, you are at increased risk of certain hormonal (endocrine) conditions (which we discuss in detail in Chapter 8):

✔ **Addison's disease** is a disorder of the adrenal glands in which one loses weight loss and has low blood pressure and the skin darkens.

✔ **Type 1 diabetes** is a condition in which the body is unable to produce insulin, and as a result high blood glucose levels develop. Symptoms of elevated blood glucose include excess thirst, frequent urination, and weight loss.

✔ **Thyroid over-functioning (hyperthyroidism),** which can cause weight loss, fatigue, tremor, palpitations, diarrhea, and other symptoms.

✔ **Thyroid under-functioning (hypothyroidism),** which can cause weight gain, fatigue, dry skin, brittle hair, muscle aching, and other symptoms.

## Musculoskeletal problems

If you have celiac disease you may be at increased risk of the following musculoskeletal disorders:

✔ **Rickets and osteoporosis** are conditions in which there is insufficient bone strength and mass. We discuss these ailments in detail in Chapter 7.

✔ **Rheumatologic problems** (we discuss these in detail in Chapter 8) including:

- **Sjogren's syndrome** is a condition in which you have decreased ability to make saliva and tears.
- **SLE** ("lupus" or, more fully, *systemic lupus erythematosis*) is a disorder in which the joints and other body tissues become inflamed and painful.
- **Raynaud's phenomenon** is a condition in which blood flow to the fingers and toes is temporarily impaired upon exposure to cold temperatures leading to episodes of pallor of the digits.
- **Fibromyalgia** is a condition in which one experiences a variety of aches and pains but without evidence of inflammation in the body.

## Cancer

Fortunately, cancer related to celiac disease (which we discuss in detail in Chapter 9) seldom occurs, but it can. Following are the most important types to be aware of:

✔ **Enteropathy-associated T cell lymphoma** is a form of lymph cell cancer.

✔ **Small intestine adenocarcinoma** is a form of cancer of the small intestine.

## Gynecological and obstetrical problems

A variety of different, but related gynecological and obstetrical problems may occur if a woman has celiac disease, including:

✔ Irregular periods.

✔ Infertility. We discuss infertility in detail in Chapter 7.

✔ Miscarriages. We discuss pregnancy issues in detail in Chapter 14.

✔ Early (premature) delivery.

## Other problems

Of the remaining, important disorders associated with celiac disease, the key ones to be aware of are:

- ✔ **Anemia.** Anemia can cause fatigue, shortness of breath, rapid heart beat, and other symptoms. We discuss anemia in Chapter 7.

- ✔ **Mouth ailments** such as aphthous ulcers ("canker sores"). See Chapter 7 for more on mouth ailments.

- ✔ **Dental problems** such as loss of the tooth's protective enamel coating. We discuss this in Chapter 7.

- ✔ **Liver and bile duct disorders.** Liver disease can lead to jaundice, bleeding problems, and, potentially, many other problems. See Chapter 8 for a discussion on liver and bile duct disorders.

- ✔ **IgA deficiency.** This is a congenital (meaning that one is born with it) inability to produce normal amounts of the IgA form of antibody. We discuss IgA deficiency in Chapter 8.

- ✔ **Chromosome defects.** Turner syndrome and Down syndrome are conditions due to abnormalities in the chromosomes. (Chromosomes contain DNA, which is the genetic blueprint responsible for many of the traits of living organisms.) We discuss these conditions in Chapter 8.

# Chapter 7

# Conditions Caused by Celiac Disease

. . . . . . . . . . . . . . . . . . . . . . . . . . . . . . . . . . . . . . . . . . . . . . . . . . . . . .

## In This Chapter

▶ Discovering the ins and outs of malabsorption

▶ Dealing with vanishing vitamins and missing minerals

▶ Exploring how celiac disease can cause anemia and osteoporosis

▶ Looking at the link between celiac disease and infertility

. . . . . . . . . . . . . . . . . . . . . . . . . . . . . . . . . . . . . . . . . . . . . . . . . . . . . .

*A*s we explain in Chapter 2, celiac disease damages the small intestine and, as a result, impairs the ability to properly absorb nutrients into the body. This is called *malabsorption*. If you have malabsorption, nutrients you eat end up being wasted as they are lost from your body with your stool. The way in which malabsorption affects you depends on both the type of nutrients being malabsorbed and the degree to which this is happening. In this chapter, we look in detail at this subject. We also look at several other conditions that are related to celiac disease but where the connection to malabsorption is less clearly established.

As you read through the sometimes intimidating information you'll find here, we hope you bear in mind two very important things: The various ailments we discuss in this chapter are often *preventable* (depending how and when your celiac disease was discovered) and are *always* treatable. And speaking of treatment, in Chapter 15 we look at how often you should have laboratory tests done to monitor your body's levels of many of the things we discuss here.

## Vanishing Vitamins

For the most part, the vitamins that people require for good health are readily available and consumed as part of a healthy diet. However, if you have celiac disease, you're prone to malabsorbing some of the vitamins you ingest, leading to insufficient levels of these vitamins in your body. As a result, your health can suffer. In this section we look at the various vitamin deficiencies that can be seen with celiac disease.

## Considerations about taking vitamin supplements

Whether or not you have celiac disease, if you are currently taking, or are considering taking, vitamin supplements, bear in mind that, just like taking a prescription or over-the-counter medicine, taking vitamin supplements should be done with proper caution in order to ensure:

- ✔ You actually need *any* type of vitamin supplement in the first place. If you don't need one, we're sure you can find better things on which to spend your hard earned money.

- ✔ You take only the particular vitamin supplement(s) you need (that is, the vitamin(s) in which you are lacking or potentially lacking).

- ✔ You don't take too much. Unbeknownst to many people, taking too much of a vitamin can be toxic.

When it comes to all things nutrition, including the taking of vitamin supplements, your dietitian is the expert and best resource. (We like to think that as physicians we know a thing or two about nutrition, but we always gladly defer to the incredible expertise of the professional, highly trained, dietitians with whom we work in our clinics.) We recommend, if you have celiac disease, you make a point of speaking to your dietitian about your vitamin requirements and how best you can ensure you meet these through your healthy, gluten-free eating and, when necessary, by taking supplements. (Your doctor, however, needs to be involved, too, because he or she is typically the one to decide, with you, whether you need tests to measure certain of your vitamin levels, discussed in the following sections.)

In this section when we discuss the treatment of vitamin deficiencies, our recommendations should always be considered as *supplementary* to meticulously following a gluten-free diet.

## Vitamin A

Vitamin A is found in:

- ✔ Liver, beef, chicken
- ✔ Eggs, cheese, milk, butter, margarine
- ✔ Carrots, sweet potatoes, spinach, and other green vegetables
- ✔ Mangoes, oranges

Deficiency of vitamin A can lead to:

✔ The inability to properly see in dim light (*night blindness*). If not treated, with time this can progress to complete blindness.

✔ Poor bone development and impaired growth in children.

✔ Reduced functioning of the immune system, thus increasing one's susceptibility to infections.

✔ Dry hair, dry and itchy skin, fragile and easily broken fingernails.

✔ Miscarriages and reduced ability to breastfeed.

Healthy people living in developed societies like North America rarely develop vitamin A deficiency. If you have celiac disease, you will be unlikely to ever develop vitamin A deficiency unless your condition is very severe. Therefore, routine use of vitamin A supplements is not necessary. However, if your eyesight in low light conditions is not what it should be, let your doctor know. He or she can send you for a blood test to measure your vitamin A level.

## Vitamin $B_9$ (folate or folic acid)

Vitamin $B_9$, more commonly known as *folate* or *folic acid*, is found in:

✔ Green, leafy vegetables (such as spinach, swiss chard, cabbage, kale, cauliflower, broccoli, and Brussels sprouts)

✔ Citrus fruits

✔ Beans

✔ Animal products

Deficiency of vitamin $B_9$ can lead to:

✔ Anemia (see "Low Blood: Anemia" later in this chapter for more information).

✔ Premature atherosclerosis ("hardening of the arteries") which, in turn, increases the risk of heart attack and stroke. (This is not yet fully proven.)

✔ Pregnancy complications including damage to the fetus's developing spinal cord.

✔ Soreness and inflammation of the tongue.

Contrary to what many people think, vitamin $B_9$ deficiency does *not* cause nerve damage.

Folic acid deficiency is fairly common if you have celiac disease. Therefore, when they are first "working up" a person for celiac disease, doctors routinely test a patient's blood to see whether the patient is low in this vitamin. If you have celiac disease and you are deficient in folic acid, in addition to following a gluten-free diet, you should ensure that your diet is rich in foods containing this vitamin. It's also advisable that you take a folic acid supplement (typically in a dose of 1 to 5 mg per day) for anywhere from 1 to 4 months. Of course, be sure to check with your own health care provider to find out what your specific situation calls for.

## Vitamin B₁₂

Vitamin $B_{12}$ is found in:

- ✔ Animal products
- ✔ Dairy products

Because vitamin $B_{12}$ is found only in animal products (dairy products being an extension of this), deficiency is common amongst otherwise healthy people who avoid all animal products.

Deficiency of vitamin $B_{12}$ can lead to:

- ✔ Anemia (see "Low Blood: Anemia" later in this chapter).
- ✔ Nerve damage leading to an unsteady gait.
- ✔ Impaired thinking, memory, and change to one's personality.
- ✔ Soreness and inflammation of the tongue.

Vitamin $B_{12}$ is absorbed into the body from the end part of the small intestine (the *terminal ileum;* see Chapter 2 for an in-depth discussion of the small intestine). Because this area of the bowel is seldom damaged by celiac disease, vitamin $B_{12}$ deficiency is not common in this condition. If, however, you do have vitamin $B_{12}$ deficiency (which can generally be determined by a routine blood test) due to celiac disease, then the treatment consists of consuming sufficient quantities of foods that are rich in this vitamin and, until your bowel is healed and your vitamin $B_{12}$ levels are back to normal, taking an oral vitamin $B_{12}$ supplement. In some cases, celiac disease leads to severe enough malabsorption of this vitamin that oral supplements aren't sufficient; in those cases, vitamin $B_{12}$ needs to be given by periodic injection into a muscle.

## *Vitamin D*

Vitamin D is found in:

- ✔ Fatty fish
- ✔ Eggs

Because so few foods naturally contain vitamin D, it is added to many other food products (such as milk). Also, sun exposure allows a person's skin to naturally make one's own vitamin D (which we think is pretty cool).

Deficiency of vitamin D can lead to:

- ✔ Osteoporosis in adults, rickets in children, and bone pain. (We discuss osteoporosis and rickets later in this chapter.)
- ✔ Calcium deficiency.
- ✔ Decreased immune function.

Many other ailments including some types of cancer, premature atherosclerosis ("hardening of the arteries"), diabetes, and multiple sclerosis also seem to occur more often in people with vitamin D deficiency although whether this is related to cause and effect is not yet known. Determining if there is a link between low vitamin D levels and these other diseases — and, if so, why the link is there — has become a hot topic in medical research circles.

Although vitamin D deficiency occurs commonly in the general population, it is particularly frequent in people with celiac disease and doctors, therefore, routinely measure their patients' vitamin D levels. In addition to following a gluten-free diet, treatment consists of taking vitamin D supplements and, when necessary, calcium. The dose of vitamin D that you require needs be to individualized but usual doses, depending on your dietary intake, range from 400 to 1,000 units per day.

As they get older, many people, with or without celiac disease, do not have sufficient intake of vitamin D in their diets or sufficient sun exposure to make enough vitamin D. (Also, the skin's ability to make vitamin D deteriorates as one ages. Geesh, this getting old stuff sure has its challenges!) For this reason, routine use of vitamin D supplements is often advised by health care providers for their patients in this situation. Be sure to ask your health care provider whether you should routinely take vitamin D (and calcium) regardless of how active your celiac disease is.

## Vitamin E

Vitamin E is found in:

- Green, leafy vegetables (such as spinach, swiss chard, cabbage, kale, cauliflower, broccoli, Brussels sprouts)
- Asparagus, avocado
- Oils (vegetable, soybean, canola, corn, cottonseed)
- Nuts and seeds
- Milk, eggs

Deficiency of vitamin E can lead to:

- Anemia
- Nerve damage
- Muscle injury

Unless your celiac disease is very severe, you are unlikely to ever develop vitamin E deficiency. Therefore, routine testing for vitamin E deficiency is not required, and routine supplements are unnecessary.

## Vitamin K

Vitamin K is found in:

- Green, leafy vegetables (such as spinach, swiss chard, cabbage, kale, cauliflower, broccoli, Brussels sprouts)
- Avocado
- Kiwi fruit

The human gut, through the action of the bacteria that normally reside in the small intestine (part of the *microbiome*, the name for the collective group of microbes that live within our gut), also manufacturers some vitamin K from other nutrients that are eaten. (Clearly — and we admit to some editorial and perhaps philosophical license here — the fact that the human body with its resident microbiome actually *makes* vitamin K, just as it does vitamin D (see the earlier section) — suggests to us that evolution has determined these to be incredibly important vitamins for human survival.)

Deficiency of vitamin K can lead to:

- Impaired ability of the blood to clot (coagulate); this can result in easy bruising, and bleeding from the gums, bladder, gut, and other organs.

✔ Impaired bone growth and strength. (Why vitamin K deficiency leads to bone problems is not fully sorted out.)

Unless your celiac disease is very severe, it is highly unlikely you will be deficient in vitamin K, and neither routinely testing for this nor use of vitamin K supplements is necessary. Having said that, if ever you notice unexpected or undue bleeding, it is imperative that you — or *anyone* for that matter — seek urgent medical attention.

# Missing Minerals

Like vitamins and other nutrients, minerals are also absorbed into our bodies in the small intestine so if you have active celiac disease (that is, there is ongoing inflammation of your small intestine), you're at risk of certain mineral deficiencies.

In this section, when we discuss the treatment of mineral deficiencies, our recommendations should always be considered as *supplementary* to meticulously following a gluten-free diet.

## Calcium deficiency

Calcium is found in:

✔ Milk products including milk, yogurt, ice cream, certain cheeses

✔ Tofu

✔ Canned salmon or sardines containing bones

✔ Dark green vegetables, dried beans

Calcium is also often added to foods such as some brands of orange juice, rice beverages, and soy beverages.

Deficiency of calcium can lead to:

✔ Osteoporosis and, in children, rickets. (We discuss these conditions later in this chapter.)

✔ Muscle spasms.

✔ Seizures (also known as convulsions or epilepsy).

✔ Fatigue, irritability, anxiety, and depression.

Calcium deficiency due to celiac disease is seldom severe enough to cause seizures. More often, when present, it's impact is confined to interfering with normal bone growth and strength.

Health care providers routinely monitor blood calcium (and vitamin D) levels in people with celiac disease — particularly, active celiac disease. If you are deficient in calcium, treatment consists of taking calcium supplements, usually in a dose ranging from one to several grams per day depending on your specific situation including your dietary intake. Also, to maintain good bone health, many women — regardless of whether or not they have celiac disease — are recommended to take calcium supplements. Speak to your dietitian to find out your particular requirements.

Low calcium due to celiac disease rarely occurs in isolation; more commonly it occurs in the context of low levels of vitamin D. Therefore, supplements of both calcium and vitamin D are typically required in this situation.

## Iron deficiency

Iron is found in:

- ✔ Red meat
- ✔ Tuna, salmon
- ✔ Chicken and other poultry
- ✔ Clams, oysters, mussels
- ✔ Lentils, beans, chick peas

Some foods are supplemented with iron (so called "iron fortified" foods) during processing.

Iron found in red meat, fish, poultry, and seafood is more readily absorbed into the body (more *bioavailable*) than is iron found in vegetables, fortified foods, or in oral iron supplements.

Deficiency of iron can lead to:

- ✔ Anemia (discussed in detail in the later section "Low Blood: Anemia").
- ✔ Fatigue. (Iron deficiency can cause fatigue even if anemia is not present.)
- ✔ Tongue pain, dry mouth, and hair loss. These occur infrequently.

Iron deficiency occurs commonly in people with celiac disease. In fact, the detection of anemia (due to iron deficiency) is often the first clue that a person has celiac disease. Health care providers routinely measure iron levels in people with celiac disease.

## Successfully treating iron deficiency

The mainstays of treating iron deficiency due to celiac disease are to follow a gluten-free diet, to ensure one's diet contains sufficient iron, and, for most people, to take an iron supplement. We list iron-rich foods earlier in this section; for a full discussion of a gluten-free diet, go to Chapter 10. Here are key points regarding oral iron supplements:

- **Three types of oral iron supplements are available:** *ferrous fumarate, ferrous gluconate,* **and** *ferrous sulfate.* Although a virtually infinite number of oral iron preparations are sold on the market, they all contain just one of these three types of iron (called *iron salts*).

- **Each of the available iron supplements contain different amounts of iron.** When reading the labels on iron supplements, be sure to differentiate the total iron content of a pill from the *elemental iron content*. It is only the elemental iron content that is meaningful. Also, each of these iron salts has a different cost, ferrous sulfate being the least expensive.

- *Coated* **or** *sustained-release* **iron supplements are less effective than regular iron supplements.** Iron is absorbed best from the duodenum and the first part of the jejunum (refer to Chapter 2 for a discussion of these parts of the small intestine), but coated and sustained-release iron formulations are absorbed further down the gut. This mismatch means that these iron preparations are less well absorbed into the body.

- **They work less well when taken at the same time as food.** Certain constituents of food (such as phosphates) attach to the orally taken iron and interfere with its absorption into the body. This is particularly true of milk, eggs, coffee, tea, fiber, and cereals. In general, it is best to take oral iron supplements on an empty stomach (see later in this list).

- **They shouldn't be taken at the same time as antacids.** Antacids interfere with the absorption of oral iron supplements; therefore, take your iron at least 2 hours before, or at least 4 hours after, taking an antacid.

- **Taking vitamin C (ascorbic acid) or drinking a glass of citrus juice (like orange juice) at the same time as your iron pill will help the iron get absorbed into your body.** If you are taking vitamin C, a dose of 250 mg is recommended.

- **Iron supplements can cause gastrointestinal side effects.** GI side-effects due to oral iron therapy are quite commonly seen. Symptoms include nausea, vomiting, abdominal discomfort, constipation, and, sometimes, diarrhea. It's important to be aware of this lest you think these symptoms reflect a problem with your celiac disease acting up. If you are having GI side effects from your oral iron pills, speak to your doctor or dietician who may recommend the following:

  - *Reducing your dose then gradually building the dose back up*. Using a low dose then gradually increasing the dose may be better tolerated by the gut.

- *Taking your iron with food rather than on an empty stomach.* Oral iron taken with food causes fewer GI side effects than when it is taken on an empty stomach. On the other hand, when taken with food, the iron is less well absorbed. One way around this is to take a higher dose of the iron with food.

- *Changing to a different iron preparation.* Ferrous gluconate *may* cause fewer GI side effects than the other types of oral iron. (This, however, is arguable since the amount of elemental, as opposed to *total,* iron in ferrous gluconate pills is considerably less than is found in ferrous fumarate or ferrous sulfate. In other words, it may be the *amount* of iron, not the *type* of iron, that is responsible for the side effects.)

- *Taking liquid iron supplements if you are unable to tolerate any of the available iron pills.* Liquid iron is called *ferrous sulfate elixir.*

Speak to your dietitian to find out which type and what amount of iron supplement is recommended for your specific situation.

### What about iron given by injection?

Because iron taken by mouth is often not well-tolerated, the question comes up whether iron can be given by injection instead. Indeed, there are iron preparations, expressly designed for this purpose, that are injected by a health care provider into a patient's muscle or vein. Such injections are sometimes used to treat iron deficiency in very special situations (such as in people who cannot benefit from oral iron because they have had surgical removal of their small intestine) and can prove invaluable. Nonetheless, this form of iron therapy should not be used routinely, especially when oral iron can be used instead.

These are potential hazards to iron injections:

- ✔ The iron leaving a permanent mark (a tattooing effect) on the skin where the needle was inserted when injecting iron into a muscle.

- ✔ An allergic reaction to the iron. Such reactions, not seen with oral iron, can be dangerous, even fatal. We can think of few things worse than someone dying from being given an injection of a medicine that could have been given perfectly safely in an oral form.

- ✔ Animal studies suggest that iron injections into muscle can lead to tumors.

- ✔ Injections can cause side effects such as joint pains, back pain, chills, muscle aching, nausea, and vomiting. These side effects typically go away within a few days.

If the preceding information is a shock to you, you are in good company. Indeed, we routinely witness the stunned expression on the faces of the medical students and junior doctors we teach when we share this same information with them.

## Other mineral deficiencies

In addition to the minerals discussed previously, small amounts of copper, magnesium, selenium, and zinc are also required for good health. It is rare for a person with celiac disease to be deficient in these elements; therefore, routine testing or supplementing for these is unnecessary unless a person has severe diarrhea or evidence of marked malnutrition.

# Low Blood: Anemia

*Anemia* is defined as an insufficient number of red blood cells. To make red blood cells, the bone marrow requires iron, folic acid, and vitamin $B_{12}$. If your celiac disease has lead to deficiency in these nutrients, anemia may result. Since the main job of red blood cells is to carry oxygen to the body's various organs, if you're anemic, your heart, muscles, and other organs are deprived of this vital substance. As a result, you may experience symptoms such as fatigue, shortness of breath, and reduced stamina when exercising.

If you experience the symptoms we just mentioned, be sure to ask your doctor whether he or she has recently checked your hemoglobin level (it's done on a blood test) — and, if not, ask for the test.

## Anemia due to low iron ("iron-deficiency anemia")

As we discuss earlier in this chapter, iron deficiency occurs commonly in active celiac disease. When iron deficiency leads to anemia, the condition is (unimaginatively, but straightforwardly) called *iron deficiency anemia*. Because iron deficiency anemia is so common in celiac disease, we look at it in detail in this section.

### How is iron deficiency anemia diagnosed?

Iron deficiency anemia is diagnosed when blood tests show that a person has both anemia and low iron.

Several different types of blood tests are used to determine whether someone is iron deficient. Each of these tests has its pros and cons. The most accurate test to determine if you lack sufficient iron is the *ferritin*. Having a low ferritin guarantees you are deficient in iron. Nonetheless, a normal ferritin doesn't guarantee that you are *not* iron deficient so other tests or a combination of tests are often used.

### Ensuring your celiac disease isn't overlooked if you have iron deficiency anemia

If your celiac disease has not yet been discovered, and your doctor determines that you have iron deficiency anemia, celiac disease will likely not be high on the radar and you'll be at risk of having the real cause of your anemia (that is, your celiac disease) overlooked. Why? Because from the beginning of medical school, doctors-to-be are taught that if they hear hoof beats, they should "think horses, not zebras." This advice is perfectly reasonable and sensible, but what if what they're hearing actually is a zebra? In other words, what if your iron deficiency anemia is caused by celiac disease rather than one of the more common causes such as menstrual blood loss in a woman or colon cancer in an older person of either gender?

Following are a few scenarios where iron deficiency anemia is commonly misattributed. If ever you — or a loved one — are in this situation, you can help steer the doctor in the right direction. (Fortunately, doctors nowadays are more aware of celiac disease in general and iron deficiency due to celiac disease in particular, so they're less likely to overlook this cause than they used to be.)

#### The woman who has periods

Many, many women who have periods have iron deficiency anemia because of the iron lost with their periods (blood is rich in iron). Because this occurs so often, most doctors who discover one of their female patients who menstruates has iron deficiency anemia will, perfectly appropriately, forego what would typically be unnecessary tests and, instead, simply prescribe iron therapy. We wouldn't be surprised if you, too, have been in this situation.

The key to avoiding having the diagnosis of celiac disease overlooked is this: If your iron deficiency anemia is being treated with iron supplements — and assuming you've been taking them as prescribed — yet you continue to be iron deficient, ask your doctor about the possibility that the real problem is malabsorption of iron due to celiac disease.

#### The older person

Any doctor worth his salt (or worthy of your trust as a patient) would never, *ever*, fail to investigate the cause of iron deficiency anemia amongst older people (or, for that matter, in women who don't menstruate or in men of any age).

Iron deficiency anemia in the elderly is most commonly due to bleeding from the intestine, invariably in such tiny quantities that it's not visible. This is called *occult GI blood loss*. (Occult as in *hidden*, not as in sorcery, witchcraft, or other such things.)

Because occult GI blood loss is often due to serious diseases, a thorough search for the cause must be undertaken. This search typically involves having a colonoscopy (where the doctor performing the test will look for a

variety of abnormalities, the most important of which is colon cancer). If the colonoscopy is normal, the next step is typically to have an upper endoscopy (that is, a scope of your esophagus, stomach, and duodenum; we discuss this procedure in Chapter 3) where the doctor will look for problems such as cancer, ulcers, and abnormal blood vessels.

The key to avoiding having the diagnosis of celiac disease overlooked in this situation is this: if you have had all the appropriate investigations looking for evidence of occult GI bleeding and if the tests have found no such cause, your doctor should test you for celiac disease. They may know this or they may not. If your doctor doesn't raise the possibility that you may have celiac disease and doesn't arrange further investigations to look for this condition, take the initiative and mention to your doctor the possible diagnosis of celiac disease. (As always, feel free to blame us for putting you up to this task!)

Save yourself an extra endoscopy! If as part of investigations to determine if you're having occult GI bleeding you're scheduled for an endoscopy, in advance of having the procedure done, ask the doctor doing the test to do a small intestine biopsy while they're at it. Otherwise, the endoscopy may end up needing to be repeated later on if, once GI bleeding has been excluded, the diagnosis of celiac disease is only then being entertained.

### How is iron deficiency anemia treated?

The treatment of iron deficiency due to celiac disease is to follow a gluten-free diet, to ensure your diet includes sufficient iron, and to take oral iron supplements as needed. We discuss this topic in detail in the earlier section "Iron deficiency."

Andrew, a 35 year-old plumber, was seeing his family physician for a regular check-up. He had routine blood tests performed and, to the doctor's and Andrew's surprise, these revealed that Andrew had anemia. Further blood tests revealed that the cause of the anemia was low iron. The doctor sent Andrew for a colonoscopy to make sure he wasn't losing blood from the large intestine. The test was normal. Similarly, an endoscopy found Andrew's stomach and small intestine to look normal. Nonetheless, the wise doctor performing the endoscopy thought to perform small intestine biopsies, and these came back showing typical features of celiac disease. Andrew was sent to a dietitian, placed on a gluten-free diet and iron supplements, and in a few months his iron level and hemoglobin were both back to normal. At no time had Andrew experienced symptoms.

As Andrew from the preceding anecdote discovered, you can have celiac disease even if you feel completely well, and iron deficiency anemia may be the first clue to the presence of your ailment. Indeed, this is one of the most common ways that celiac disease first shows up.

If you have iron deficiency due to celiac disease, once you have been on a gluten-free diet and iron supplements for a number of months and your iron

levels are back to normal, ongoing iron supplements are typically no longer required. There are, however, two main exceptions to this: if you're a vegetarian, especially a vegan (as we discuss in Chapter 11, such individuals can have difficulty consuming sufficient quantities of dietary iron) or a woman who experiences heavy periods. For these people, ongoing use of oral iron supplements is often required.

## Anemia due to low levels of folic acid

Like iron deficiency, folic acid (folate) deficiency is also common in people with active celiac disease. Anemia from folic acid deficiency, however, occurs far less often than anemia due to iron deficiency.

In your Internet travels, you may come across the term *megaloblastic anemia*. This refers to anemia due to either folic acid or vitamin $B_{12}$ deficiency.

Celiac disease leads to folic acid deficiency and, hence, anemia because of insufficient absorption of this nutrient into the body which in turn occurs because of inflammation in the small intestine. If you are known to have celiac disease, your doctor will likely be routinely monitoring your hemoglobin and folic acid levels. (We discuss ongoing monitoring of celiac disease in Chapter 15.)

In addition to following a gluten-free diet, treatment consists of ensuring your diet is rich in folic acid. We discuss this topic in detail earlier in this chapter; see the section "Vitamin $B_9$ (folate or folic acid)."

## Anemia due to low levels of vitamin $B_{12}$

Anemia due to low levels of vitamin $B_{12}$ occurs *un*commonly in celiac disease. Unlike iron and folic acid, vitamin $B_{12}$ is absorbed into the body from the end part of the small intestine (the terminal ileum); an area of the bowel seldom damaged by celiac disease.

We discuss the symptoms of — and the treatment of — vitamin $B_{12}$ deficiency earlier in this chapter; see "Vitamin $B_{12}$ deficiency".

In your other reading — of the cyber or more conventional varieties — you may come across the term *pernicious anemia*. Like celiac disease, pernicious anemia is also an autoimmune disease; however, the mechanism by which it leads to vitamin $B_{12}$ deficiency is very different.

# Skeleton Isn't Just An Olympic Sport: Celiac Disease and Your Bones

Although people often tend to think of their bones as being inanimate, in fact, bones are incredibly dynamic, with new bone constantly being formed and old bone constantly being removed. During childhood, the amount of new bone being formed is much greater than the amount being removed and, as people age (particularly as we reach our later years), the converse is true.

Since, as we discuss earlier in this chapter, celiac disease may cause malabsorption of calcium and vitamin D (both of which are essential for healthy bone development and maintenance), this condition puts you at risk of bone problems. We discuss these bone abnormalities in this section.

## Osteoporosis

*Osteoporosis* is a condition in which you lose bone mass (quantity) and strength. If you have osteoporosis, you are at increased risk of having a hip fracture or a fracture of a bone (vertebrae) in your back. Though osteoporosis is very common even in otherwise perfectly healthy people, having celiac disease increases your risk that much further.

### Testing you for osteoporosis

The standard test to detect osteoporosis is a form of x-ray called a *bone mineral density* (BMD) test. During this fast and painless procedure, measurements of bone density are made in both the back (the *lumbar spine*) and the hip (the *femur*; that is, the thigh bone).

Most people in North America are sent by their primary care provider for routine BMD testing once they reach the age of 65; however, if you have celiac disease, you're at risk of developing osteoporosis at a considerably younger age. For this reason, if you have celiac disease, discuss with your doctor whether you should have your BMD test performed even if you are decades from collecting your old age pension. The need for this will vary depending on your particular situation.

### Treating your osteoporosis

Treatment for osteoporosis due to celiac disease includes the following:

✔ **Following a gluten-free diet.** Like other complications related to celiac disease, the first step in successfully treating your osteoporosis is following a gluten-free diet. Doing so helps ensure you properly absorb the calcium and vitamin D you ingest.

We strongly advise that *everyone* with celiac disease see a registered dietitian to receive expert guidance regarding a gluten-free diet; seeing a dietitian becomes even more important if you have osteoporosis. If you have celiac disease and you haven't yet seen a dietitian, ask your doctor to refer you to one or refer yourself.

✔ **Consuming sufficient amounts of calcium.** You should ingest 1.5 grams of calcium per day if you have osteoporosis. As most people don't get this amount from their diet, calcium supplements are typically necessary to make up the shortfall. (Again, your dietitian is the best person to help you determine how to get the right amount of calcium in your diet and how much, if any, supplemental calcium you should take.)

✔ **Consuming sufficient quantities of magnesium.** Magnesium is involved with regulating how calcium is absorbed into the body. It is important, therefore, that you consume sufficient quantities of magnesium. Your dietitian can advise you whether you require magnesium supplements and, if so, how much.

✔ **Consuming sufficient quantities of vitamin D.** You should ingest approximately 1000 units of vitamin D per day. As with calcium, most people require vitamin D supplements in order to reach this amount. Your dietitian can review with you how much vitamin D you are getting in your diet and how much supplemental vitamin D you need to take.

✔ **Prescription medication.** Depending on the severity of your osteoporosis, you may benefit from taking prescription drugs such as *bisphosphonates*. Your family doctor is typically the first person you should speak to regarding whether or not you should take prescription drugs for your osteoporosis.

The preceding recommendations regarding diet, calcium, and vitamin D intake are also the most effective strategies to *prevent* osteoporosis from developing in the first place. As we discuss in Chapter 11, the quantity of vitamin D and calcium you need to ingest to help prevent osteoporosis depends on your age and other factors. We recommend you speak to your dietitian and physician to find out the best amounts for your specific situation.

If you have osteoporosis, your doctor should periodically send you for follow-up BMD testing to ensure you are responding sufficiently well to the therapies we just discussed. (Many U.S. insurers cover the cost of BMD tests performed every 2 years if your initial test was abnormal.)

# Rickets

Whereas osteoporosis (see the preceding section) is a condition wherein adults lose bone they've previously acquired, *rickets* is a disease of childhood in which bone is not properly or sufficiently made in the first place.

Just like you need sufficient amounts of raw materials (brick, mortar, and so on) to make a brick house, so too do children need the right amounts of calcium and vitamin D in order to create a healthy skeleton. If a child has undiagnosed or untreated celiac disease, he or she may not be able to properly absorb these nutrients into the body and as a result can develop rickets.

The skeletal abnormality most likely to develop depends on the age of the affected child; toddlers, for example, may develop outward bowing of the legs (unimaginatively — but aptly — referred to as *bow legs*), and older children may develop inward bending of the legs (*knock knees*).

Impaired bone development isn't the only feature of rickets. Other findings include:

✔ Bone pain

✔ Muscle weakness

✔ Dental problems (such as poor enamel)

✔ Seizures. These are most likely to occur in infants with rickets and are related to low calcium levels.

If a child has rickets, it is usually detected when either a parent notices the child is not developing normally and therefore brings the youngster to the doctor (who confirms the observation), or when a physician examines a child brought in for a routine check-up.

 If your child has celiac disease, the doctor will know that celiac disease can cause rickets and will monitor your child for this. A child with celiac disease who carefully follows a gluten-free diet and ingests the right amounts of the right nutrients (which your dietitian can teach you all about) as part of a healthy diet can expect to develop perfectly healthy bones.

The treatment of rickets (if the rickets is caused by celiac disease) consists of a gluten-free diet and sufficient ingestion of calcium and vitamin D. The required amounts of calcium and vitamin D depend on the age of the child and the severity of the problem. As always, it's essential that you and your child meet with a dietitian to receive expert advice tailored for your specific situation. Fortunately, if rickets is detected and treated sufficiently early (especially if the child's bones are still developing), an excellent response to therapy is typically seen and, ultimately, the child's bones can return to normal.

## Osteomalacia

*Osteomalacia,* like osteoporosis, is a condition in which the bones are "weak" and prone to fracturing. Also, both conditions have reduced bone density. The main difference between the two conditions is that in osteoporosis the internal architecture of the bones is preserved, whereas in osteomalacia the

architecture is damaged (referred to as *defective bone mineralization*). By way of analogy, imagine a thick wall built of reinforced concrete. If this wall had osteoporosis (hmm, we did say *imagine*), the concrete would be too thin but otherwise preserved. If this wall had osteomalacia, the main problem would be that the internal reinforcing rods were defective and weak at the time the wall was first constructed.

Osteoporosis and osteomalacia share much in common, such as vitamin D malabsorption being an important cause and treatment including taking supplemental vitamin D and calcium (in addition, of course, to following a gluten-free diet). One significant difference between the two conditions is that although osteoporosis does not cause symptoms (unless it causes a fracture), osteomalacia can be associated with bone pains and tenderness, and muscle weakness. Also, osteomalacia often requires treatment with higher doses of vitamin D than does osteoporosis.

# Oral Health

Celiac disease can affect various parts of the mouth including the teeth, tongue, and gums. We, ahem, look into mouth issues in this section.

## Dental health

*Enamel* is the hard, white, outer coating of the teeth. Children with celiac disease may develop dental problems as a result of defects in this enamel.

When Marjorie noticed her five year-old son, Jimmy, to have yellowed teeth she became concerned and took him to the dentist. The dentist asked her if she had taken tetracycline during her pregnancy (a known cause of this), but she hadn't. Had he been receiving excess fluoride (another known cause)? Nope. Being both smart and tenacious, the dentist did not leave things at that, but rather considered other possible causes including celiac disease. She referred Jimmy to a pediatric gastroenterologist and, several investigations later, the diagnosis of celiac disease was confirmed. Jimmy had not had even a single other symptom.

When celiac disease causes damage to the enamel, the affected teeth are typically located symmetrically within the mouth (that is, the same teeth on both sides of the mouth are affected). Also, the teeth most likely to be injured are the incisors. (The incisors are the pointed teeth toward the front of the mouth.) Although the enamel can be injured in several different ways, discoloration (with the teeth turning cream-, yellow-, or brown-colored) is the most common problem.

The exact cause of the damage to the enamel is unknown, but it is likely not simply a problem with insufficient absorption of nutrients — such as calcium — from the gut. Treatment with a gluten-free diet helps prevent further dental problems, but, unfortunately, the established enamel defects do not resolve. Older children and adults can be treated by their dentist with a variety of cosmetic procedures to cover the enamel defects.

## The rest of the mouth

These are other things that can go wrong in the mouth if you have celiac disease:

- ✔ The tongue can become sore or have a burning feeling. (Similar symptoms can also be seen if you have low levels of iron, folic acid, or vitamin $B_{12}$.)

- ✔ Canker sores (*aphthous ulcers*) can develop.

- ✔ You may develop sore, cracking of the skin at the corners of the mouth (a condition called *angular stomatitis* or *angular cheiltis*).

- ✔ The mouth may feel dry. This may be due to decreased saliva production; however, in some people this symptom is present despite normal amounts of saliva.

Typically, all these problems nicely improve soon after you start a gluten-free diet.

# Infertility and Complications of Pregnancy

Having celiac disease may make it more difficult for a couple to conceive; that is, celiac disease may increase the risk of infertility. Also, once pregnant, a woman with celiac disease may be at increased risk of having a miscarriage. These risks are most likely to apply to people with *untreated* or *insufficiently treated* celiac disease.

Although the explanation(s) for the increased risk of infertility and miscarriages is not fully sorted out, factors may include reduced levels of important nutrients and abnormal hormone levels. In a woman with active celiac disease there may be less frequent ovulation, and in a man, sperm may be abnormal or male hormone levels (such as testosterone) may be reduced. Additionally, both men and women with active celiac disease are at increased risk of other hormonal disorders — such as thyroid disease — that can impact on normal reproductive function.

We discuss these topics in detail in Chapter 14.

# Hyposplenism and Increased Risk of Infection

Until not too long ago, the spleen was thought to be an unimportant organ. And until not too long ago, it was also thought that a man couldn't run a four minute mile, the atom couldn't be split, the sound barrier couldn't be broken, we'd never finish this book before our editor's deadline . . . well, you get the point. In fact, it is now known that the spleen has a number of important functions in maintaining good health, one of which is to help protect against serious infections from a bacteria called *pneumococcus*.

There is some (limited) evidence that if a person has active celiac disease, his or her spleen may not function normally (a condition called *hyposplenism*) and as a result that person would be at increased risk of infections from the aforementioned pneumococcus germ. For this reason, some experts recommend that people with celiac disease be given a pneumococcal vaccination to lower the risk of getting this infection. The jury is still out on this advice, and we feel it's premature to recommend this to all people with celiac disease. Instead, it should be determined on a case-by-case basis depending on your individual circumstances. (There are other conditions for which the pneumococcal vaccine is recommended, so speak to your health care provider to see whether your particular health situation may warrant you being given this vaccine.)

# Chapter 8

# Conditions Associated with Celiac Disease

. . . . . . . . . . . . . . . . . . . . . . . . . . . . . . . . . . . . . . . . . . . . .

## In This Chapter

▶ Looking at how celiac disease can affect the skin

▶ Thinking about mood and neurological problems

▶ Examining hormonal abnormalities

▶ Discovering the connection between arthritis and celiac disease

▶ Probing liver malfunction

▶ Monitoring for celiac disease if you have a genetic disorder

. . . . . . . . . . . . . . . . . . . . . . . . . . . . . . . . . . . . . . . . . . . . .

*H*aving celiac disease doesn't make you an unhealthy person. Indeed, once you found out you had celiac disease, you may have become more knowledgeable about your health and more aware of good nutrition than most people around you. Not only that, you likely also discovered that (gluten-containing foods excepted) you can eat a wide variety of foods, exercise regularly, and, basically, do anything you want to do.

You may be awaiting a "but" and, indeed, here it is: Because you have celiac disease, you are at increased risk of having certain other types of health conditions. Some of these are *directly related* to celiac disease, and others are simply *associated with* celiac disease. In Chapter 7, we look at those conditions that are directly related (such as active celiac disease causing malabsorption of iron in turn leading to anemia). In this chapter, we look at those conditions, such as type 1 diabetes, that are associated with celiac disease.

We discuss a number of different health conditions in this chapter. Although disparate in many ways, they do have one important thing in common: Apart from dermatitis herpetiformis, no definitive proof exists that following a gluten-free diet will improve any of these conditions; instead, you need to rely on other, effective therapies.

# *Understanding What "Associated" Means*

Although you are at increased risk compared to someone without celiac disease of developing certain health problems associated with celiac disease, the odds remain darned good that you will *never get any* of these conditions. (Just like buying two lottery tickets instead of one may double your "risk" of winning the big prize, but your likelihood of winning still remains small. Rats!)

Distinguishing between those things in life that are directly related and those that are simply associated can be a challenge. Here are examples to help clarify the distinction. If you use a hammer and you hit your thumb, the action and outcome are directly related. The hammer *directly* caused your thumb injury (and the oh-so-delicate words that you quietly murmured). On the other hand (so to speak), if you have red hair and skin freckles, your red hair did not cause you to have skin freckles; the two traits are simply *associated*.

We strongly suspect that as more becomes known about celiac disease, many of the ailments now said to be linked to celiac disease (as we discuss in this chapter) will turn out to be present either with no greater frequency than if you didn't have celiac disease, or alternatively, will be found to be victims of "guilt by association" and have no causal relationship.

# *Skin Deep: Dermatological Conditions*

As anatomy professors love to tell first year med students, the skin is a person's largest organ. Sheila, a gastroenterologist, and Ian, an internist, admit to occasional envy of our dermatologist ("skin doctor") colleagues. While we often have to poke and prod, x-ray and ultrasound, endoscope and colonoscope, to find out what's causing our patients' ailments, the fortunate dermatologist — occasional skin biopsies aside — just has to look.

There are several skin ailments that are associated with celiac disease. We explore these conditions in this section.

If you have not been diagnosed with celiac disease and you have a skin rash that you think may indicate you have celiac disease, we recommend that before you start yourself on a gluten-free diet in the hope this will help your skin condition, you first speak to your doctor. As we discuss in Chapter 3, if you are on a gluten-free diet, figuring out whether you do or don't have celiac disease is more difficult.

# Dermatitis herpetiformis

*Dermatitis herpetiformis* (DH), literally translated, means "skin inflammation resembling herpes." Despite the name, DH is not caused by the herpes virus and, apart from some similarities in the way the rash looks, has no other relationship to herpes.

Between 15 and 25 percent of people with celiac disease either have or at some point develop dermatitis herpetiformis. Conversely, virtually everyone with dermatitis herpetiformis has, if looked for sufficiently thoroughly, some evidence of celiac disease. As you may expect, therefore, those people who are genetically at risk of celiac disease are the same people at risk of DH. (We look at the genetics of celiac disease in Chapter 2.) Although dermatitis herpetiformis can be found at any age, you are most likely to first develop it if you are between the ages of 15 and 40.

Celiac disease and DH share so much in common that DH is sometimes referred to as "celiac disease of the skin." Nonetheless, even if a person has both conditions, their severity is not necessarily similar. You can have severe GI symptoms from celiac disease but only mild skin problems from DH, or you can have very mild (or even nonexistent) GI symptoms from celiac disease and have severe skin issues from DH.

Today, every doctor has at least some familiarity with celiac disease, but many physicians are not familiar with (and may have never even heard of) dermatitis herpetiformis. For this reason, if you have celiac disease and you also have a skin rash — especially if it's one that has gone undiagnosed or persists despite treatment — there's no harm in asking your doctor (even your dermatologist) whether you might have DH.

## Knowing the features of dermatitis herpetiformis

DH is a form of skin rash. Although there can be many exceptions, DH generally has the following features:

- ✔ The areas most likely to be affected are the elbows, knees, and buttocks (less often, the shoulders, scalp, face, and back). The oral or genital areas are only occasionally involved. DH doesn't affect the palms or soles.

- ✔ It consists of groupings of small, flesh colored-to-pink, blister-like sores that are raised above the surface of the skin.

- ✔ The rash is intensely itchy. Intense as in "I'm scratching so hard I'm worried I'm going to peel my skin right down to the bone." Before the itching develops, the small blisters or bumps may have a burning feeling.

Because the itch is so intense, and because the affected person understandably tends to scratch so vigorously, the typical appearance of DH (as we describe in the preceding list) can become obscured by the effects of the scratching itself (including the absence of blisters if they've been scratched off before being seen by the doctor). This is one of the reasons that doctors — even dermatologists — may (mis)diagnose the rash as being something else altogether, like eczema, mosquito bites, allergies, or even psoriasis.

### Diagnosing dermatitis herpetiformis

Like pretty well any other disease, the first step in diagnosing DH is having a doctor who considers the possibility (or a patient who brings the possibility to the doctor's attention). In determining whether you have DH, your doctor will do these key things:

- ✔ **Talk to you.** The doctor needs to determine when your rash started, what it feels like, whether it's getting better or worse, and so on. Also, if DH is suspected, your doctor will want to know whether you have celiac disease or symptoms suggesting that you might (see Chapter 6).

- ✔ **Examine you.** Your doctor will need to carefully inspect your skin, looking particularly for what the skin rash looks like and where on your body the rash is located.

- ✔ **Send you for blood tests.** The most important of these is, as with celiac disease, to look for the presence of *tissue transglutaminase antibody* (see Chapter 3). This antibody is present in the majority of people with DH. Because a skin biopsy, as we mention in the next bullet, is the only definitive way to diagnose DH, a dermatologist may elect to forego this or other blood tests in lieu of proceeding directly with a biopsy.

- ✔ **Have a skin biopsy performed.** The *only* way that DH can be definitively diagnosed is with a skin biopsy. Everything else we mention in the preceding bullets is complementary to this. These are the most important features of having a skin biopsy:

  - A skin biopsy is a fast and safe outpatient procedure.

  - In order to get a high quality specimen, the biopsy needs to be done by a doctor who is skilled at performing the procedure.

  - The biopsy should, ideally, be taken from a newly developed blister because, once it's scratched and/or sufficiently healed, the characteristic findings may no longer be present.

  - The biopsy specimen is sent by the dermatologist to the laboratory where it is analyzed by a pathologist. The pathologist looks at the pattern of cells in the biopsy sample and also looks specifically for a substance unique to DH called *granular IgA antibodies* which, if present, clinch the diagnosis.

No test is perfect. Therefore, if you have other features of dermatitis herpetiformis, yet your skin biopsy does not confirm this, you should either have the biopsy repeated or, alternatively, your doctor should have the specimen reviewed by another pathologist.

### Understanding why celiac disease is associated with dermatitis herpetiformis

At first blush (well, maybe second and third blush, too) it may seem peculiar that a condition — celiac disease — that affects the intestine is associated with a condition — DH — that affects the skin. The quick and dirty explanation is that both conditions are caused by the same antibodies in response to the same trigger (gluten). The more difficult part here is to figure out *why* these antibodies target such different parts of the body. Most likely this is because both the skin and the bowel contain certain proteins (called *antigens*) that are similar enough that the antibodies cannot tell them apart and target them regardless of their location. (Just like the old expression: Give someone a hammer and suddenly, everything looks like a nail.) If this sounds straightforward enough, we're doing you a disservice! Because why, then, do only a fairly small percentage of people with celiac disease get DH? The answer is we simply don't know.

### How dermatitis herpetiformis is treated

Although much is unknown about DH, what is, however, abundantly clear is how to make it better. Don't consume gluten. Period. That much is simple. What is far less simple is trying to predict how long it will take from the time that you eliminate gluten until your skin rash goes away. Generally speaking:

- ✔ Most people notice some initial improvement within a few weeks of adopting a gluten-free diet and have almost complete resolution of their DH within a few months.

- ✔ The longer and more severe the DH, the longer it takes to start to improve and, ultimately, resolve. In the most severe cases, it can take well over a year before things are entirely back to normal.

If your symptoms are bothersome enough, while you await the benefits of your gluten-free diet to take hold, there are medications you can take to make you feel better, faster. We look at these next.

Although medications are helpful in the treatment of DH, they do not treat the underlying immune problem that causes this disease. The only therapy that targets the underlying problem is the elimination of gluten from your diet. When you use these medicines, you must, therefore, continue to follow your gluten-free diet.

### Dapsone

Dapsone is an oral medication. It reduces the inflammation present in the skin sores and, as a result, helps improve the rash and ease the itch of DH.

Although generally well-tolerated, dapsone can have serious side effects, such as anemia, decreased white blood cell production (which increases the risk of infection), kidney damage, and nerve damage. For these reasons, your doctor needs to use the lowest effective dose of dapsone for the shortest possible period of time. Nonetheless, some people — particularly those with severe DH — can take a very long time to sufficiently respond to a gluten-free diet, and therefore may need to take the medicine for as long as 6 to 12 months before the dose can be reduced. The occasional person simply has such refractory DH that they need to stay on dapsone indefinitely (though, again, this should be in the lowest possible dose).

### Topical medications

Two types of topical medication can be tried to treat DH (but because they aren't typically helpful, they are not routinely used):

- *Corticosteroid-containing creams* work by reducing the amount of inflammation in the affected skin. (Corticosteroids are potent anti-inflammatory medications.)

- *Immune-modulating creams* (such as drugs called *tacrolimus* and *pimecrolimus*) modulate (hence the name for this drug class) part of the immune system and, by doing so, help to suppress the immune reaction in the affected skin. As a result, inflammation is reduced.

# Vitiligo

*Vitiligo* is a chronic condition in which a person loses pigment from various areas of the skin, and as a result, the affected areas turn white. The hands, abdomen, chest, and sometimes face can be involved. In extreme cases, virtually the entire body can turn white. Although vitiligo is not a threat to one's physical health, the cosmetic appearance, depending on the extent and on one's natural skin color, may be bothersome.

Although the cause of vitiligo is not fully sorted out, it is thought likely to be an autoimmune disease, that is, a condition in which the body makes antibodies to its own tissues. Multiple autoimmune diseases tend to occur in the same person; this likely explains why people with celiac disease (which is, in itself an autoimmune condition) are more prone to vitiligo.

There's no cure for vitiligo, and it seldom requires treatment beyond sunscreens, makeup, or skin stains; however, ultraviolet light or prescription drug therapy (such as with corticosteroids) is sometimes used.

# Psoriasis

*Psoriasis* is a chronic skin condition in which areas of the body (most commonly the scalp, elbows, knees, and back, though other areas can also be affected) become red and scaly. These sores are called *plaques*.

Psoriasis, like celiac disease, is an autoimmune condition, and it is likely for this reason that the two conditions may co-exist. (This association is, however, controversial and many experts believe that it is just statistical chance that psoriasis and celiac disease — neither being rare disorders — both develop in certain individuals.)

If your psoriasis is mild, the only treatment typically required is a topical therapy such as applying petroleum jelly (one type being Vaseline), tar, or corticosteroids. (There are a great many different types of topical corticosteroid medication; your family physician or dermatologist will recommend the one he or she feels will work best for you.) Other, more powerful therapies are reserved for particularly severe cases. Although it is not as yet proven, most experts feel that a gluten-free diet seldom, if ever, helps control psoriasis.

# Eczema

*Eczema,* also known as *atopic dermatitis*, is a chronic skin condition, often onsetting in childhood, characterized by itchy, thickened skin most commonly affecting creased areas of the body, such as the neck, the front of the elbows, and the backs of the knees. Affected somewhat less often are the face, wrists, and forearms. Other areas of the body can also be involved.

Eczema is a very common condition in the general population and, like many other frequently occurring conditions, a proven link with celiac disease has not been established, and its presence may be purely coincidental.

In terms of celiac disease, the most important thing to know about eczema is that dermatitis herpetiformis (see "Knowing the features of dermatitis herpetiformis") can be misdiagnosed as being eczema.

If you have celiac disease and you are diagnosed with eczema, the odds are good that you have this condition. Nonetheless, there is no harm (and could be much good) in your mentioning to your doctor that you have celiac disease and asking if, therefore, the possibility exists that your skin rash actually represents dermatitis herpetiformis.

# Feeling Down in the Dumps: Depression

Feeling sad is a normal part of life. Sadness is a temporary feeling typically related to an identifiable and specific cause, be it something as relatively minor as having an argument with a friend or as devastating as the loss of a loved one. *Depression*, on the other hand is a severe, overwhelming, and persisting feeling of despair often not clearly related to a triggering event. Depressed people often sleep poorly, feel tired, have a decreased appetite and weight loss and, in some cases, may be suicidal.

Although the exact reasons that people with celiac disease are at increased risk of depression are not known, several factors may account for at least part of the explanation:

- ✔ Prior to being diagnosed with celiac disease, you may have felt unwell for a long time. Indeed, you may have suffered for years from indigestion, abdominal cramps, diarrhea, fatigue, and other symptoms before their cause was discovered. Feeling chronically ill can understandably take a heavy emotional toll.

- ✔ Before your celiac disease was diagnosed you may have attributed — or your family, friends, or doctor may have attributed — your gastrointestinal or other symptoms to emotional causes such as stress. Perhaps you came to "beat yourself up" over having symptoms which were inaccurately thought to be due to emotional "weakness" (whatever that is!).

- ✔ After being diagnosed with celiac disease and having started on a gluten-free diet, you may have concluded this treatment was overly restrictive and interfered unduly with your ability to share in the pleasures of family celebrations, parties, and other events where food is often front and center.

- ✔ Celiac disease causes decreased absorption of certain nutrients. One theory holds that this may lead to decreased levels of the brain's chemical messengers (*neurotransmitters*) and that this chemical imbalance is a factor in causing depression.

- ✔ The inflammation in the body that results from celiac disease may, in itself, affect one's mood and thinking.

- ✔ Celiac disease is more common among people that share certain genes (like family members). This is also true of depression. It could be, therefore, that the genes that put someone at risk for celiac disease share some link to the genes that put someone at risk for depression, so if you have the one condition, you may be at increased risk for the other.

If you are suffering from depression, it is essential that you seek help. Although your family and friends may offer invaluable support, you should let your doctor know how you are feeling so that they can provide you with — or arrange for — the medical care you require.

## What causes celiac disease neurological problems?

In some circumstances, the connection between neurological problems and celiac disease is easy to find; for example, the person with such severe malabsorption that he or she develops a very low calcium level (*hypocalcemia*) and as a result has a seizure.

In other cases, the link is less clear, but can be inferred. For example, some infants with untreated celiac disease, although having normal routine blood tests, nonetheless are slow to mentally develop (something called *developmental delay*) but improve nicely once they are treated with a gluten-free diet. This outcome suggests they were suffering from a deficiency of nutrients but of such a small (though significant) magnitude that blood tests were unable to detect it.

Another mechanism has also been described. It could be that neurological problems in some people with celiac disease develop not from malabsorption, but from a defect in the immune system itself. Celiac disease is an autoimmune

disorder (see Chapter 2) leading to inflammation in the lining of the intestine (and, in the case of dermatitis herpetiformis, in the skin). Cases have been described where people with celiac disease and brain malfunction had evidence of autoimmune damage in the brain itself. Whether this was the cause of their neurological problems or was coincidental is unknown.

Antibodies to gliadin (AGA) have been suspected as one cause of neurological problems in celiac disease, but the evidence for this is limited. It has also been proposed that gliadin itself is in some way toxic to the nervous system and that a leaky gut may also be a factor. Again, there is very little scientific information to support such claims. More recently, antibodies to another form of transglutaminase that is found in nervous tissue known as neuronal TG or TG6 have been detected, and it is possible that these may be involved in the neurological problems associated with celiac disease. More research is needed in this area.

# Getting a Head Start: Neurological Manifestations

As with other ailments we discuss in this chapter, the link between celiac disease and certain neurological disorders is unclear and may simply reflect the coincidental occurrence of relatively common disorders. Having said that, there are some neurological conditions which *possibly* do occur more commonly if you have celiac disease. We discuss these in this section.

## Migraine headache

*Migraine headaches* are typically felt as throbbing, intense, headaches that occur on one side of the head or the other and can range in severity from the mild to the disabling. The headache is often accompanied by nausea and

vomiting. Migraine headaches are often foreshadowed by a warning (*aura*) symptom (or symptoms) such as seeing flashing lights or geometric patterns. Some people experience the aura without the headache.

If your migraines are infrequent, the usual treatment strategy is to take a *serotonin (5-HT) receptor agonist* medicine at the first hint you are getting a migraine. If your migraines are more frequent, then taking a preventative medicine (such as a drug — like propranolol — from the *beta blocker* family) is often advised.

## *Peripheral neuropathy*

The *peripheral nervous system* is that collection of nerves that carries messages between the *central nervous system* (the brain and spinal cord) and your organs such as the muscles and skin. So, for example, if you move your fingers to turn this page (no, not yet!), it is your peripheral nervous system that is receiving the instructions from your central nervous system and "telling" the muscles in your hand and fingers what to do. Conversely, if you turn this page and get a paper cut (*sorry*), it is your peripheral nervous system that carries the pain message from your finger to your central nervous system.

*Peripheral neuropathy* is the condition wherein nerves within the peripheral nervous system are damaged. Depending on which part of the peripheral nervous system is damaged, symptoms can vary from numbness, burning, or other types of pain in the fingers or toes, to weak muscles.

In most cases, a direct connection between celiac disease and peripheral neuropathy is not found and, when a person has both conditions, the connection is likely to be coincidental. An exception to this rule, however, is vitamin $B_{12}$ deficiency. As we discuss in Chapter 7, vitamin $B_{12}$ is an important nutrient to keep nerves healthy. If, as occasionally happens, celiac disease damages the end part of the small intestine (the *terminal ileum*) — where vitamin $B_{12}$ is absorbed into the body — you will be at risk of vitamin $B_{12}$ deficiency and, as a result, peripheral neuropathy.

If you have symptoms like those we have just described, ask your doctor to check your vitamin $B_{12}$ level. This is done on a blood sample.

## *Ataxia*

*Ataxia* is the medical term for imbalance and incoordination. It occurs when there is damage to the parts of the nervous system that control balance, position, and movement.

An (extreme) example of ataxia is the "I can barely walk on my own two feet" gait of the bar patron that has had one too many. Many people, however, have much more subtle degrees of ataxia. Of all the various neurological problems that seem linked to celiac disease, ataxia is the one that occurs most commonly, being present, to some degree, in up to 10 to 15 percent of people with celiac disease. Nonetheless, it remains to be proven whether celiac disease actually causes ataxia and, if so, how it does this.

The one exception is the established link between vitamin $B_{12}$ deficiency — see the immediately preceding section, "Peripheral neuropathy" — and ataxia that can result from this deficiency.

If you have ataxia, ask your doctor to check the vitamin $B_{12}$ level in your blood.

## Epilepsy (seizures)

*Epilepsy* is a condition in which episodes of abnormal electrical discharge occur in the brain leading, depending on the area involved, to abnormal movements or behaviors. There are a variety of types of epilepsy, the one most familiar to people being *grand mal* seizures in which an affected individual suddenly and with little or no warning loses consciousness, has thrashing movements of their arms and legs, incontinence, and then a period of confusion lasting up to a few hours before returning to normal.

*Some* evidence exists that epilepsy is more common in people with celiac disease, but the relationship (if any) — with one exception we mention in a moment — is far from clear, and the great majority of people with celiac disease never experience seizures.

Here is the one exception: Celiac disease can cause malabsorption of calcium and magnesium leading to deficiency of these minerals; if sufficiently severe, you can have a seizure. Fortunately, this degree of calcium and magnesium deficiency seldom happens. Doctors routinely check calcium and magnesium levels (on a blood test) in people with unexplained seizures.

## Attention-Deficit/Hyperactivity Disorder (ADHD)

*Attention-Deficit/Hyperactivity Disorder* (ADHD) is a condition in which the affected person has difficulty paying attention, tends to be overly active, and often acts impulsively. ADHD is typically diagnosed in childhood; however, increasing numbers of adults are also being diagnosed. The cause (or causes) of ADHD is not known, although numerous theories abound, including the possibility that ADHD is, in some way, connected to celiac disease.

At present, there is very limited evidence for a connection between ADHD and celiac disease. Given the lack of good scientific evidence linking celiac disease and ADHD and given the many challenges of following a gluten-free diet (especially, perhaps, in a child with ADHD), treating ADHD with a gluten-free diet is not advised. Similarly, there is insufficient evidence of a link between the two ailments to warrant routinely screening people with ADHD for celiac disease. (It is, however, certainly understandable that parents of a child with ADHD and the child's physician, often out of desperation, choose to test a given child with ADHD for celiac disease.) Of course, if a person with ADHD has other features (as we discuss throughout this book) suggesting he or she may have celiac disease, then naturally the appropriate tests should be performed.

## Autism

*Autism* is a condition in which the affected person has difficulties communicating and interacting socially.

The link, if any, between autism and celiac disease is unclear. Some earlier scientific studies had suggested that children with autism were more likely to have celiac disease, but more recent evidence does not support there being an association. Currently, it is not recommended that children with autism be routinely screened for celiac disease, nor is it advised that children with autism be placed on a gluten-free diet on speculation that it will be of benefit. (Nonetheless, we recognize that parents, out of frustration and desperation, and also the lack of other treatments, may elect to try their autistic child on a gluten-free diet in spite of a lack of scientific evidence that such dietary therapy is of benefit.)

## Trouble below the surface: Hidden neurological problems

Although the great majority of people (of any age) with celiac disease do not have obvious neurological problems, if sophisticated medical tests are done on children with celiac disease, up to 20 percent of them will have some evidence of neurological dysfunction. Problems identified range from very mild nerve damage in the limbs (so mild, the child doesn't have symptoms) to a small brain (something called *cortical atrophy*). Also, some adults with celiac disease have been found to have decreased blood flow to part of the brain.

Whereas for people who have both celiac disease and *overt* neurological disease (such as those conditions we discuss in this chapter) the connection between the ailments is tenuous and treating celiac disease typically has no impact on the neurological condition, some scientific evidence suggests people with celiac disease and *subclinical* (that is, not having obvious symptoms or physical examination abnormalities) neurological dysfunction do, in fact, have neurological improvement after following a gluten-free diet.

# Hormonal Health: Endocrine Disorders and Celiac Disease

The *endocrine system* refers to the body's complex network of glands that produce ("secrete") hormones. Hormones control an array of bodily functions including growth, metabolism, and sexual and reproductive function to name but a few.

As you discover in Chapter 2, celiac disease is an autoimmune disease. So, too, are a variety of endocrine disorders. If you have one autoimmune disease, you are at increased risk of having others. Thus, if you have celiac disease, you are more likely to have some types of endocrine disease. We look at these types in this section.

## Type 1 diabetes

*Diabetes mellitus* (virtually always abbreviated simply as "diabetes") is a disease in which one has elevated *blood glucose* (blood sugar) levels due to insufficient insulin or ineffective insulin or both. (Another, entirely unrelated form of diabetes is called *diabetes insipidus*; the only thing it has in common with diabetes mellitus is a tendency to pass lots of urine; our discussion here pertains only to diabetes mellitus.) There are two main types of diabetes mellitus:

- **Type 1 diabetes** is an autoimmune disorder that typically first onsets in adolescents, teens, or young adults, and always requires insulin therapy.

- **Type 2 diabetes** is not autoimmune, typically develops in middle-aged or older individuals, and can often be managed — especially in its first few years — without insulin.

If you have type 1 diabetes, you have about a 5 percent lifetime risk of being found to also have celiac disease (compared to the general population risk of about 1 percent).

### Exploring how celiac disease affects diabetes

People with type 1 diabetes need to inject themselves with insulin immediately before they eat in an amount proportionate to the amount of carbohydrate they are about to ingest. (Carbohydrates make blood glucose go up; insulin helps bring it down or helps prevent the blood glucose from going up in the first place.) This treatment strategy (called *carbohydrate counting* or *carb counting* for short) generally works very well but is dependent on the ingested carbohydrates being predictably absorbed into the body. Undiagnosed or insufficiently treated celiac disease (with its attendant affect on carbohydrate — and other nutrient — absorption into the body) — confounds this predictability and leads to erratic blood glucose levels. Conversely, there is good —

though not foolproof — evidence that once the celiac disease is controlled, blood glucose control also improves. See the sidebar, "Why blood glucose control is erratic if you have type 1 diabetes and untreated celiac disease," for more on this topic.

Anne was a 22-year-old patient of Ian's with type 1 diabetes. Her blood glucose control had been typically excellent over the years, but for the past 6 months her control had become increasingly erratic to the point that Anne felt she was on a perpetual roller coaster. She couldn't fathom why this had happened. She felt otherwise completely well, her diet hadn't changed, her exercise pattern had remained consistent, and her insulin therapy hadn't altered. Further investigations were undertaken including blood tests and, subsequently, a small intestinal biopsy (see Chapter 3). The results came back showing that Anne had celiac disease. When Anne heard the news, she was initially (understandably) upset, but when she started a gluten-free diet and found her blood glucose control to come back in line, she was both pleased and relieved.

If you have type 1 diabetes and your blood glucose control is erratic for no clear reason, discuss with your diabetes specialist whether or not you should be tested for celiac disease.

### Screening for celiac disease if you have type 1 diabetes

As we discuss in Chapter 4, screening for a disease means testing for it in the absence of any evidence that it is present. A common example of screening is having your blood pressure checked even when no suspicion exists that it's high; this is done by doctors as part of a routine checkup.

Because your risk of having celiac disease is much greater if you have type 1 diabetes, some experts advocate that *all* people (especially children) with type 1 diabetes be tested for celiac disease. Other experts advise that, because it is not proven that treating entirely *a*symptomatic people with celiac disease improves their long-term health, such testing should only be done on people — including those with type 1 diabetes — who are having symptoms or other evidence (such as erratic blood glucose levels) that they may have celiac disease.

The American Diabetes Association (ADA) has published recommendations regarding screening for celiac disease in *children and adolescents* with type 1 diabetes. The ADA recommends that they be screened for celiac disease soon after the diagnosis of type 1 diabetes has been made and, if celiac disease isn't found, that screening be redone if the child or adolescent:

✔ Fails to grow properly

✔ Fails to gain weight properly or loses weight

✔ Has gastrointestinal symptoms

## Why blood glucose control is erratic if you have diabetes and untreated celiac disease

When a person with no health problems ingests carbohydrates (some examples being bread, potatoes, grains, cereals, rice, and some dairy products like milk and yogurt), the carbohydrates are quickly absorbed into the body and converted to a sugar molecule called *glucose*. The pancreas recognizes that additional glucose has entered the blood stream and instantly releases precise quantities of a hormone called *insulin* which allows the glucose to move, in just the right amounts, from the blood into the body's cells.

A person with diabetes who is being treated with a quick-acting form of insulin taken with meals does so in a dose designed to match the expected amount of carbohydrate about to be absorbed into the body. If you have active celiac disease, however, malabsorption may cause only a portion of the ingested carbohydrate to be absorbed. As a result, a mismatch occurs, with too much insulin having been given for the amount of glucose present in the blood. As a result, low blood glucose (*hypoglycemia*) occurs. Fortunately, once your celiac disease is discovered and treated, your bowel will heal and the carbohydrates you ingest will once again be consistently and predictably absorbed with, in most cases, an attendant return of more predictable insulin requirements.

The ADA also suggests that doctors consider periodically rescreening children and adolescents even if they are asymptomatic (that is, not having any symptoms to suggest they have celiac disease).

## Thyroid disease

The *thyroid gland* is a small organ located low down in the neck in front of and beside the windpipe (the *trachea*). The thyroid makes thyroid hormone which is involved with controlling and regulating many different processes within the body. Indeed, if it moves (think bowels), squeezes (heart), bleeds (uterus), pulls (muscles), grows (nails), or pretty much performs any other bodily function, then the thyroid typically plays at least some role.

The thyroid gland is commonly affected by autoimmune disease and, as multiple autoimmune diseases tend to occur in the same individual, if you have celiac disease (which is an autoimmune condition) you are at increased risk of having one of these conditions. Approximately 5 percent of people with celiac disease have one of the two thyroid conditions we discuss in this section.

If, after the reading this section, you're looking for more information on thyroid disease, have a look at the excellent Web site www.mythyroid.com.

### Graves disease

*Graves disease* — so called because it was first described by Dr. Robert Graves, not because it is a grave disease — is an autoimmune condition in which antibodies attack the thyroid and cause it to over-function (a condition called *hyperthyroidism*).

These are some common symptoms of hyperthyroidism:

- ✔ Excess sweating
- ✔ Fatigue
- ✔ Feeling overly hot
- ✔ Frequent bowel movements (sometimes to the point of having diarrhea)
- ✔ Palpitations
- ✔ Thyroid swelling (*goiter*)
- ✔ Tremor
- ✔ Weight loss

Looking at the preceding list, you can see that some of the symptoms of hyperthyroidism are also symptoms of active celiac disease. Specifically, both conditions can cause frequent stools, weight loss, and fatigue. For this reason, if you have celiac disease and you develop these symptoms you may understandably be inclined to attribute them to your bowel disease and question whether you've inadvertently been ingesting gluten. This makes perfect sense, but if the real problem is that you've developed hyperthyroidism, this will be overlooked. Therefore, if you develop these symptoms, mention them to your physician so that you can be assessed and, if indicated, tested for hyperthyroidism.

The diagnosis of hyperthyroidism is usually easily confirmed by measuring your thyroid hormone levels on a blood test and by performing a nuclear medicine test called a *thyroid scan*. Treatment is with either a drink of radioactive iodine (which generally cures the hyperthyroidism within a few months) or, used less often, oral medications (which control the problem but are unlikely to cure it).

### Hashimoto's thyroiditis

*Hashimoto's thyroiditis* is an autoimmune condition in which antibodies attack the thyroid and, often, cause it to under-function; a condition called *hypothyroidism*.

These are some common symptoms of hypothyroidism:

- ✔ Brittle hair
- ✔ Constipation

✔ Dry skin

✔ Fatigue

✔ Thyroid swelling (*goiter*)

✔ Weight gain

If you develop these symptoms, be sure to see your doctor so that they can check to see whether you may have hypothyroidism.

The diagnosis of hypothyroidism is easily made by measuring your thyroid hormone levels on a blood test. Hashimoto's thyroiditis is similarly easily diagnosed by finding certain thyroid antibodies on a blood test.

Hypothyroidism is treated with oral thyroid hormone supplements. If you're on the right dose of thyroid hormone (this is readily determined by measuring your thyroid hormone levels on a blood test), your symptoms of hypothyroidism will all gradually resolve. If, however, they persist despite normal thyroid hormone levels, then your doctor will need to look for a non-thyroid cause.

## Adrenal insufficiency (Addison's disease)

*Adrenal insufficiency* (typically referred to as Addison's disease though technically Addison's disease is but one form of adrenal insufficiency) is a condition in which the adrenal glands (small, paired organs which are located just above the kidneys) become damaged — typically as part of an autoimmune process — and as a result become unable to make sufficient quantities of certain types of hormones, called *corticosteroids.*

Two types of corticosteroids are available and, depending on which type is lacking, different symptoms result:

✔ *Glucocorticoid* deficiency leads to

- Weight loss

- Fatigue

- Nausea

- Abdominal pain

- Malaise (meaning you feel generally poorly).

✔ *Mineralocorticoid* deficiency leads to

- Increased thirst

- Craving for salty foods

- Dehydration

- Low blood pressure. (Low blood pressure has a range of severity. If it's mild, it may only cause lightheadedness or faintness, especially when you first stand up. *Severe* low blood pressure, however, can be life-threatening.)

Because both celiac disease and the most common form of adrenal insufficiency are autoimmune diseases, and because having one such condition increases the risk of having another, if you have celiac disease you are at increased — though still small — risk of developing Addison's disease.

If you think of the symptoms you had prior to your celiac disease having been discovered and treated, it's quite possible you recall having had some of the same symptoms — such as weight loss, fatigue, nausea, abdominal pain, and malaise — we mention in the preceding list. That doesn't mean you have Addison's disease; indeed, if your symptoms went away once you got going on your gluten-free diet and you've been fine since, it is highly *un*likely you have Addison's disease. Nonetheless, you are at increased risk of developing Addison's disease, so it is important that, should you develop the symptoms we mention in the previous list — especially if they are severe or persisting — that you seek medical attention to have the cause determined.

The symptoms of Addison's disease can be quite nonspecific. For this reason, doctors typically (and understandably) look for more common causes to explain them. This often leads to a delay in the diagnosis with the correct cause not being determined until someone is quite ill.

The diagnosis of Addison's disease is confirmed by blood tests showing decreased glucocorticoid levels (specifically, *cortisol*), and, sometimes, imbalance of sodium and potassium levels. Treatment consists of taking (oral) supplements of the missing hormones.

Now that you are armed with the knowledge we've shared in this section, you can help avoid this happening to you if you have celiac disease by seeking medical attention when necessary and, even better, mentioning to your doctor the possible diagnosis of Addison's disease when you have (unexplained) symptoms like we describe in this section. You may turn out to have been very wise to have done so; indeed, you could save your own life!

# Disjointed: Rheumatologic Disorders

Rheumatologic disorders are those ailments affecting the musculoskeletal system (the muscles, joints, cartilage, and other parts of our anatomy responsible for — and, for pop music fans, *doing* the — locomotion). Because many rheumatologic diseases are caused by immune problems, and because the immune system is directly involved in how the entire body functions, many rheumatologic diseases also affect the internal organs.

# Connective tissue disorders

*Connective tissue disorders* comprise a wide range of diseases in which connective tissues (such as tendons, ligaments, and cartilage) become inflamed and damaged. Connective tissue diseases are typically considered under the umbrella of "arthritis" ailments; however, joint pains, per se, are not necessarily prominent. Because connective tissue diseases are typically due to an autoimmune process and because autoimmune conditions tend to occur in groups, if you have celiac disease (which is an autoimmune disease), you are at increased risk of also having certain types of connective tissue disease. We discuss these conditions in the following sections.

### Sjogren's syndrome

*Sjogren's syndrome* is an autoimmune condition in which there is a reduced ability to produce certain bodily fluids, especially saliva and tears. Although this may, at first blush, seem to be simply an inconvenience, in reality, it can cause substantial hardship as we discover in this section. We first look at the various ways in which Sjogren's syndrome can affect someone and, following that, we look at helpful ways to reduce symptoms.

Like many other of the conditions we discuss in this chapter, if you have celiac disease you are at increased risk of Sjogren's syndrome, but your overall risk of acquiring this is still low. Nonetheless, it's important to know about this condition because, armed with this awareness, you can keep an eye out for the symptoms we discuss here and seek timely medical attention should they develop.

#### Insufficient ability to make saliva

Like many things in life — and with apologies to songstress Joni Mitchell and "Big Yellow Taxi" ("Don't it always seem to go . . .") — the ability to make saliva is one of those things people don't think about much, if at all, until its gone. And when its gone, it can cause big problems indeed, including:

- **Difficulty chewing food.** (Imagine chewing a cracker with no saliva in your mouth.)

- **Difficulty swallowing.** (Imagine now swallowing that same cracker without any moisture in your mouth.) If chewing and swallowing is sufficiently severe, you may find eating so onerous that you actually start to eat less and, as a result, lose weight.

- **Increased risk of oral diseases,** such as the following:

  - **Dental cavities (*caries*).** This point is a surprise to most people. As it turns out, saliva is an essential element in protecting your teeth from damage.

  - **Gum disease.** Inflammation and infection can occur leading to loss of teeth.

- **Yeast infections within the mouth (*candidiasis*).** With this problem, you may find your mouth feels uncomfortable, burns or even feels painful. If you look in the mirror and stick out your tongue, it can look redder than normal or, conversely, can have white patches.

Other oral problems include difficulty speaking for long periods of time and altered food taste.

### Insufficient ability to make tears

Many people think of tears as being primarily related to shows of emotion. And indeed, this is true. Tears, however, are also a key element of the eyes' defense shield protecting these vital structures from being damaged. If you don't make sufficient tears, you are prone to

- ✔ **Eye irritation.** Eyes have a constant sensation of grittiness as if some sand got in your eye and, try as you might, you can't get rid of it. This symptom is usually worse as the day progresses. Eye irritation due to Sjogren's syndrome comes on gradually over years.

- ✔ **Ulceration of the cornea.** The cornea is the clear outermost part of the eye through which light first passes as it first enters your eye. If your cornea becomes ulcerated, it can lead to sight-threatening complications.

Surprisingly, even people with profoundly dry eyes typically retain the ability to cry.

### Insufficient ability to make vaginal secretions

As the glands responsible for providing moisture to the vagina are frequently involved, women with Sjogren's syndrome are prone to vaginal dryness. Vaginal dryness is a common cause of painful sexual intercourse (*dyspareunia*).

### Insufficient ability to make upper airways secretions

The upper airways are those parts of the respiratory system well above the lungs, such as the nose and sinuses. When Sjogren's syndrome affects these parts of one's anatomy, a dry cough can develop.

### Treating Sjogren's syndrome

A mainstay of treating Sjogren's syndrome is to maintain moisture in the various parts of the body that have become dry. Good oral hygiene is also imperative. There are very many therapies available to treat Sjogren's syndrome including the use of mediations. We recommend you speak to your health care provider (typically this condition is looked after by a *rheumatologist,* an arthritis specialist) about these. Here we list a few basic elements of treating this condition:

✔ Avoid drugs (such as decongestants) that can exacerbate oral dryness.

✔ Avoid unduly lowering the humidity in your house. Use a humidifier if your house is overly dry.

✔ Use artificial tears.

✔ Sip water regularly, use artificial saliva preparations, and suck on sugar-free lozenges. (Sugar-free so as to not promote dental cavities.)

✔ Maintain excellent oral hygiene. Brush and floss after every meal. See your dentist regularly. Ask your dentist about dental fluoride treatment.

✔ Use a vaginal lubricant during intercourse.

### Lupus (systemic lupus erythematosis or SLE)

*Lupus,* or *SLE,* (the thankfully short forms for *systemic lupus erythematosis*) is an autoimmune connective tissue disease in which there is inflammation of the joints and, potentially, many internal organs including the lungs, heart, and kidneys. Having celiac disease increases your risk of also having lupus; however, your overall risk of acquiring this condition remains low.

Because lupus is often characterized, especially early on, by nonspecific symptoms, a number of which are common to celiac disease, there is a real possibility that you may pass off symptoms you are experiencing as being due to your celiac disease when, in fact, they are due to lupus. Therefore, should you develop symptoms such as those we discuss in this section — especially if they are severe or persisting — be sure to speak to your health care provider about them.

Lupus can cause many, many, different symptoms — far more than we can cover here. These are, however, some of the most common symptoms for you to be aware of:

✔ **Fatigue.** This is the most common symptom of all and can be severe.

✔ **Joint pains.** This most commonly affects the joints in the fingers, wrists, ankles, and the balls of the feet.

✔ **Skin rash.** The most common type of rash affects the nose and cheeks and is in the shape of a butterfly; this type of rash is unsurprisingly referred to as a *butterfly rash.* Another common type of rash is one that develops in sun-exposed areas upon, well, exposure to sun.

✔ **Upper abdominal pain.** This can occur with lupus (sometimes as a side effect from anti-inflammatory medicines used to treat it) and also commonly occurs with celiac disease. As you may imagine, therefore, there is the significant chance of misattributing this discomfort to the one condition when it is really due to the other.

If despite carefully following your gluten-free diet you have symptoms such as those we just described, be sure to see your physician to have the cause — be it lupus or something else altogether — sorted out. Don't do yourself the disservice (and cause yourself the potential hazards) of assuming that just because you have celiac disease, this explains all that ails you.

The treatment of lupus can be involved and highly complex and typically involves a combination of certain lifestyle measures (such as using sun protection to help avoid getting a skin rash) and medications that help to reduce inflammation, control symptoms, and protect your organs.

## Fibromyalgia

*Fibromyalgia* (also known as *fibromyalgia syndrome* or *FMS*) is, to borrow Winston Churchill's words about an entirely different subject, a riddle wrapped in a mystery inside an enigma.

This very common condition causes various musculoskeletal aches and pains yet is unassociated with evidence of inflammation or other form of injury to muscles, joints, or other organs. Indeed, fibromyalgia is as remarkable for what it is (a constellation of aches and pains) as for what it isn't (inflammation or apparent damage to the body).

The relationship between celiac disease and fibromyalgia is far from clear and could just be a chance association, but there does appear to be a slight increased likelihood of having FMS if you have celiac disease. (If a person with FMS has intestinal troubles, it is much more likely that these intestinal symptoms are due to irritable bowel syndrome than celiac disease. We discuss this further in Chapter 12.)

These are some of the most common features of fibromyalgia:

 ✔ Six times more common in women than men.

 ✔ Diffuse, unremitting, waxing and waning pain, most commonly in the neck, back, chest, arms, and legs.

 ✔ Fatigue and/or lack of feeling refreshed after sleeping.

 ✔ Mood problems (such as depression or anxiety), thinking problems (such as poor short-term memory), or headaches.

 ✔ Tender points (despite having what can be very bothersome — even disabling — symptoms, the affected person typically looks well and, when examined by a doctor, the only significant finding is that of discomfort when the doctor presses on certain muscles and tendons, collectively referred to as *tender points*.)

 ✔ Normal laboratory tests and x-rays.

Although fibromyalgia has no cure, a variety of therapies are available to help ease fibromyalgia symptoms, including:

- ✔ Patient education (our all time favorite treatment for so many different ailments) — which in and of itself is associated with lessening of symptoms.
- ✔ Anti-depressant medication.
- ✔ Analgesics (that is, pain killers).
- ✔ Anti-convulsant medication (that is, anti-epilepsy drugs). Despite the name, these types of medicines are often used, with varying success, to treat a wide variety of ailments, including FMS, where pain is a feature.

## Raynaud's phenomenon

*Raynaud's phenomenon* is a condition in which the fingertips or toes temporarily turn white upon exposure to cold (such as taking something out of the freezer). The cold exposure causes small arteries in the digits to go into spasm which blocks the flow of blood and hence the reason for the white appearance.

Raynaud's is often present in people with connective tissue diseases (see the earlier section "Connective tissue disorders"), and also occurs in people who use vibrating machinery such as jackhammers. Some evidence exists that people with celiac disease are more prone to Raynaud's phenomenon.

The mainstay of treatment is to avoid cold exposure by, for example, making sure to dress warmly, wear gloves in cold weather or when taking items out of the fridge or freezer, and so on. There are also medications available to help prevent attacks, the most commonly used ones belonging to a class of drug called *calcium channel blockers*.

# Liver and Bile Duct Conditions

Having celiac disease increases your risk of developing certain disorders of the liver and the bile ducts. We discuss these disorders in this section.

The liver performs a number of essential functions including assisting with digestion (by making *bile acids* that help to digest fat), making clotting factors to prevent bleeding, storing and manufacturing glucose, and the list goes on. Suffice to say that a healthy liver is integral to good health and just as much a vital organ as the heart. The *bile ducts* are those tubes that take bile acids from the liver and deliver them to the small intestine.

## Abnormal liver enzyme levels

If you have newly diagnosed celiac disease, you have up to about a 40 percent likelihood that your liver enzyme levels (specifically the *transaminase* levels) will be mildly elevated on a blood test. Elevated liver enzyme levels do *not* necessarily mean that you have significant liver disease. Indeed, these enzyme levels typically return to normal within months of starting a gluten-free diet.

Although we haven't seen a study that proves this, we strongly suspect that the great majority of non-celiac disease specialists are unaware of the preceding point. Therefore, if you have newly diagnosed celiac disease and if a doctor advises you that your liver tests are abnormal and recommends further investigations be undertaken, there's no harm in asking whether it would be safe to simply wait and recheck the tests a few months after you've gotten on track with your diet. Depending on the state of your health, the degree of abnormality of your liver tests, and so on, it may or may not be appropriate to adopt this "wait and see" approach.

If you and your doctor elect to follow this "wait and see" approach, and your liver tests do not improve despite your following a gluten-free diet, you then need to be checked for liver disease. One of the most common causes of elevated liver enzymes, and unrelated to celiac disease, is so-called "fatty liver" (which goes by a variety of other, more formal medical terms including *non-alcoholic steatohepatitis* or NASH). In the next few sections, we look at liver diseases that are related to celiac disease.

Common to all these liver conditions is the need for blood tests as well as imaging studies such as an abdominal ultrasound to look at the structure of the liver and bile duct system. (To see an illustration of the digestive system, see Chapter 2.)

## Primary biliary cirrhosis

*Primary biliary cirrhosis* (PBC) is an autoimmune disease that leads to permanent scarring of the liver. It derives its name from *primary* (meaning of unknown cause), *biliary* (pertaining, in this case, to the damage to the bile ducts within the liver that occurs with this disease), and *cirrhosis* (meaning permanent, severe liver damage). PBC is the most common of the serious liver diseases found in people with celiac disease.

Some of the more common symptoms of PBC are

- ✔ Fatigue
- ✔ Itchy skin (*pruritis*)
- ✔ Jaundice (yellowing of the skin and eyes)

If, as unfortunately often happens, PBC progresses to the stage of liver failure, serious complications develop including excess bleeding and thinking problems.

Treatment is geared toward controlling symptoms, treating complications as they arise, and using medicines to try to stop worsening liver injury from occurring. This last strategy often does not meet with success, and should cirrhosis develop, the remaining therapeutic option is to have a liver transplant which is not only life-enhancing, but also life-saving.

# Autoimmune hepatitis

*Autoimmune hepatitis* is a chronic autoimmune disease characterized by liver inflammation. It goes by many aliases including *active chronic hepatitis* and *autoimmune chronic active hepatitis*.

Unlike primary biliary cirrhosis (see the immediately preceding section, "Primary biliary cirrhosis"), autoimmune hepatitis typically does not lead to progressively worsening liver damage. Indeed, many affected individuals remain free of symptoms for many years. Some people, however, have severe autoimmune hepatitis with rapid deterioration in their condition.

If you have autoimmune hepatitis, you are at a small increased risk of having celiac disease. The converse, however, is not true; that is, the vast majority of people with celiac disease never develop autoimmune hepatitis.

Not everyone with autoimmune hepatitis requires treatment. For instance, if the condition is very mild, some patients do not require therapy. For more active cases, potent medicines are used to suppress the inflammation present in the liver.

# Primary sclerosing cholangitis

*Primary sclerosing cholangitis* (PSC) is a disease of unknown cause that leads to progressively worsening narrowing and, ultimately, destruction of the bile ducts. (Bile ducts carry bile from the liver to the small intestine.) This, in turn, leads to severe liver damage.

Most patients with primary sclerosing cholangitis initially have no symptoms. As the condition worsens symptoms then develop, the first ones typically being fatigue and skin itching (pruritis). Fevers and night sweats are also common early symptoms.

As is true of primary biliary cirrhosis (covered in the previous section, "Primary biliary cirrhosis"), treatment of primary sclerosing cholangitis is geared toward controlling symptoms, treating complications as they arise, and using medicines to try to stop worsening liver injury from occurring. Unfortunately, despite therapy, the disease tends to progress leading to severe liver damage requiring liver transplantation.

A variety of other liver diseases (including some forms of viral hepatitis) have also been reported to occur more frequently in people with celiac disease, but a clearly defined relationship remains to be proven and the relationship is likely purely coincidental.

# Chromosomal Disorders

DNA is the substance in the body's cells that provides the genetic blueprint that is directly responsible for some traits (such as hair and eye color) and also plays a role in establishing the risk for certain diseases such as heart disease, high blood pressure, diabetes, celiac disease, and many other conditions. DNA is contained in a person's 23 pairs of chromosomes. Chromosomes, in turn, are made up of many small regions called genes. Certain chromosomal (meaning, related to the chromosomes) and genetic (related to the genes) disorders are associated with celiac disease. We discuss these disorders in the following sections.

## Down syndrome

*Down syndrome* is a condition in which a person has an extra chromosome number 21. Normally, people have 23 *pairs* of chromosomes (numbered 1 through 23). A person with Down syndrome, however, has three of chromosome number 21 instead of the normal two. Although the way in which Down syndrome affects people varies, some of the more common features include distinct facial characteristics and a reduced IQ. People with Down syndrome have the highest risk of celiac disease of any population group — about 16 percent.

Because celiac disease is so common among people with Down syndrome, some medical authorities recommend routinely screening for celiac disease in these patients. On the other hand, because following a gluten-free diet can be difficult and may reduce quality of life in people with Down syndrome who often have a shortened life expectancy as it is, other experts caution against such routine screening in this population.

Making a diagnosis of celiac disease in a person with Down syndrome can be challenging because the affected person may not necessarily be able to readily describe his or her symptoms. For this reason, if you have a loved one with Down syndrome who develops persisting or worsening symptoms of celiac disease such as weight loss, abdominal pain, or diarrhea, we recommend you let the doctor know and ask that celiac disease be considered as a possible cause. There's nothing wrong about being a (well-informed) advocate for the ones you love.

## Turner syndrome

*Turner syndrome* is a genetic condition in which a female is missing all (or part of) one of her two X chromosomes. A person with Turner syndrome is likely to be short and have other distinct physical traits. She is also at increased risk of having celiac disease. About 10 percent of people with Turner syndrome also have celiac disease. Because of this increased risk, if you have Turner syndrome and you develop symptoms suggestive of celiac disease (see Chapter 6), be sure to notify your physician.

# IgA Deficiency

IgA (short for *Immunoglobulin A*) is a group of antibodies that help fight infection. Some people are genetically deficient in IgA. The great majority of these people never have any ill-effect from it, but a small percent do have an increased number of respiratory and digestive tract infections.

As we discuss in Chapter 3, people with celiac disease face a double-edged sword: Not only are they at increased risk of IgA deficiency, but having this deficiency further complicates matters because it makes it harder to diagnose celiac deficiency. (The best blood test — the IgA tissue transglutaminase antibody — to assist with diagnosing celiac disease is unhelpful in the setting of IgA deficiency, so other diagnostic measures, such as the IgG tissue transglutaminase antibody, need to be performed instead.)

# Chapter 9

# Celiac Disease and Cancer

## In This Chapter

▶ Looking at the risk of developing celiac disease-related cancer

▶ Exploring the types of cancers that are associated with celiac disease

▶ Screening for and detecting cancer

▶ Preventing gastrointestinal cancer

*H*aving celiac disease increases your risk of developing certain types of cancer. This is understandably upsetting news to most people living with celiac disease; however, as the expression goes, being forewarned is to be forearmed. Being aware of this risk allows you to follow precautions to reduce your risk of developing cancers related to celiac disease and also to monitor yourself for clues that cancer may have developed. In this chapter we look in detail at these issues.

As you read the potentially intimidating or even downright scary information in this chapter, please bear in mind two very important things:

✔ **Having an *increased* risk is not the same as having a *high* risk.** The vast majority of people with celiac disease *never* develop any of the cancers we discuss in this section.

✔ **There is evidence that the risk of developing the cancers we discuss is reduced, if you have celiac disease, by following a gluten-free diet.** Indeed, within a few years of being on this diet, your risk will likely return to that of someone who has never had celiac disease for even a day in their life.

One rather unexpected and pleasantly surprising finding about celiac disease and cancer deserves special mention here. Some studies suggest that celiac disease actually *reduces* (!) the risk of a few malignancies including breast cancer and, possibly, lung cancer. One reason for the lower risk of lung cancer may lie in the observation that people with celiac disease are less likely to smoke. That's certainly a welcome finding! Clearly, there is a lot yet to learn about the relationship between celiac disease and cancer.

# Assessing How Great the Increased Risk Is

Your risk of developing any type of cancer as a direct result of your celiac disease is very, very small indeed. You may not, however, readily glean this from the sometimes alarmist information on this topic that one comes across on the Internet. In this section, we explore the topic of cancer risk.

When doctors talk of a person being at increased risk of having a particular disease, they are actually referring to two different types of risk: *relative risk* and *absolute risk.*

The differences between these are legion and we wish not only that physicians were more precise in their use of these terms, but that the press was, too (regardless whether the press is discussing the risk of a disease, the risk of a natural disaster, or any other risk for that matter). Much undo fear is created because of the overly loose use of the term "risk."

  ✔ **Relative risk:** *Relative risk* is the risk, or likelihood, of one thing happening compared to the risk of something else happening. For example, the relative risk of a person with celiac disease developing a type of cancer called *EATCL* (which we discuss in detail later in this chapter) compared with the risk of this same cancer developing in someone who does not have celiac disease is about four fold. (This number varies somewhat from study to study, but averages out to four.) In other words, the fact that you have celiac disease means you have an approximately four times greater likelihood of developing this type of cancer compared to the population at large. (It used to be thought that the risk for this type of cancer for patients with celiac disease was as high as 50 to 100 times greater than for the general population! Recent studies, however, reveal that this risk is much, much lower.)

  ✔ **Absolute risk:** *Absolute risk* is the risk of something happening without comparing it to another risk. If we again look at the risk of developing the EATCL cancer mentioned earlier, if you have celiac disease your absolute risk of developing this cancer is about *one in two hundred and fifty thousand* which is clearly a very low risk indeed.

Looking at both relative and absolute risk at the same time, for EATCL, if you have celiac disease, your *relative risk* of developing this cancer goes up by about four times (which is concerning), which means that your *absolute risk* goes from one in one million to one in two hundred and fifty thousand (which is not nearly as concerning). Clearly, despite the higher risk, the odds are overwhelming you're never going to acquire this type of cancer! Basically, if something happens very rarely — like this type of cancer — even if the risk goes up, it still happens very rarely.

If you have celiac disease and remain concerned about your risk of EATCL — which would be completely understandable — you might also ponder this: Your risk of developing this cancer is the same, according to no less than the British Medical Journal — of being killed in your home . . . by a falling airplane! Not worried about an airplane hitting your house? Then you likely need not be overly worried about getting this form of cancer either.

Of course, even though you are at *low* risk, this is clearly not the same as being at *no* risk, and cancer due to celiac disease does happen. In the remainder of this chapter we look in detail at the key information you should know about the various celiac disease-related cancers starting with those factors that influence your risk of developing cancer.

## Factors influencing your risk of cancer

Looking at all people with celiac disease, the risk of any particular individual developing a celiac disease-related cancer is very small. But, of course, you are an individual, not just a member of a group, and individuals with celiac disease have differing cancer risks depending on a few, particular characteristics. Specifically, compared with all people with celiac disease, your individual risk of acquiring a cancer related to celiac disease is increased if:

- ✔ You had celiac disease for quite some time before it was diagnosed. (This likely increases your risk of cancer by virtue of the longer duration of time that you would have been exposed to gluten.)

- ✔ Your celiac disease has been poorly controlled; especially if you have refractory celiac disease (see Chapter 12 for more on refractory celiac disease).

- ✔ You haven't been following a gluten-free diet.

- ✔ You were diagnosed with celiac disease as an adult, especially over age 50, and not as a child. (*Note:* This does not apply if you were diagnosed as a child and were later told you had outgrown this illness and you then returned to eating gluten. In this situation, you have an increased risk of developing *refractory celiac disease* (see Chapter 12) later in life, which, in turn, increases the risk of developing EATCL. We discuss the fallacy of "outgrowing" celiac disease in Chapter 17.)

Although you can't control all of these factors, you *can* follow a gluten-free diet. By doing so, your cancer risk will likely quickly fall to the same level as people who do not have celiac disease. We discuss other ways to prevent cancer later in the later section "Preventing cancer."

## Possible reasons for an increased risk of cancer

Why does celiac disease increase the risk of some cancers? The quick answer is that medical science simply doesn't know. Having said that, there are no shortage of theories such as these:

- The chronic, over-stimulation of the immune system caused by celiac disease may promote the development of cancer cells and/or interfere with the immune system's normal ability to destroy cancer cells or potentially cancerous cells.

- Celiac disease causes malabsorption of important substances, possibly including cancer-fighting nutrients and vitamins. As a result you have fewer of these substances to help protect you from cancer.

- Celiac disease may make the intestine more susceptible to absorbing into the body potentially carcinogenic/toxic substances present in the foods we eat.

- The inflammation in the body caused by celiac disease may, in itself, be toxic on some tissues and cause them to become cancerous.

# Looking at the Types of Cancer for Which You Are at Increased Risk

There are several types of cancer for which you may be at increased risk if you have celiac disease. Here we list them and in the following sections we look at the more common types in detail:

- *Enteropathy-associated T cell lymphoma (EATCL)* is a rare form of cancer affecting the small intestine. It's the cancer most closely linked to celiac disease.

- **Certain other types of lymphomas** including other T cell as well as B cell lymphomas (we discuss T and B lymphocytes that give rise to these cancers in Chapter 2).

- *Small intestine adenocarcinoma* is a rare cancer of the small intestine.

- *Oropharyngeal cancer* is cancer of the mouth and throat.

- *Esophageal cancer* is a cancer of the esophagus.

In your travels of the cyberspace kind, you may come across discussions about a variety of other cancers that are said to occur more commonly if you have celiac disease. The reason why different sources say different things lies

in the fact that scientific studies can vary considerably in the way they are performed and the groups of people they evaluate; as a result, different studies often arrive at different conclusions.

## *Enteropathy-associated T cell lymphoma*

Of the various cancers associated with celiac disease, enteropathy-associated T cell lymphoma is the cancer that is most closely linked. Nonetheless, whether or not you have celiac disease, it occurs only rarely (that is, your absolute risk for this cancer remains tiny). Because this is the type of cancer most closely linked to celiac disease, we look at it in detail in this section.

In your Internet travels, you may come across three different abbreviations for this one condition:

- ✔ **EATCL** for enteropathy-associated T cell lymphoma. This abbreviation is the one most often used, and it's the one we use in this book.
- ✔ **EATL** for enteropathy-associated T cell lymphoma.
- ✔ **EITL** for enteropathy-associated intestinal T cell lymphoma.

Enteropathy-associated T cell lymphoma derives its name from *entero* (meaning intestinal), *pathy* (short for pathology or abnormality) *associated* (having to do with), *T cell* (T cells are the specific type of white blood cells — specifically white blood cells called *lymphocytes* — that are involved), *lymphoma* (meaning a cancer that begins in cells of the immune system). You can readily see why it's called EATCL instead!

In your travels you may also come across the term *non-Hodgkin lymphoma*. Non-Hodgkin lymphoma (abbreviated NHL) is the name for a group of different types of lymphomas that share certain features in common. EATCL is a member of this group.

Like virtually every other cell type in the body, cells in the immune system can become cancerous (and, as mentioned, these types of cancers are called lymphomas). EATCL is a type of lymphoma that starts in the *intra-epithelial lymphocytes (IELs)*, which are located in the lining of the small intestine. A hallmark of celiac disease (and present in virtually all cases) is an increased number of these cells. In those rare cases where these cells become cancerous, it is thought to be a result of their being excessively stimulated by the overly active immune system in the small intestine that occurs if celiac disease is insufficiently treated.

### Symptoms of EATCL

These are the most common symptoms of EATCL:

- Abdominal pain (typically felt as a dull ache or fullness)
- Diarrhea
- Fever
- Loss of appetite (anorexia)
- Malaise (that is, feeling generally unwell)
- Weight loss

At one time or another you (and everyone else) have likely experienced most, or even all, of the symptoms in the preceding list. Most likely they quickly passed on their own. With EATCL, however, the symptoms don't pass. Day after day after day you continue to feel unwell, your weight may progressively fall, fevers may persist, and so forth. If ever you are in this situation, you should contact your doctor to be checked out. It may turn out to be nothing; however, it could also be that something is seriously wrong, be it EATCL or some other, significant ailment. EATCL can also lead to perforation (a hole or tear) in the wall of the intestine. If this happens, you can experience, sudden, severe abdominal pain that requires immediate medical attention.

Other features of EATCL that a doctor looks for when they suspect you have this condition are:

- An enlarged liver.
- A mass (that is, a growth) in your abdomen.
- Swollen lymph glands. Although EATCL begins in the lymph cells in the small intestine, it often spreads to lymph glands elsewhere in the body including those that a doctor can feel in locations such as the groin.

### Tests to investigate suspected EATCL

If your doctor suspects you have EATCL, you will be sent for a number of different tests, both to establish the diagnosis and, if present, to determine its extent. Tests may include the following:

- **An ear, nose, and throat examination** to look for swollen lymph glands in these areas of your body.
- **A CT ("CAT") scan of your chest.** A CT scan is a type of x-ray and is done, in this context, to look for evidence of lymph gland cancer within your chest.

✔ **A CT scan of your abdomen** to look for this cancer within your abdomen. This test sometimes includes having you swallow barium (a chalky liquid) before the CT scan is performed. The barium shows up white on the x-ray and allows fine details of your small intestine's appearance to be better visualized. This combined barium/CT scan procedure is called *CT enteroclysis.*

✔ **Barium x-rays** to look for this cancer within your gastrointestinal tract.

✔ **Capsule endoscopy** to look for cancerous growths within your gastrointestinal tract. (See Chapter 3 for more on capsule endoscopy.)

✔ **Endoscopic procedures** to directly visualize the area where a tumor is suspected. (For more on endoscopic procedures, see Chapter 3.)

✔ **A biopsy** of the suspected cancerous tissue.

Like virtually any other cancer, a diagnosis of EATCL should *only* be made if a tissue sample (biopsy) of the suspected cancer has been obtained and, when analyzed by the pathologist, is found to show certain specific features of this disease. In some cases, a biopsy sample of suspected EATCL can be obtained by performing an endoscopy; in other cases, abdominal surgery may be required.

### Treatment of EATCL

EATCL is treated with surgery and chemotherapy (that is, drugs) to try to shrink the cancerous tissue. Unfortunately, this treatment often has limited effectiveness and the prognosis is poor.

# Other lymphomas

Of the various cancers associated with celiac disease, enteropathy-associated T cell lymphoma (see the preceding section) has the strongest association with celiac disease. However, other types of non-Hodgkin lymphomas are somewhat more likely to occur in celiac disease. These include other non-intestinal T cell lymphomas as well as *B cell lymphomas* including *diffuse large B cell lymphoma.*

These lymphomas can be associated with swollen lymph glands. Symptoms such as fever, drenching sweats, and weight loss may also develop. The mainstay of therapy is with chemotherapy. Radiation therapy is also often used. If a large tumor mass is present, this may require surgery to remove it.

# Small intestine adenocarcinoma

Small intestine adenocarcinoma is a form of cancer of the *epithelial cells* that make up the top layer of cells lining the small intestine. This cancer is uncommon in the general population. Having celiac disease seems to increase the risk of this cancer. This increased risk may be related to the known cancer risk associated with chronic inflammation in the body (as is seen if celiac disease is untreated or insufficiently treated).

The most common symptoms of small intestine adenocarcinoma are abdominal pain and weight loss. Sometimes, the tumor can lead to bleeding, in which case you would start to pass blood with your stools. Everyone gets abdominal pain of one type or another from time to time; however, if you get abdominal pain that is particularly bad or that persists (especially if you are also losing weight), see your doctor.

Small intestine adenocarcinoma can often be treated by surgically removing the diseased part of the intestine.

# Oropharyngeal cancer

Oropharyngeal cancer is cancer of the *oral cavity* (mouth, tongue, and so forth). Cancer of the inside lining of the mouth or tongue typically appears as a painless area of firm, often pale-colored tissue.

Reports of an increased risk of oropharyngeal cancers come from European studies. Interestingly these cancers have not been observed at an increased rate in North Americans with celiac disease. We suspect this difference is accounted for by the methods used in the studies, not by a true difference in the frequency of these tumors on different sides of the Atlantic.

Treatment consists of surgery, sometimes also with radiation therapy.

Tobacco smoking and chewing are tremendous risk factors for oral cancer. This huge risk is made even higher if you also have celiac disease. We cannot emphasize strongly enough the importance, if you smoke, of doing everything humanly possible to quit.

Oral cancers are often first detected by the dentist during a routine dental examination. However, you can look inside your own mouth from time to time by using a light and a mirror, and if you see (or feel) anything suspicious, let your doctor know.

# Esophageal cancer

As we discuss in Chapter 2, the *esophagus* is the swallowing tube that connects the mouth to the stomach.

There are two main types of esophageal cancer: *squamous cell cancer* and *adenocarcinoma*. It is the squamous cell type of cancer of the esophagus that has been reported to be increased in celiac disease. However, the studies that showed this increased risk looked at European populations and similar evidence of risk for North Americans is lacking. This discrepancy is not readily explained and, as we noted in the previous section regarding orpharyngeal cancers, we suspect it relates more to the manner in which the studies were done than to true differences in the populations in question.

The most common symptoms of esophageal cancer are weight loss and difficulty swallowing larger, dry items such as toast or meat, with them getting stuck in the esophagus. This is typically felt as a sudden uncomfortable pain behind the breast bone (the *sternum*) developing immediately after swallowing and quickly going away by drinking fluids (which push the food down into the stomach). Let your doctor know if you develop these symptoms.

As with cancer of the mouth, tobacco use is a major risk factor in the development of squamous cell cancer of the esophagus, so avoiding tobacco is the best way to prevent this (and many other kinds of cancer, too).

Treatment of esophageal cancer includes radiation therapy, chemotherapy, and surgery.

# Other cancers and celiac disease

In addition to the cancers we have already discussed, various medical studies suggest there may be a small increase of some other types of cancers if you have celiac disease.

### Cancer of the pancreas, liver, and bile ducts

The risk of cancer of the pancreas, liver, and bile ducts may be increased. Cancer of the pancreas typically causes rapid and profound weight loss, and upper abdominal and back pain. Liver cancer and bile duct cancer are commonly discovered after someone becomes jaundiced (in which a yellow tinge affecting the skin and the whites of the eyes is found).

### Cancer of the colon (large intestine)

There is conflicting information regarding the risk of colon cancer if you have celiac disease. Some medical studies suggest your risk goes up if you have celiac disease, and some studies suggest your risk goes down. The fact that such opposite research results have been found suggests that, if an increased risk of this cancer does exist, it must be very small. (If the risk of a disease is dramatically increased, typically different studies carried out in different populations should consistently show at least some degree of increased risk.)

Colon cancer is quite a common cancer in the general population. We recommend that *everyone* — whether they have celiac disease or not — starting at age 50 get checked out for colon cancer. If you are at increased risk of colon cancer because colon cancer developed in a first degree family member (your parents or siblings) at a relatively young age (under age 60), then you should start having you check-ups earlier than 50 years of age.

### Leukemia

*Leukemias* are cancers of the white blood cells. Studies have not shown an increased rate of these cancers in people with celiac disease, but have reported an increased rate if you have a closely related condition called *dermatitis herpetiformis*. We discuss dermatitis herpetiformis in Chapter 8.

### Breast cancer

Several studies suggest that the risk of a woman developing breast cancer is decreased if you have celiac disease but, of course, this is not a reason to ignore your breast health. Your primary health care provider or gynecologist can tell you the best screening schedule for you to follow.

# Screening for Cancer

*Screening* for a disease is searching for a condition in the absence of evidence, such as symptoms, to suggest it is present. Examples of screening for cancer in the general population are performing breast self-examination or mammograms in women and performing a prostate examination or PSA blood test in men.

Knowing that certain cancers occur with increased frequency in people with celiac disease, the question arises whether these cancers should be routinely screened for in this population. In order to justify screening for a celiac disease-related cancer, the probability of having the cancer would have to be sufficient to justify the time, labor, costs, hassles, discomfort, and, importantly, the risks of the screening tests themselves. (*Everything* has a risk including, for example, the risk of a test result being incorrect and indicating an abnormality when, in fact, none exists — a so-called *false positive* result — which would lead to further, unnecessary tests.)

At present, *routine* screening for celiac disease-related cancers is not thought to be justified. Screening is, however, warranted for certain individuals such as those with refractory celiac disease where the risk of cancer becomes sufficiently high as to make screening appropriate. Screening procedures would include a doctor interviewing you to review how you're feeling and then examining your abdomen and checking for swollen lymph glands. A capsule endoscopy, an ultrasound of the abdomen, and other tests may also be done. We discuss this further in Chapter 12.

# Preventing Cancer

As we mention at the outset of this chapter, there is scientific evidence that people with celiac disease can reduce the likelihood of developing celiac disease-associated cancer by following a gluten-free diet and that doing so reduces the risk to the same level as someone without celiac disease within a few years.

The most likely reason why following a gluten-free diet provides this protection (in people with celiac disease) lies in the now well-established link between chronic inflammation in the body and cancer. Active celiac disease is, by definition, a condition in which there is inflammation. Following a gluten-free diet eliminates this inflammation and, hence, reduces your cancer risk.

Another option, used specifically to prevent EATCL (explained in the earlier section "Enteropathy-associated T cell lymphoma") is to have a bone marrow transplant. In this procedure, you are given in intravenous injection of bone marrow tissue taken from a donor. The complexity and hazards of this form of therapy warrant its use, in terms of celiac disease, only to people with severe refractory celiac disease because only these people would be at sufficiently high risk of cancer to justify it. This method to prevent EATCL is only available in a few university hospitals worldwide. We discuss refractory disease and other treatment options for it in Chapter 12.

 Because, for most individuals with celiac disease, the likelihood of getting cancer is so minimally, if at all, increased (compared to someone without celiac disease), special screening and prevention strategies are seldom necessary. As we tell members of celiac support groups who are worried about getting a celiac disease-related cancer such as EATCL, if you have celiac disease, the best possible thing for you to do to protect yourself from cancer is to follow the same healthy living strategies as the general population; focusing undue attention on the "rare bird" cancers seen with celiac disease is not nearly as helpful.

Here are some ways to protect yourself from getting gastrointestinal cancer (and many other health problems while you're at it):

- ✔ Avoid tobacco products of any kind.
- ✔ Drink alcohol in moderation.
- ✔ Get regular physical exercise.
- ✔ Maintain a healthy weight (Chapter 11 has pointers).
- ✔ Eat a balanced diet that is not too high in fat, red meat, and processed foods, and that contains fiber, fruits, and vegetables.

Here's to your (celiac) good health!

# Part III
# Treating Celiac Disease

The 5th Wave                    By Rich Tennant

"There's nothing to worry about, Mr. Halloran.
I've performed many endoscopies in the past,
including an esophagagastroduodenoscopy,
which I can also spell."

# In this part . . .

*T*he essential ingredient to treating celiac disease is removal of an ingredient: gluten! In this part, you discover the whys and wherefores of eliminating gluten from your diet to keep you healthy. We also explore other important nutritional considerations and what to do if following a gluten-free diet doesn't appear to be working the way it should.

# Chapter 10

# Treating Celiac Disease with a Gluten-Free Diet

. . . . . . . . . . . . . . . . . . . . . . . . . . . . . . . . . . . . . . . . . . . . . .

### In This Chapter

▶ Examining the what, where, how, and why of a gluten-free diet

▶ Knowing how to shop gluten-free

▶ Mastering the art of cooking gluten-free

▶ Discovering how to eat out gluten-free

▶ Tracking down hidden sources of gluten

. . . . . . . . . . . . . . . . . . . . . . . . . . . . . . . . . . . . . . . . . . . . . .

*I*f you are looking for a silver lining to having celiac disease, perhaps it is that you can successfully treat your condition without needing even a single medication. (As physicians, we *love* being able to tell our patients who are newly diagnosed with celiac disease that we don't have to even take our prescription pad out of the drawer!) The power to controlling your celiac disease is all yours.

The key to successfully treating your celiac disease is changing your diet. Because consuming gluten is what triggers celiac disease in predisposed individuals, the treatment relies on *eliminating* — not just reducing — gluten from your diet.

A diet in which gluten is eliminated is unimaginatively, but fittingly, called a *gluten-free diet*. (Oh wouldn't it be a joy if doctors could always be so plain-spoken!) Following a gluten-free diet can be challenging because so many of the foods people routinely eat contain gluten and, also, it's not always readily apparent whether a food contains gluten in the first place.

In this chapter, we look at the ins and outs of following a gluten-free diet, how to find gluten-free foods when you're doing your grocery shopping, and how to take those purchases and turn them into tasty and healthy gluten-free meals. We also look at hidden sources of gluten for which you'll need to be on the lookout to avoid inadvertently consuming gluten.

# Going Gluten-Free

So you've just been to your doctor and been told you have celiac disease and need to go on a gluten-free diet. As you left the office you may well have asked yourself, "What *is* a "gluten-free diet?" and "What am I supposed to do?" You may have felt disarmed, frustrated, and anxious all at once. Unfortunately, some busy doctors sometimes don't say much more than telling their newly diagnosed patients to look up this diet on the Internet. Looking up medical information on the Internet can be confusing for patients and their families because there are so many sites to look at, and these often offer very contrasting — or even contradictory — advice. As we tell all our patients with celiac disease (and many other diseases, too), and as we discuss in Chapter 1, the Internet is a wonderful resource but is also a some-times dangerous place from which to glean medical information (which is, by the way, a major reason we wrote this book).

## Knowing what "gluten-free" means

As we discuss in Chapter 2, glutens are proteins found in grains such as wheat, rye (in which gluten is in the form of a protein called *secalin*), and barley (in which gluten is in the form of a protein called *hordein*). Various other gluten-containing grains include bulgur, couscous, durum, einkorn, emmer, farina, farro, kamut, semolina, spelt (dinkel), and triticale. In North America and most of the western world, the major source of gluten is wheat because this is the most commonly eaten cereal grain.

The key to staying healthy with celiac disease is following a gluten-free diet. This means avoiding any and all gluten.

 Gluten can be found in many different types of packaged and processed foods. Therefore, to succeed with your gluten-free diet, you need to carefully scruti-nize the labels of any food products you buy or cook with to ensure they don't contain gluten. This is the single biggest challenge in living gluten-free.

In the United States, labeling for the eight main food allergens — milk, eggs, peanuts, tree nuts (almonds, Brazil nuts, cashews, hazelnuts [filberts], macadamia nuts, pecans, pine nuts [pignolias], pistachio nuts, and walnuts), fish, shellfish, soy, and wheat — began in 2006 and labeling for gluten began in 2008.

We wholeheartedly support this important labeling when, indeed, a product contains these substances. Most people consider it a mixed blessing, how-ever, when a manufacturer indicates not that *the product* contains one of these food ingredients, but that it was produced *in a facility* that processes these food ingredients.

## Defining a gluten-free diet, according to international standards

Different countries have different standards as to what constitutes a gluten-free diet. As of July 2008, a new international codex standard defines gluten-free as containing not more than 20 milligrams of gluten per kilogram of food or less than 20 parts per million (ppm). This is similar to a new proposed U.S. standard which is expected to be put into practice soon. The international codex standard also defines "reduced gluten" foods as containing between 20 and 100 ppm of gluten. However, it is not recommended in North America that those with celiac disease consume reduced gluten foods. As little as 50 milligrams of gluten a day can cause intestinal damage! The bottom line: Don't play with fire; if you have celiac disease, avoid any and all gluten.

On the one hand, it makes sense to exercise this extra caution, for example, if there is a chance that consuming a food item (which may be contaminated with an allergen) could cause a serious or even fatal reaction. On the other hand, it means this same warning is present when there is only the most remote likelihood of causing any sort of problem at all. By way of example, Sheila recently purchased a salsa containing tomatoes, onions, peppers, cilantro, garlic, lemon juice, vinegar, salt, and spices. As expected, and as appropriate, neither wheat nor gluten were listed. Indeed, gluten was assuredly not present. However, printed below this list of ingredients was the statement "Made on shared equipment with wheat, milk, eggs, peanuts, tree nuts, soy, fish, and shellfish." In other words, this product, which clearly didn't contain gluten, was now flagged (likely for legal reasons alone) as potentially dangerous. What is the consumer to do in this situation? (And, as Sheila's husband has celiac disease, she is indeed just such a consumer.)

When you encounter this predicament, we suggest using common sense when deciding whether or not to purchase such an item. Contamination by gluten is highly unlikely to occur if a product is, like Sheila's aforementioned salsa, *naturally* gluten-free. In contrast, if you're considering whether to purchase a *baked good* (which, therefore, is at higher risk of contamination with gluten) made without gluten but in a facility that produces foods containing gluten, then we suggest taking a pass on the item.

## *Knowing whether you need to eliminate other things besides gluten*

Wheat and other grains contain many different proteins. Of these, glutens are the ones responsible for the problems seen with celiac disease. The other proteins found in these foodstuffs seldom cause health problems regardless of whether you have celiac disease.

Just because you have celiac disease does *not* mean that you are also prone to having food allergies. Indeed, although we've looked after numerous patients with celiac disease, between us we've only had a few patients who had both celiac disease *and* a true food allergy. Similarly, if you have celiac disease, you are *not* at an increased risk of other food intolerances (with the exception of lactose intolerance — see Chapter 11 — which can be present in some patients who have yet to begin their gluten-free diet). Therefore, the only restriction for most individuals with celiac disease is to avoid gluten.

Life with celiac disease is complicated enough; don't make things more difficult on yourself by looking for things other than gluten to eliminate from your diet.

Many people with untreated celiac disease observe what they interpret to be intolerance or sensitivity to many different types of foods, but once they eliminate gluten from their diet, these other problems melt away. In other words, it had been gluten *alone* to which they had truly been intolerant.

If you have celiac disease and have successfully removed all gluten from your diet yet you continue to have gastrointestinal (GI) symptoms (such as abdominal cramps and diarrhea), speak to your doctor about whether you may also have some other GI disorder such as irritable bowel syndrome or functional dyspepsia (which we discuss in Chapter 12).

To find out more about the differences between food allergies, food sensitivities, and gluten's effect if you have celiac disease, have a look at Chapter 2.

## *Examining the reasons for a gluten-free diet*

As we discuss in Chapter 2, gluten is the driving force in the immune response that leads to intestinal damage in celiac disease. Without gluten in the diet, even someone with the genetic predisposition to celiac disease would never develop the condition. (This is one reason why some individuals, once they've had a family member diagnosed with celiac disease, elect to put their entire family on a gluten-free diet "just in case" other members of the family may also be prone to this condition. We look at the pros and cons of doing so in Chapters 14 and 17.)

Once gluten is no longer present in the diet, the immune reaction it triggered quickly starts to settle, and the intestine starts to heal. However, if you then consume even a small amount of gluten, you reactivate the immune system problem that led to your original intestinal damage; in other words, you'll immediately start to undo the healing process. Moral of the story: If you have celiac disease, never consume gluten! (Sorry if we sound like a broken record on this point, but it's so important, we'll risk redundancy for the sake of emphasis.)

Richard was a 49 year-old Italian-American man who, having recently moved to Sheila's locale, was referred to her for ongoing management of his celiac disease. At the time of their first meeting, Richard told Sheila that he was following a gluten-free diet and that he felt perfectly well. When Sheila examined him, she didn't find anything amiss. Nonetheless, subsequent blood tests came back abnormal, revealing both a positive tissue transglutaminase antibody (see Chapter 3) and iron deficiency anemia (Chapter 7) — findings that were in keeping with active bowel damage from celiac disease. Sheila then performed an endoscopy and small intestine biopsy which confirmed the previous test results. When Sheila shared these results with Richard, he sheepishly told her that he "loved pasta" and just "couldn't stay away from it." Sheila explained to Richard the hazards of ongoing consumption of gluten (as is found in pasta) and had Richard meet with an expert nutritionist who reinforced this message. Regrettably, Richard ignored the advice, and it was only when he then became ill with worsening anemia, shortness of breath, and fatigue that he finally took things to heart, eliminated gluten from his diet (including changing to gluten-free pasta), and gradually improved. Sheila well recalls Richard's parting words from their most recent visit: "Dr. Crowe, I guess I'm lucky that I eventually smartened up. It could've been a lot worse. Heck, I could have gotten osteoporosis or," he hesitated, "even cancer."

## *Understanding the downsides of a gluten-free diet*

Following a gluten-free diet is not an easy task. Regrettably, some well-meaning doctors, in an attempt to reassure their patients, make it out to be. Clearly they don't have to follow it themselves! Figuring out which foods are gluten-free and which are not is a big task for most people with newly diagnosed celiac disease and can be down-right overwhelming at times. And because the person with celiac disease isn't necessarily the one who buys the family's groceries or does the family's cooking, these challenges fall on other shoulders, too.

Living gluten-free requires knowledge, motivation, and perseverance. Here are some of the hurdles you will confront:

- ✔ **Preparing gluten-free baked goods.** Food preparation involves trial and error and, as Sheila knows from her own experiences, can be frustrating and downright disappointing at times.

- ✔ **Eating out of the home.** Whether you eat at the homes of friends and relatives, school and work events, or parties; while traveling; or in any of the vast number of other situations in which you find yourself eating away from home, you can find yourself exposed to gluten even when you don't intend to.

✔ **Social pressures.** It isn't always easy to contend with friends or relatives who say "Oh, just a bit won't hurt you" or, in the case of a child with celiac disease, the situation where other children make fun of him or her for not eating birthday cake at a friend's party (instead, having brought their own gluten-free treat).

✔ **Being tempted to revert back to gluten-containing foods.** As Richard discovered in an anecdote earlier in this chapter, it can be darn hard to say good-bye to your favorite foods.

Most people with celiac disease complain about missing a few key foods, such as bread, pizza, and pasta, when they start a gluten-free diet. In spite of the many recent advances in the types and quality of gluten-free food availability in North America, the truth of the matter remains that gluten-free products are often simply not as tasty as their gluten-containing counterparts. Adding insult to injury, gluten-free products such as cookies, breads, cakes, and other baked goods are generally more expensive than their gluten-containing equivalents. Indeed, a study conducted by the Celiac Disease Center at Columbia University in New York reported that gluten-free versions of products like bread, pizza, and crackers are nearly three times as expensive as regular products. (Similar observations have been made in a study performed in Canada.) Geesh.

Now, lest we leave this section on a dour note, we must add this: Despite all the hurdles we've just listed, the vast majority of patients with celiac disease and their families adjust very well to a gluten-free diet. Indeed, as the family watches a previously ill loved one with recently diagnosed celiac disease recover good health, following a gluten-free diet becomes, if not necessarily a pleasure, at least a true labor of love.

## Getting help

Learning about a gluten-free diet takes time and effort and, most importantly, a reliable source of information. It is, therefore, essential that you meet with an experienced and knowledgeable registered dietitian (nutritionist) to receive expert guidance. Most physicians have neither the time nor the necessary knowledge to provide this counseling. (Sheila, who is married to a person with celiac disease, likes to refer to herself as one of the few gastroenterologists in North America who knows firsthand about the gluten-free diet, yet she still relies on nutritionists to assist her in educating her patients and their families.)

# Saving on your taxes if you are living gluten-free

Having celiac disease can be considered for a tax deduction in Canada and the United States. The eligibility requirements and the amount you can deduct vary depending on the jurisdiction in which you live, but in this sidebar, we look at some *general* policies that are typically in place.

To qualify for a tax benefit, you need a letter or a completed form from a physician certifying your diagnosis of celiac disease. This typically requires that you've had a small intestine biopsy that showed changes of celiac disease.

Eligibility for a possible tax benefit typically applies only to the individuals in the household who have celiac disease, not to other members of the family.

Your annual income, deductions, plus other medical expenses are factors that determine whether keeping track of the cost of being gluten-free and submitting this information is worth doing. In the United States, if your total medical expenses for the tax year exceed 7.5 percent of your adjusted gross income, you can write off certain expenses associated with celiac disease. More information about deducting the costs of food as they apply in the United States can be found at www.irs.gov/pub/irs-pdf/p502.pdf and the Canadian counterpart is available at www.cra-arc.gc.ca/tx/ndvdls/tpcs/clc-eng.html.

Here are some expenses that qualify as additional costs of living gluten-free:

✔ Differences in the costs of buying gluten-free foods compared to their gluten-containing equivalents. Again, document the costs of comparable products that are not gluten-free.

✔ Extra automobile mileage to obtain gluten-free foods. Keep a log of miles incurred for such outings.

✔ Shipping charges for mail-orders for purchasing gluten-free ingredients, foods, cookbooks, and so on. Itemize these and make a note of what the comparable costs would have been had you instead bought similar, but gluten-containing items. The tax department may want this information.

✔ Special items that are not used except in gluten-free cooking, such as xantham gum.

Be sure to always save any and all receipts for these purchases. The tax department requires these to support your medical expense claims.

To paraphrase advice from Janet Rinehart, chairman and founder of the Houston Celiac Support Group and Sheila's friend and colleague from the years she spent in Texas, if you have a lot of annual medical expenses, keeping track of costs of gluten-free items and the associated costs is probably worthwhile; otherwise, probably not.

Not all dietitians know as much about celiac disease as would be ideal. Therefore, rather than you referring yourself to a dietitian you find in the phone book or online, we recommend that you ask your celiac disease specialist or family physician to refer you to one. Alternatively, you can call your local hospital and ask whether it has a celiac disease clinic; if it does, then you can book your own appointment with the clinic's dietitian. Another option is to be in touch with a celiac disease support group and find out who other people living with celiac disease are seeing for nutrition counseling.

 If you have private health insurance, check with your insurer to see whether your policy covers the costs of dietary counseling. In Canada, there is typically no charge for obtaining nutrition counseling as long as it is provided in a hospital-based clinic.

# Shopping Successfully for Gluten-Free Foods

The first rule of thumb in going gluten-free is giving up foods that come in cans, boxes, jars, and other packages. Eating naturally gluten-free foods such as fruits, vegetables, legumes, nuts, meat, poultry, fish, seafood, dairy products, and certain grains such as rice and (pure) oats will ensure you are not inadvertently consuming gluten. These basic items should become the staple foods of your diet. (Because processed foods are typically not as healthy as non-processed foods, avoiding these is a good idea not only for those with celiac disease but for everyone.)

If you're going to shop successfully for gluten-free foods, you need to know which foods contain gluten and which do not. As we discuss in Chapter 2, rice, corn, (pure) oats, soy, millet, teff, sorghum, buckwheat (kasha), quinoa, and amaranth do not contain gluten. These grains can be used to make flours which are helpful when baking gluten-free goods. Other items that can be milled into flour and are gluten-free are:

- Chickpeas (garbanzos)
- Job's Tears (Hato Mugi, Juno's Tears, River Grain)
- Lentils
- Peas
- Ragi
- Tapioca
- Wild rice

Corn flours such as masa and hominy are also gluten-free.

When you do have to purchase foods that come in cans, jars, packets, and boxes, learning how to read the list of ingredients on the food label is crucial to determining whether the product contains gluten. For some time in Canada and recently in the United States, it is the law that these labels indicate if the product contains gluten.

As we mention earlier in this chapter in the section "Knowing what gluten-free means," similar to the situation with peanuts and other foods to which

one may be allergic, manufacturers who cannot guarantee that an item is entirely gluten-free must indicate this on the food label using phrases such as "Made on shared equipment used for wheat" or "Facility processes wheat." That's good. What's bad is that foods that are intrinsically gluten-free must, nonetheless, have a food label that implies the manufacturer cannot guarantee the absence of gluten if even the remotest chance exists that during their processing they may have become contaminated by some other gluten-containing product. This is designed to ensure safety, but we think there is, at times, excess caution (perhaps for legal reasons) and that all this sometimes does is make it harder to shop. Indeed, many theoretical situations of gluten contamination during the manufacturing process in reality are highly unlikely to lead to a meaningful or significant level of gluten in the food product.

Here is a list of certain common, gluten-containing ingredients found in prepared foods. *Avoid* foods with these ingredients:

- **Barley malt, malt extract, malt syrup, and malt vinegar.** These malt-based products all contain gluten (in the form of hordein) as they are derived from barley.

- **Soya sauce manufactured from wheat.** Soya sauce made from *non-gluten-containing food sources* is, however, permitted. More and more gluten-free labeled soya sauce brands are available; however, you will still come across soya sauce labels that don't indicate whether or not the product contains gluten. In this case, you can contact the manufacturer of the particular brand to find out.

- **Modified food starch if it is derived from wheat.** Modified food starch made from corn, rice, potato, or tapioca is safe to consume. If the label simply says "starch" (rather than "modified food starch"), then that food starch is cornstarch and is allowed. Other sources of starches must be identified in North America.

- **Brewer's yeast.** Brewer's yeast is not gluten-free. Baker's yeast and yeast extract are gluten-free and are permitted.

- **Products that do not specify their content.** Items such as packaged flavorings or seasonings may contain flour and other gluten-containing products such as malt or soya sauce and thus should be avoided. Spices and herbs on their own are naturally gluten-free and thus can be safely consumed.

Here are a few items that generate some controversy as to whether they are gluten-free or not:

- **Maltodextrin.** This can be derived from wheat and is most commonly seen in imported European food products. *Safe* dextrin sources include *dextrose* from corn and *dextrans* from corn or potato starch. However, even wheat maltodextrin is highly processed and purified and studies suggest gluten cannot be detected in such products.

✔ **Wheat starch.** This is used in European gluten-free products but is not considered gluten-free in North America because it is not certain whether all traces of wheat protein are removed during the processing of wheat starch.

For a complete listing of foods allowed and not allowed on a gluten-free diet including a detailed discussion of every ingredient and many food products, we advise you to read the Gluten-Free Diet by Shelley Case, BSc, RD. Be sure to read the revised and expanded edition published in October 2008 (see Appendix A).

# Cooking Gluten-Free Food

Cooking gluten-free isn't easy, but is very doable. Indeed, millions of families successfully do this every day. Here are key elements and some tips to help you succeed with gluten-free cooking:

✔ Almost all meat, poultry, fish, seafood, egg, vegetable, potato, and rice dishes can be made without adding any gluten-containing ingredients. (These foods don't contain gluten and thus serve as an excellent foundation from which to make a dish.)

✔ Avoid flour as a thickener and instead, substitute a gluten-free item such as cornstarch, tapioca starch or, when the dish calls for it, cream or butter. Although you may be tempted to use a can of mushroom soup as a thickener, avoid doing so unless the manufacturer specifically states on the food label that the soup is not thickened with flour; if the soup contains flour, as it typically does, then it contains gluten.

✔ Substitute gluten-free pasta for classical family favorites such as macaroni and cheese or lasagna.

✔ Leave out the croutons in salads and instead use nuts, sunflower seeds, or gluten-free croutons to add crunchy and tasty items.

✔ Make your own salad dressings using various oils and vinegars along with salt, pepper, mustard powder, and herbs. All these items are free of preservatives and are gluten-free.

✔ If a dish calls for breadcrumbs, omit them or substitute gluten-free crackers or bread crumbs.

✔ A nut-butter-sugar crust for a cheesecake base is a very tasty substitute for a graham cracker crust.

Using naturally gluten-free ingredients is the best way to create tasty, nutritious and healthy meals.

## Meal preparation tips from Sheila's household

Sheila's husband Peter has celiac disease, but neither Sheila nor their children do. As a result of being a celiac disease specialist and, moreover, as a result of living with a family member with celiac disease, Sheila (and, of course, her husband) has discovered a number of strategies that have made meal preparation a success for her household:

✔ Most meals are based on fish, seafood, dairy products, poultry or meat, potatoes, rice, legumes, many other vegetables, fruits, nuts, dried fruits, and sorbets.

✔ Salad dressings are made from scratch while cheese sauces and gravies are made with gluten-free thickening agents.

✔ For the members of the family that do not have celiac disease, an item or two of gluten-containing food such as bread or another baked good is added per meal.

✔ Wherever possible, similar gluten-free items (biscuits, bread, or a sweet baked item) are brought out of the pantry or freezer for the celiac member of the family.

✔ About once a week, dinner is based on gluten-containing foods such as pasta or homemade pizza. In these instances, while Sheila and the kids have the gluten-containing items, Peter has gluten-free pasta or pizza crust which is used as the base for the same gluten-free sauces or toppings that are being used by the rest of the family.

## *Baking your own gluten-free food*

As we discuss in this section, doing one's own baking often presents the greatest challenge when it comes to cooking gluten-free. And trying to get around this by purchasing gluten-free baked goods is no mean feat either. Although more and more stores in North America are carrying gluten-free baking, these are not readily available in all parts of the continent and also, these goods are expensive.

You will likely find your baking challenges are, well, somewhat less challenging if you have at least one good cookbook on hand which is specifically written for people who, like yourself, want to prepare high quality, tasty, gluten-free baked foods.

Learning how to bake gluten-free cakes, quick breads, muffins, cookies, piecrusts, and squares is important for most families living with celiac disease. Mixes for various baked goods are available primarily from smaller companies that specialize in gluten-free products, but, as a sign of the times, Betty Crocker has just recently come out with a few gluten-free mixes for baked goods. As Sheila's husband said, his mother, who founded the Canadian Celiac Association over 35 years ago and who died in 2002, would not believe how much more is now available for those with celiac disease!

Note that gluten-free mixes and purchased gluten-free baked goods, though often very welcome time-savers, are generally more expensive than are made-from-scratch gluten-free goods, and may not be as good as the homemade product.

If there was an Olympic medal for gluten-free cooking, it would surely go to the person who best masters the art of baking gluten-free bread. Successfully doing so makes climbing Everest look like a comparative walk in the park. (Well, okay, maybe not a walk in the park, but you get the point.) Bread relies on glutenin (as we discuss in Chapter 2, glutenin is a component of gluten) to give it the texture and other qualities, such as elasticity, that we learn to characterize as belonging to bread. Gluten-free breads are often dry and crumbly and need to be toasted to make them more palatable. Our patients with celiac disease routinely tell us that the number one item that ends up going in the garbage (or compost heap), whether homemade or purchased at a store, is bread.

## Planning meals for the newly diagnosed

If you or a family member has just been diagnosed with celiac disease, you will likely find that getting started on a gluten-free diet can be a daunting task. Here are some strategies to help you get started with meal planning:

- ✔ **Keep things simple and organized.** After you've mastered the basics, allow yourself to move on to more complicated and more varied gluten-free food shopping and meal preparation.

- ✔ **Use the resources available to you.** Your dietitian, local support groups, gluten-free cookbooks, reputable Web sites, and books (like ours!) can help you learn about where to find gluten-free foods and how to prepare them.

- ✔ **Plan meals and snacks ahead of time.** Make a shopping list before going to the store. Become familiar with stores that sell gluten-free items and learn to read labels.

- ✔ **Start with a tried-and-true recipe.** When baking, start with a simple gluten-free recipe which other people you know have already mastered.

If you are the parent of a child with celiac disease, once your child is old enough, be sure to involve him or her in the shopping and preparation of meals as we discuss in Chapter 14.

# Eating Out Gluten-Free

Eating out of the home presents special challenges for people living with celiac disease. Whether it's going to a restaurant; attending a wedding, birthday party, or other family celebration; joining the gang at the annual office holiday party; or simply visiting friends or family, these situations create dilemmas and difficulties that you don't encounter at home. In the following sections, we look at these challenges and provide helpful tips to assist you when you are in these situations. (In Chapter 14, we discuss the special challenges that the childhood and teenage years present.)

## Eating in restaurants

Eating gluten-free in restaurants, though not easy, is eas*ier* than it was only very recently. The reason is that more and more national chain restaurants are offering gluten-free foods on their menus. Most restaurants, however, do not provide this information so, just like when buying anything else, the old adage of "buyer beware" holds true here.

When it comes to successfully navigating restaurant foods, bear in mind the following:

- ✔ **Avoid fast food.** Fast food restaurants, which are often life-savers for busy families, are generally off limits for those with celiac disease. Sorry. The problem is that many of their staples including hamburgers, chicken nuggets, seasoned French fries, pizza, hotdogs, and the like, contain gluten.

- ✔ **Pick the right restaurant.** In general, restaurants that are more expensive or are very small are more likely to be able to (and willing to) prepare custom meals from scratch that are free of gluten.

- ✔ **Look for high quality cuts of meat or fish.** When navigating the menu, be aware that dishes prepared with high quality cuts of meat or fish, and that use ingredients such as cream, butter, and wine, are more likely to be gluten-free.

- ✔ **Pay special attention to the side dishes.** Even if you've ordered a gluten-free food item, an accompaniment such as a bread roll may contain gluten, even if the waiter assures you it does not! Sheila well remembers the time she and her family were in a restaurant and the "gluten-free" bread roll given to her husband was identical to the regular rolls given to the rest of the family. Geesh! (To be fair to restaurant staff, they may simply have insufficient training and as a result may not know what they don't know. As we said earlier, it's always best to follow the old adage about buyer — or, in this case, *eater* — beware.)

Here are some gluten-free foods to look for when scanning a restaurant menu for suitable foods (or about which you can ask a knowledgeable wait staff):

- ✔ Natural broths

- ✔ Cornstarch thickened gravies and sauces

- ✔ Vinaigrette salad dressings

- ✔ Gluten-free soya sauce

- ✔ Tortillas made from all-corn grain

- ✔ Desserts such as crème brûlée, sorbet, and sherbet. Ice cream is also okay as long as it is gluten-free.

Some traditional specialities such as gnocchi and matzoh balls may be available in gluten-free forms but you need to check with the restaurant that they do no contain wheat or other gluten-containing flours.

Just like bringing crayons and the like makes dining out with little ones immeasurably easier, so too will following some "heads up" tips make your gluten-free restaurant dining experience — with or without children — less stressful and, ultimately, more pleasant. When you're dining out:

- ✔ **Call ahead.** Call ahead to ask questions and let the restaurant know of your needs.

- ✔ **Avoid busy dining times.** Avoid dining at the busiest times, especially on a first visit. That way, the wait staff will be able to provide you the extra time you may need to discuss your food needs with them.

- ✔ **Explain your dietary restrictions.** Explain your dietary restrictions to the staff. Some staff will be very knowledgeable (in which case the conversation will be brief), but others may need a more detailed explanation.

- ✔ **Ask questions.** Ask about what gluten-free items or meals the restaurant has on its menu. Ask how meals are prepared and how gluten-free the kitchen and food preparation areas are. In Appendix A, we discuss online resources that address issues associated with dining out and having celiac disease.

- ✔ **Check about cross-contamination.** Check into situations of possible *cross-contamination* wherein non-gluten-containing foods become contaminated with gluten-containing products. (We discuss this topic in detail in the section, "Dealing with Cross-Contamination.")

- ✔ **Use dining cards.** If you encounter a language barrier as you try to explain your dietary needs, show wait staff *dining cards* which provide information about celiac disease dietary restrictions in a wide variety of

languages. Depending on the supplier of the cards, these are available in English, Thai, Chinese, Japanese, Indian, Spanish, French, German, Italian, Dutch, Portuguese, Greek, and even Swahili. These cards make it easier for you to order and eat a gluten-free meal in restaurants in many places around the world. There are quite a number of sources for these cards, which we list in Appendix A.

✔ **Express appreciation.** Make sure the staff know you are appreciative when their extra effort has helped you have a good experience. This can be in the form of a generous tip, a thank you note, or another token of appreciation. (We realize this point may have sounded kind of patronizing, but hey, the more that restaurant staff are rewarded for being gluten-savvy, the more likely that they will put in extra effort the next time that a person with celiac disease comes to dine. And we think that would be great!)

✔ **Offer repeat business.** Return to dining establishments where you have had an enjoyable gluten-free meal. Being a "frequent flyer" will likely help you get better service.

## Traveling with celiac disease

Taking a flight presents its own special challenges. Airline meals (whether provided gratis or offered for sale) typically consist of a sandwich or other gluten-containing food. Even snacks can be off limits for those with celiac disease since fewer airlines pass out peanuts and instead offer gluten-containing pretzels, crackers, or cookies. For these reasons, we recommend you bring your own, gluten-free food with you. Also, any of you who have flown in recent years know your own food will likely taste better and cost less than what you'd get onboard.

One way of getting around the onboard eating dilemma is to eat a meal before you leave home. (We'd caution against you leaving home with the expectation you'll be able to find gluten-free food at the airport. It will be a very unpleasant surprise if — as may well be the case — you get there only to find out that gluten-free food is not available.) Regardless of what strategy you employ, you need to plan ahead because ordering in food at 35,000 feet isn't an option (at least, not as far as we're aware).

Good gluten-free snacks to bring with you on your flight could include a dried fruit/nut mixture, pieces of fruit such as apples and oranges, gluten-free granola bars, and chunks of cheese and gluten-free crackers. Bear in mind that if you're traveling to another country, bringing in certain foods such as fruit will be off limits.

Traveling by train can also present challenges because, depending on the train you take, the food selection available may be very limited. It is always safer to bring along a few gluten-free items like those we just discussed.

Car travel allows far more options because you can pack items in a cooler for longer trips and you can also stop to buy gluten-free food supplies along the way. Nonetheless, even here some advanced planning is needed since the average rest stop will, naturally enough, not have the gluten-free selection of a full grocery store and you may find yourself needing to take an unwanted detour off the highway to find a shopping area.

## Visiting friends and family

If you were found to have celiac disease when you were very young, it's likely that your friends and loved ones have become at least somewhat familiar with your special dietary needs and have learned to make some accommodations for them (even if only to accept that you may opt to bring your own food to get-togethers). On the other hand, if you have only recently been diagnosed, your friends and relatives may not yet know this and, even if they do, like many people they may have minimal knowledge of celiac disease and even less knowledge of its dietary requirements.

Bill, a 30 year-old patient of Ian's, shared with Ian the story of his visit to his grandmother the day after he had been diagnosed with celiac disease ten years earlier. She had lovingly and painstakingly prepared his favorite casserole; a dish now off limits for him because it contained gluten. Try as he might, Bill was unsuccessful at explaining to his grandmother why he couldn't eat the food, and it was clear she felt hurt and disappointed. Over the next few months and after a number of further conversations, Bill's grandmother did ultimately come to a firm grasp of the condition and was able to come up with new favorites for him. A few years thereafter, when Bill's own son was diagnosed with celiac disease, Bill remembers marveling at the totally nonchalant way in which his grandmother greeted the news and whipped up an exquisite gluten-free dish in no time.

The best way of avoiding the potentially uncomfortable situation of having friends and family perplexed at your new eating needs is, *in advance* of a get-together, to inform them of your new dietary requirements. You may even want to share your copy of this book with them (but remember to ask for it back!). Depending on your comfort with this, you may elect to do as some folks with celiac disease have done, and let friends and family know via the annual holiday letter of your or a family member's new need for a special diet.

You will likely discover that for smaller get-togethers, so long as you provide your host or hostess with some advance warning of your nutrition requirements, they will be pleased to do their best to accommodate. However, for larger events such as a wedding, it may not be possible to make changes to a menu. In this situation, bring along snacks or even eat in advance of going to such a social event where one cannot be assured of receiving gluten-free foods. (When Sheila was a medical student, it was not uncommon for her husband — who has celiac disease — to eat dinner in advance of going to a potluck dinner where gluten-containing pasta dishes would be served. It was also not uncommon for him to then eat a second meal if he discovered gluten-free foods were available at the dinner. Of course, he was able to eat a lot more calories in those days and not gain weight!)

Although you may feel it is impolite to refuse Aunt Lucinda's famous trifle or Uncle Joe's ultimate macaroni and cheese, if they contain gluten, refuse them you must. Hurt feelings are unpleasant, harming your health is worse. Just like Bill's grandmother in the preceding anecdote, your friends and loved ones will gradually learn to deal with your dietary needs and will ultimately be perfectly accepting of them. Why? Because they are your friends and loved ones.

# Planning for Emergencies

In the wake of Hurricane Katrina and Hurricane Rita, members of Gulf Coast celiac support groups had renewed awareness of the need to be prepared for such disasters. Everyone, whether or not having celiac disease, should have an emergency preparedness plan which includes having on hand bottled water, flashlights, candles, matches, compasses, blankets, a can opener, butane lighter, pocket knife, something with which to boil water, and non-perishable foods.

If you have celiac disease, have the following (or similar) items available in the event that a hurricane or other disaster forces you to leave your home:

- Gluten-free protein and/or cereal bars
- Rice crackers
- Gluten-free snacks such as gluten-free chocolate bars
- Dried fruits
- Nuts
- Tinned foods
- Dried packets of gluten-free soups
- Sugar, tea, coffee, and powdered milk or coffee creamer

Eat the items in your cache before they get too old and replenish these goods as they are used up so if, heaven forbid, disaster strikes, you and your family are ready to make a hasty exit.

# Dealing with Cross-Contamination

*Cross-contamination*, as it pertains to living gluten-free, refers to the process by which an item which should be gluten-free becomes contaminated with gluten during the processing or preparation of the food. Cross-contamination can occur in manufacturing plants, grocery stores, restaurants, and in the home. Because having celiac disease means you must be strictly gluten-free, cross-contamination is a very real concern.

These are examples of settings in which cross-contamination may occur:

- ✔ **During food processing in manufacturing plants.** As we discuss in Chapter 2, oats are often milled in plants where gluten-containing grains are also milled. This results in cross-contamination of the oats and means you mustn't eat them. (If, however, the label says they are "pure oats" then it is alright to eat them.) We list various sources of pure oats in Appendix A.

- ✔ **Stores with bulk food bins.** It is easy to imagine how a bit of the contents of, for example, the wheat flakes cereal bin makes its way into a bin of something that is supposed to be gluten free thanks to shared scoops, curious kids, and other things along those lines.

- ✔ **Re-use of frying oil that was previously used to fry gluten-containing foods** such as breaded or battered meats, French fries dusted in spiced flour, or doughnuts. This can be an issue at restaurants and in the home.

- ✔ **Sharing knives.** This can lead to breadcrumbs in jams, peanut butter, butter, spreads, and dips. It is best to have one serving knife (or other serving utensil) per food item that is placed on the table. This utensil can then be used to dish out the dollop of jam, butter, or whatever onto each person's plate, not directly onto their toast, bread, crackers, and so on. From there each person can use his or her own, individual utensil to do the spreading. Not only does this prevent gluten cross-contamination, it is the more hygienic way to eat in any event.

- ✔ **Using toasters and cutting boards for both gluten-containing foods and gluten-free foods.** Toaster ovens are easier to clean and keep free of gluten-containing crumbs than the traditional upright toaster where crumbs collect at the bottom and can cling to the next bread slice. If your family elects to use an upright toaster, you may want to have a separate one for use by members of the family who have celiac disease.

If you are making homemade gluten-free burgers, toast the gluten-free buns before the ones with gluten. This will reduce the risk of cross-contamination.

✔ **Grilling surfaces.** Grilling surfaces are likely to be used to prepare both gluten-containing and gluten-free foods. Therefore, after grilling a gluten-containing product, be sure to clean the grill before cooking gluten-free food. (Also, try to grill the gluten-free food first in any event.)

Once a utensil or cutting board is properly washed, the risk of cross-contamination with gluten disappears. Thus, there is no need for separate sets of dishes, cutlery, and other washable food preparation paraphernalia for different members of the family.

# Sticking with a Gluten-Free Diet

If you have celiac disease, in order to maintain good health, it is essential that you follow a gluten-free diet. However, whether you are a kid at a birthday party or an adult in a fancy restaurant, it is human nature to want to taste a delicious (gluten-containing) cake or other treat that everyone else is oohing and aahing over. If you find yourself giving in to temptation (which, by the way, we recommend you *don't*), don't beat yourself up over it or dwell on it. Instead, the best way to handle a little dietary indiscretion is to get back with the (gluten-free) program as soon as possible.

When it comes to voluntarily straying from living gluten-free, we don't like to call it *cheating.* Maybe it's just us, but we find the word "cheating" to sound patronizing and besides, it tends to connote guilt, which isn't a particularly helpful feeling anyhow. (Well maybe a tinge of guilt is helpful at times, but that's about it.) We prefer to call falling off the gluten-free wagon *straying* from the diet.

Unlike many others with a chronic illness, if you have celiac disease, you are able to fully take control of, or "own" your disease. You don't need medicines to control your celiac disease, you don't need fancy technologies, gadgets or wizardry; you just need *you*. And that involves finding the wherewithal to avoid any and all gluten. It also involves recognizing that to err is to be human.

Living gluten-free is often facilitated and, ultimately, more likely to succeed if one is a member of a support or advocacy group, and if there is regular follow-up with a dietitian. We recommend you do both. In Chapter 1, we discuss how to find a celiac disease support group.

# Tracking Down Hidden Sources of Gluten

Through careful label reading and diligent homework you will almost always be able to determine which foods are gluten-free (and hence okay for you to eat) and which contain gluten (and thus need to be avoided). There are, however, sources of gluten other than what is found in food. It is important that you be aware of these so-called hidden sources of gluten lest you inadvertently consume them and trigger your celiac disease. We look at hidden sources of gluten in this section.

## Checking the ingredients of prescription medications

One of the things Ian hears most often from readers of one of his other *For Dummies* books — *Understanding Prescription Drugs For Canadians For Dummies* — is that they are shocked to find out the number of different non-medicinal ingredients present in their prescription drugs. Indeed, in addition to the actual medicine, drugs may contain one or more of many other ingredients including (but not limited to) lubricants, coatings, preservatives, dyes, sweeteners and, ready for this, gluten! (Gluten is used as a filler or as a vehicle to keep the active ingredient in suspension.)

You will not be able to tell from looking at a pill whether or not it contains gluten. If you've been provided with a package insert it may reveal this, but you'll likely only see this after you're home and long after you've already paid for the medicine. Your doctor is highly unlikely to know which company makes which drug with gluten. And your pharmacist may not know that you have celiac disease and so won't know to not dispense a gluten-containing medicine to you. For all these reasons, the best thing to do is, any time you are having a prescription filled at the drug store, tell the pharmacist you have celiac disease and ask him to check whether the particular drug contains gluten. The pharmacists can look this up on the computer or, if necessary, can call the manufacturer on your behalf.

## Verifying the ingredients of over-the-counter medications

As with prescription medications, over-the-counter drugs may also contain gluten. Making things even more difficult is that if you simply pick the package up off the shelf and leave the store, you will not have had the opportunity to have checked with the pharmacist whether the product contains gluten.

In addition, the pharmacist may not have access in their databa the-counter product's ingredients. In these situations the best t before you take even a single dose of the medicine, contact the to find out if the drug contains gluten.

Some celiac disease support groups maintain databases about the gluten content of common medications, but bear in mind these may not be fully reliable. Other sources include the Ask a Pharmacist option on Web sites for certain retail pharmacies and other Web sites such as www.glutenfreedrugs.com. A longer list of Web sites with this information is included in Appendix A.

## Knowing other sources of gluten

We are commonly asked by our patients with celiac disease whether it is hazardous for them to use gluten-containing skin creams and lotions. This misinformation is unfortunately commonly acquired from online sites. If you, too, have wondered about the safety of gluten-containing skin creams and lotions, then we can reassure you — as we do them — that using these products is perfectly safe. The only way gluten can cause intestinal damage is for it to be ingested; gluten applied to the skin or scalp or hair does not put you at risk. However, listed below are some real and potential sources of gluten which aren't readily appreciated as problems:

✔ **Bakeries.** Occasionally, bakers who work with wheat flour may inadvertently ingest flour that has become airborne and comes to rest in their mouth and is then swallowed. If you are a baker with celiac disease, you may need to change to a different working environment or, at the very least, have your working environment modified.

✔ **Communion wafers.** Communion wafers typically contain gluten. Recognizing, however, that some parishioners must avoid gluten, certain manufacturers have developed gluten-free wafers. Nonetheless, in some more strict interpretations of the Eucharist, gluten-free alternatives are not always considered acceptable. As with many things religious, there is a range of interpretations on such matters. Some people with celiac disease just pass the plate or use a substitute that they bring with them. If you are unsure how to proceed, a consultation with your priest or minister may be a good idea.

✔ **Lipstick.** The only cosmetic which might be a source of problems is gluten-containing lipstick because it is possible that some of the product could enter your digestive system. This is, however, seldom a problem since you are highly unlikely to ever ingest any sort of meaningful quantity of this. If, however, you and your doctor discover that your celiac disease is not settling the way it should, consider your lipstick as a possible culprit. The only way that you may be able to determine whether your preferred lipstick contains gluten would be for you to contact the manufacturer.

✔ **Postage stamps and envelope labels.** Other sources of hidden gluten include some postage stamps and envelope labels. Use a sponge rather than your tongue to moisten such items.

✔ **Play dough.** Young children who put things in their mouth are at risk of gluten if they consume play dough made with wheat flour. Whether your child has celiac disease or not it is advisable to keep them away from using play dough until they are past this stage of life.

# Chapter 11

# Exploring Other Nutritional Considerations

*In This Chapter*

▶ Looking at how celiac disease affects the state of your nutrition

▶ Carrying excess weight

▶ Examining lactose intolerance

▶ Eating gluten-free when you are a vegetarian

▶ Investigating other important nutritional considerations

*Y*ears ago, before much was known about celiac disease, affected people often became increasingly malnourished and, tragically, sometimes died as a result. This isn't going to happen to you! Nowadays, with celiac disease being so much better understood and with excellent therapy now available in the form of modifying one's diet, if you have celiac disease, you can be — and will be! — fully nourished and as a result, you can look forward to a healthy, active, full, productive, and long life.

As we discuss in Chapter 10 and throughout this book, the key to successfully living with celiac disease is following a gluten-free diet. In this chapter we look at *additional* nutritional issues that need to be considered.

## Understanding Nutritional Deficiencies in Celiac Disease

If you are like many people with celiac disease, once your condition is diagnosed and successfully treated, you'll probably look back and realize that your now-resolved symptoms had likely been with you for quite some time, perhaps years. Indeed, however long you *think* you've had celiac disease, you may *actually* have had it considerably longer because it can take years from the time that gluten first starts to inflame the bowel until the time that symptoms first develop. Nonetheless, during those early years — even in the

absence of symptoms — your damaged intestine was likely already interfering with your ability to properly absorb nutrients into your body. This, in turn, may have made you deficient in these nutrients.

In discussing the implications of nutritional deficiencies, it's helpful to first look at what are the types of nutrients that you need in the first place. This is the way in which most nutrients are categorized:

- ✔ **Carbohydrates, fat, and protein** are the major components of your diet. Of their various roles, carbohydrates and fat provide energy (calories), and protein provides nutrients to maintain and repair the body.

- ✔ **Fluids** are necessary to maintain hydration. (A human is 60 percent water after all.)

- ✔ **Electrolytes** include sodium, potassium, and chloride and are vital for proper functioning of the body's cells, including those found in the nervous system, heart, and muscles.

- ✔ **Minerals** include calcium, iron, magnesium, phosphorus, selenium, zinc, and other elements. Minerals play a variety of important roles. Calcium, for example, is necessary to build and maintain bone strength and mass. Iron is required to make red blood cells. (See Chapter 7 for more on calcium and iron.)

- ✔ **Vitamins,** also discussed in Chapter 7, are typically divided into two categories:

    - *Fat-soluble vitamins* are A, D, E, and K.

    - *Water-soluble vitamins* are all the rest including the large family of B vitamins, and vitamin C.

## Malnutrition in celiac disease

*Malnutrition* is a general term for the condition in which the body is lacking sufficient nourishment. Most people with celiac disease ingest what should be adequate quantities of nutrients in the form of food and liquid; the problem is that these nutrients are not sufficiently absorbed into the body — a condition called *malabsorption*. We discuss malabsorption in detail in Chapter 2.

If celiac disease is severe, it can lead to such marked damage to the small intestine that it results in profound malabsorption with dehydration, loss of muscle mass, and, in the case of children, a distended belly and skinny limbs. The severely affected child with celiac disease resembles youngsters without celiac disease from impoverished regions of the world. Fortunately, celiac disease rarely gets to this stage nowadays because doctors are more aware of the condition, look for it sooner than in the old days, and know how to successfully treat it.

Although knowledge about celiac disease continues to grow in the medical community, it still isn't always considered as soon as it should be. For this reason, if you or someone you care about has symptoms or other health problems that we discuss in this book, and if celiac disease hasn't been considered, raise this possible diagnosis with your physician.

## Looking at common nutritional challenges

As we discuss in Chapter 5, several forms of celiac disease exist, including the *classical* form in which the affected individual has, well, classical symptoms of this condition including diarrhea, abdominal pain, and, often, severe malnutrition. It is now known, however, that most people with celiac disease have the so-called *atypical* type in which symptoms are far less severe. Having less severe symptoms is, of course, good, but it can lead both patient and doctor alike to overlook nutrient deficiencies that can be present despite the small number of symptoms and a person's healthy appearance.

Poor nutritional status is a concern for all people with celiac disease. Even following a gluten-free diet does *not* guarantee you are receiving all the nutrients you need.

Recent medical studies suggest that in treating celiac disease, too much emphasis has been placed on categorizing foods as "allowed" versus "not allowed," and too little emphasis placed on looking at the nutritional *quality* of a person's gluten-free diet. In particular, these studies have found evidence that many people with celiac disease who are following a gluten-free diet are not consuming enough of the following:

- Calcium (see the later section "Consuming calcium" and Chapter 7)
- Fiber (see the section "Figuring out fiber" and Chapter 15)
- Iron (see the section "Ironing out iron deficiency" and Chapter 7)
- Vitamin D (see Chapter 7)

Some studies have also suggested that people with celiac disease following a gluten-free diet tend to eat too much in the way of saturated fats.

Part of the reason the gluten-free diet can lead to nutritional deficiencies is that gluten-free foods are rarely fortified with (that is, contain added) iron, calcium, and other nutrients. These dietary deficiencies of a gluten-free diet can make it difficult to correct the deficit in nutrients that were caused by the untreated celiac disease in the first place.

If you've not had occasion to discuss with your dietitian your intake of calcium, fiber, iron, vitamin D, and saturated fats, bring this up the next time you meet. Haven't seen your dietitian in quite some time and no appointment booked? Well, stick a bookmark in this page (we'll wait till you get back), grab the phone, and arrange one.

As we discuss in Chapters 14 and 17, some families elect to have everyone in the household follow a gluten-free diet even if only one person has the condition. If this is true of your situation, then be sure you ask your dietitian about whether or not the other members of your family are having their nutritional needs met. Children in particular have different requirements than do adults.

### Ironing out iron deficiency

As we discuss in Chapter 7, many people with active celiac disease have iron deficiency due to malabsorption of this mineral. Once you're on track with a gluten-free diet and your small intestine has healed, you will recover your ability to properly absorb iron into your body. Nonetheless, you may still find yourself being told by your doctor that your iron level (measured on a blood test) is low. The reason for this is that a gluten-free diet often contains insufficient iron. You need, therefore, to make a point of ensuring you're diet is sufficiently rich in iron to meet your body's needs.

Foods that can supply iron in your gluten-free diet include:

- Baked potato with skin
- Red meat
- Chicken and other poultry
- Fish such as salmon and tuna
- Legumes (lentils, kidney beans, chick peas)
- Seeds, especially pumpkin seeds and sunflower seeds
- Shellfish (clams, oysters, mussels)
- Tofu
- Certain gluten-free grains (amaranth, buckwheat bran, quinoa, rice bran, teff)
- Some types of dried fruits (apricots, figs, raisins)
- Some nuts (cashews, almonds)

When choosing where you are going to get your nutritional iron needs meet, it's important to consider that iron from plant foods is less *bioavailable* (that is, less easily absorbed into the body) than is iron from animal sources. Also, certain plant compounds such as *phytates* found in legumes and grains can inhibit iron absorption. You can, however, increase the amount of iron you absorb from plants sources. To do this, when you are eating plant sources of iron:

✔ **Ingest vitamin C and other organic acids as found in oranges, bell peppers, and broccoli.** These enhance plant iron absorption.

✔ **Don't ingest coffee, tea, calcium or fiber.** These interfere with plant iron absorption.

If, despite following a gluten-free diet, ingesting sufficient quantities of iron rich foods, and, when necessary, taking iron supplements, your iron level doesn't return to normal, then your physician needs to ensure your celiac disease isn't still active (that is, still causing inflammation and damage to your small intestine). The first step in making this determination is typically to recheck your tissue transglutaminase IgA (TTG IgA) level. We discuss this test in detail in Chapter 3, and in Chapter 15 we look at the role of this test in monitoring your celiac disease.

### Consuming calcium

Many people — whether they're following a gluten-free diet or not — don't consume sufficient amounts of calcium. This is especially challenging if you also follow a lactose-free diet (see "Lactose intolerance" later in this chapter) or a vegan diet as both these diets are intrinsically low in calcium.

These are the recommended *daily* amounts of calcium intake:

✔ **For infants:** 500 mg.

✔ **For children:** 800 mg.

✔ **For adolescents and lactating mothers:** 1,300 mg.

✔ **For the average adult up to the age of 50:** 1,000 mg.

✔ **For adults over age 50:** 1,200 mg.

These are gluten-free, calcium-rich foods:

✔ Milk products including milk, yogurt, ice cream, certain cheeses

✔ Tofu

✔ Canned salmon or sardines containing bones

✔ Dark green vegetables, dried beans

Calcium is also often added to foods such as some brands of orange juice, rice beverages, and soy beverages.

If you have lactose intolerance (which we discuss later in this chapter), you can still ingest these calcium-rich dairy products as they are (intrinsically) lactose-free:

✔ Yogurt

✔ Kiefer

✔ Other fermented milk products (sour milk, butter milk)

✔ Old or hard cheeses

The best-absorbed source of calcium in the diet is that found in dairy products. If you cannot consume any dairy products due to cows' milk allergy, religious beliefs, or other reasons, getting enough calcium can be an extra challenge. There are, however, a number of non-dairy sources of calcium that you can include in your diet:

✔ Amaranth (75 mg, ¼ cup)

✔ Blackstrap molasses (172 mg, 1 Tbsp)

✔ Bok choy (Chinese cabbage) (~175 mg, 1 cup cooked)

✔ Broccoli (79 mg, 1 cup cooked)

✔ Collard greens (239 mg, 1 cup cooked)

✔ Figs (137 mg, 5 figs)

✔ Kale (99 mg, 1 cup cooked)

✔ Mustard greens (109 mg, 1 cup cooked)

✔ Orange juice with calcium (333 mg, 1 cup)

✔ Salmon, pink with bones, canned (181 mg, 3 oz)

✔ Sesame tahini (128 mg, 2 Tbsp)

✔ Soybeans, green (edamame) (130 mg, ½ cup)

✔ Soymilk, fortified (100–159 mg, 1 cup)

✔ Teff, dry (82 mg, ½ cup)

✔ Tempeh (92 mg, ½ cup)

✔ Tofu, firm, calcium-set (137–230 mg, ½ cup)

### *Figuring out fiber*

Over the past few decades, much has been discovered about the importance of consuming sufficient fiber. Not only does a fiber-rich diet help "keep one regular" (that is, helps prevent constipation), there is also strong scientific evidence that eating lots of fiber reduces the risk of developing a variety of diseases including heart disease and certain types of cancer.

Unfortunately, following a gluten-free diet makes
the fiber you need. This is a result of the low fi
free flours and other gluten-free grain produc
lent ways of overcoming this hurdle by gettir
including:

- Rice products such as:
    - Brown rice
    - Rice bran
    - Rice polish
    - Wild rice
- Whole grain corn
- Non-gluten-containing grains such as:
    - Amaranth
    - Millet
    - Quinoa
    - Oat bran
    - Teff

## Other gluten-free healthy-eating tips

There are many other healthy ways you can add variety, fiber, and a whole
host of nutrients including vitamins and minerals to your diet while at the
same time avoiding gluten:

- Eat fruits or vegetables with every meal.
- Sprinkle nuts and seeds (sesame, poppy, sunflower, pumpkin) on salads,
  stir-fry dishes, cooked vegetables, and other dishes.
- Add dried fruits (raisins, currants, cranberries, cherries, apricots,
  apples), various fresh fruits, and berries of all kinds to cereal, salads,
  desserts, baking batter (pancakes, quick breads, muffins).
- Add flax seeds or flax seed powder to foods to increase the fiber
  content.
- Use brown rice or quinoa instead of white rice.
- Add legumes (like pinto beans, navy beans, black-eyed peas, kidney
  beans), cabbage, and cruciferous vegetables (cauliflower and broccoli)
  to your diet.

### Sorting out saturated fats

*Saturated* fat is the type of fat that comes from animal sources. Saturated fat is found in meat (for example, bacon or the marbling seen on steak), butter, and cream. (*Unsaturated* fat comes vegetable sources such as olive oil, canola oil, and margarine.)

The increased amounts of saturated fat in the diets of some people with celiac disease is explained by the tendency for individuals with this condition to eat relatively more meat and dairy products at meals because they cannot eat gluten-containing bread.

An incredibly handsome, very clever, athletic, and personable young man with celiac disease — we'll arbitrarily call him Peter as in, ahem, Sheila's husband, who, after reading this over-the-top description of himself, is hopefully going to be so flattered that he will promise to do the dishes for life — certainly demonstrated this over-reliance on saturated fat intake in days gone by. While the rest of the family was filling up on a single hamburger (with bun), Peter needed to eat two or more gluten-free hamburger patties (sans bun) in order to feel satiated. While Sheila and the kids would have a single sandwich for lunch, without benefit of bread to fill him up, Peter ate slice after slice of cold meat and cheese. Breakfast out of the home could be eggs, bacon or sausage, and fried potatoes instead of filling up on toast. As Peter got older, as a greater variety of tasty, gluten-free sources of fiber-rich and filling foods became available, and as he eventually succumbed to his loving wife's, ah, gentle encouragement, he was able to successfully cut way back on his saturated food intake.

A gluten-free diet doesn't have to be rich in saturated fats. Indeed, as we discuss in Chapter 10, a gluten-free diet can be very healthful because eating fresh foods instead of processed, packaged, or prepared foods is the best way to avoid ingesting gluten. Adding the extra nutritious foods listed in the preceding section to every meal is one way to keep the gluten-free diet more varied and minimize the tendency to rely on fatty (and sugar-laden) foods.

Here are some other ways you can reduce the saturated fat in your diet:

- Instead of bacon and eggs, serve gluten-free oatmeal or another gluten-free cereal topped with fresh fruit, dried fruit, and/or nuts.
- Replace processed meat-containing sandwiches for lunch with a salad with cheese, nuts, unprocessed meat, and lots of chopped vegetables. Include gluten-free breads, breadsticks, biscuits, or crackers.
- Rather than serving burgers, make a gluten-free noodle or pasta dish served with lots of vegetables.

In case you think these suggestions are just for show, they are actually based on what Sheila and Peter ate this Saturday — a Greek salad with tomatoes, cucumbers, black olives, and feta cheese at lunch, and a chicken Pad Thai with rice noodles, peanuts, red peppers, green beans, and cilantro for dinner.

Having gluten-free items on hand and the time to cook allows you to create healthy and tasty gluten-free meals.

# Being Overweight and Having Celiac Disease

More than half of the people with celiac disease living in the United States are overweight at the time their condition is diagnosed. Even overweight people, however, may still be malnourished due either to poor eating habits leading to insufficient ingestion of important nutrients or, in the case of celiac disease, malabsorption of certain nutrients.

Whereas historically celiac disease was considered a childhood ailment, currently the average age at which someone is diagnosed is in their fifties. Since most North Americans get increasingly overweight as they age, this also applies to people with celiac disease.

Every person, whether they have celiac disease or not, should strive to be at a healthy weight. In Chapter 3,we discuss how you can determine if you are overweight (or underweight), and in Chapter 15 we look at helpful measures you can follow to achieve and maintain a healthy body weight whilst living gluten-free.

# Celiac Disease and Lactose Intolerance

Lactose intolerance, a situation in which one cannot digest lactose, the sugar found in milk, is a very, very common condition whether one has or does not have celiac disease. Although lactose intolerance is seldom a serious problem, it can cause additional difficulties for people with celiac disease. Also, symptoms of lactose intolerance are often confused with symptoms of celiac disease. In this section we sort through these issues.

*Lactose* is a sugar (which is a form of carbohydrate) found in all mammalian milk (human, cow, sheep, goat, and so on). Lactose is also present in milk products such as ice cream, cheese, cream, and butter. Lactose is actually comprised of two smaller sugars (*galactose* and *glucose*) which are joined together. Lactose is not directly absorbed into the body, but rather must first be broken down into these two smaller sugars. This is accomplished with the aid of a special enzyme called *lactase* which is found on the inner surface of the small intestine in an area called the *brush border* (see Chapter 2 for more on the what the small intestine does.) If an individual lacks sufficient lactase, the result is that lactose is not properly broken down and absorbed into the body.

## *Who gets lactose intolerance?*

It's hard to truly consider lactose intolerance a disease or an abnormal condition since most of the world has this condition. Indeed, it affects the majority (over 85 percent) of people originating from Asia, Africa, the Mediterranean, and also native North and South Americans. Even in northern European populations, lactose intolerance affects about 30 percent of the healthy population. It is only relatively recently, with the advent of refrigerators (and hence the ability to consume dairy products such as milk, ice cream, and butter), that the issue of lactose intolerance has come into the fore.

Almost everyone in the world is born with normal intestinal levels of lactase. This is of tremendous importance since ideally a newborn's nutrition comes from drinking breast milk, and without lactase an infant isn't able to absorb the milk's lactose. As people grow up the amount of lactase present in the intestine progressively declines eventually leading, in many people, to lactose intolerance. The reason for the decline is not known for certain, but probably lies in the evolutionary fact that, in pre-historic times, a child who had outgrown drinking breast milk would have had no need for lactase because the only other milk products available for consumption would have been fermented milk products such as cheese and yogurt, in which bacteria did the work of digesting the lactose.

## *How lactose intolerance makes you feel*

Symptoms of lactose intolerance include flatulence (that is, farting) and diarrhea. These arise because the lactose-intolerant person is unable to sufficiently break down (and absorb) lactose in the small intestine, so the lactose travels to the large intestine where bacteria find it a tasty snack and munch on it, thereby turning it into gas and diarrhea-promoting substances. Oh joy. Fortunately, these symptoms are rarely severe and affected individuals typically learn to recognize which foods cause the problems and so avoid them.

Unlike celiac disease or a food allergy, it is important to note that lactose intolerance does *not* cause any lasting or even transient damage to the intestine.

## *Celiac disease and your lactase levels*

As we mention earlier in this section, the amount of lactase in the small intestine normally falls as one becomes an adult. Nonetheless, there is typically a sufficient level to keep most adults free or nearly free of symptoms of lactose intolerance. However, if you have celiac disease and your small intestine becomes damaged as a result, you are prone to having profoundly low levels of lactase. As a result, you may have symptoms not only from your celiac disease (see Chapter 6) but also from lactose intolerance.

As we discuss in more detail in Chapter 12, because temporary lactose intolerance is so common with newly diagnosed celiac disease, we recommend you follow a lactose-free diet for a minimum of a few weeks after you begin your gluten-free diet. Once you are on track with your gluten-free diet and your intestine heals, your lactase level will return to normal, you will regain the ability to digest lactose, and your symptoms from both conditions will go away. Well . . . with one exception: If you already had lactose intolerance before you developed celiac disease, you may still have it even after your celiac disease is treated and under control.

If despite adherence to a gluten-free diet you continue to have symptoms of abdominal bloating, flatulence, and diarrhea, let your doctor know. It could be that you have lactose intolerance. We discuss how to diagnose and treat this condition next.

## Diagnosing lactose intolerance

Lactose intolerance in otherwise healthy individuals is typically easily recognized — both by people with the condition and by doctors — based on two findings:

- ✔ The rapid development of abdominal cramping, bloating, and diarrhea soon after drinking milk or a milkshake, eating ice cream, or consuming other lactose-containing products.
- ✔ Quick improvement in these symptoms once lactose-containing substances have been removed from the diet.

The diagnosis of lactose intolerance is often straightforward enough that an affected person can correctly identify it before he or she even sees a doctor. When a person has the typical features of lactose intolerance that we just described, no special diagnostic tests are needed.

In some situations, the diagnosis of lactose intolerance is less apparent and a doctor may request you have a special diagnostic procedure called a *breath test*. In this test, you drink a lactose-containing beverage, and your breath is then analyzed to see how much hydrogen gas it contains. If you have lactose intolerance, you have excess amounts of hydrogen gas. (As we discuss in the earlier section "How lactose intolerance makes you feel," lactose intolerance leads to excess gas being produced in the large intestine. Some of this gas is absorbed from the colon into the body and is then present in the mouth where the breath test can measure it. Sure beats having a probe put, ah, *elsewhere*, to obtain a direct measurement of the hydrogen content of the gas in your colon!)

If you are asked to perform the breath test, be sure to hang out near a toilet for a few hours after the test. If you have lactose intolerance, the extra lactose you consume during the test can act as a laxative.

If you have celiac disease, the main reason to have a breath test would be if, despite following a gluten-free diet, you continue to have symptoms such as abdominal bloating, cramps, and diarrhea, and the cause is unclear.

## Treating lactose intolerance

You can treat your lactose intolerance in three ways:

- ✔ **Take a lactase enzyme supplement immediately before ingesting a lactose-containing food.** These are available as drops or pills which serve the same digestive role as naturally occurring lactase enzyme found in the healthy gut. This is the preferred option for most people.

- ✔ **Avoid consuming any lactose-containing foods.** This option is effective, but it can be very restricting.

- ✔ **Consume milk products which, prior to sale, have been pre-treated so that they no longer contain lactose.** This is also an effective option; however, these products are more expensive than simply adding your own lactase drops to a jug of milk at home.

Despite what many people (including many doctors) think, if you have lactose intolerance, there *are* some dairy products you can consume. Since almost all aged (hard) cheeses, yogurts (unless, as is done only rarely, fresh milk has been added after pasteurization), sour milk, and buttermilk are naturally lactose free, you can safely consume these.

Many manufacturers label their lactose-free products as, well, "lactose-free." Also, the symbol "live and active culture" on yogurt denotes that the yogurt is lactose-free.

If you are seemingly intolerant of many or all milk products, it may be that you have a different form of sensitivity to dairy products than lactose intolerance or cows' milk allergy. The long-chain triacylglycerol (a form of fat) content of whole milk and cream, as well as items made from these dairy products including butter, ice cream, cheese, and yogurt, may be a factor in perceived dairy intolerance in patients with functional GI disorders (discussed in Chapter 12) and other digestive conditions.

If you have celiac disease, you must avoid any and all gluten because consuming even tiny amounts will damage your intestine. If, on the other hand, you have lactose intolerance or another form of milk intolerance, consuming milk products won't damage your gut, but it will make you feel unwell.

# Living Gluten-Free as a Vegetarian

A small but growing number of the North American population are *vegetarians*; that is, they do not consume animal flesh whether it is meat, fowl, fish, or seafood. A subset of vegetarians are *vegans,* meaning that they avoid *all* animal products including eggs and dairy products.

As people who follow a vegetarian diet invariably know, there are a number of health benefits to this diet (compared to a non-vegetarian diet) including:

✔ Less consumption of saturated fat and cholesterol.

✔ Greater intake of fiber.

✔ Increased ingestion of the mineral magnesium.

✔ More ingestion of certain vitamins such as folic acid, vitamin C, and vitamin E.

✔ Greater intake of some *antioxidants* such as *carotenoids*. Antioxidants are substances that protect cells from damage caused by *free radicals* (compounds formed during the metabolism of oxygen in our bodies). Carotenoids are certain nutrients, like provitamin A and lycopene, that are found in yellow, orange, or red fruits and vegetables.

✔ Less likelihood of being overweight.

✔ Better blood cholesterol levels.

✔ Lower blood pressure.

✔ Less risk of heart disease.

Although there are health benefits to following a vegetarian diet, there are challenges as well:

✔ By avoiding meat, poultry, fish, and seafood, your diet is devoid of the major sources of protein, iron, zinc, omega-3-fatty acids, and vitamins A and $B_{12}$.

✔ Eliminating eggs and milk products removes from your diet calcium and vitamin D in addition to other sources of dietary protein.

Despite these obstacles, with knowledge and care a nutritious, vegetarian, gluten-free diet is possible.

Earlier in this chapter, we look at sources of calcium and iron, many of which can be consumed by people following a vegetarian diet. See the sections "Consuming calcium" and "Ironing out iron deficiency" for details.

Since ingesting sufficient protein can be a problem for vegetarians, especially vegans, make sure you eat a variety of alternate protein sources such as nuts, legumes, and various soy products like tofu. Many gluten-free grains such as amaranth, buckwheat, millet, quinoa, sorghum, teff, and wild rice contain higher levels of protein than wheat. Quinoa is probably the best grain in this regard because it is considered a *complete protein*; that is, it contains adequate levels of all essential amino acids, the building blocks of proteins.

Absorption of the mineral zinc is enhanced by ingesting animal protein and inhibited by consuming *phyates,* compounds found in legumes and whole grains. Because of this, it is recommended that vegetarians consume twice as much zinc as non-vegetarians. Non-animal sources of foods that are high in zinc include nuts, seeds, legumes, and various grains including wild rice.

Insufficient ingestion of vitamin $B_{12}$ is only a problem for vegetarians who do not eat eggs or dairy products. Vegans must use either vitamin $B_{12}$-fortified foods such as soymilk or take vitamin $B_{12}$ supplements.

If you are following a vegetarian diet — especially the vegan form — we strongly encourage you to sit down and spend time with a dietitian. They can work closely with you to design a nutritious, gluten-free and vegetarian diet.

A list of Internet resources providing dietary information for vegetarians is included in Appendix A.

# Chapter 12

# Are You Responding to Your Gluten-Free Diet? (And What to Do If You Aren't)

. . . . . . . . . . . . . . . . . . . . . . . . . . . . . . . . . . . . . . . . . . . . . . . . . . . . . . . . . . .

### In This Chapter

▶ Knowing whether your gluten-free diet is working

▶ Situations that keep your gluten-free diet from working

▶ Looking at other possible causes to explain why you aren't responding to your diet

. . . . . . . . . . . . . . . . . . . . . . . . . . . . . . . . . . . . . . . . . . . . . . . . . . . . . . . . . . .

*I*f you have very recently been diagnosed with celiac disease and you are now starting on your gluten-free diet, you're probably wondering how long it will take for you to feel better, what symptoms will go away the fastest, and how long it will take for you to again feel one hundred percent (something which, if you've been ill for a long time, may be but a distant memory). In this chapter we look at these issues and also discuss what you should do if, despite following a gluten-free diet, things just aren't coming around the way you expect.

To succeed with a gluten-free diet, you must know what is a gluten-free diet in the first place! We discuss this in detail in Chapter 10, but even if you've read and re-read that chapter, we cannot emphasize strongly enough the impor-tance of you meeting with a skilled, celiac disease-savvy dietitian to receive expert advice on how to live gluten-free.

## Knowing Whether Your Gluten-Free Diet Is Working

There are several ways in which you and your health care team can deter-mine whether your gluten-free diet is working. You can keep a look out for symptoms, blood tests can be performed, and, in some cases, a repeat small intestine biopsy is performed. We look at these topics in this section.

Speaking of blood tests to monitor your response to a gluten-free diet: There are no rules regarding what tests you should have or how often you should have them. As we discuss in Chapter 15, the testing your doctor sends you for to monitor your celiac disease depends on your particular circumstances and your doctor's best judgment. In general, though, the more the blood abnormalities and the greater their severity *prior to* your beginning your diet, the more often you're likely to need these tests rechecked *after* you begin your diet.

## Surveying your symptoms

The best and easiest way for you to tell whether your gluten-free diet is working is for you to simply ask yourself, "How am I feeling?" If you are like most people with celiac disease, within a matter of weeks of starting a gluten-free diet, you'll find yourself answering with a resounding, "A whole lot better."

If you had celiac disease for a long time before it was discovered, and especially if you've been quite ill from it, it may take longer than usual for you to feel better.

Following are key symptoms you and your doctor can monitor to track your progress (we discuss these and other symptoms in detail in Chapter 6; in Chapter 15, we talk about monitoring celiac disease):

- ✔ **Your general sense of well-being.** This is often one of the very first things to improve.

- ✔ **Your energy level.** This tends to improve in tandem with your sense of well-being.

- ✔ **Gastrointestinal symptoms.** Your indigestions, bloating, flatulence, and diarrhea will likely start to ease within a few weeks.

Although monitoring how you're responding to your gluten-free diet by keeping tabs on these symptoms is very helpful, it's important to remember that these and other symptoms also can be present due to conditions totally unrelated to celiac disease. For this reason, although doctors (including us) put great emphasis on learning about and following your symptoms to help gauge your response to your diet, if your symptoms persist, neither you nor your doctor should automatically assume the problem is your celiac disease. It could, in fact, be that you have some other condition altogether. In this situation, your doctor will need to send you for other investigations in order to determine what is amiss.

## Antibody blood tests

As we discuss in Chapter 3, the single most important blood test to help diagnose celiac disease is the tissue transglutaminase (TTG) IgA antibody. The TTG IgA antibody can also be used to monitor how your gut is healing. If checked a few months after you've been on your gluten-free diet, your TTG IgA antibody level should be lower in amount than before you started treatment. (The antigliadin IgA antibody — which we also discuss in Chapter 3 — can also be used for this purpose but it less reliable so is not as often used.)

If you are IgA deficient (see Chapter 3 for more in-depth information), monitoring your response to your gluten-free diet by measuring your TTG IgA antibody level won't be helpful because your body can't make IgA in the first place. If this is the case, your doctor will use other means to monitor your progress, including other blood tests such as the *IgG* form of TTG antibody, a hemoglobin level to monitor for anemia (if you were anemic to begin with), or a vitamin D level if, prior to treatment, it was low. Sometimes, a follow-up endoscopy and small intestine biopsy are required.

If you've never had a small intestine biopsy performed that proved you have celiac disease, monitoring your response to your gluten-free diet by following your antibody tests becomes less reliable. It could be, in fact, that you don't actually have celiac disease, and any positive antibody tests you've had (or continue to have) may be positive for reasons unrelated to celiac disease.

## Other blood tests

If, when you were diagnosed with celiac disease, your doctor discovered you had a low hemoglobin level (that is, you were anemic) or were deficient in iron, vitamin D, calcium, or other nutrients, your physician can monitor your progress by checking these levels in your blood from time to time. As you follow your gluten-free diet, your bowel should be healing and regaining its ability to absorb these nutrients into your body; hence, your levels should gradually return to normal.

Once your blood chemistry levels are back to normal, if your doctor had previously advised you to take supplements (such as iron), he or she may now tell you to discontinue them. If so, it's important to then have these levels rechecked a few months later to ensure they remain normal. If they've fallen again, it may indicate that your intestine is still damaged and unable to sufficiently absorb nutrients into your body.

Vitamin D deficiency is so common in the general population (that is, in people without celiac disease or any other health problem) that many physicians and other health advocates recommend vitamin D supplements be taken routinely. This is especially so in middle-aged and older women who are also routinely advised to take supplemental calcium (to help preserve bone

strength and mass). Therefore, if you are a woman in this age group and you have celiac disease and your doctor advises you that you can discontinue your vitamin D and calcium because your bowel has healed, ask if you should continue these nutrients anyway.

## Another intestinal biopsy?

Many people with celiac disease never require a second endoscopy and small intestine biopsy. Rather, their response to their gluten-free diet can be monitored using the blood tests we describe in the preceding sections. There are, however, certain circumstances when a repeat biopsy may be necessary; for example if you have:

- ✔ Persisting gastrointestinal symptoms (like abdominal cramps and diarrhea) despite following a gluten-free diet.

- ✔ Persisting, unexplained iron deficiency.

- ✔ The return of gastrointestinal symptoms or anemia yet no rise in your antibody levels. (If your antibody levels go up simultaneously with the redevelopment of symptoms or anemia, a repeat biopsy is not usually necessary because the likelihood that gluten has re-entered your diet is overwhelming. However, even then, your doctor may decide a repeat biopsy is in order, especially if you are quite ill.)

- ✔ The new development of weight loss, anemia, and/or severe diarrhea despite following a gluten-free diet. In this situation, an endoscopy and small intestine biopsy may help confirm these symptoms are due to celiac disease or, alternatively, may reveal some other, unrelated, gastrointestinal disorder.

- ✔ Celiac disease but you never had antibodies (such as the tissue transglutaminase antibody) present that are typically seen with active celiac disease. In this case, your doctor cannot monitor your antibody levels to determine if your bowel is healing.

## The persistently abnormal small intestine biopsy

Although it's unlikely you will require a second endoscopy and small intestine biopsy, if you do and it's abnormal, that does not always mean you have active celiac disease. Basically, it depends on what types and degrees of abnormalities show up.

If your repeat biopsy shows classical features of active celiac disease such as *villous atrophy* (explained in see Chapter 3), then it's guaranteed you have active celiac disease. Conversely, if all the biopsy reveals is mild inflammation, then your celiac disease may, nonetheless, be well controlled. It can take years for these mild inflammatory changes (particularly an increased number of *intraepithelial lymphocytes*; see Chapter 3) to resolve; indeed, sometimes they never do.

If ever you have a repeat biopsy performed and you're told it shows evidence of active celiac disease, discuss with your doctor what specific findings were found and how convincing was the evidence that you still have active celiac disease. A healthy conversation with your specialist about your results can't hurt and may prove very enlightening; especially if it turns out that your biopsy results aren't proof-positive that you have active celiac disease.

Although it is unknown why increased intraepithelial lymphocytes (a possible sign of ongoing inflammation) can still be found in biopsies of some patients who have been on a gluten-free diet for years, possible explanations include the following:

- ✔ Accidental ingestion of miniscule amounts of gluten (which could maintain ongoing, mild inflammation in the gut).
- ✔ A very slow-to-heal digestive system.
- ✔ Having some other condition that causes biopsy findings similar to celiac disease but occurs unrelated to gluten ingestion. For example, increased intraepithelial lymphocytes in the small intestine can sometimes result from anti-inflammatory medications or infections (such as that caused by the *Helicobacter pylori* bacteria).

# Exploring Why Your Gluten-Free Diet May Not Be Working

In most cases, it is readily apparent if a person is succeeding with their gluten-free diet. A previously unwell person, newly diagnosed with celiac disease, is placed on a gluten-free diet and, within a matter of few weeks, is feeling much better. Soon thereafter, his blood tests are improving, and lickety-split, he's on his way to restored good health. Simple as that. But what about the person who doesn't quickly feel better, or whose lab tests don't show improvement. Could it be that he isn't responding to his gluten-free diet (that is, he has *non-responsive celiac disease*)?

The single most important clue to you and your doctor that you're not sufficiently responding to your gluten-free diet is if, despite carefully following your nutrition program, you're not feeling any better or, especially, if you're feeling worse. An additional, strong clue to your doctor that your gluten-free diet isn't working the way it should is if your lab tests are not improving (refer to the preceding sections for information on follow-up tests).

Don't wait months and months to get in touch with your doctor or dietitian if you feel that you're not responding the way you should to your gluten-free diet. Your health care providers will want to know if the treatment isn't working so that they can figure out why and get you feeling better! In this section, we look at the most common reasons why a gluten-free diet may not be working the way it should.

If you're not responding to your gluten-free diet the way you should, take heart. There is always a reason, and once the reason is discovered and rectified, you'll be back on the road to recovery.

## Continued gluten exposure

The most common reason for someone to fail to get better on a gluten-free diet is that that person isn't on a gluten-free diet! This is typically due to one of three things:

- ✔ You're unintentionally consuming gluten. Sometimes, despite your best efforts, you are still ingesting gluten-containing food. In this case, it's a matter of sitting down with your doctor and dietitian and identifying the source. Other times, non-food sources of gluten are being inadvertently consumed. In Chapter 10, we look at these non-food sources of gluten, including certain medications and even lipstick.

- ✔ You know you're consuming gluten and are aware that it can hurt you but, for whatever reason, you elect to ignore medical advice (oh yes, this does indeed happen; perhaps more often than you might think) and to carry on with your old diet.

- ✔ You (incorrectly) believe that "just a little bit of gluten won't hurt" and therefore continue to ingest it.

If you aren't responding to your diet and you recognize that you're consuming gluten, do yourself a huge favor and stop. As long as you continue to ingest gluten, your bowel will not heal, and you'll be at risk of progressive damage to your body. The only safe level of gluten that you may consume if you have celiac disease is *none at all*. Also, if you've been consuming gluten, let your doctor know; otherwise, your physician may end up asking you to perform all sorts of tests as he or she tries to discover why it is you're not getting better.

If you're following a gluten-free diet, yet you're not getting better, keep a detailed record of anything and everything that you're ingesting (foods, liquids, medicines, and so on) and bring the record with you to an appointment with your dietitian. A celiac disease-savvy dietitian may well discover sources of gluten that are not readily apparent to you.

Don't be too hard on yourself if and when you inadvertently eat something with gluten or even when you decide to taste just a tiny piece of a homemade gluten-containing baked treat. Just climb back on that horse (the gluten-free horse that is) and keep fighting to stay gluten-free. We certainly don't advocate consuming *any* gluten at all, but we also recognize that nobody is perfect. (Consuming even small amounts of gluten is unwise, but so long as the amount you've ingested is very small and so long as it happens only rarely, the odds are good that you and your bowel will be fine.)

## Conditions complicating celiac disease

Another relatively common reason why people with celiac disease may remain unwell despite following a gluten-free diet is if they have some other, additional gastrointestinal ailment that causes similar symptoms to their celiac disease. We look at these in this section.

Even if you are found to have one of the conditions we discuss here, since you also have celiac disease you must continue, uninterrupted, on your gluten-free diet.

### Lactose intolerance

As we discuss in detail in Chapter 11, lactose intolerance is a very, very common condition in which an individual lacks sufficient *lactase enzyme* to properly digest *lactose* (the sugar found in milk products) and as a result may experience gastrointestinal (GI) symptoms such as abdominal cramps, flatulence, and diarrhea.

Because lactose intolerance is so common in most population groups, there are going to be lots and lots of people with celiac disease who also have this condition. Indeed, it may well be that before you were diagnosed with celiac disease, you were already known to have lactose intolerance. In that case, after you've been diagnosed with celiac disease, you will need to continue with your lactose-free diet (with or without the use of lactase supplements). Otherwise, even if you're following a gluten-free diet, you will have GI symptoms.

If your bowel was quite inflamed before you started your gluten-free diet, you may develop *temporary* lactose intolerance due to transient loss of normal levels of lactase. As a result, you may have GI symptoms from both your

celiac disease *and* from your lactose intolerance. These may be indistinguishable from one another. Because this temporary lactose intolerance is so common with newly diagnosed celiac disease, you should follow a lactose-free diet for a minimum of a few weeks after you begin your gluten-free diet. At that point, although your bowel won't be completely healed, it will have sufficiently replenished its quantity of lactase that you can resume ingestion of lactose-containing products.

### Small intestinal bacterial overgrowth (SIBO)

Microorganisms (such as bacteria) — also known as microbes — live within much of our digestive tract. The number of microbes present increases as one moves (figuratively speaking) from the upper small intestine to the end of the large intestine. As many as 100 *trillion* microbes per 1 milliliter of fluid are within the lower part of the large intestine. How many is a trillion? Well, written out it's 100,000,000,000,000! Can you imagine that many bugs living in a space that is ⅕ of a teaspoon of liquid? Yuk! No wonder Mom and Dad taught you to wash your hands after going to the bathroom!

Although much remains to be discovered regarding the role (or roles) that gut bacteria play in maintaining human health, it is known that they are essential in helping normal digestion proceed. If, however, there are excess numbers of bacteria in the small intestine — a condition called *small intestinal bacterial overgrowth* (or SIBO for short) — the bacteria can damage the lining of the small intestine leading to malabsorption of fat, protein, carbohydrates (including lactose), and other nutrients which, in turn, causes symptoms such as diarrhea. (We discuss malabsorption in Chapter 6.)

Many diseases can be associated with small intestinal bacterial overgrowth including, importantly, celiac disease. Therefore, if you continue to have GI symptoms such as diarrhea despite following a gluten-free diet, SIBO is something your doctor needs to consider.

SIBO is diagnosed using sophisticated tests including those that measure the amounts of certain molecules in your breath, and, looking in the other direction, other tests that measure the amounts of certain molecules in your stool. Because these tests are difficult to perform, are not always available, and are not always reliable, if your doctor believes you may have SIBO, she may elect to simply treat you based on her suspicion you have it. The treatment typically consists of a 7- to 10-day course of an antibiotic and then using probiotics (see Chapter 13) or eating natural yogurt after the antibiotics are completed with the goal of increasing levels of more helpful bacteria such as *lactobacillus*.

### Pancreatic insufficiency

As we discuss in Chapter 3, the pancreas is very important in digestion because it makes enzymes that travel down into the gut and assist with the breakdown of nutrients into small molecules that can then be absorbed into the body. This is called the pancreas' *exocrine* function. (The pancreas's

other function, referred to as its *endocrine* function, is to make insulin and other hormones that help regulate blood glucose levels.)

For unclear reasons, the pancreas's exocrine function becomes impaired (a condition called *pancreatic insufficiency*) in the occasional person with celiac disease and, as a result, that person develops malabsorption. Symptoms include bloating, flatulence, diarrhea, and weight loss. Because these symptoms are often also seen with celiac disease, your doctor may not necessarily consider pancreatic insufficiency as a cause of your symptoms . . . in which case we're thrilled you're reading this section! Because now that you've read this, should your GI symptoms not be responding to a carefully followed gluten-free diet, you can bring the possible diagnosis of pancreatic insufficiency to your doctor's attention. (If — perish the thought — your doctor takes exception to your doing this, as always, feel free to blame us for putting you up to the job!)

Because there are no particularly good ways of testing for pancreatic insufficiency and because therapy is safe and simple, most physicians treat suspected cases on speculation (what doctors call *empirical therapy*). Treatment consists of taking, in pill form, the enzymes that the pancreas normally makes. We admit this isn't the most scientific process in the world, but sometimes a quick-and-dirty approach is the best.

Wendy had persistent complaints of loose stools and upper abdominal discomfort in spite of being on a strict gluten-free diet for two years. Her regular gastroenterologist suggested a lactose-free diet with lactase supplements. This helped, but not completely. Wendy was then referred to Sheila to find out why her symptoms weren't responding. Wendy's subsequent blood tests, including TTG IgA antibody (which had been mildly elevated to start with), were normal. Sheila's dietitian colleague, Nora, was certain Wendy was living completely gluten-free. Sheila organized an endoscopy and small bowel biopsy, and these were normal. She then prescribed pancreatic enzyme supplements and, lo and behold, just a few weeks later Wendy called Sheila to let her know that, since starting the enzyme supplements, her symptoms had entirely gone away.

### Microscopic colitis

*Microscopic colitis* is an *autoimmune disease* in which a special type of inflammatory cell — called a *lymphocyte* — accumulates within the lining of the large intestine (the colon). There are two types of microscopic colitis: *lymphocytic colitis* and *collagenous colitis*. If you happen to spend some time on the Internet reading about the nuances of these conditions and you find yourself feeling confused, then take some comfort with the knowledge that most every doctor and med student is also confused by this puzzling condition.

People with celiac disease, for unknown reasons, are more prone to microscopic colitis. The most common symptom is severe, watery diarrhea, typically far worse than the diarrhea that may occur with celiac disease. The condition is diagnosed by obtaining a biopsy of the colon (this is done when a colonoscopy is performed; in this procedure, a flexible tube is placed through the anus into the large bowel).

Intriguingly (well, at least to docs like us), the *large intestine* biopsy in lymphocytic colitis shows increased numbers of *intraepithelial lymphocytes* (see Chapter 3) which is the same feature that is seen in *small intestine* biopsies in active celiac disease. This hints at some common connection between the two conditions, but what, precisely, the connection may be is unknown.

For unclear reasons, ingesting gluten can sometimes promote or exacerbate the symptoms of microscopic colitis. As you therefore may expect, in this situation treatment includes following a gluten-free diet. This diet, of course, also treats the celiac disease.

There is some scientific evidence that taking ASA (Aspirin and many other brands), non-steroidal anti-inflammatory drugs (such as Motrin and many other brands), or certain other medications either causes or, at least, aggravates microscopic colitis so your doctor will likely advise you to withdraw these medications if possible.

If following a gluten-free diet and stopping any offending drug aren't sufficient to control your microscopic colitis, you then need other therapy. Options include prescription drugs such as mesalamine, prednisone or budesonide; and over-the-counter bismuth-containing products like Pepto-Bismol.

### Gastroparesis

*Gastroparesis* is a condition in which the stomach takes overly long to empty its contents into the small intestine. Although gastroparesis can affect people with celiac disease (hence the reason we discuss this condition), fortunately, this seldom happens.

The most common symptoms of gastroparesis are

- ✔ Early satiety (that is, feeling full far sooner than normal during a meal)
- ✔ Upper abdominal bloating or discomfort
- ✔ Nausea

As these symptoms can also be seen with celiac disease, on occasion the two conditions may be confused.

Gastroparesis is diagnosed by a special nuclear medicine test called a *gastric emptying scan* in which you ingest a piece of food (usually an egg sandwich) into which a tiny amount of radioactivity has been placed. Pictures are then taken of your abdomen to see how long it takes for the food to pass from your stomach into your small intestine.

If you have gastroparesis due to celiac disease, following a gluten-free diet typically helps both conditions and, indeed, your gastroparesis may entirely resolve. If, however, this doesn't happen, prescription medicines are available to help your stomach work better.

## Conditions coexisting with celiac disease

Having celiac disease does not, of course, mean that you cannot have other, unrelated, diseases including other gastrointestinal (GI) disorders. Indeed, if you have celiac disease, you remain as prone to GI conditions unrelated to celiac disease as does anyone else. Therefore, if despite carefully following a gluten-free diet, you find yourself having ongoing GI symptoms, you and your doctor should not automatically blame it all on your celiac disease. Rather, the two of you need to consider that you may also have another, *coincidental*, GI problem.

These are the three most important coincidental GI ailments to be considered:

- **Gastro-esophageal reflux disease (GERD)** is a condition in which stomach acid travels up into your esophagus and causes heartburn. We discuss this condition in Chapter 6.

- **Functional dyspepsia (also called *non-ulcer dyspepsia*)** is a condition in which you experience persisting or recurring pain or discomfort centered in the upper abdomen despite the absence of "structural" (that is, physically apparent) diseases like ulcers of the stomach or duodenum, stomach inflammation (*gastritis*), stomach cancer, and so on. Symptoms may also include nausea, feeling full overly quickly as you eat, and/or feeling bloated after finishing a meal.

- **Irritable bowel syndrome (IBS)** is a condition with variable features, but most commonly involving recurring abdominal pain or discomfort that improves with having a bowel movement. Affected people also typically notice a change in the frequency or the appearance of their bowel movements (for example, their stools may become long and skinny like licorice). Some people with IBS have problems with constipation and bloating, while others have diarrhea and urgency where they need to find a bathroom ASAP. Although IBS is not serious, for some people it can be one big nuisance.

Because conditions like functional dyspepsia and irritable bowel syndrome can cause symptoms similar to those seen with celiac disease, some people who have *not* been diagnosed with celiac disease mistakenly ascribe their symptoms *to* celiac disease and initiate a gluten-free diet without first having these other conditions looked for and without having been tested for celiac disease. As a result, the wrong (self-) diagnosis may be made and the wrong (self-) treatment given. If you find yourself in this situation, we strongly recommend you see your doctor to be properly evaluated.

If you have not been diagnosed with celiac disease, yet you find yourself feeling better after starting yourself on a gluten-free diet, don't take this as evidence that you have this ailment. In fact, a recent study showed that only one-third of people in this situation actually had celiac disease. The other two-thirds of the group were using a rather restrictive diet to treat conditions that should have been treated in other ways. Remember: The only way to be definitively diagnosed with celiac disease is to first have a small intestine biopsy. (Hmm, is that the fiftieth or fifty-first time we've mentioned this? Think we're being nags here? Oh well, if it helps keep people healthy, we can live with the label.) Go to Chapter 3 for more on how celiac disease is diagnosed.

## Wrong diagnosis

You and your doctor should question the diagnosis of celiac disease when there is little or no improvement on your gluten-free diet. As we discuss in Chapter 3, it is not so rare that a diagnosis of celiac disease is made, for a variety of reasons, in someone in whom the condition isn't actually present.

Following are some of the most common conditions that are mistakenly diagnosed as celiac disease (when, in fact, they are entirely different ailments):

- **Irritable bowel syndrome.** We discuss this condition in the preceding section.

- **Functional dyspepsia.** We discuss this condition in the preceding section.

- Other functional gastrointestinal disorders (FGID). This is a large group of conditions that include IBS, functional dyspepsia, and other problems which can either co-exist with celiac disease or be mistakenly labeled as celiac disease. (For further information on FGID see www.iffgd.org or www.theromefoundation.org.)

- Inflammatory bowel disease. This includes *ulcerative colitis* and *Crohn's disease*. These are ailments, of unknown cause, where the intestine becomes inflamed and people experience abdominal pain and diarrhea. For further information about these conditions, see www.ccfa.org or www.ccfc.ca.

The number of other, less common or even rare conditions that can be mis-diagnosed as celiac disease is lengthy, and stretches from immune diseases (such as *common variable immunodeficiency*) to other forms of bowel disease (such as *eosinophilic gastroenteritis*) to other forms of food intolerance, and the list goes on (and on and on and . . .). There's no need, however, to look for these other, rare birds unless more common conditions, such as those in the preceding list, have first been excluded.

## The overall approach if you are not responding to your gluten-free diet

If your celiac disease symptoms are not improving despite following a gluten-free diet for at least a few weeks, we recommend you follow this step-wise approach:

1. **Meet with your dietitian to review your diet in detail to ensure you are not inadvertently (or even intentionally) consuming gluten; if there is no evidence that you're ingesting gluten, move on to Step 2.**

2. **Remove all lactose from your diet (if you haven't already done so). If this has not helped within a few weeks, then go to Step 3.**

3. **Speak to your celiac disease specialist about the possibility you may also have a complicating condition. If this isn't the case, proceed to Step 4.**

   Complicating conditions included small intestinal bacterial overgrowth or pancreatic insufficiency. See the earlier section "Conditions complicating celiac disease" for a more complete list.

4. **Speak to your specialist about the possibility you may also have an unrelated, coexisting condition. If this isn't the case, move to Step 5.**

   Coexisting conditions include functional dyspepsia, irritable bowel syndrome, and others discussed in the earlier section "Conditions coexisting with celiac disease."

5. **Speak to your specialist about the possibility that the diagnosis of celiac disease is inaccurate and that you have some other ailment altogether.**

   There's no harm in raising this possibility at *any* time; you don't have to wait until this step to bring this up with your doctor.

If your doctor elects to treat you for conditions in the preceding list, we recommend you be treated for only one condition at a time; otherwise, neither you nor your doctor will know which treatment was working for what condition.

# When Your Celiac Disease Won't Settle Down

Though it is not at all likely, it is possible that you will not improve despite having gone though all of the steps we discuss earlier in this chapter. You've reviewed with your dietitian every morsel that enters your mouth and nary a spec of gluten is to be found; you and your doctor have either excluded or have sufficiently treated any complicating or coexisting condition; the diagnosis of celiac disease has been convincingly made; but, well, you're just not feeling the way you should. What then? In this section we look at two important causes of non-responsive celiac disease that you and your doctor need to consider.

## Refractory celiac disease

Refractory celiac disease (RCD) is a rare condition in which a person's celiac disease doesn't settle despite meticulously following a gluten-free diet for at least one year. These are two additional features that need to be present in order for the diagnosis to be made:

- ✔ Repeated small intestine biopsies must show persisting abnormalities of celiac disease. We discuss these in Chapter 3.

- ✔ All other causes of persistent gastrointestinal symptoms need to be excluded.

Some people have RCD from the get-go — that is, from the time they are first diagnosed with celiac disease. Other people who develop RCD had initially responded to treatment, but as time passed, they redeveloped symptoms which wouldn't go away.

The underlying mechanism involved with refractory celiac disease is not fully sorted out but is likely related to chronic stimulation of the immune system. It is as if the immune system has gotten so chronically over-stimulated that it simply won't shut off. As part of this process, special types of white blood cells called *T lymphocytes* can transform so that they first become prone to developing cancer (that is, these lymphocytes becomes *precancerous*) then may subsequently become frankly cancerous. We discuss this rare type of cancer, a form of immune system malignancy (*lymphoma*) called *EATCL,* in the next section and, in more detail, in Chapter 9.

### Who is at increased risk of refractory celiac disease?

Not every person with celiac disease is at equal risk for developing refractory celiac disease. Refractory celiac disease is most likely to occur in

- ✔ The elderly
- ✔ People in whom the diagnosis of celiac disease is very delayed
- ✔ Individuals with known celiac disease who, nonetheless, elect to continue a gluten-containing diet year after year
- ✔ Adults who were diagnosed with celiac disease when they were children, but were subsequently told they had "outgrown it" and thus resumed consuming gluten. (Sadly, often these patients present later in life with complications of untreated celiac disease.)

### How is refractory celiac disease monitored?

If you have refractory celiac disease, your specialist will monitor you very closely. They will keep a special eye out for evidence of complications from the condition including ulcers of the small intestine and enlarged lymph nodes (lymph glands), the latter being a possible sign of lymphoma.

You will likely also be sent for tests that allow for an examination of that long portion of the small intestine that lies beyond the reach of a regular endoscope. These tests include barium x-rays and capsule endoscopy. We review these tests in Chapter 9.

If you have refractory celiac disease your doctor may mention to you that you have either the type I or type II variety. Cancer is rare with either, but of the two cancer is more likely to occur with the type II variety and hence if you have this form you will be especially closely monitored for the development of cancer.

### How is refractory celiac disease treated?

There are many different treatment options for RCD including using potent drugs like *corticosteroids* which suppress the immune system, and providing supplemental nutrition administered either via a *feeding tube* (inserted into the stomach) or given through an intravenous.

Despite these measures, people with refractory celiac disease remain at increased risk of death from infection, malnutrition, and certain types of cancer, especially EATCL (which we discuss next).

Given the seriousness and rarity of refractory celiac disease, it is usually best managed by a specialist who has specific expertise in celiac disease and has access to highly sophisticated resources such as is most commonly found in university-based, teaching hospitals. We list such centers in Appendix B.

Lest we've created undue concern, before we leave this section, we'll reiterate that refractory celiac disease is a rare disease so you'll be highly unlikely to ever get it. And, even then, the odds of it progressing to the point of triggering a cancer are very low indeed.

## Enteropathy-associated T cell lymphoma (EATCL)

As we discuss in detail in Chapter 9, enteropathy-associated T cell lymphoma (EATCL) is a rare form of cancer that starts in the immune system cells located in the small intestine. EATCL is more likely to occur if you have *refractory celiac disease* (see the immediately preceding section). Symptoms of EATCL include malaise, loss of appetite, weight loss, worsening diarrhea, abdominal pain, and fevers.

If you have these symptoms, you must see your physician as soon as possible. When your doctor examines you for suspected EATCL, he or she may find enlarged lymph glands, a skin rash, an enlarged liver, or an abdominal mass. Investigations typically include special x-rays (such as CT scans) of the chest and abdomen, and GI endoscopy (see Chapter 3). Treatment may include chemotherapy, radiation therapy, and surgery.

# Part IV

# The Long-Term: Living and Thriving with Celiac Disease

The 5th Wave          By Rich Tennant

"C'mon, Darrel! Someone with celiac disease shouldn't be lying around all day. Whereas someone with no life, like myself, has a very good reason."

# In this part . . .

Celiac disease is a condition you will be reckoning with for the long haul. In this part, we explore how celiac disease is managed during the various stages of life beginning with childhood. We also look at how celiac disease is monitored and what innovations in managing celiac disease may unfold in the future.

# Chapter 13

# Alternate and Complementary Therapies

*In This Chapter*

▶ Looking at how non-traditional treatments may help celiac disease

▶ Examining whether alternative and complementary therapies are beneficial

▶ Treating celiac disease by eliminating foods other than gluten from your diet

▶ Discussing whether gluten-free diets help people without celiac disease

*A*s we explain in Chapter 10, the mainstay of therapy for celiac disease is to follow a gluten-free diet. This has been — hang on to your hats — unequivocally, definitively, absolutely, and convincingly proven to effectively control the condition. (Not that we're adamant about this point or anything!) Nonetheless, given the restrictions that a gluten-free diet imposes, many people with celiac disease understandably wonder whether other treatment option may be available, including complementary and alternative therapies. We discuss these in this chapter. And, because some people living with celiac disease consider following non-traditional (though gluten-free diets), we also discuss this topic here.

*Complementary and alternate medicine* (CAM) refers to a group of diverse medical and health care systems, practices, and products that are not generally considered a part of conventional medicine. Similarly, complementary and alternative medicines (CAMs) are therapies provided by CAM practitioners. CAMs include certain herbs, vitamins (often in high dose), minerals, amino acids, and dietary supplements.

It is estimated that Americans spend roughly $34 billion a year out-of-pocket on complementary and alternative therapies. In this chapter we look at whether CAMs may be helpful to you in the management of your celiac disease, whether they are safe to use, and whether they are a good use of your hard-earned dollars.

# Important Safety Info about Complementary and Alternative Medicines

A frequent appeal of complementary and alternative medicines is that they are typically considered to be "natural." And, true enough, CAMs *are* found in nature rather than being created in a laboratory. It is essential, however, that you not automatically equate "natural" with necessarily meaning "healthy" or "good." After all, poison ivy, poison mushrooms, lead, arsenic, mercury, and a host of other potentially toxic products are also natural. Whether dealing with a prescription drug or a CAM, safety is always paramount.

Before you start taking complementary and alternative medicines, you should be aware of these important safety considerations:

- **If you have celiac disease and you choose to use an alternative or complementary medicine, make sure that it is gluten-free.** This may be very difficult to determine because the label will probably not provide this information and reaching the manufacturer — particularly when the manufacturer is overseas — may be difficult, if not impossible. Furthermore, the manufacturer may simply not be aware of this information one way or the other.

- **CAMs are not subject to the same legislative regulations or scrutiny as are prescription drugs.** For this reason, knowing if a CAM is safe to take is harder to determine.

- **CAMs that have similar labeling may nonetheless vary considerably in their potency.** In other words, you may think you're purchasing the same strength product time-after-time whereas what you're actually getting may differ significantly.

- **Certain CAMs can lead to a dangerous *increase* in potency of some prescription drugs.** For example, garlic can increase the potency of a strong *anticoagulant* (blood thinner) called *warfarin*, potentially leading to dangerous bleeding.

- **Some CAMs can lead to a dangerous *decrease* in potency of some prescription drugs.** For example, Coenzyme Q10 can decrease the potency of warfarin, leading to dangerous blood clotting.

- **Certain CAMs can *alter the amount* of a prescription medicine in the blood.** For example, St. John's wort can cause the blood level of a potent heart drug called digoxin to fall, which could result in a worsening of your heart condition.

> ✔ **CAMs themselves often contain many different ingredients.** Knowing how these interact with each other can be very difficult or even impossible to determine.

Just as with prescription drugs, be sure to let your health care provider know what, if any, alternative or complementary products you are taking. Some physicians, possibly including yours, may express frustration or become overtly upset when they find out you're taking complementary and alternative medicines. Nonetheless, this must not dissuade you from sharing your CAM use with your doctor. Your health may well depend on your doctor being aware of what CAMs you are taking so that he can do his best to determine whether the CAMs may adversely impact on your prescription medications, your celiac disease, or any other health conditions you may have. (By the way, most physicians, including us, even when skeptical of the putative benefits of a given CAM, are fine with patients taking them so long as the product isn't likely to be harmful.)

# Prebiotics and Probiotics

*Prebiotics* are defined as foods that do not get absorbed into the body. Instead they pass into the colon where they stimulate the growth in numbers of healthy bacteria. *Probiotics* are live bacteria or yeasts that you ingest to increase the numbers of these organisms living inside the gut.

People with celiac disease not infrequently consume prebiotics and probiotics to try to help treat their condition. Although there is little in the way of scientific studies to recommend their routine use to treat celiac disease, there is one special circumstance where probiotics do have a role to play. As we discuss in Chapter 12, small intestinal bacterial overgrowth is treated with antibiotics and ingesting probiotics. (This does, of course, raise the conundrum as to whether probiotics, if recommended by both CAM practitioners and mainstream health care providers alike, should be truly considered a CAM. In this case, it's not the product that makes it a CAM, but how it's used.)

Unlike most other CAM therapies, prebiotics and probiotics are proven to be both very safe when used on their own and also when used in combination with prescription drugs.

Fermented milk products such as yogurt contain probiotic organisms like Lactobacillus and are also a good source of calcium, protein, and other nutrients.

# Herbal Supplements

An *herb* is defined as a plant without a woody stem. Hmm. All we can say is thank goodness Simon and Garfunkel opted to sing about "Parsley, Sage, Rosemary and Thyme" instead!

Herbs are tasty, smell nice, and are fun to grow. They are sometimes used as part of CAM therapy for celiac disease (and many other disorders, too). Some people living with celiac disease take evening primrose, dandelion, saffron, nutmeg, or one or more many other herbs. Despite this, there is no credible evidence that eating herbs will help control your celiac disease.

Although herbal therapies are generally safe, there are reports of people who, having consumed herbal medicines, developed various side effects including hepatitis, liver failure, and kidney failure. As we say earlier in this chapter, *any* form of therapy must be approached with due caution.

# Vitamin Supplements

As we discover in detail in Chapter 7, some people with celiac disease benefit from *selective* use of *specific* vitamins, particularly vitamin $B_{12}$, vitamin D, and folic acid (also known as vitamin $B_9$). The main role for these supplements is in the early stages of celiac disease when you've been newly diagnosed, have symptoms (such as diarrhea and, possibly, weight loss), and you are just getting going on your gluten-free diet.

Once your celiac disease is under good control and your vitamin stores are replenished, it is seldom necessary to continue taking these vitamin supplements — with one exception relating to women and vitamin D. Because most North Americans do not get enough vitamin D from their diets or from sun exposure and because women are especially in need of sufficient vitamin D to help protect their bones from osteoporosis, it may be advisable to carry on taking vitamin D indefinitely. If you are a woman with celiac disease, we recommend you speak to your primary care provider (such as your family doctor) to find out if you should continue to take vitamin D on an ongoing basis.

Although you can find many multivitamins containing every vitamin (and, often, a host of other ingredients) under the sun, their use in celiac disease (or pretty well any other health condition) is seldom warranted or of value unless your eating habits are particularly poor. Further, it is possible to overdose from taking too much of a certain vitamin, like vitamin A, which accumulates in the body. Taking excess doses of other vitamins that are excreted in your urine is harmful only to the health of your wallet as you flush away some very expensive urine.

Nature designed us to obtain the nutrients we need *from food*. Studies indicate that diets high in fruits and vegetables are associated with lower rates of various conditions including cancers. However, the same benefits are not seen when we try to use vitamin supplements to mimic the effect of such vitamin-rich foods. This suggests that the healthful components of food are complex and cannot be fully replaced by supplements, at least at the current time.

# Digestive Enzymes

Digestive enzymes are available without prescription in health food stores and other commercial outlets. As we discuss in Chapter 12, such enzymes do have a proven role to play if you have *pancreatic insufficiency* (that is, a condition in which your pancreas is unable to make sufficient amounts of digestive enzymes). However, if you have celiac disease and a healthy pancreas (which is true of the vast majority of people with celiac disease), then taking digestive enzyme supplements provides no health value to you. Having said that, they're not likely to be harmful either, but hey, if you don't need these supplements, we're sure you can find better ways to spend your hard-earned dollars.

# Following the Specific Carbohydrate Diet

Some people with celiac disease (and other health disorders such as inflammatory bowel disease, explained in Chapter 12) place themselves on the *Specific Carbohydrate Diet* (SCD).

The SCD is a very restrictive diet that excludes most carbohydrates, including lactose-containing milk products. The theoretical basis for the diet — there is no scientific proof of this — goes like this:

1. Intestinal inflammation associated with conditions such as celiac disease and inflammatory bowel disease (IBD) is caused by intestinal microbes. (Remember, we're talking *theoretical* here; there is *no proof* whatsoever for this.)

2. Intestinal microbes feed off carbohydrates present in the bowel.

3. Ingesting less carbohydrate causes the intestinal microbes to starve and helps control the celiac disease or IBD.

It is also postulated that undigested carbohydrates can lead to formation of toxic products that destroy intestinal enzymes required for carbohydrate digestion and absorption.

Unfortunately, there are no well-designed medical research studies to support the use of this dietary intervention. Some people with various gastrointestinal illnesses report benefit from following the SCD, but most people who try it subsequently discontinue it because they observe no benefit.

The major concern about the SCD is whether you will be able, given the severe dietary restriction, to consume sufficient calories to maintain good nutrition and health. For this reason, we caution against children or underweight adults from following this diet.

If you think a gluten-free diet is restrictive then the specific carbohydrate diet is not for you!

# Treating Celiac Disease by Avoiding Foods Other Than Gluten

The mainstay of therapy for celiac disease is the elimination of gluten from one's diet. The only other necessary food restriction is the temporary elimination of lactose (this is the sugar found in milk products) for a time after celiac disease is first diagnosed (unless you also have pre-existing or ongoing lactose intolerance in which case you will need to remain lactose-free indefinitely.) We discuss lactose intolerance and celiac disease in detail in Chapter 11.

Although there are no scientifically proven benefits to be achieved by people living with celiac disease eliminating other types of foods from their diet, some individuals do find that they feel better if they do. Sometimes this is a general feeling of improved health, and sometimes it is a perceived reduction in specific symptoms such as abdominal discomfort, cramps, or diarrhea. In this situation the person is said to have a *food sensitivity* or *food intolerance*.

It's important to avoid confusing a food sensitivity (which is never serious) with a *food allergy* (which can be so serious as to be life-threatening). As we discuss in Chapter 2, a food sensitivity is an entirely different kettle of fish from a food allergy. A food allergy (such as a peanut allergy for example) is a serious problem in which, shortly after ingesting a substance, one develops symptoms such as skin rash (hives), shortness of breath, wheezing, swelling, and, sometimes, nausea, vomiting, and diarrhea. If you think you have a food allergy, you need to see an allergist to have this fully sorted out and, if the problem is confirmed, you should then meet with a dietitian to learn more about how to avoid the specific food to which you are allergic. A helpful website about food allergies is `www.foodallergy.org`.

Because it is not possible to medically test for food intolerances, except for a few sugar intolerances including milk sugar (lactose) and fructose, the only way to determine if a specific food may be causing your gastrointestinal symptoms is to remove it from your diet and see if, having done so, you feel better.

# Removing a limited number of foods from your diet

If you are pretty certain one or two foods are the cause of your abdominal pains or diarrhea, then try living without this food for a week or so. If this doesn't help, keep a daily record for a few weeks of everything you ingest and also note when your symptoms occur. Doing so may allow you to find a pattern wherein ingesting certain foods correlates with when you have your symptoms. If you find this type of match, you can then try eliminating the possibly "guilty" food from your diet and see whether you then feel better.

Bear in mind that, although there is no harm in doing any or all of these things, this is, at best, only a semi-scientific approach, and it will be difficult or even impossible to ever establish with certainty that any of these changes to your diet are actually responsible for any changes in your symptoms.

# Trying an elimination diet

If you seem to react to *lots* of foods and, in spite of keeping a food diary, you can't figure out what foods are making you feel unwell, then we suggest going on a so-called *elimination diet* (also known as an *exclusion diet* or a *hypo-allergenic diet)*. This diet is also gluten-free. If you decide to go on an elimination diet, make sure to do so with the advice and assistance of a physician knowledge-able in this field, such as an allergist, and a nutritionist. This approach is not recommended for children, those who are malnourished, and those with other conditions managed by dietary means, including diabetes.

With the elimination diet, you severely restrict the variety of foods you eat and, if your symptoms resolve, you then begin the detective work of finding out what food (or foods) might have been causing your symptoms before you removed it (or them) from your diet. The strategy here is to add one food type back in to your diet every 3 to 5 days and if this food doesn't cause problems, you keep adding another food into your diet until — *voila!* — you realize it was pork (or chicken or avocados or . . .) that was the reason you had nausea, vomiting, and diarrhea soon after you would eat certain meals. If specific foods are identified, then you can avoid eating such foods.

If, however, after being on the elimination diet for a few weeks, you do not feel any better or if you feel better but, upon sequentially reintroducing foods, you are unable to find any specific foods that trigger your symptoms, then you can be reassured it is not a specific food or group of foods causing the problem but rather just eating in general. Lots of patients have irritable bowel syndrome and other so-called functional gastrointestinal disorders (FGID; see Chapter 12) and experience non-specific reactions such as bloat-ing, belching, indigestion, and a sensation of urgently needing to have a bowel movement in response to eating. This is particularly likely if meals are large, fat-laden, or consumed quickly.

## Why it's okay to empirically withdraw lactose, but not gluten from your diet

Doctors commonly advise patients with suspected lactose intolerance (see Chapter 11) to avoid lactose containing foods for a week or two to see if this improves their symptoms. You may rightly ask why can't you can't do the same with gluten. Here are some reasons:

✔ Going off lactose will *not* alter the accuracy of subsequent medical testing for lactose intolerance whereas living gluten-free, depending on the duration, *can* affect the results of diagnostic tests for celiac disease thereby making it harder to determine if you or do not have the condition.

✔ Avoiding lactose is generally easier to do without professional dietary counselling than is avoiding gluten.

✔ Perhaps most importantly, feeling better off lactose is very likely to predict that you do, indeed, have lactose intolerance (that is, your own experiment with dietary manipulation allowed for a correct diagnosis) whereas feeling better off gluten does *not* accurately predict that the cause is celiac disease.

In Chapter 3 we look at additional reasons why we recommend against empirically removing gluten from your diet.

## *Removing certain sugars from the diet*

Lactose is not the only sugar (or carbohydrate) that can cause gastrointestinal complaints. *Fructose* and related products (called *fructans*) as well as *sorbitol* (which is a sugar alcohol) can cause diarrhea and bloating in some individuals. There is growing recognition that a larger group of dietary carbohydrates referred to as FODMAPS (hold on now; this stands for the following mouthful: *fermentable oligosaccharides, disaccharides, monosaccharides, and polyols*) can also cause gastrointestinal (GI) symptoms in certain settings.

Intolerance to FODMAPs has been studied primarily in people with irritable bowel syndrome (IBS), but could well play a role in some folks with celiac disease, particularly those with an IBS component to their illness. Not enough is as yet known about this to routinely warrant any reduction in your consumption of FODMAPS if you're having GI symptoms (hence we're including it in this chapter on complementary and alternative therapies), but it is something to consider if you still have problems in spite of a gluten-free diet, and if your doctor is not able to find any other reason for this.

# Going Gluten-Free to Treat Disorders Other Than Celiac Disease

Many people consider following a gluten-free diet even if they have neither celiac disease nor dermatitis herpetiformis (a skin disease closely related to celiac disease; we discuss this condition in Chapter 8). This is most common amongst those who believe they have a *food sensitivity* specifically to gluten (that is, *gluten sensitivity*) or if they are hoping that avoiding gluten may help neurological or mood symptoms they're experiencing. We discuss these issues in this section.

## Gluten sensitivity

*Gluten sensitivity* is not to be confused with the similar sounding term, *gluten-sensitive enteropathy*. Gluten-sensitive enteropathy is simply a synonym for celiac disease. Gluten sensitivity, on the other hand, refers to the situation wherein a person who does *not* have celiac disease finds that ingesting gluten makes him or her feel unwell in one way or another.

Although much is yet to be learned about gluten sensitivity, two key points are well recognized:

- ✔ Gluten sensitivity and celiac disease can cause *some* similar *gastrointestinal* symptoms such as nausea, abdominal discomfort or cramps, and diarrhea. Gluten sensitivity, however, does not cause the severe or specific problems that can sometimes be seen with celiac disease, such as malabsorption and osteoporosis.

- ✔ Whereas celiac disease causes demonstrable inflammation of the small intestine, gluten sensitivity does not damage the intestine or, for that matter, any other organs. In this sense, gluten sensitivity, even if it makes you feel unwell, does not carry the same potential dangers as does celiac disease.

### The cause of gluten sensitivity

Gluten sensitivity is neither a food allergy (like a peanut allergy) nor a T cell mediated disease (like celiac disease). In fact, it is not necessarily gluten that is responsible for the symptoms of gluten-sensitivity in the first place.

If you are thought to have gluten sensitivity and have eliminated gluten from your diet and felt better thereafter, you may well be wondering how it could be that gluten wasn't actually responsible for your previous symptoms. (We'd sure wonder this if we were in this position.) Here's the explanation: Those who adopt a gluten-free diet can no longer eat fast-food and prepared foods (as these things contain gluten) and their diet starts to contain more

*un*processed or natural foods. Going gluten-free gets rid of many additives, preservatives, fats, and other potentially unhealthy substances from the diet. Making this major improvement in your diet, it's no wonder that you would feel better! In other words, it's likely not the removal of gluten that made you feel better if you had gluten-sensitivity; it's eliminating all the other, unhealthy stuff that made the difference.

In some individuals with gluten-sensitivity, however, it may be gluten that is actually causing symptoms. Gluten can be hard to digest, and some medical studies have shown that diets high in gluten resulted in a larger output of stool compared to low gluten diets. Perhaps this somehow results in the GI symptoms that are noted by people with gluten sensitivity. At present this and other existing theories must be considered, well, just that: *theories*.

### The potential hazards of treating presumed gluten sensitivity without first ruling out celiac disease

If for any reason you or a family member have symptoms that you believe are due to gluten, do *not* commit yourself or a family member to a long-term gluten-free diet without first seeing a physician to have appropriate evaluation to determine whether celiac disease or some other potentially serious medical disorder is present.

Here are some of the many reasons why you or your family member should not follow a gluten-free diet without knowing what is being treated:

- ✔ **A gluten-free diet may not be the correct treatment for the underlying medical problem.** A gluten-free diet, for instance, won't help inflammatory bowel disease (explained in Chapter 12).

- ✔ **If you have been on a gluten-free diet for a number of months or more, it makes it more difficult to determine whether you have celiac disease (see Chapter 3).** Similarly, screening family members for celiac disease is more difficult if they are already on a gluten-free diet (see Chapter 4).

- ✔ **A gluten-free diet is expensive, especially if the whole family eats gluten-free.** Why spend this extra money if you don't have to? Make sure at least someone in the family has a good reason to be eating gluten-free (be it celiac disease or gluten sensitivity) before committing to this expense.

- ✔ **There is a risk of being less well nourished on a gluten-free diet**. Before you put yourself on a gluten-free diet you should first meet with a registered dietitian to receive their expert advice. (See Chapter 11 for more on potential nutritional deficiencies due to celiac disease.)

- ✔ **For medical insurance and tax reasons, it can be important to have a *proven* diagnosis of celiac disease.** Simply advising an insurer or tax department that you felt better not consuming gluten is unlikely to be sufficient to assist you with any insurance claims or applications for tax deductions. We discuss these issues in Chapter 15.

See Chapter 3 for a further discussion on why empirically removing gluten from your diet isn't wise.

Despite our major concerns about people self-diagnosing and self-treating for presumed gluten sensitivity or celiac disease, we do admit there *is* actually one benefit to be had from this. Marketers estimate that 15 to 25 percent of consumers want gluten-free foods even though only one percent have celiac disease. Even celebrities are "purifying" or "cleansing" using diets without meat, diary, sugar, caffeine, and, you guessed it, gluten! With so many people putting themselves on a gluten-free diet, the food industry is going gang-busters to accommodate the burgeoning demand and, as a result, is coming up with increasing variety (and palatability) in the gluten-free foods they offer. Indeed, creating gluten-free products is now one of the fastest growing aspect of the food industry. For those millions of people with celiac disease (and for those who have gluten sensitivity) who are looking for new food options, this is surely welcome news indeed.

## Going gluten-free to treat neurological and mood disorders

A gluten-free diet is sometimes used for the treatment of neurological and mood disorders ranging from Attention–Deficit/Hyperactivity Disorder (ADHD) and autism, to depression, schizophrenia, neuropathy, seizures, and migraines.

As we discuss in Chapter 6 and Chapter 8, celiac disease is associated with a variety of different neurological and mood issues. The reason (or reasons) for this association is largely unknown. One theory, however, is that gluten or components of gluten may be toxic to the brain or nerves. Another theory is that the immune response to gluten can lead to antibodies that may damage the nervous system. This has prompted some people to follow a gluten-free diet to treat neurological or mood ailments, even if they don't have celiac disease.

The scientific evidence for following a gluten-free diet in the absence of celiac disease is largely lacking.

We strongly recommend that if you or a family member suffer from a neurological or mood disorder, you contact your physician to be thoroughly assessed before you start yourself or a loved one on a gluten-free diet since other, more proven and more effective medical treatments are likely to be available.

# Chapter 14

# Celiac Disease and Pregnancy, Children, and Beyond

---

*In This Chapter*

▶ Getting pregnant and having celiac disease

▶ Dealing with celiac disease in infancy

▶ Diagnosing celiac disease in children

▶ Knowing how celiac disease can affect your child

▶ Beginning a child on a gluten-free diet

▶ Showing your child how to shop and cook to meet her special needs

▶ Growing pains for the parent of a child with celiac disease

---

*A*lthough everyone living with celiac disease shares certain things in common — such as the need to avoid consuming gluten — children face additional, special challenges that adults do not. And, if you are the parent of a child with celiac disease, you likely have already discovered that you, too, have challenges that other parents may not have to contend with.

If you have celiac disease and are trying to have a child, you may face certain hurdles. Celiac disease can cause infertility (in both men and women) and, once you're pregnant, it can increase the risk of certain obstetrical complications, including miscarriages.

In this chapter, we look at these important issues. As always, we encourage you to bear in mind that, although having celiac disease increases your risk of fertility and obstetrical difficulties, the great majority of people living with celiac disease are able to successfully conceive, deliver, and raise healthy children. (Well, the women do the conceiving and delivering!)

# Pregnancy and Celiac Disease

Celiac disease can interfere with a woman's reproductive function. This fact is unknown to most health care providers and, less surprisingly, is also unknown to most people living with celiac disease. Even more overlooked is that celiac disease can also interfere with a *man's* reproductive function. Reproductive difficulties range from infertility to miscarriages to delivering a small baby. We discuss these important topics in this section.

Like so very many other complications of celiac disease, these reproductive difficulties apply to *active* celiac disease. When you're on track with your gluten-free diet, these problems typically resolve.

## Infertility and celiac disease

*Infertility* is typically defined as the inability to conceive (that is, to become pregnant) despite a year or more of regular intercourse without contraception. Although the findings remain controversial, some scientific evidence is available to indicate that active celiac disease can cause infertility and, moreover, that this can happen in both men and women.

### Female infertility

In order for a woman to get pregnant, she must be able to ovulate. Ovulation is the process wherein an *ovum* (an "egg") is released from an ovary. After leaving the ovary, the ovum makes its way down the fallopian tube where, if one has had recent intercourse, it can then meet up with a sperm and the ovum can then be fertilized.

In the absence of ovulation, pregnancy cannot occur (except through in vitro fertilization — IVF — but that's a subject for a different book). Women with untreated or insufficiently treated celiac disease have fewer years in which they ovulate and, hence, fewer opportunities to become pregnant. This can occur on either side of the fertile age spectrum; in other words, women with active celiac disease may:

- First start ovulating (and therefore, first begin having periods) later than normal.
- Stop ovulating (and hence, develop menopause) earlier than normal.
- Have times where ovulation — and, hence, periods — stop. (This is referred to in medical jargon as *secondary amenorrhea*.)

It is not known with certainty why some women with active celiac disease have these problems with ovulation, but possible factors may be:

- **Malabsorption of nutrients.** Celiac disease can result in malabsorption of important nutrients required to allow for normal female hormone production that regulates ovulation and the menstrual cycle. The poor nutrition that results from malabsorption is especially likely to play a role if untreated celiac disease has led to a lower than normal body weight. We discuss malabsorption in detail in Chapter 6.

- **Endocrine dysfunction.** Having celiac disease increases the probability of a person also having certain endocrine (that is, hormonal) disorders, such as thyroid disease, which in their own right can disrupt ovarian function. We discuss this issue further in Chapter 8.

The preceding discussion applies to women with *active* celiac disease. If you follow a strict gluten-free diet, your celiac disease will be *in*active and you will likely have normal ovulation and normal ability to conceive. Nonetheless, and for reasons that are not fully understood, even when having normal ovulation and menstrual cycles, occasionally a woman with celiac disease may still be at increased risk (compared to women without celiac disease) of having difficulty conceiving.

Infertility (or recurring miscarriages, which we discuss in the section, "Miscarriages") may be the only manifestation of celiac disease and, indeed, can be the very first clue that you have this ailment. If you are having unexplained problems with infertility or recurring miscarriages, ask your doctor about the possibility that you have (undiscovered) celiac disease.

One final observation before we leave this section: IVF aside, unless you're having intercourse, pregnancy ain't gonna happen. One scientific study found that couples in which one of the partners had celiac disease had sex less often than couples in which celiac disease wasn't present. The reason? Probably that the person with celiac disease didn't feel well and as a result was less interested in having intercourse. Makes sense. So too, does it make sense that, once the affected person started a gluten-free diet, the frequency with which they were having sex — and their satisfaction with their sex life — both returned to normal. The moral of the story? Forget about the oysters, dark chocolate, and the like; the newest aphrodisiac on the block is clearly following a gluten-free diet! (Well, at least if you have celiac disease.)

### Male infertility

Many possible reasons exist for a man to have infertility, but increasingly recognized is the potential for celiac disease to cause this problem. Active celiac disease can lead to:

✓ **Low male hormone levels.** Lower than normal amounts of testosterone may occur.

✓ **Abnormal sperm.** Some ways that sperm can be abnormal are

- **Reduced sperm count.** Not enough sperm is present.

- **Abnormally shaped sperm.** Such sperm are less capable of fertilizing an ovum.

- **Defective sperm function.** Sperm, as you likely recall from those oh-so-uncomfortable sex education classes way back when, "swim" up from the vagina into the uterus and then into the fallopian tubes where, if there is an available ovum, fertilization takes place. Some evidence exists that this swimming action (called *motility*) is impaired in men with active celiac disease.

The reason for these abnormalities is not known for certain, but it could be that they result from:

✓ **Malabsorption.** Malabsorption of important nutrients required to allow for normal male hormone and sperm production. We discuss malabsorption in detail in Chapter 6.

✓ **Androgen resistance.** In this condition, a man has ample quantities of testosterone (testosterone is a member of the group of male hormones collectively called *androgens*) but the hormone doesn't work properly because the man's tissues are resistant to its actions.

If you are having problems with infertility on the basis of untreated or insufficiently treated celiac disease, once you're on track with your gluten-free diet your infertility will likely improve.

## Complications of pregnancy

Most women with celiac disease have uneventful pregnancies; however, some evidence exists that women with *active* celiac disease may be at increased risk of pregnancy-related complications. (Reassuringly, recent studies suggest that even among women with active celiac disease, the risk of these complications may not always be greater than what you may expect in individuals without celiac disease.)

### Miscarriages

A *miscarriage* (also referred to as a *spontaneous abortion*) is the spontaneous end of a pregnancy at a stage where the embryo or fetus is incapable of surviving, generally defined in humans as being prior to 20 weeks of pregnancy (*gestation*). Women with active celiac disease have an increased risk of miscarrying a pregnancy. Indeed, as we mention in the preceding section,

miscarriage may be the only clue that a person has (as yet undiagnosed) celiac disease.

If you have the sad misfortune to have a miscarriage, lest you automatically attribute it to your celiac disease or, even worse, blame yourself for not being careful enough with your gluten-free diet, bear in mind that miscarriages are very common in women *without* celiac disease. Indeed, 25 percent or more of pregnancies result in a miscarriage within a few weeks of conceiving. Miscarriages are not only common, but they can also occur for many different reasons. Therefore, if you have celiac disease and you have a miscarriage, it may well be *unrelated* to your celiac disease. In other words, don't feel guilty. Having said all that, it always remains terribly important — especially if you are pregnant — to follow a healthy, nutritious, gluten-free diet. We discuss the gluten-free diet in Chapter 10.

### Small babies, intrauterine growth retardation, and premature delivery

A fetus that is smaller than expected for the length of time a women has been pregnant is referred to as being *small for gestational age*. Being small for gestational age occurs as a consequence of *intrauterine growth restriction (IUGR)*; formerly termed *intrauterine growth retardation*. IUGR is a condition in which the fetus grows and develops more slowly than normal then, when subsequently born, is typically underweight.

Many causes exist for IUGR, including a fetus having a genetic defect or infection, or the pregnant woman having diabetes or a malfunctioning placenta. An additional cause of IUGR may be celiac disease, which, in some studies, has been associated with as much as a threefold increased risk. This finding, however, has not been corroborated in other medical studies which, in fact, suggested there was no increased risk. Clearly, the jury is still out on this issue.

Another reason for delivering a small baby is an early delivery called *a preterm* or *premature* delivery. Here, too, the evidence that celiac disease may be responsible is contradictory.

*If* celiac disease does, in fact, contribute to an increased risk of a fetus being small, having IUGR, or being delivered prematurely, the cause remains to be determined.

### Helping avoid pregnancy complications due to celiac disease

Although no woman with celiac disease can ever be guaranteed that she can avoid pregnancy-related complications, women with celiac disease can follow certain precautions to make what are good odds of a healthy outcome into even better odds.

We recommend that if you are a woman with celiac disease and you are contemplating pregnancy, do the following *before* you try to get pregnant:

✔ Make sure you are meticulously following your gluten-free diet.

✔ Ensure your celiac disease symptoms, such as diarrhea, abdominal discomfort, and fatigue, are better or completely gone. (We discuss symptoms of celiac disease in Chapter 6.)

✔ If you've had problems with anemia, iron deficiency, or other abnormal blood chemistry tests, review these with your family doctor or celiac disease specialist to make sure they have resolved. (We discuss anemia and iron deficiency in Chapter 7.)

✔ Check with your celiac disease specialist that your celiac antibody tests (such as your IgA tissue transglutaminase antibody level) have returned to normal. (We discuss antibody tests in Chapter 3.)

✔ Speak to your obstetrician/gynecologist to determine if he is satisfied that you are in suitable gynecologic health to attempt to conceive.

---

# Screening infertile women and women with recurring miscarriages for celiac disease

Whether or not to screen (that is, test) women with infertility for undiagnosed celiac disease is controversial.

Some medical studies have found that screening infertile women for celiac disease detects larger numbers of women with celiac disease than are seen in control populations made up of fertile women. In other words, researchers determined that there were significant numbers of women with infertility who had hitherto undiscovered celiac disease.

Other medical studies, however, have shown contradicting findings with researchers determining that, in fact, there was no greater likelihood — in these studies — of an infertile woman having celiac disease than of a fertile woman having celiac disease.

In the face of this contradictory scientific evidence, doctors need to rely on their best judgment. And this is ours. . . .

Given that:

1. Some women with celiac disease are infertile due — often in unknown ways — to their celiac disease, and

2. Treating celiac disease can, is many such women, restore fertility, and

3. Testing for celiac disease is *relatively* straightforward, and

4. Studies like those quoted above look at population groups, not unique individuals and their personal situation,

we feel that if you have infertility (or recurring miscarriages), your doctor can reasonably decide to check you for possible celiac disease. We would also add that, although doctors shouldn't be swayed from objectively looking at the available medical research, it is awfully hard to not be influenced by the stories we've heard of infertile or miscarriage-prone women whose celiac disease was discovered only after they were tested for this and whose fertility/pregnancy difficulties resolved after their celiac disease was treated.

# Timing of Gluten Introduction in Infancy

Growing interest exists among people living with celiac disease who are about to become (or are new) parents regarding when to introduce gluten into the diet of their infant child. Because celiac disease is more common among close family members, these parents recognize that their child is, therefore, at increased risk of developing celiac disease and, of course, like any loving parent, they want to lessen the likelihood of this happening.

Some medical studies suggest that the risk to a child of later developing celiac disease is reduced if the child has gluten introduced into their diet at a very early stage (before they are 4 months of age). Conversely, other studies suggest that it is best to delay introduction of gluten until the child is many months older.

How is a parent to know what to do? Pending the results of what hopefully will be definitive research results, the current consensus amongst most celiac disease experts is that it is best to first introduce gluten to infants who are genetically at risk of celiac disease between 4 and 6 months of age.

Breastfeeding, which is always the best way to provide nutrition to an infant, also seems to help prevent a child from later developing celiac disease. Breastfeeding is especially important during the period of introducing gluten into an infant's diet.

# Detecting Celiac Disease in Children

Until not too long ago, celiac disease was thought to be a pediatric condition and was seldom first detected in people beyond young adulthood. Today, however, we know that not only is celiac disease not exclusively a pediatric condition, in fact — and you may, perhaps find this surprising — it is most commonly diagnosed in people in their forties and older.

As we discuss in Chapter 5, there are several forms of celiac disease. In the past, most children diagnosed with celiac disease had the *classical* form with the main symptoms being gastrointestinal in nature. These children would have diarrhea and abdominal discomfort (and, because of malnutrition, would often have failed to properly grow, develop, and thrive).

Today, increasing numbers of children are diagnosed with *atypical* celiac disease with few or no gastrointestinal symptoms, the main or only features instead being impaired development or growth.

Thankfully, studies suggest that the time to making a diagnosis is shorter in children than for adults in whom a diagnosis can be delayed by over ten years. Also, increasing numbers of children are being diagnosed through screening (we discuss screening in detail later in this chapter), which means they are able to be successfully treated for their condition long before it has had time to cause them to fall ill.

## Diagnosing children with celiac disease

As we discuss in Chapter 3, the first step that must occur when a doctor diagnoses an illness is that she must think of the possibility that the illness is present. For celiac disease in a child, certain observations — as we discuss in the following sections — may lead a physician to consider this ailment.

We think that you should be aware of these features, too; this way, if you have a child without known celiac disease who develops these symptoms, you can mention, when you see the doctor, that you are wondering whether your child has this condition. Who knows? Perhaps you will have helped make an otherwise overlooked diagnosis. (As we say elsewhere in this book, lest you be concerned your doctor will, perish the thought, admonish you for telling them their business, feel free to take this book with you and blame us for putting you up to the task!)

### Looking at symptoms

Unlike in adults, where the doctor gets the story directly from the patient, when it comes to children — especially young children — the doctor needs to rely on you, the parent, to provide your observations. It will, therefore, be helpful for you to mull over the information we discuss in this section *before* you take your child to the doctor so that you have collected as much information as possible to share with the physician.

These symptoms can be present in a child with celiac disease (note that these symptoms can also occur with other ailments and thus are *not* unique to celiac disease):

- **Abdominal discomfort**. Cramping and distention.

- **Abnormal bowel habits.** Loose or watery stools, frequent large stools, and very smelly stools. Sometimes, however, constipation is the main problem.

- **Behavior problems.** Irritability, restlessness, and the inability to remain attentive or focused. (If you are a parent in this situation, rest assured that once your child is following their diet, their mood will likely quickly improve — and thus, yours will likely too!).

As we discuss in detail in Chapter 8, there is some evidence that certain neurological and behavior problems such as ADHD and autism are more likely to occur in children who have celiac disease. Nonetheless, the great majority of children with ADHD and autism do not have celiac disease and, conversely, the great majority of children with celiac disease do not have ADHD, autism, or other neurological or behavioral difficulties.

✔ **Dermatitis herpetiformis.** A very itchy skin rash with little blisters over the elbows, shoulders, and buttocks. (These symptoms suggest the child may have dermatitis herpetiformis, a condition we discuss in detail in Chapter 8.)

✔ **Insufficient growth and development.** Failure to grow and develop normally (called *failure to thrive*), lack of normal weight gain, and, especially, the development of weight loss. The child may be shorter than others of the same age and may also be shorter than their siblings were at a comparable age.

Some children, because of malabsorption of calcium and vitamin D, develop a condition called *rickets* in which the bones have impaired growth and strength. We discuss rickets in detail in Chapter 7.

✔ **Other nonspecific symptoms.** Generalized, nonspecific symptoms such as pale skin, lack of energy, malaise, and fatigue.

If your unwell child is still in diapers, pay special attention to your infant's stools as it will be very helpful for the doctor to hear from you regarding how often diapers need to be changed and what is the consistency of your infant's stools.

Another set of important observations you should make before you see the doctor is to note your child's mood, energy, and level of physical activity. Does your child appear sullen and withdrawn, or happy and energetic? Does your child appear listless or is your child crawling, walking, or running around all day? A child who is fatigued, sullen, and listless may have these symptoms for a host of different reasons, one of which is celiac disease.

We recommend that you also share with the doctor when your child reached various developmental milestones (such as sitting, crawling, standing, walking, and talking) and whether your child is smaller or shorter than other of your children. A child who is slow to reach milestones and is shorter than his or her siblings were at that age does not necessarily have celiac disease, but it is certainly something that needs to be considered.

All these pieces of information will help your doctor fit the puzzle together.

### Undergoing a physical examination

When a doctor examines any sick child, there are very many features they are seeking. However, specifically in terms of whether the child may have celiac disease, the doctor will be checking for the following:

- ✔ **Abnormal behavior.** Evidence of abnormal behavior, failure to achieve developmental milestones, and reduced energy level.

- ✔ **Anemia.** Pale skin, which might indicate anemia.

- ✔ **Dermatitis herpetiformis.** Skin rash with characteristics suggesting dermatitis herpetiformis. (See the previous section.)

- ✔ **Insufficient growth and development.** One way the doctor determines this is by comparing the child's weight and height to the child's peer group average as well as the child's prior measurements.

- ✔ **Malnourishment.** Evidence of malnourishment can reflect the presence of malabsorption.

### Testing for celiac disease

If, after talking to you and assessing your child, the doctor suspects celiac disease may be present, investigations will be required:

- ✔ **Stool samples.** Analyzed for evidence of malabsorption. (Stool samples can also be analyzed to look for other ailments — such as a bowel infection — that may be masquerading as, or mimicking, celiac disease.)

- ✔ **Blood tests** may be requested to look for a variety of different abnormalities, including:

  - • Anemia

  - • Vitamin deficiencies

  - • Abnormal body chemistry

  - • Celiac disease antibodies, including the tissue transglutaminase (TTG) IgA antibody and the antigliadin antibody (AGA). We discuss these tests in detail in Chapter 3.

- ✔ **Endoscopy and small intestine biopsy.** As we discuss in Chapter 3, an endoscopy and small intestine biopsy is — regardless of the age of the patient — the only definitive way to diagnose celiac disease. For this reason, if the doctor has a strong suspicion that your child has celiac disease, she may recommend proceeding directly with this test rather than first doing much, if any, other preliminary testing.

If your child's doctor sends your child directly for a small intestine biopsy and it confirms celiac disease, the doctor will still likely then ask for the TTG IgA and AGA IgA antibody tests to be done because the result will be helpful to monitor your child's progress. For more info on this topic, have a look at Chapter 15.

Doing an endoscopy in kids is not too much different than for adults. In very young children, different sedative medications are used and kid-sized endoscopes may be used as well. Typically, a parent comes into the endoscopy room to provide support until the child is sedated and is then again present when the child awakens in the recovery area of the endoscopy unit.

An endoscopy and small intestine biopsy are *always* necessary before a diagnosis of celiac disease can be made. We strongly recommend *against* foregoing these investigations and, based purely on speculation, making the diagnosis and placing a child on a gluten-free diet. Celiac disease is a serious, lifelong condition and following a gluten-free diet is no mean feat. Saddling a child with the diagnosis and treatment without first being certain of the diagnosis is simply neither fair nor appropriate. (Also, lest you think that a child who feels better on a gluten-free diet must surely have celiac disease and that other, confirmatory testing is unnecessary, we will note that lots of kids — and adults, too — feel better on a gluten-free diet whether or not they have celiac disease.)

## Screening children for celiac disease

As we discuss in Chapter 4, screening for a disease is testing a person for it even if that person has no symptoms or other manifestations of the condition being looked for.

Several specific situations exist in which a doctor should consider screening a child for celiac disease, including when a child has:

- ✔ **An immediate family member (or members) who are known to have celiac disease.** If one person in the family has celiac disease, other immediate family members are at increased risk of also having the condition.

- ✔ **Neurological or behavioral problems.** As we discuss in Chapter 8, a variety of different neurological and behavioral problems exist that, for unclear reasons, may be more likely to occur if a child also has celiac disease. For this reason, some physicians screen for celiac disease in a child who has one or more of these other ailments.

- ✔ **Type 1 diabetes.** As we discuss in Chapter 8, type 1 diabetes is an autoimmune disease often onsetting in childhood and associated with an approximately 5 percent likelihood of the child also having celiac disease. Quite commonly, such children do not have any symptoms of celiac disease, and celiac disease wouldn't have been detected if they hadn't been screened for it.

For children who are being screened for celiac disease because they have an immediate family member with this condition, the best initial screening test is to see whether the child has the HLA DQ2 and/or DQ8 genes. If these genes are not present, the risk of the child having or later developing celiac disease is so low that further screening for celiac disease is unnecessary.

As Sheila knows from her own family's experience, knowing these genetic screening results — whether positive or negative — can be a huge help:

- ✔ If your child does *not* have the HLA DQ2 or DQ8 genes, you can feel greatly reassured that the child will almost certainly never develop celiac disease and, as mentioned, repeat screening is not be required.

- ✔ If your child *does* have either of these genes, you will be armed with the important knowledge that further action needs to be taken. Specifically, the next step is to check for TTG IgA and AGA IgA antibodies (see the immediately preceding section, "Testing for celiac disease," and the following discussion).

In the event that your child has the HLA DQ2 or DQ8 genes, testing for celiac disease antibodies should first be performed when your child is between 5 and 7 years of age. If these antibodies are normal (that is, depending on the laboratory's testing methods, either completely absent or, at the least, in the so-called "normal range"), most pediatric celiac disease specialists suggest repeating the antibody tests every 2 to 3 years until the child reaches age 18 at which point, if the antibody tests have remained negative, they are typically no longer tested for. *However*, if at any point your child later develops symptoms that suggest celiac disease and he or she is know to be genetically at risk, then a TTG IgA antibody test should again be performed, regardless of what age your child is (indeed, even if your "child" is now an adult). If the antibody tests are increased at any point, an endoscopy and small intestine biopsy should be performed to determine if celiac disease is present.

If your child has an autoimmune disease like type 1 diabetes, then HLA DQ testing is not very helpful and going straight to the antibody testing is recommended.

If your child has the HLA DQ2 or DQ8 genes, or has TTG IgA or AGA IgA antibodies, that does *not* mean he or she necessarily has celiac disease. It does, however, mean that your child *may* have the condition and that further investigations could be warranted including an endoscopy and small intestine biopsy. Only the presence of a confirmatory small intestine biopsy allows the diagnosis of celiac disease to be made.

# Starting Your Child on a Gluten-free Diet

After your child has been diagnosed with celiac disease, he or she should begin a gluten-free diet. Chapter 10 covers in detail the reality of following a gluten-free diet; this section revisits some tips from that chapter.

Living gluten-free can pose quite a few challenges; especially for children. Here are some tips — some admittedly harder to follow than others — that parents of children with celiac disease have shared with us that helped them deal with these challenges:

- Base the family's diet around naturally gluten-free foods such as fruits, vegetables, nuts, gluten-free grains and carbohydrates, meats, fish, and dairy products.

- Keep on hand (a limited number of) gluten-free treats that the whole family can enjoy. These can include gluten-free packaged and prepared foods like rice crackers or rice snacks, popcorn, ice creams, sorbets, and candies.

- When buying items such as cookies, cereals, and certain baked goods (scones, loaves), purchase both gluten-free and gluten-containing versions. Of course, the gluten-containing version should be given only to those family members who do not have celiac disease.

- When baking, prepare gluten-free and gluten-containing versions. Placing similar foods on everyone's plate helps the child with celiac disease not feel left out.

As you embark on creating a healthy, gluten-free diet for your child, you may wonder if life would be easier if your entire family were also eating gluten-free. Many parents tell us that doing this simplifies shopping and preparing food and also makes keeping the child with celiac disease on track with the diet easier. (Less temptation is present if everyone in the family is eating the same way and if no "off limits" foods are nearby.)

There are, however, challenges to having the entire family eat gluten-free, including the difficulty of finding sufficient quantities of gluten-free foods each time you shop, incurring additional expense (as we discuss in Chapter 10, gluten-free foods often cost more than other foods), and asking the entire family to take on what are otherwise unnecessary dietary restrictions.

Some parents of children with celiac disease make the point that, in their opinion, teaching a child *early in life* to deal with the challenges they will face *all of their life* keeping gluten-free is best. They feel that having the rest of the family eat normally allows the child to develop the "right attitude" and learn boundaries at home. Other parents have very different and equally strongly held opinions. Needless to say, this topic is hotly debated among families and members of celiac support groups.

# Shopping and Cooking with Your Child Who Has Celiac Disease

Your child with celiac disease, at the appropriate age, needs to learn how to recognize gluten-free foods and where to find them not only at home, but also in stores and online. Of course, educating your child in these ways is a gradual process that evolves as your child grows up.

Even more important is to encourage your child to develop an interest in cooking and baking gluten-free. Cooking and baking gluten-free are skills that will help throughout the rest of your child's life. Sheila, her children, and their friends are the benefactors of her husband's interest in cooking, which started when he was a child learning to cook gluten-free foods.

In Chapter 10, we look in detail at shopping and cooking gluten-free.

# Growing Up Gluten-Free

As any parent knows (or eventually finds out), parenting a child presents different challenges that depend on the age of the offspring. In this section, we look at some of these age-dependent challenges as they pertain to celiac disease.

## Dealing with the preschool years

One of the most challenging aspects of keeping a pre-schooler gluten-free is when the child is away from home and, especially, when they are out of your supervision. Whether attending daycare or preschool, going to a friend's house or attending a birthday party, your child will be constantly at risk of being exposed to gluten. Children like to share their food and try other's food.

The best way to deal with this issue is to educate the people (teachers, other parents, babysitters, and so on) who will be interacting with your child about celiac disease. Make them aware of what is a gluten-free diet, and the importance of not deviating from it.

Working with others on this issue will require diligence on your part because most people are not particularly conversant with celiac disease and may mistakenly believe that "just a little bit" of gluten couldn't possibly hurt. If they feel this way, make sure you correct them on this potentially dangerous misconception! (If you are concerned that you will be met with skepticism — or worse — consider showing them this book; as always, we're happy to be the heavies here.)

You may find that providing your child with gluten-free snacks and treats to take with them when they are attending celebrations or even simply visiting a friend's house is often helpful — not only for you and your child, but also for the parent(s) of the child that he or she is visiting.

## Helping your child through the elementary school years

As your child goes through the elementary school years, a main challenge will be living gluten-free while eating in cafeterias or at sleepovers, camp, and other such away-from-home activities. Fortunately, at this age your child can be actively involved in their care by letting those people (and their supervisors) with whom they're spending time know about the need to follow a gluten-free diet and, depending on your child's age and level of maturity, telling others of what that diet consists.

We recommend that, when appropriate, you speak to the people who will be supervising your child when outside of the home to inform them about the basics regarding celiac disease and gluten-free eating. Again, feel free to let them borrow this book; perhaps with you having tagged key pages for them to read.

Anytime your child will be away from home overnight, whether for a one night sleepover or a summer-long stay at camp, he or she will be at increased risk of eating gluten. It is important to remind your child to not be lulled into thinking that eating gluten must be okay just because he or she doesn't feel immediately unwell after consuming it. You may well find her friends and camp-mates pressuring her into consuming gluten. Feel free to both forewarn your child of this and to prepare her with ammunition to resist such temptation by saying — even if not completely accurately — that she is allergic to gluten. Nowadays, with so many children having dangerous allergies to things like nuts, using the term "allergic" is more likely to convey a sense of importance than would be an attempt at explaining the true (and complex) immune nature of celiac disease (which, by the way, we describe in Chapter 2).

## Grasping teenage challenges

As any parent of a teenager — whether or not the teen has celiac disease — knows, the teenage years pose their own special set of parental challenges. (We speak from experience in case you're wondering.) These years represent a time when your child wants to exercise his or her independence and this often entails a certain amount of rebelling against things that are imposed by authority including parents.

If your child has celiac disease, you may find that even if he was previously very good at sticking to a gluten-free diet, he may now go out with his friends to have regular pizza, burgers, and other gluten-containing fast foods. Sometimes, this experimenting leads to symptoms of indigestion, abdominal pain, and diarrhea, in which case the teen typically quickly gets back on track with gluten-free eating. If, however, your teenage child doesn't develop symptoms, he may be less inclined to resume living gluten-free. This, in turn, will put him at risk of developing complications of celiac disease (as we describe in Chapter 7).

Giving your teen control of his or her own gluten-free diet is important. You should start to let go even in the pre-teen or early teen years depending on the maturity of your child. Here are some suggestions for you as a parent of a teenager with celiac disease:

- **Don't punish.** Realize that gluten-ingestion "accidents" happen and don't punish them for this.

- **Educate your teen.** Facilitate his learning and allow him to develop an understanding of his own health issues. Talk to him about the gluten-free diet and celiac disease as you would or should for other health issues like texting while driving, alcohol, drugs, smoking, and sexual activities. Speaking in an open, educational, and non-threatening manner is often the best way of doing this.

- **Involve your teen in the shopping and cooking.** Learning the ropes of how to identify food products that are gluten-free and where to find them is an important skill to acquire before leaving home. Similarly being able to prepare gluten-free foods at home is another helpful skill to learn early in life.

- **Have your teen check on gluten-free food availability.** Let her check out what foods will be available at parties, restaurants, school trips, and other activities. That way, she will either be reassured that gluten-free foods are going to be available or, if not, can make alternative preparations.

- **Encourage your teen to build a supportive peer group.** Just like friends don't let friends drink and drive, your child will want to have friends who support their efforts to stay gluten-free. Finding friends who won't make fun of him for his special diet or encourage him to stray from the diet is important in teenage years and beyond.

- **Task your teen with exploring menu options at prospective colleges.** When seeking out colleges, in addition to finding out about the expected educational and social experiences, determine what are the available eating options. Once she knows where she will be going to college, your child can then arrange to meet with the kitchen manager, cook, dietitian, or other relevant personnel at the college cafeteria to discuss your child's gluten-free needs.

We recognize that there are no easy solutions to dealing with a teenage child with celiac disease who elects to not follow a gluten-free diet. Each teenager is different, each situation is different, and what works for one family may or not work for another. Letting your teenage child know that your concerns are born of love and caring is essential. You may also choose to enlist the support of others (family, friends, and so forth) that love and care about your child. If necessary, ask your doctor for help, either directly by speaking to your child or by referring your teenager to another, appropriate health care professional such as a social worker. Ultimately, however, it will be your child's responsibility to regain control of their health by returning to a gluten-free diet.

## Sending your child off to college

By the time a child with celiac disease has reached young adulthood, he or she has typically become accustomed to living gluten-free. Nonetheless, new challenges emerge when it's time to leave home for college. In addition to the usual trials and tribulations (adjusting to campus life, dealing with courses that are typically harder than those in high school, exploring a new social life, and so on), your young adult will face the additional hurdle of trying to live gluten-free while eating at cafeterias and with meal-plans that typically center around gluten-containing foods such as pizza, pasta, burgers, subs, breaded meats, and breads. You probably aren't surprised to find that more than a few college students with celiac disease end up at the health services department with a flare of the disease.

Here are some food venues your teenage child must explore in order to stay gluten-free during the college years:

- ✔ **Cafeteria or dining hall.** Meet with the chef or cook at the dining facility where your child will be eating. Your child can share with the chef or cook her dietary needs and, in particular, the importance of having gluten-free foods available. (Lest your child feel she's imposing by making special dietary requests, she can rest assured that celiac disease is common enough that many other students will likely share the same needs. Also, this is a health priority; nothing to be hesitant about here!)

- ✔ **Living situation.** Choose a living situation that doesn't mandate use of the school or fraternity or sorority meal-plan. That way your teenage child can buy and prepare his own food. (See the anecdote which follows this list.)

- ✔ **Nearby stores.** Specialty food stores are often located in areas around colleges and universities. These shops and even some chains of grocery stores carry gluten-free foods. Identify these ahead of time, and if none are available, seek other options as listed below.

✔ **Online grocery providers.** Discover online purveyors of gluten-free foods. (Trust us, your young adult child is incredibly well acquainted with how to successfully surf the Web.)

✔ **Restaurants.** Locate local restaurants that have gluten-free offerings on their menus.

✔ **Snacks.** Eat a gluten-free meal or snack before going out with friends. (This isn't usually necessary, but if your child isn't sure the gang will be heading out to a place that has gluten-free food offerings, it can be helpful.)

Melissa, a patient of Sheila's, was diagnosed with celiac disease during her sophomore year of college. She did very well on her gluten-free diet (available to her at the school cafeteria) and remained symptom-free. As the year was coming to a close, Melissa confided to Sheila that her sorority required that she live in the sorority house for her third year and this concerned her because many of the meals provided at the sorority consisted of gluten-laden items such as lasagna and other pasta dishes. At Melissa's request, Sheila wrote a letter to the head of the local sorority chapter explaining the need for Melissa to live gluten-free. As a result of this letter, Melissa was granted an exemption by the sorority and allowed to remain a member but live outside of the sorority house. This enabled Melissa to continue to live gluten-free and she remained in good health. Did this put her at odds with her sorority? Apparently not; she was subsequently elected chapter treasurer!

Because gluten-free foods are often more expensive than gluten-containing foods, your young adult child's food budget may be higher than that of other students. As we discuss in Chapter 10, in some settings these extra costs may qualify for a tax benefit, so be sure to save all receipts.

# Chapter 15

# Ongoing Care of Celiac Disease

## In This Chapter

▶ Monitoring your condition

▶ Watching for ongoing nutrition issues

▶ Falling off your gluten-free diet

▶ Taking control of your celiac health

▶ Becoming your own best advocate

*I*f you've recently been diagnosed with celiac disease and have now started a gluten-free diet, you may be wondering what to expect next, both in the near term and over the longer haul. Perhaps you've asked yourself questions such as "What do I need to keep an eye on?" or "What does *my doctor* need to keep an eye on?" In other words, what is the ongoing care of your celiac disease? It's also quite possible that these are questions that you may have even if you've had celiac disease for many a year. In either case, you've come to the right place, because in this chapter, we answer these very questions.

## Monitoring Your Celiac Disease

In medical school, doctors-to-be are taught rule after rule about how to manage a person's health (or illness). Indeed, by the time newly crowned med students walk up to get their diplomas, their heads are crammed with literally thousands upon thousands of "proper ways" to do things. What a shock it is when one actually starts to work as a doctor and immediately learns that, in fact, there are no rules! There are approaches, guidelines, recommendations, policies . . . yes. But as for rules, well, not so much. Or, looked at another way, there are as many unique situations as there are unique patients, which is, pretty well, everyone a doctor sees. Why this preamble? Simply this: You are a unique individual, so the monitoring you require and how often you require it depends on your specific situation. (And, lest any of our colleagues take offense, okay, we admit there are *some* rules in medicine, but not very many.)

## Why no rules exist when monitoring patients with celiac disease

In the world of medicine, the stronger the scientific proof of something, the stronger are the recommendations that result from the scientific proof. For example, there are so many thousands of studies showing that smoking is harmful to one's health that doctors can say with complete confidence and conviction to all their patients that they should not smoke and, if they do, they should do their utmost to quit. Unfortunately, in the world of medicine, things are seldom this cut and dry. Indeed, there is seldom scientific evidence of such overwhelming, incontrovertible, perfectly consistent, and universally applicable character that a doctor can reflexively recommend to a patient a single course of action. This reality is very much the case when it comes to monitoring a person who has celiac disease.

Because of the paucity of studies on this subject, doctors have no rules or even rigid guidelines to follow regarding what monitoring tests should be done or how often they should be done (or even if they should be done at all!). When health care providers find themselves in this situation, they end up, pending new scientific information providing a clearer path, following what is referred to as "common practice" or "best practice." *Common practice*, as you might imagine, simply means it's what, for better or worse, most doctors do. *Best practice* typically means that a whole bunch of recognized authorities have gotten together, analyzed the available medical literature and anecdotal experience, and, using common sense, have come up with suggested recommendations for physicians to follow.

## *Determining how often you should see your health care providers*

The factors that influence how often you need to be seen by your health care providers, including your primary care physician (such as your family doctor), your celiac disease specialist, and your dietitian, are based on a number of factors, including:

- How you are feeling.
- If you were diagnosed with celiac disease in the recent past, how sick you were when you were first diagnosed.
- Whether you're having a hard time adhering to your gluten-free diet. We discuss the gluten-free diet in Chapter 10.
- Whether you're having complications from your diet such as undue weight gain, weight loss, or constipation. We discuss these topics later in this chapter.
- If you have complications from your celiac disease. We discuss this topic in Chapter 7.

✔ If you have conditions associated with celiac disease. We discuss this topic in Chapter 8.

✔ What laboratory test abnormalities you had when you were diagnosed, how severe they were, and whether they are improving.

By way of extreme examples to make a point: If your celiac disease was only recently diagnosed, and if you were very unwell at the time with bad symptoms and markedly abnormal blood chemistry tests, you will need to be a frequent visitor to your celiac disease specialist. If you've had celiac disease for years, you've had no problems adhering to your gluten-free diet, you're feeling well, and you've had no complications, then your specialist may need to see you very seldom. As you may imagine, most people with celiac disease — likely including yourself — fall somewhere in between.

As a *very rough* rule of thumb, if you're pretty healthy overall when you're first diagnosed with celiac disease, you may expect to see your celiac disease specialist and your dietitian collectively no more than a handful of times over the subsequent six months and less and less often as time goes by. It is our personal preference, as specialists, to routinely see our healthy, uncomplicated patients with celiac disease every year or two, but again, there are no rules.

## Knowing who does the monitoring

The health care professional who is most responsible for monitoring your celiac disease varies depending on your specific circumstances and, in part, on the availability of a specialist. Although the diagnosis of celiac disease is almost always made by a specialist and although the early monitoring is typically done by this same doctor and a dietitian, as time goes by, if you're doing well, your primary health care provider (such as your family doctor) will likely have a central role in keeping tabs on your progress. Of course, if you are not responding to therapy as you should or if you have complications from your celiac disease, then the ongoing involvement of a specialist will be essential.

If you've been doing very well — and especially if there is limited availability of celiac disease specialists — the entirety of your celiac disease medical care may be handed back to your family doctor by the specialist. If your specialist has handed your care back to your family doctor, that should not be taken to mean that you cannot again be seen by a specialist. Indeed, if ever you run into problems with your celiac disease — or if you or your family doctor even *think* you may have run into problems — you *can* be referred back to a specialist.

Registered dietitians are an invaluable resource when it comes to matters of nutrition. If your problem may relate to dietary issues, a dietitian is typically the best person to see.

## Knowing what is discussed during a monitoring visit

When you see your doctor for a routine celiac disease monitoring appointment, your doctor will want to find out from you many details regarding how you've been feeling since your last appointment. We discuss these details in this section.

You may find reviewing this section helpful to prepare for an appointment with the health care providers assisting you with your celiac disease. You will be less likely to feel caught off-guard during the meeting or, even worse, leave the interview only to then say to yourself "Oh shoot, I forgot to tell/ask the doctor. . . ."

When you see your doctor for your appointment, that appointment is *your appointment* and you should not feel constrained in what you bring up; indeed, you absolutely must share with your doctor anything at all that you feel may relate to your celiac disease. You never know when something that seems, at first blush, to be unimportant will in fact turn out to be highly significant.

### How you're feeling in general

When discussing various and sundry health concerns, regardless of whether the issues are related to celiac disease, very often doctors and patients (appropriately) spend considerable time discussing specific issues such as, for example, chest pain, joint pain, diarrhea, and so on. What risks getting missed, however, is an overview of how you're feeling. Mary, in the following anecdote, illustrates just such a circumstance.

Mary was a 45-year-old accountant who came to see Ian for assessment of her celiac disease. She had recently moved to the area and this was her first visit to him. Ian asked Mary how she was doing to which she responded, in great detail and at length, that since starting a gluten-free diet at the time of her diagnosis six months earlier, her diarrhea had settled, she had regained some weight she had lost, and she no longer had abdominal pains. She continued, over the next five minutes, to provide a detailed description of various and sundry symptoms she had previously had and noted how they had all improved. After Mary had finished, Ian recalls saying to her, "Mary, that's great. And very helpful to know. Thanks for the information. Clearly you've had a major improvement in each of the symptoms that were previously bothering you. But what about how you are feeling *in general*? Do you feel healthy or not quite so well?" Mary was taken aback by the question and sat silently for a moment. "You know," she then started, "I hadn't really thought about that. I guess I've been so caught up with analyzing each specific symptom, I hadn't thought about how I've been feeling *in general*. Well, now that I think about it, even though each of the symptoms I just mentioned is much better, I'm actually feeling generally not so hot." Mary wasn't aware of any specific way in which she was unwell; she just didn't feel as healthy as she should and

couldn't put a finger on why. As it turned out, further investigations revealed that Mary had an underfunctioning thyroid (hypothyroidism); a condition which, as we discuss in Chapter 8, is known to be associated with celiac disease. Treatment was started and when Mary returned to see Ian a while later, she made a point of telling him not only how she was feeling in terms of specifics, but how she was feeling generally which, she was thrilled to report — and Ian was thrilled to hear — was now terrific.

### What your energy level is like

If you are lacking in energy, feeling generally fatigued, listless, or tired, this can be an important clue to your physician that something is amiss with your health. The cause may be entirely unrelated to your celiac disease, but of the many possible causes for these symptoms, quite a few are known to be associated with celiac disease, and therefore need to be considered by your health care provider. Possible causes include anemia, iron deficiency, thyroid disease, and depression to name but a few. We discuss this topic in detail in Chapter 6.

### How your bowel habits are and, in particular, whether you're having diarrhea or constipation

Although celiac disease can show itself in *many* varied ways, the common denominator with this condition is inflammation of the bowel, and so keeping tabs on whether you have symptoms related to your intestines is important.

If you're having diarrhea, letting your doctor know is essential. A slew of possible causes of diarrhea exist, some serious, some not. As we discuss in detail in Chapter 12, possibilities include gluten remaining in the diet (that is, your diet isn't truly gluten-free), having a complication from celiac disease, having some other, possibly unrelated condition, and so on.

 Constipation, as we discuss later in this chapter, is a not uncommon consequence of following a gluten-free diet. Be sure to let both your physician and your dietitian know if you've developed constipation so that they can assist you not only with determining the cause, but helping relieve you of the problem.

### Whether your weight is going up, down, or remaining steady

As we discuss further on in this chapter (see the section "Weighty issues"), treatment of celiac disease can lead to both weight loss and weight gain. A few pounds in either direction is seldom a cause for concern, but if your weight is changing in amounts beyond a few pounds, be sure to let your physician know. Your doctor will need to determine whether anything of concern is present. If no additional medical issue is responsible, then a visit to your dietitian will be in order.

For children, their pediatrician must make sure that they are on track on the *growth curve*; that is, gaining the appropriate amount of height and weight for their age. (You can find growth curves at www.cdc.gov/GrowthCharts). Often, children are below the expected height and weight for their age when they are first diagnosed with celiac disease. Once they are on a gluten-free diet and their intestines start to heal, they regain the ability to properly absorb nutrients into their body, and they begin the process of catching up on height and weight. The amount they catch up will depend on the age of the child when they first begin treatment. We discuss this in detail in Chapter 6.

If you have any doubt whether your child is growing and developing normally, and if the physician doesn't happen to bring up this topic when you take your child in for a visit, be sure to raise your concerns with the doctor.

### Whether you are on track with your gluten-free diet

As we mention literally dozens of times throughout this book, if you have celiac disease and continue to ingest gluten, you will experience ongoing damage to your small intestine and risk developing complications of this condition. How essential is following a gluten-free diet if you have celiac disease? In a word, *absolutely*.

Letting your doctor know whether you're on track — or whether you're *not* on track — with your gluten-free diet is essential. If you're not following the diet, your physician needs to spend time with you discussing what obstacles or barriers are limiting your adherence to your nutrition program. Recently, the Celiac Center at Beth Israel Deaconess Hospital developed a questionnaire to assess whether patients were adhering to their gluten-free diet. Two questions turned out to be most predictive of how well patients fared adhering to the diet – 1) the frequency of purposeful gluten ingestion and 2) the ability to follow a gluten-free diet outside the home. If your answers to these questions are "often" and "with difficulty" then we suggest you discuss this with your health care provider.

Your doctor is not there to judge you; if he is, he's in the wrong profession! If you're not following your gluten-free diet, you must — this is crucial — let your doctor know. If you don't, your doctor may end up sending you for all sorts of unnecessary tests as he tries to discover why you're not responding to your treatment program the way you should.

## Monitoring you through testing

If, once you got on track with your gluten-free diet, you quickly became free of symptoms (especially gastrointestinal symptoms), and if you haven't had complications from your celiac disease, your doctor will likely not ask you to go for much in the way of routing monitoring tests.

Several situations exist, however, where additional testing becomes more important, such as:

- ✔ **If despite following a gluten-free diet you continue to feel unwell.** In this case, you need to have further testing done to see whether evidence exists of ongoing intestinal damage.

- ✔ **If you have complications from your celiac disease.** In this situation, you need to have testing done to ensure that these complications are resolving. Here are some examples of complications (we discuss these in detail in Chapter 7) that would require monitoring through further testing:

  - **Iron deficiency anemia.** If you have this problem, your doctor needs to keep tabs on your iron and hemoglobin levels.

  - **Vitamin D deficiency and/or calcium deficiency.** In this case, your doctor needs to monitor your blood levels of these substances.

  - **Osteoporosis.** If you have osteoporosis, your doctor needs to monitor your bone density with periodic bone mineral density (BMD) tests.

Although tests can be very important in monitoring your progress, testing is always of secondary importance compared to the crucial information your doctor will learn about you by simply hearing from you how you're feeling, how you're doing with your diet, if you're having symptoms, and so on.

## Understanding the role of repeat blood antibody testing

As we discuss in Chapter 3, the IgA tissue transglutaminase antibody (TTG IgA) is a key blood test to help determine whether someone may have celiac disease. Almost all people with active celiac disease have this antibody. As you continue your gluten-free diet, your level of this antibody progressively falls and eventually become normal.

Monitoring your TTG IgA level is particularly helpful when you're not responding to your gluten-free diet. For example, if despite having eliminated gluten you continue to have symptoms (such as abdominal cramping or diarrhea), your doctor can then test your TTG IgA level. If your level hasn't significantly fallen since you started your nutrition program, your doctor and you will know that the odds are darned good that gluten is somehow continuing to make its way into your diet (and thus into your gut). At that point, solving the mystery is a matter of donning your Sherlock Holmes cap, figuring out what is the source of the gluten, and eliminating it.

When the TTG IgA is no longer elevated, most specialists recommend that this test be checked every year or two, even if the patient is well and all the laboratory studies are normal. The rationale for doing this is that if the level unexpectedly goes up, it is strong evidence that a person's celiac disease has

again become active. No one has examined whether this type of laboratory monitoring practice is medically useful, but the tests are commonly done anyhow. (In medicine, as all physicians would readily admit, there is both art and science.)

Though used less often, the antigliadin (AGA) IgA antibody level can also be measured to monitor your progress. This test is of use primarily in children. (It appears to be more helpful in this age group compared with adults.)

The main reason for an adult to be monitored by testing their AGA IgA level is the unusual circumstance of an elevated AGA IgA level *and a normal TTG IgA level* at the time of diagnosis.

How the newer test that measures antibodies to deamidated gliadin peptides (DGP) — see Chapter 3 — might also be used in monitoring patients on a gluten-free diet has not as yet been studied.

### Knowing the role of a repeat small intestine biopsy

As we discuss in Chapter 3, in order be diagnosed with celiac disease, you first need to have a biopsy of your small intestine. So long as the biopsy is conclusive, you remain on track with your gluten-free diet, you continue to feel well, and your laboratory tests don't show anything remarkable, many celiac disease specialists (including us) will not find it necessary to have you again undergo the procedure in the future.

Some circumstances exist, however, where your doctor may recommend that you have a repeat small intestine biopsy. These include:

- **Ongoing symptoms or evidence of malabsorption.** If you are having ongoing symptoms of celiac disease or if you have persistently low iron levels or other evidence of malabsorption despite following a gluten-free diet, your doctor may first recommend you have antibody studies performed or alternatively, may reasonably forego this and recommend proceeding directly with a repeat biopsy since it is only a biopsy that provides definitive evidence of whether or not there is ongoing bowel inflammation.

- **Failure of your antibodies to return to normal levels.** If your celiac disease antibodies (see the preceding section) do not normalize despite what appears to be complete abstinence from gluten, a repeat biopsy will help determine whether, despite your careful diet, there is ongoing evidence of small intestine injury. If present, it is once again a matter of playing detective and hunting down where the ingested gluten is coming from.

✔ **Having had no evidence of celiac disease except on a biopsy specimen.** If when you were diagnosed with celiac disease you had no other features to suggest you had this condition except for a positive biopsy, the only way your doctor can know whether you still have active celiac disease is to once again perform a biopsy. (In other words if you never had symptoms, never had abnormal antibodies, and never had other abnormal lab tests, then monitoring these parameters will not be of value in determining whether you do or don't have active disease; only a biopsy will tell the tale.)

✔ **Involvement in a research study.** If you are enrolled in a research study looking at new therapies for celiac disease, the study protocol will almost certainly involve having a follow-up biopsy. (If so, you will be made aware of this at the time you sign on to participate in the study.)

Some celiac disease specialists, as a matter of routine practice, recommend to their patients that a repeat biopsy be performed a year or two after a gluten-free diet has been started.

In some situations, during monitoring of your celiac disease, the TTG IgA level is elevated and a repeat endoscopy and small intestine biopsy are performed, yet — lo and behold — the pathologist finds the biopsy to show nothing wrong at all. This doesn't happen often, but it can and, as we discuss in Chapter 3, indicates that the elevated TTG IgA level is, in this particular situation, not due to celiac disease, but some other health condition. This doesn't mean the biopsy was for naught; on the contrary, the normal result provided the important information that the doctor needed to look elsewhere for a cause of the abnormal antibody test because celiac disease wasn't responsible.

**Here is a case where an abnormal repeat small intestine biopsy provided invaluable information.** Ian recalls seeing a 35-year-old man who had been diagnosed with celiac disease five years earlier after an endoscopy and small intestine biopsy showed typical changes of the disease. He was treated with a gluten-free diet and did very well, but his symptoms had returned. Ian checked the patient's blood tests and found the TTG IgA level to be elevated. The patient, however, was certain he was not consuming gluten. A subsequent small intestine biopsy nonetheless showed evidence of active damage from celiac disease. The mystery was solved when it was discovered that he had recently started taking an over-the-counter medication that, unbeknownst to him, contained gluten. He discontinued the medicine and soon thereafter started to feel much better.

**Here is a case where a *normal* repeat small intestine biopsy provided invaluable information.** Amy was an 18-year-old who was referred to Sheila for investigation of iron deficiency anemia. A blood test revealed that Amy had an elevated TTG IgA level, and a subsequent endoscopy and small intestine biopsy confirmed the diagnosis of celiac disease. Amy was treated with a gluten-free diet and iron supplements, but she remained anemic. Repeat TTG IgA

testing showed improvement, but in view of her persisting anemia, a repeat endoscopy and small intestine biopsy were performed. As it turned out, these were normal and, active bowel injury having now been excluded, it was determined that the actual cause for Amy's ongoing anemia was not, in fact, celiac disease, but rather, was due to menstrual blood loss (and, as it happens, her having discontinued her iron supplements). Amy resumed her iron supplements and within a few months her anemia resolved.

### Using capsule endoscopy

As we discuss in Chapter 3, capsule endoscopy is a procedure in which you swallow a pill-sized camera that then transmits pictures of your gastrointestinal system. Some studies have been done to determine whether this may be a better way to monitor the response of celiac disease to a gluten-free diet. At the present time, using capsule endoscopy is not common practice. (Also, this test is not necessarily covered by health insurance; especially if you are doing well on your treatment). However, if you are having ongoing difficulties and a regular endoscopy and biopsy can't sort out what is wrong, then a capsule study may be a good next test.

# Managing Ongoing Nutrition Issues

If you felt unwell at the time you were diagnosed with celiac disease, you will almost certainly find that, soon after you've gotten on track with your gluten-free diet, you start to feel better. Previous symptoms you may have had such as abdominal discomfort, diarrhea, bloating, gas, indigestion, or fatigue quickly ease, and abnormal body chemistry such as anemia and low vitamin levels also start to correct. All of this, of course, is wonderful news. There are, however, a few possible downsides to following a gluten-free diet including gaining or losing weight and developing constipation. We discuss these issues here.

## Weighty issues

As we discuss in detail in Chapter 10, adopting a gluten-free diet isn't a simple matter. It requires much learning and requires great attention to pretty well everything that goes in your mouth.

Aside from water and a select few other beverages and foods, everything you eat contains energy in the form of calories. And everything a person does from sleeping to walking to running a marathon uses up calories. For most people, balancing calorie intake with calorie expenditure is a huge challenge;

indeed, most North Americans tip the balance (in a manner of speaking) in favor of excess ingested calories for their body's needs and, as a result, the majority of North Americans are overweight. Having celiac disease and following a gluten-free diet can add to this challenge as, at least for some people with this condition, it can be even harder to avoid weight gain. On the other hand, some people find that adopting a gluten-free diet results in losing weight. We look at both sides of this issue in this section.

The ideal weight ranges for height for adult men and women is known as *body mass index* (BMI), which we also discuss in Chapter 3. You can calculate your BMI by using an online calculator. Many online calculators are available, including one you can find at `www.cdc.gov/healthyweight/assessing/bmi`.

A normal BMI is 18.5 to 24.9. This range is most strongly associated with good health and, hence, is the target. These are the other categories:

✔ Less than 18.5 is considered *underweight*.

✔ 25.0 to 29.9 is called *overweight*.

✔ 30.0 to 39.9 is termed *obese*.

✔ 40.0 or more is considered *morbidly obese*.

### Gaining weight

As we discuss in Chapter 6, some people with untreated celiac disease do not properly absorb nutrients into the body (a condition called *malabsorption*) and as a result, lose weight. When you follow a gluten-free diet, these nutrients — and the calories they contain — become properly used by the body and as a result, you may gain weight. Another reason for gaining weight is that eating gluten-free can sometimes lead to an increase in fat in your diet. We discuss this and other nutritional issues associated with a gluten-free diet in Chapter 11.

If you found yourself gaining weight after you started your gluten-free diet, you are surely not alone. Indeed, in one study from Ireland, over 80 percent of people with celiac disease gained weight over the 2 years after starting on a gluten-free diet. (Only 15 percent lost weight.)

For some people, it can seem that each calorie seems to end up on the hips. This can be a shock for someone who was underweight and never watched — or needed to watch — what they ate. If you find yourself in this situation, you will need to not only watch *what* you eat (to ensure that your diet is gluten-free) but also *how much* you eat (in terms of the number of calories you are consuming).

Maurice was a fit, 30-year-old personal support worker at a nursing home. He was sent by his family doctor to see Ian after having been found, at the time of a routine physical, to be low in vitamin D. Investigations were undertaken and it was determined that Maurice was malabsorbing nutrients — including vitamin D — because his small intestine was damaged from celiac disease. Ian had Maurice meet with a dietitian, a gluten-free diet was successfully instituted, a vitamin D supplement was begun, and in short order Maurice's vitamin D level started to improve. Unfortunately, his weight also climbed. Maurice didn't feel that he was over-eating and he hadn't reduced his level of exercise, yet over the next 2 months, he gained 10 pounds and for the first time in his memory, he was overweight. Ian arranged for Maurice to meet again with the dietitian and it was determined that in attempts to increase his vitamin D levels, Maurice had been drinking an *extra* 6 glasses of vitamin D-fortified milk per day, each of which contained 120 calories. This was providing Maurice with an extra 720 calories per day! He was shocked with this discovery and, as he exclaimed at the time, "No wonder I'm gaining weight!" Maurice returned to his usual — perfectly sufficient — quantity of milk intake and, by following his gluten-free diet and taking a vitamin D supplement, his vitamin D level returned to normal while, at the same time, he lost the extra weight he had gained.

Because gaining weight requires an excess of calorie intake compared to expenditure, if you are overweight, in addition to being careful about what you eat, increasing the number of calories you burn is also helpful. (That is, as long as you avoid the trap that so many fall into of eating extra heartily as a reward for the exercise you just did!)

If you are progressively gaining weight for no ready explanation, get in touch with your physician. Your doctor can check to see whether you have some other, additional health issue — such as thyroid under-functioning (see Chapter 8). If not, then seeing your dietitian would be wise as she can review your nutrition program, including your calorie intake and expenditure, and help you come up with a plan to achieve and maintain a healthy weight.

A person with celiac disease should *never, ever,* intentionally resume eating gluten to purposefully cause malabsorption of calories in attempts to control one's weight. Doing so has the potential to lead to severe health problems, such as progressive, severe, bowel damage, and even, potentially, cancer.

### Losing weight

Although some people with celiac disease gain weight after they initiate a gluten-free diet, the opposite situation can also occur. If you've been eating pizza, pasta, and many other calorie-rich foods, once you go gluten-free you may find yourself eating less of these and also being more circumspect in terms of food choices. As we discuss in Chapter 10, living gluten-free typically means avoiding junk food and also often means avoiding buffet meals or prepared foods (because many of the items contain gluten). As a result, many

people with celiac disease end up eating a healthier diet that contains more natural foods and fewer processed foods. The net result can be a loss in weight in addition to other health benefits. Although we mention this "problem" here, we admit that we've not met too many people who complain to us about shedding excess weight they've been carrying around. And as for people that didn't need to lose weight, the pounds that are lost tend to be relatively few in number and one's weight typically stabilizes within a few months.

Christine was a 22-year-old somewhat overweight woman who, having just graduated from college, headed off to Europe to celebrate. While she was enjoying the sights and sounds of Paris, to her dismay she developed abdominal cramping and diarrhea. She wondered if she'd "eaten something bad." ("Can this really happen in Paris?" she wondered.) Her symptoms persisted, forcing her to cut her trip short. Upon her return to the United States, she met with her family physician who then referred her to Sheila. Tests were performed including an upper endoscopy and small intestine biopsy (see Chapter 3), and the results revealed that Christine had celiac disease. She began a gluten-free diet and, when she returned to see Sheila eight weeks later, Christine was pleased to report that not only had her symptoms gone away, but to her pleasant surprise she had noticed that — with her now eating healthier — the extra weight she had gained during her college years was disappearing. When Sheila saw Christine later that year, Christine's weight had stabilized at a healthy level, she was carefully following her gluten-free diet, and she was feeling great. She celebrated by booking a flight to Paris!

If, after starting a gluten-free diet, your weight progressively falls — especially if to the point that you are underweight — then you must see your primary care provider (such as your family physician) or your celiac disease specialist to be assessed. The problem could be as simple as you not consuming sufficient calories (in which case you will then need to also see your dietitian) or as complicated as you having some other, undiagnosed, associated ailment (see Chapter 8).

## Becoming constipated

If you have the classical form of celiac disease (which we discuss in Chapter 5), then you are well acquainted with the hassles of frequent trips to the bathroom with diarrhea. And we suspect you will be relieved to hear that following a gluten-free diet will correct this problem. Alas, although you will no longer have diarrhea, your new diet may lead to constipation. (Clearly, there is no justice here.) Indeed, regardless of what form of celiac disease you have, following a gluten-free diet can lead to this problem.

Constipation can be severe enough that your stools become hard and infrequent. The only good thing we can say about this is that it is a sure sign that you are on track with your gluten-free diet! Now, lest you think constipation is your new and ongoing destiny, let us reassure you that this is not the case. Here are some measures you can follow to, ahem, eliminate your constipation:

- **Drink more liquids.** Consume at least 8 eight-ounce glasses of liquid per day. Also, be sure to ingest liquid-rich foods such as fruits. Be aware, however, that apart from water, diet soft drinks and the like, liquids have calories and this needs to be taken into account.
- **Eat more (gluten-free) soluble and insoluble fiber.** *Soluble fiber* dissolves in water, and *insoluble fiber* does not dissolve in water. We discuss fiber in more detail in the next section.
- **Exercise more.** Exercise helps all aspects of one's physical and emotional health including bowel regularity.

### Treating constipation with soluble fiber

Ingesting soluble fiber, the kind that dissolves in water, not only helps ease constipation, but it can also help improve your cholesterol (and, if you have diabetes, can help lower your blood glucose levels). Soluble fiber is found in varying quantities in all plant foods. Here are some good sources of soluble fiber:

- **Legumes,** such as peas, soybeans, and other beans.
- **Oats,** including oat bran. (As we discuss in detail in Chapter 2, when purchasing oat-containing products be sure you are getting "pure oats," not an oat product that is mixed in with other grains.)
- **Some fruits and fruit juices,** including prune juice, plums, berries, bananas, and the insides of apples and pears.
- **Certain vegetables,** such as broccoli, carrots, and Jerusalem artichokes.
- **Root vegetables,** such as potatoes, sweet potatoes, and onions. (The skins of these vegetables, however, are sources of *insoluble* fiber.)
- **Psyllium seed husk.** Psyllium is found in certain cereals and is widely available commercially in pre-packaged containers.

### Treating constipation with insoluble fiber

Insoluble fiber is also known as *bulk* or *roughage*. Unlike soluble fiber, insoluble fiber does not dissolve in water.

Here are good sources of insoluble fiber:

✔ Whole grains. (Remember that you can safely consume only *gluten-free* grains; we list many of these in Chapter 11.)

✔ Corn bran. (Again, you can safely consume only gluten-free bran products. Therefore, for example, you cannot consume gluten-containing bran products such as wheat bran.)

✔ Nuts and seeds

✔ Potato skins

✔ Flax seed

✔ Vegetables such as green beans, cauliflower, zucchini, and celery

✔ The skins of some fruits, including tomatoes

Four of the five most fiber-rich plant foods are gluten-free! These are:

✔ Legumes (including several types of beans, lentils and peas)

✔ Prunes

✔ Asian pears

✔ Quinoa

A complete list of gluten-free grains and other dietary sources of fiber are discussed in Chapter 11.

### Treating constipation with commercial fiber supplements

If you find getting enough fiber in your diet difficult (for whatever reason, including simple aversion to fiber-rich foods), then eat gluten-free fiber supplements. At least 20 to 30 grams of fiber a day are recommended.

Here are some gluten-free commercial fiber supplements you can use (the type of fiber these supplements contain is noted in parenthesis):

✔ **Benefiber** (guar gum).

✔ **Citrucel** (methylcellulose).

✔ **Konsyl, Metamucil** (psyllium). Metamucil products are gluten-free with the exception of Metamucil Wafers; these contain gluten, so avoid this form of the product.

Generic versions of nearly all these and other brand name fiber products are available, but you will need to check with the manufacturer to determine whether a particular product is gluten-free.

### *Treating constipation with laxatives*

If you've followed the strategies we've just discussed yet you continue to have problems with constipation, you may need to have tests done to make sure no other ailment is responsible. What tests, if any, you will need depends on a number of factors including your age, how severe is the problem, whether you have other medical problems, whether you have previously had a colonoscopy, whether you have a family history of colon cancer, what medications you are taking (some can cause constipation), and so on.

If further investigations are either not necessary or are performed and found to be normal, it comes down to how best to treat your problem. This typically consists of stool softeners or laxatives or both. Your doctor can advise you which of the following products is best for you to take for your particular situation:

- ✔ **Bulk flow laxatives.** These contain *polyethylene glycol (PEG)* and work by causing better flow of the feces. (Hmm, too much information?) These products contain smaller amounts of the same compounds used in the large volume clean-out preparations for colonoscopy. These are available over-the-counter (that is, without a prescription) and are very safe and effective.

- ✔ **Osmotic laxatives.** *Milk of magnesium* is an example of an osmotic laxative. Osmotic laxatives work by promoting accumulation of water within the bowel. (This is termed an *osmotic effect.*) They are available over-the-counter and are safe as long as you do not exceed standard doses. Drinking plenty of liquids is recommended when you take this type of laxative.

- ✔ **Stimulant laxatives.** These work by stimulating the intestine to contract and push materials along. Examples of these products are Ex-Lax, Senekot, Doxidan (*casanthranol*), and Dulcolax (*bisacodyl*). It is okay to use these on occasion, but they are not safe for long-term use because, if used in this way, the colon can become damaged.

- ✔ **Stool softeners.** Stool softeners such as Colace and Surfak contain a medicine called *docusate*. Stool softeners have a mild stimulant action and, though okay to use for short periods of time, they are best not used chronically.

See your health care provider if in spite of these measures you have severe constipation (bowel movements once or twice a week or even less), if you develop rectal bleeding, if you have severe abdominal pain, or if it appears that you have become obstructed (nothing, not even gas, is coming out). These symptoms may signify you have a serious medical problem that requires prompt attention.

# Falling Off the Diet

As you continue your journey with gluten-free living, you may find yourself tempted, at times, to either abandon or, at the very least not fully adhere to your gluten-free diet. If you feel this way, you're in very good company. Many other people with celiac disease feel the same way. Nevertheless, we strongly encourage you not to "give in to temptation" or, if you have, to as quickly as possible get back to being gluten-free again.

The problem with resuming the consumption of gluten is that it will lead to the redevelopment of damage to your intestine, can cause symptoms of celiac disease to reappear, and may lead to the serious condition called *refractory celiac disease* (which we discuss in Chapter 11) that causes dreadful symptoms and increases your risk of cancer (specifically, a form of immune system cancer called EATCL which we discuss in detail in Chapter 9). For all these reasons — and at the risk of sounding redundant — we strongly advise against resuming *any* gluten ingestion.

Don't fall victim to the illusion — which we recognize can so easily happen — of believing that, if you've resumed consuming gluten yet you feel well that everything therefore must be alright. This simply isn't the case. You may feel perfectly fine (at least initially anyhow) all the while your small intestine and, potentially other parts of your body, are being progressively damaged.

We recognize that all this may sound pretty scary. We also recognize that the simple fact of human nature remains that following a gluten-free diet (or, for that matter, many other forms of restricted diet) can be very tough and that, people being people, you may find yourself at times not only tempted to fall off the gluten-free wagon, but actually doing just that. Many people with celiac disease do indeed have periods of time where this occurs. To put it succinctly, *life happens.*

If you find yourself in this situation, then we have two things to share. One, to paraphrase the famous song ("Pick Yourself Up"), what you need to do is pick yourself up, dust yourself off, and start living gluten-free all over again. And two, not that we'd *ever* counsel people with celiac disease to even fleetingly resume eating gluten (because we don't and never would), but, having said that, so long as you get back on track right away and so long as the period of time for which you were consuming gluten was very brief, you'll likely be fine.

People with celiac disease are less likely to fall off their gluten-free diet if they have the support of others; not just family, but also membership in a celiac disease support group. We suggest you consider joining such a group. For many people joining a group is hugely helpful. Your celiac disease specialist or dietitian may be able to tell you of a group local to you. Another option is to join an online discussion group. In Appendix B, we list some organizations for people living with celiac disease.

# Taking Charge of Your Celiac Health

As we emphasize throughout this book, we want you to have control over your own health and, in particular, control over your celiac disease. We bet you feel the same way or you wouldn't be reading this book right now! In this section we share with you some tips on how you can empower yourself by ensuring you get the best possible care from your celiac disease health care providers. We also discuss being an advocate for you or your loved one with celiac disease in matters that extend beyond routine health care.

(How passionately do we feel about the importance of patients being empowered through knowledge? Well, suffice to say that Sheila counsels people around the country on this topic and Ian has even written a book on the subject. Years ago, he wrote *What Your Doctor Really Thinks: Diagnosing the Doctor-Patient Relationship.*)

## Preparing for your appointment with your celiac disease specialist

Just like the Boy Scouts motto, when it comes to your forthcoming appointment with your celiac disease specialist — especially if it is your first visit — be prepared. Being prepared helps ensure you — and your doctor for that matter — get the most out of your visit and sets the stage for future good care.

Here are some ways you can help make your visit to the doctor a success:

- ✔ **Bring your records.** Bring written records of your prior medical history including previous test results. (This is only necessary for your first visit to the doctor.)

- ✔ **Bring your medications.** Bring all your prescription and non-prescription drugs with you in their original containers. (Bringing a list is not as helpful as even the most carefully itemized lists are notoriously inaccurate.)

- ✔ **Bring someone with you.** Bring a loved one or trusted friend with you to act as a second set of ears. (See the next section for more information.)

- ✔ **Bring questions.** Write down questions you have *prior to* the visit. That way you won't forget your questions when you're at your appointment. (Also, make notes *during* the visit and write down questions as you think of them.)

✔ **Arrive sufficiently early.** Arrive ahead of time for your appointment, but understand that the doctor may be running late. Often this is due to the fact that the physician is spending extra time with sick patients, and you can be confident they would do the same with you. Bring a book or other way to spend time in case your appointment is delayed.

✔ **Bring resources you've read.** If you want to educate your heath care provider, feel free to bring with you information you've read — and you want them to see, but be as sure as you can that the information you're about to share is reliable; otherwise, you may find your doctor discounting your concerns. (By way of example, bringing in a newspaper clipping discussing a recent scientific publication about which you have questions is a great idea. Bringing in a printed page from Uncle Joe's Miracle Cure for Celiac Disease Web site is, well, hmm, not such a great idea.)

Before you leave the appointment, be sure to also prepare for what comes next. Are you to go to the lab for blood tests? Are you supposed to call the office to report on your progress? Are you to book a return visit with the doctor? Knowing what you are to do is essential; trust us, you don't want to risk being "lost in the shuffle." Your doctor or her staff will likely spontaneously bring up the answers to these questions before you leave. If, however, she hasn't, be sure to bring them up yourself with the office staff.

## Knowing what to ask your doctor

Asking questions when you visit with your doctor is always a good idea. And, of course, your questions will only help you if they get proper answers! If what you are told is confusing or does not make sense, ask for clarification. It's your health after all, and you deserve to have sufficiently clear answers given to you.

Here are some questions to consider asking your doctor (if they didn't happen to get discussed routinely when you spoke with your physician):

✔ Is my diagnosis of celiac disease certain or is there an element of doubt? If an element of doubt exists, how is this going to be sorted out?

✔ What kinds of tests will I need to have done to monitor my celiac disease? How often will these need to be done?

✔ When do I need to see you again? How often, if at all, will I need to be seen by you on an ongoing basis?

✔ What symptoms should I look out for? What should I do if they develop? Who should I call if they occur?

 We are strong believers in having two sets of ears present during your first visits to your celiac disease specialist. During these early appointments, a great deal of information is being shared and questions like those just listed are most likely to come up. At this time in the process, people are most likely to be nervous and thus least likely to retain information. Bring a loved one or trusted friend with you to your doctor's appointment; you'll be glad you did.

## Becoming an expert on your condition

We hope that you find this book to be a helpful resource to allow you to master your celiac disease (or to allow you to help a loved one master his condition). Indeed, we'd be disappointed if you don't. We also hope that you will avail yourself of the myriad resources available to you on the Web. The Internet is an incredible storehouse of information on celiac disease (and every other topic under the sun). The Internet is, however, also an incredibly large repository of *mis*information, so you must tread with care and not be taken in by "experts" who are out to take you for a financial ride by offering some (useless) "miracle therapy" for celiac disease. It's also very important to take with a very large grain of salt those Internet sources that offer expertise (or even just plain opinion) without providing any scientific references or background to support their statements.

To help you find reputable information online, have a look at Chapter 2, as well as Appendix A where we list good Web sites that provide celiac disease information and Appendix B where we list celiac disease organizations and centers you may want to contact.

# Being an Advocate for Your Celiac Health

Celiac disease is a condition in which you, the person living with the condition, is largely in charge of your own treatment. You should also feel empowered to advocate for yourself to make sure you receive the care that you (or a loved one who cannot advocate for himself or herself) deserves.

The first step to being an effective advocate is being knowledgeable about your condition, so we're glad you're reading this book. Making sure that you get the medical care you need is also critical. In the previous few sections, we look at how to help ensure productive sessions with your doctor. In the following sections, we discuss some other situations you may encounter and how you can effectively advocate for yourself.

# Dealing with insurance companies

Two main situations exist where an insurer may deny you coverage for certain celiac disease-related care: When you are seeking reimbursement for genetic testing and when you are looking for medical health insurance. We discuss these and other insurance-related issues in this section.

### Getting insurance coverage for genetic testing for celiac disease

As we discuss in Chapter 3 and Chapter 4, testing for the HLA DQ2 and DQ8 genes can be very helpful in both diagnosing and screening for celiac disease. Insurance companies may, however, not cover you or your family members to have these tests done.

In this circumstance, you can try to persuade your insurer to change its mind by pointing out that performing these genetic tests may actually *save* money in the long run. For example, if a child is screened for celiac disease — and found not to be at risk for it — by testing for (and finding they don't have) the HLA DQ2 or DQ8 genes, the child will not, as a rule, need to have repeated antibody screening testing done every few years until adulthood).

### Getting health insurance

When you apply for health insurance, the insurer will typically ask whether you have any known (so-called *pre-existing*) health issues.

There is often a perfectly understandable rationale for this as the insurer wants to protect its investment. (By way of extreme example to make a point, an insurer would likely not grant you a million dollar life insurance policy if you had but days to live.) The thing is, however, your having celiac disease doesn't make you a bad investment. Heck, you may be a great investment!

If your insurer needs convincing of your being a suitable candidate for health insurance, try pointing out that a person with treated celiac disease is as healthy as or, because of necessarily needing to eat healthfully, perhaps even healthier than the average North American.

### Getting insurance coverage for visits to the dietitian

Seeing a dietitian is essential if you are to be knowledgeable about how to live gluten-free. Unfortunately, despite this fact, celiac disease is not a condition for which insurance coverage for a visit to a dietitian is mandated by law in the United States. Unless this situation changes, you need to pay out of pocket for such a visit. (In Canada, visits to a dietitian are typically paid for by the government insurance plan as long as the appointment is with a dietitian working in a hospital.)

## Having your doctor help you advocate for yourself

Your doctor can arm you with information that will help you advocate for yourself. Most often this is in the form of a letter that spells out important information such as:

- ✔ Your diagnosis
- ✔ Your treatment plan
- ✔ How long you've been under their care
- ✔ Your treatment costs including:
    - The extra costs of buying gluten-free foods
    - The need for extra travel (for example, to and from appointments with the doctor)
- ✔ The doctor's invitation (with your permission of course) to speak to relevant third parties (such as a potential insurer) on your behalf

This letter should be printed on the doctor's letterhead and signed by the doctor. Make an extra copy (or copies) of the letter to use as you need and keep the original in a safe place.

Remember to ask your doctor to update the letter periodically; especially if you will need it for tax purposes or for travel out of the country.

## Handling hospitalizations

As a well-informed patient, you know how to look after your celiac disease. Indeed, it is often the case that a person with celiac disease knows more than the average health care provider including those working in hospitals. For this reason, if you are in the hospital, you need to work especially hard at being your own best advocate. Here are some ways you can advocate for yourself from within a hospital:

- ✔ Tell all your health care providers including doctors, nurses, dietitians, and so forth that you have celiac disease.
- ✔ Before you eat anything that is brought to you, ensure the tag on the food tray states that the food is gluten-free.

✔ Tell the clerk who admits you to hospital that you need to eat a gluten-free diet. You may find it helps to tell them you are "allergic" to gluten, wheat, rye, and barley products.

✔ Bring to the hospital copies of an information sheet on celiac disease. (Many of the celiac societies and organizations — see Appendix B — have these for their members.) You can then hand these out to the members of the health care team that are looking after you.

✔ Tell the doctors and nurses looking after you (especially the nurse dispensing your medications to you) that you can only take gluten-free medications. (Be prepared for blank looks; many otherwise well-informed health care providers will be hearing this for the first time.)

✔ Ask for a dietitian to visit with you. He will help ensure you get a gluten-free diet while you're in hospital.

✔ If the admission is not an emergency, you may want to bring some gluten-free supplies with you, including crackers, cereals, and breakfast bars. However, before you eat any food you've brought make sure to ask the doctor or nurse whether it is okay for you to eat. Sometimes tests, health issues, or other reasons require you to not eat anything at all for a period of time.

## Selecting a nursing home

Finding a suitable nursing home is invariably a challenge even at the best of times. Add in the extra needs of a person with celiac disease, and finding a good place can be especially challenging.

Here are some ways you can help ease the process of finding a nursing home for yourself or a loved one with celiac disease:

✔ Plan well ahead; it may take visits to a number of different facilities before you find one that meets your needs.

✔ Partner with a loved one or close friend who can help advocate for you.

✔ Interview the nursing home administration and, if possible, some of the staff, to ensure they are sufficiently knowledgeable about — and comfortable with — celiac disease and, in particular, what a gluten-free diet is. If they tell you that they "can't guarantee your food will always be gluten-free," then run for cover; this place isn't for you.

We list contact information to obtain assistance resolving nursing home problems in Appendix A.

# Chapter 16

# What the Future May Hold

## In This Chapter

▶ Developing better ways of determining the risk of getting celiac disease

▶ Improving the tests used to diagnose celiac disease

▶ Discovering new treatments for celiac disease

▶ Preventing celiac disease

▶ Increasing awareness of celiac disease

▶ Furthering the research of celiac disease

Sheila and her husband Peter are quite sure that if Kay Ernst, Peter's mother who co-founded the Canadian Celiac Association in 1972 and passed away in 2002, were alive today she would not believe the changes that have recently occurred in the world of celiac disease. So much has happened to advance the scientific understanding of celiac disease, its diagnosis, how commonly it occurs, the different ways it presents, and perhaps most importantly of all, the greater availability of more and better quality gluten-free foods. It is clear that if things continue to advance at the rate they have, the future for people living with celiac disease will be brighter and brighter.

In this chapter, we look at what this bright future may hold. Now we're the first to admit that predicting the future is, at the best of times, a fanciful thing to do. And we wouldn't want for one moment to suggest that *all* the things we discuss in this chapter are going to happen or even predict when *any* of them will happen. But we also wouldn't want to leave the impression that the status quo will persist indefinitely. It won't. Indeed, in one form or another, better and better ways of managing celiac disease will emerge. Doctors don't typically guarantee much, but this, indeed, we will guarantee.

In this chapter, we mention a number of different research studies that are underway. If you would like to keep abreast of these and other celiac disease studies, check out www.clinicaltrials.gov. This excellent Web site contains a huge inventory of medical studies on all manner of subjects, so to narrow your search to just those studies on celiac disease, enter that term into the site's search engine.

# Devising Better Ways of Determining Your Risk of Getting Celiac Disease

As we discuss in Chapter 2, the genes a person is born with (conceived with, actually) predict many things about that person's future, including skin color, eye color, and, most relevant to this discussion, much of their risk for getting certain diseases including celiac disease. Celiac disease is triggered by exposure to gluten, but this only happens if you are susceptible to celiac disease in the first place and this susceptibility is directly related to your genetic makeup.

One of the most robust and exciting areas of medical research these days is the field of genetics. With each passing day, more and more discoveries are being made. In terms of celiac disease, over the past few years scientists have discovered increasing numbers of genes that are linked to the risk of a person getting this condition. It's only a matter of time before this stream of discoveries leads to the ability to precisely identify who is and who is not at risk for celiac disease. And, armed with this information, a person with a very high (or near certain) risk of getting celiac disease has a whole range of options available to help him or her avoid running into problems related to celiac disease, including being able to

✔ Avoid gluten from day one. No gluten exposure, no risk of developing gluten-induced damage to the body.

✔ Monitor for evidence that celiac disease has developed so that it can be picked up early on, before it's had a chance to take a toll on the person that has it.

✔ Intervene with other, novel therapies, perhaps even curative ones. (If you knew, based on your genes, it was a certainty you were going to develop celiac disease, would you submit to experimental therapy to "cure" it before it happens? Perhaps yes, perhaps no; either way, this type of genetic knowledge would give you the ability to at least consider the option.)

# Finding Out Why Genetically Susceptible People Get Celiac Disease

As we discuss in Chapter 2, people with certain genes, most notably the HLA DQ2 and DQ8 genes, are at increased risk for developing celiac disease. If you have neither of these genes, you have virtually no risk of developing celiac disease. The converse, however, is not true; that is, if you *have* these genes you will not necessarily develop celiac disease.

Why does having certain genes make a person more susceptible to celiac disease (and why does the absence of these genes seemingly protect against getting it)? The quick answer is no one knows for sure. The more complex answer is that certain genes in people with celiac disease likely influence the behavior of their white blood cells (actually a particular type of white blood cell called a T cell) leading these cells, when they come across gluten protein, to think they've come across a foreign invader (like a bacteria) rather than recognizing gluten for what it is: a nutrient. The T cells' "intruder alert, intruder alert" announcement triggers an immune response, and the small intestine becomes damaged as a result. So that's the bad news.

The good news is that scientists are learning more and more about how the immune system of a person with celiac disease responds to gluten exposure. Armed with this knowledge, doctors can use novel therapies to target the immune problem seen with celiac disease, thereby preventing gluten from triggering the condition. ("Ah," a naysayer may say, "why mess around with the immune system when all you have to do is avoid eating gluten." To which we would respond, you're right . . . except that millions of people with celiac disease either don't follow this advice or, try as they might, still inadvertently ingest gluten and become ill as a result; therefore, we need to find better treatment strategies.)

Over the past few years, using a scientific method called *genome wide analysis study* (GWAS), scientists have discovered a number of other genes that put a person at increased risk of developing celiac disease. It is unclear why or how these genes lead to this risk, but future research will undoubtedly clarify this.

Some of these gene discoveries may shed light on associations between celiac disease and other conditions. For example, the 10 non-HLA genes identified by GWAS thus far include some that are also found in people with a type of inflammatory bowel disease called Crohn disease. Is this coincidence or is there some link between these two diseases? The answer is unknown at present, but future research will likely sort this out. Understanding these genes may also lead to better diagnostic tests. At present, the only way to definitively diagnose celiac disease is by performing a small intestine biopsy (as we discuss in Chapter 3); perhaps in the future, a simple blood test will be sufficiently accurate, and performing these other procedures will not be necessary. (We look at this further in the next section.)

To learn more about the genetics of celiac disease, have a look at the work of Dr. Cisca Wijmenga and her European collaborators, leading researchers in this field. Visit www.rug.nl and type her name in the search engine located on this site to get to her Web page.

# Improving Ways to Diagnose and Monitor Celiac Disease

As medical science and medical technology continue their rapid advance, newer and better ways of diagnosing and monitoring celiac disease are evolving. We discuss these here.

## Better ways to diagnose celiac disease

As we discuss in Chapter 3, the only *definitive* way to diagnose celiac disease is by performing an endoscopy and small intestine biopsy. Blood tests that are currently available, though very helpful, are simply not sufficiently accurate to do away with the need for these other procedures.

There is ongoing research looking for more accurate antibody blood tests to help diagnose celiac disease. Although an endoscopy and small intestine biopsy aren't by any means particularly unpleasant procedures, they do require you to give up some time to visit a clinic, and it would certainly be far better if a simple blood test could instead be done.

It may turn out that antibodies to *deamidated gliadin peptide* (DGP; see Chapter 3) when combined with other available antibody tests prove to be sufficiently accurate to allow for a definitive diagnosis without need for a small intestine biopsy. Even if not, with time other precise diagnostic tests will undoubtedly become available.

## Better ways to monitor celiac disease that isn't responding to a gluten-free diet

When it comes to monitoring celiac disease, if you have ongoing or recurring unexplained gastrointestinal symptoms, your doctor may recommend an endoscopy so that he can directly visualize what is the state of affairs in your stomach and small intestine. An endoscopy (see Chapter 3) may not be particularly unpleasant, but, curious medical students aside, we don't know too many people who would line up to swallow a four-foot long rubber hose if an easier alternative were available. At the present time, no other equivalent or better option exists to routinely provide the type of images that are seen with an endoscope, but newer ways are now playing a role in *select* situations including refractory celiac disease (see Chapter 12) and cancer of the intestine (Chapter 9).

As time goes by, these emerging procedures will become increasingly sophisticated and increasingly used. Further studies are needed to assess how best to use the new technologies in monitoring celiac disease and to determine whether the endoscopic findings using a technique known as *confocal microscopy* may one day be able to replace the need for a biopsy. One limitation of the more advanced scoping procedures, such as *double balloon enteroscopy*, is that they are time-consuming. Fortunately, technology is continually improving, and in the future, better instruments and techniques, including better *capsule endoscopy* (see Chapter 3), will become available.

# Developing New Treatments for Celiac Disease

The proven, highly effective way to treat celiac disease is to follow a gluten-free diet. There are millions upon millions of people — likely including yourself — who know this and do this. But we suspect that, given the choice, most of these people would happily return to consuming a full diet if they could safely do so. If you also feel that way, we're happy to tell you that there is a bit of light at the end of the gluten-free tunnel. In this section, we look at current research efforts being made toward finding celiac disease therapies that would allow you to once again consume gluten.

## Reducing intestinal exposure to gluten

Have you ever seen a parent bird regurgitate some food and then drop it into the waiting mouth of its offspring? Well, maybe we can learn something from them. While we wouldn't want to suggest that human moms and dads should — yuck! — pre-digest food for their kids with celiac disease, if we could achieve this same effect by use of digestive enzymes, this could, perhaps, allow for affected individuals to ingest gluten. In what is clearly a great bit of lateral thinking, scientists are looking at just this trick; that is, rather than avoiding gluten, one would ingest special enzymes that would do the work of digestion for you, and by the time the gluten hit your gut, it would have been transformed into smaller proteins that wouldn't trigger the immune response (and subsequent bowel damage) that is seen with celiac disease.

Even if it turns out that this type of therapy isn't able to completely and routinely replace your gluten-free diet, it could still be a great help in a pinch. Let's say, for example, that you're in a restaurant or at a party or maybe even at home and, having just swallowed a mouthful of some scrumptious treat, it suddenly dawns on you that it may have contained gluten. All you'd need

to do is reach into your pocket or purse, pull out your enzyme supplement and swallow it. (If you're familiar with the treatment of *lactose intolerance* — which we discuss in Chapter 11 — you may note some similarities. Lactose intolerance is a condition in which one lacks an enzyme called *lactase.* One form of therapy for this condition is to swallow an oral enzyme supplement when you're consuming lactose.)

The enzymes that are currently being tested are called *prolyl endopeptidases* and are found in nature in plants and microorganisms. Two such products are currently being tested in clinical studies; *ALV-003* from Alvine Pharmaceuticals in the U.S. and *ANPEP* developed at VU University in the Netherlands. The research that led to ALV-003 was the work of Dr. Chaitan Khosla at Stanford University, an accomplished professor who turned his attention to celiac disease research after his son, and, subsequently, his wife were found to have celiac disease. Sometimes necessity truly is the mother of invention!

We're very excited about the potential of this form of therapy. Although it wouldn't be a cure, it could make living with celiac disease immeasurably easier.

## Decreasing gluten uptake by the intestinal wall

If you have celiac disease, greater than normal quantities of gluten can be taken up through the leakier intestine present with active celiac disease. The taking up of more gluten stimulates the immune system and results in damage to the lining of the small intestine, which in turn can cause symptoms such as diarrhea. As we discuss in Chapter 2, the specific component of gluten that is responsible for triggering the abnormal immune response is *gliadin*. Scientists have discovered a protein called *zonulin* which appears to be a factor in this process. The thinking is that, in celiac disease, ingesting gliadin leads to zonulin release which makes the bowel wall more porous (leaky). This allows more gluten to get into the intestinal tissues where it can cause activation of the immune system which in turn leads to intestinal damage.

Dr. Alessio Fasano and his colleagues at the University of Maryland wondered if, by interfering with how zonulin works, a person with celiac disease would have less uptake of gluten by the intestinal wall (and, thus, less intestinal damage). Acting on this suspicion, they discovered a small protein called *larazotide* that inhibits the action of zonulin. This protein (also called *AT-1001*) has been developed as a potential treatment for celiac disease by Alba Therapeutics Corporation, USA. Preliminary clinical studies with larazotide have shown favorable results in terms of reducing the levels of IgA tissue transglutaminase antibody in people with celiac disease. (As we discuss in detail in Chapter 3, the level of this antibody typically parallels the degree of ongoing intestinal damage caused by celiac disease.) We look forward to further studies to determine if this is both a safe and effective therapy. Stay tuned.

# Changing the immune response to gluten

Because celiac disease is related to a problem with the immune system (see Chapter 2), one theoretical way of handling this ailment would be to get the immune system to stop malfunctioning when exposed to gluten. If immune system therapy were to be helpful, there are several places this system could be targeted including:

- **Blocking tissue transglutaminase enzyme.** Doing so would make gliadin (gliadin is a component of gluten; see Chapter 2) less likely to stimulate the immune system and, hence, there would be less small intestine injury. Laboratory research is underway at Numerate, Inc., and Stanford University to develop this as a potential treatment.

- **Blocking the action of proteins made by the HLA DQ2 or DQ8 genes.** Doing so would reduce the T cell immune response to gluten and result in less damage to the intestine. Researchers at Leiden University in the Netherlands and at Stanford University have created molecules that, by mimicking gluten, may be able to block the effects of HLA DQ2.

- **Blocking T cells or the T cell receptor (TCR).** By blocking T cells or the T cell receptor (this is a molecule on the surface of T cells), the T cell is prevented from reacting to gluten (so-called immune tolerance). One example of how to do this is to use an altered type of gliadin which blocks the immune response to normal gliadin. This is called *peptide therapy* and recent pilot studies in a species of mouse show this approach to hold real promise. This strategy is being applied to humans with celiac disease by an Australian company, Nexpep, that has developed Nexvax2, which contains gluten peptides that will induce immune tolerance to gluten.

- **Blocking the migration of so-called killer T cells into the intestine.** Blocking the migration of "killer T cells" into the intestine may prevent damage to the intestine. A compound that blocks T cell migration, CCX282-B from ChemoCentryx, is being tested for its effect in celiac disease in clinical studies in Finland.

- **Promoting a different T cell response to gliadin.** The typical T cell response in celiac disease is called a T helper 1 (Th1) response. It is thought that by switching this to a T helper 2 (Th2) response the effect of gliadin will be lessened. Allergies and parasite infections naturally cause Th2 responses. One way to make the body develop a Th2 response is through infection with parasites. This has been used with some success in Crohn disease. Scientists in Brisbane, Australia have launched a study using a hookworm called *Necatur americanus* which is inoculated into the skin of people with celiac disease. Sure doesn't sound pretty, but, hey if it is found to work safely and effectively that's okay with us!

- **Modulate the way in which specific cytokines, which are part of the immune response to gluten (as discussed in Chapter 2), act on the intestinal lining.** The hope is that this will diminish the intestinal damage that arises in patients with celiac disease.

Modifying the immune response to gluten is attractive in concept but, at this stage in the evolution of medical science, is not yet tested in humans. Also, because it is not known how one could selectively change the immune system only within the gut, there would be dangers that the immune system in the rest of the body would be adversely affected by this form of treatment.

# Preventing Celiac Disease: When to Introduce Gluten in a Child's Diet

It is highly controversial whether or not celiac disease may be avoided by specifically timing when to first introduce gluten-containing foods into a child's diet. Some studies suggest that early exposure to gluten increases the risk of celiac disease. And, just to confuse everyone, other studies suggest that early exposure to gluten *decreases* the risk of celiac disease. Gee, glad that's clear. Hmm.

Fortunately, there are currently studies underway in the United States, Finland, and Italy which, upon their completion, will hopefully tell us which of these opposite strategies is the better one.

We discuss this topic in detail in Chapter 14.

# Increasing Public Awareness

Not so very long ago, when celiac disease was thought to be a rare disease, relatively little attention was paid to it (by lay and professional people alike). Nowadays, however, armed with evidence that far more people are affected by celiac disease than was formerly thought, there is heightened awareness of the condition not only by the public, but also by the medical and scientific communities and, importantly, the press, too. In this section, we look at some of the implications of this.

## Public awareness and public policy

For better or worse, it is a simple fact of life that if a disease garners lots of public attention, there is an increased likelihood that politicians and other health care and research funders will also pay attention and provide more robust financial support for researching and treating the condition. In terms of celiac disease, its increasing prominence in the public eye has enhanced the relative importance given to it by governments and other bodies that determine priorities for how research dollars are spent and medical care monies used. All this attention can only help lead to better ways to prevent, diagnose, treat, and, hopefully, one day cure celiac disease. To which we simply say: Thank goodness!

One example of how advocacy can make a difference is illustrated by the proactive actions of members of the University of Virginia's Celiac Support Group, the CharlottesVILLI. Members of this group make a point of keeping abreast of social and political developments in the celiac disease world and

as a result knew of New York Congresswoman Nita Lowey's re-introducing legislation recognizing May as National Celiac Awareness Month. (This bill also proposes to educate other lawmakers about celiac disease.) CharlottesVILLI members as well as many other members of celiac disease support groups in the U.S. have helped support this important bill by writing to their Representatives.

Like the actions that the CharlottesVILLI and other support groups undertook? So do we. Perhaps, then, if you're not a member of a support group or another celiac disease organization (we list a number of these in Appendix B), you may want to consider joining one in your community. If none exists, maybe you'll want to look at starting one or, alternatively, joining an online group.

Grass roots organizations, advocacy groups, education, patience, and persistence have all contributed to bringing a once little known condition to the attention of health care providers, politicians, and the public.

## Public awareness, information, and misinformation

There has been a virtual explosion in the number of Web sites (see Appendix A for a listing of some of these) and organizations (see Appendix B for a listing of some of these) that focus on celiac disease. This is wonderful in so many ways (knowledge is power after all), but as with any explosion there can be untoward consequences.

### The trouble with Web sites

The greater the number of Web sites and online discussion groups, the more likely it is that misinformation will creep in and potentially mislead people living with celiac disease. For example, some sites say one thing about what constitutes a gluten-free diet and other sites say very different things. We see no solution to this — the Internet is (as it should be in our opinion) a place of great freedom for the delivery of information — except to advise caution to always question not only the information one reads on the Internet, but the *source* of the information.

### The difficulty with organizations and groups

Different celiac disease organizations sometimes offer very different and conflicting advice to their members on topics such as whether or not a person with celiac disease can safely consume buckwheat (you can) or vinegar (again, you can, so long as it's not *malt* vinegar).

Different celiac disease support groups sometimes offer discrepant information regarding the inclusion of oats into the diet. (Oats are almost always okay for a person with celiac disease to consume so long as they are not

contaminated with other grains; in other words, they need to be "pure oats.") Another unfortunate discrepancy is in regard to whether or not it is safe to use gluten-containing topical products such as some lotions, shampoos, and soaps. (It most certainly is as long as you don't drink the stuff!) This misinformation can still be found in printed and online information of some support groups, but we hope this will be changed soon.

As you can likely imagine (or perhaps have already experienced), getting conflicting information or advice can be terribly frustrating and leave you not knowing what to do.

There can be a number of reasons behind well-intentioned and well-meaning organizations and groups providing less than fully accurate information. One thing's for certain: It is not the result of malicious intent. Here are a few reasons why people and groups who are trying to be helpful sometimes get things wrong:

- ✔ As most people have done themselves in other contexts, when one feels strongly about something, opinion sometimes manages to get in the way of the facts.

- ✔ Even when one has the facts straight, they can, at times, be interpreted in different ways.

- ✔ Scientific discoveries typically occur in research laboratories and are generally of a "basic science" nature, meaning that what has been found is something to do with molecules, genes, cells, and so on, not flesh and blood people. These discoveries can take ten or more years to lead to clinical applications (that is, therapy you can actually use). Unfortunately, what so often happens is that these very early, very preliminary discoveries, which are of uncertain ultimate value, are interpreted by the press and then by the world at large as being far more definitive and having far greater implications than they often actually do.

## Making sense of new information

This is what we recommend you do when you either read about some new "discovery" in the world of celiac disease. (Or, as so often happens, when it is a loved one or concerned friend who shares the news with you. "Hey Jim, did you see the news? There's a cure for celiac disease." "Thanks Bob; yup, that's the tenth cure I've heard about this month."):

1. **Be skeptical — optimistic, but skeptical.**

2. **Check out the details.**

    Is it really a new discovery or just another article rehashing old data?

3. **Assess the validity of the source of the information.**

Is it, for example, an article in *The New York Times* (a good sign that it's reliable) or was it on an anonymous online blog (in which case its reliability would be far more suspect)?

4. **Discuss the findings with your celiac disease specialist.**

They'll almost certainly be aware of the information and can shed further light on it. Nonetheless, in this information age, it is possible that you've found something before he or she has, so be sure to bring a printed copy of the information you found and show it to the doctor.

# Identifying Areas for Further Investigation

Huge strides have been made in the field of celiac disease in the past number of years. Indeed, a mind boggling array of discoveries have been made including in (but certainly not limited to) the following fields (***Note:*** We discuss each of the topics in this list in Chapter 2 and, in the case of zonulin, also see the discussion in the section "Decreasing gluten uptake by the intestinal wall" earlier this chapter):

✔ **Genetics.** For example, the discovery of the role of the HLA DQ2 and DQ8 genes.

✔ **Immunology**. For example, the discovery of the tissue transglutaminase antibody.

✔ **Epidemiology** (the study of diseases within population groups). For example, the discovery that celiac disease is much more prevalent than was formerly thought.

✔ **Pathogenesis** (the study of how diseases develop). For example, the determination of the role of zonulin.

Armed with this new information, doctors are now better able to diagnose, screen for, and treat celiac disease.

In spite of all these exciting developments, there are lots of things that remain unknown. Fortunately, there are many, many scientists and clinical researchers busily working on filling in the numerous gaps that exist.

Though many areas of celiac disease research are needed, and at the risk — egads — of offending some of our colleagues and friends whose areas of study aren't included, in the rest of this section we look at those topics that we feel are in special need of attention.

## Discovering more about who gets celiac disease and why

Much is yet to be discovered in the realm of who gets celiac disease and why they get it. We suspect you've asked yourself these very questions after you or your loved one were diagnosed. Here are some areas in this domain that are in need of further research:

- **Understanding more about the pathogenesis of celiac disease.** One example is learning what role, if any, the TTG antibodies play in causing intestinal injury. That is, are they directly damaging to the intestine or just innocent bystanders? We discuss celiac disease antibodies in Chapter 2.

- **Finding those additional genes that predispose someone to acquiring celiac disease.** Much is now known about the importance of the HLA DQ2 and DQ8 genes, but other as yet largely undefined genes are also known to play a role. We discuss the genetics of celiac disease in Chapter 2.

- **Discovering factors that lead to the development of celiac disease.** At present we have *lots* of theories, but no certainty. (Is it a virus that leads to celiac disease? The time that gluten is first introduced into an infant's diet? Improved hygiene in developed countries? Increased amounts of gluten in the grains we eat? We look at these and other possible factors in Chapter 2.)

- **Finding out why celiac disease has increased in prevalence over time.** Studies by Dr. Joseph Murray and his colleagues at the Mayo clinic using tissue transglutaminase IgA (TTG IgA) testing of stored blood samples show that celiac disease was as much as four times *less* common half a century ago.

- **Knowing why the clinical presentation of celiac disease has changed over time.** For example, most cases are now diagnosed in adulthood and most are of the atypical type (whereas in the past most new diagnoses were in children who had the classical form). This remains an area wide-open for investigation. We discuss the classification of celiac disease in Chapter 5.

## Preventing and screening for celiac disease

Although consuming a gluten-free diet is very effective therapy for celiac disease, following this diet is not an easy task. Far better would be preventing celiac disease in the first place. Figuring out how to prevent celiac disease is an important area of research, and ongoing research studies are currently being conducted in this field.

Screening for celiac disease is designed to discover it before it has had a chance to make someone ill. Knowing who, exactly, should be screened for celiac disease is, however, both controversial and uncertain. (Naturally enough, uncertainty breeds controversy).

As we discuss in Chapter 4, celiac disease is far less common in some regions of the world than in others. In those countries with populations who are at significant risk of getting celiac disease the prevalence of celiac disease is estimated to be approximately 1 percent. In the U.S. and many European countries it is estimated that only 10 to 20 percent of these individuals have actually been diagnosed. Finland is one country in which 50 percent have been diagnosed. This much higher rate of diagnosis was the result of large-scale screening.

To better know who should be screened amongst the general population, it would be a huge help to know what is the natural history of the silent and latent forms of celiac disease (we discuss the forms of celiac disease in Chapter 5). Because these types of celiac disease have only relatively recently become recognized, there isn't all that much known about how they will affect people as time goes by. This isn't a moot point because if it turns out that, on the one hand, silent and latent celiac disease virtually never cause damage to the body, then screening for them wouldn't likely be necessary because treatment wouldn't be warranted. On the other hand, if it is determined that, if left untreated, they lead to a whole host of problems, then screening for silent and latent celiac disease would be invaluable because treatment could then be undertaken before complications arise.

We discuss screening for celiac disease in detail in Chapter 4.

## Finding better ways to make the diagnosis of celiac disease

At present, celiac disease can only be diagnosed by having an endoscopy and small intestine biopsy. Other tests, such as blood tests and the like, are helpful but are never definitive. As we discuss elsewhere in this chapter and in Chapter 3, an endoscopy (and small intestine biopsy) may not be particularly unpleasant, but we have yet to encounter a single patient who wouldn't prefer, all things being equal, to take a pass on these tests if there were only a simple blood test that could establish the diagnosis. Finding better ways to diagnose celiac disease is an area of active research.

## Finding out what happens to people with celiac disease as time goes by

As we discuss in Chapter 1, celiac disease was first described centuries ago. It was, however, only the *classical* form of celiac disease that was known to exist until fairly recently when the other types (atypical, silent, and latent) have been discovered.

Whereas it is abundantly clear that people with the classical form of celiac disease must be treated because otherwise the disease will lead to progressively worsening damage to one's body, there is less known about the long-term implications of having atypical celiac disease, and hardly anything at all known about the long-term implications of having the silent and latent forms of the disease. (Initial studies suggest that individuals with the atypical, silent, and latent forms of celiac disease have a better course, even without treatment, than those with classical celiac disease.) These are huge gaps in knowledge about a condition which affects millions of people. More scientific research is needed to fill in these blanks.

## Improving treatment

The treatment of celiac disease must be made literally and figuratively more palatable for people living with this condition. Meeting this need is essential.

Earlier in this chapter, in the section, "Changing the immune response to gluten," we discuss current research that is looking at innovative ways of getting around the current need to avoid all gluten-containing foods. While the fruits of this research are awaited, what is needed in the here and now is better availability, nutritional quality, palatability (there's that word again), and affordability of gluten-free foods.

A need also exists for:

- Better labelling of gluten-containing foods and medications.
- Easier methods to avoid cross contamination during food preparation. (See Chapter 10.)
- Reducing the costs of living gluten-free, including how governments assist people in offsetting the costs.

## Finding better ways of managing refractory celiac disease

Another area of needed research relates to the therapy of refractory celiac disease (RCD). As we discuss in Chapter 12, this is a rare, but serious complication of celiac disease in which severe intestinal inflammation is present. There are several treatment options to manage RCD, but none that is clearly the best option and, accordingly, none that is ideal.

Dr. Christopher Mulder and his colleagues in the Netherlands are leaders in managing RCD and are studying innovative therapies including the use of bone marrow transplants and the use of a drug called *cladribine*. Another area of promising research relates to a type of inflammatory substance in the blood called a *cytokine*, (specifically one called *IL-15*), which is thought to trigger the intestinal lymphocytes (a type of immune system white blood cell) to become pre-cancerous.

## Discovering more about gluten sensitivity

As we discuss in Chapter 13, some people react adversely to ingesting gluten, but for reasons not necessarily related to the immune system or to celiac disease. The reason or reasons for this are unknown and requiring further scientific investigation.

## Knowing whether tolerance to gluten occurs

Gluten "tolerance" refers to the theoretical development of immunity to the damaging effects of gluten on the intestine of a person with celiac disease. Most celiac disease specialists doubt this exists, but could they be wrong?

A study by Dr. Tamara Matysiak and other European colleagues reported that some adults with celiac disease can resume eating gluten without apparent ill effects. This is obviously an intriguing prospect, but one that needs much more research before anyone with celiac disease — including you! — abandons a gluten-free diet.

## *Increasing public awareness of celiac disease*

We saved our favorite topic of all for last. As evidenced by the fact that we've written this book, you may already suspect that we feel passionately about empowerment though knowledge of celiac disease. You bet we do!

We also feel passionately that this knowledge can be used to great effect by people living with celiac disease and by health care providers and researchers alike to advocate for causes related to celiac disease. Indeed, as a result of people advocating for celiac disease, there is now better funding of labs making innovative and potentially life-altering discoveries, a quickly expanding array of gluten-free foods available on grocery store shelves and in restaurants, and the availability of tax deductions of certain expenses related to living gluten-free, to name but a few success stories.

The work is, of course, not yet done, and it will require ongoing and concerted efforts at increasing public awareness of celiac disease if the recent, wonderful strides that have been made are to continue (which, by the way, we feel confident will indeed happen).

# Part V
# The Part of Tens

The 5th Wave        By Rich Tennant

"Relax everyone! It's <u>not</u> celiac disease, just an internal alien implantation."

# In this part . . .

This part is actually three parts. Here we answer ten frequently asked questions, share ten key tips for living normally with celiac disease, and dispel ten myths, misperceptions, and falsehoods.

# Chapter 17

# Ten Frequently Asked Questions

*In This Chapter*

▶ Questions about diagnosis and screening

▶ Pondering who's at risk and whether prevention is possible

▶ Investigating the best way to manage celiac disease

▶ Wondering whether to include the family in your gluten-free diet

*O*ver our combined 50-plus years in practice (how lucky that we started medical school at the age of 9!), our patients have collectively asked us hundreds of different questions regarding their celiac disease. Queries have ranged from the easily answered ("Can I catch celiac disease?" No, you can't.) to the nearly-impossible-to-answer ("When will there be a cure for celiac disease?" Alas, we just don't know.). Some questions — whether easily answered or not — come up much more often than others. In this chapter, we've compiled the 10 most frequently asked questions (FAQs).

## Do I Need to Have a Small Intestine Biopsy to Diagnose Celiac Disease?

Yes you do. Next question . . .

Nah, we wouldn't be so dismissive as to not answer this perfectly reasonable question more fully. Indeed, this question is often raised; not only by lay people, but by health care professionals, too. Like much else in the world of medicine, there are arguments for and against requiring a small intestine biopsy in order to diagnose celiac disease.

We'll start with the argument *against* requiring a small intestine biopsy to make the diagnosis. People in this camp argue that if someone has symptoms of celiac disease (see Chapter 6) and has antibodies that are typically present if you have celiac disease (see Chapter 3), then the probability of celiac

disease is high enough that there's no reason to burden the person with an endoscopy (and small intestine biopsy). Instead, the diagnosis can be made on these grounds alone, and treatment with a gluten-free diet can begin. In addition, even if the diagnosis is wrong, the person wouldn't come to harm by unnecessarily following a gluten-free diet, and if the diet wasn't helping because, in fact, the person didn't have celiac disease, they'd seek medical attention, and the correct diagnosis would ultimately surface anyhow. Fair enough.

Now take look at the other side of the argument: Those who argue that a small intestine biopsy *should* always be done prior to diagnosing celiac disease say that symptoms of celiac disease are never specific and that similar symptoms can be seen with many other ailments, too. Further, they point out that the antibodies found in a person with celiac disease can also be seen with a variety of other, unrelated health problems. They may also add, given the great importance of knowing whether one has celiac disease (in terms of the risk of other family members having it, the need to adhere lifelong to a special — and costly — diet, the potential health complications arising from celiac disease, and so on), that it doesn't make sense to risk uncertainty regarding diagnosis when a simple, safe, fast, and very accurate endoscopy and small intestine biopsy can almost always provide definitive evidence one way or the other.

These are pretty darn good arguments on either side. But we don't think it's a toss-up. In our opinion, the implications of having celiac disease are so great that the diagnosis should only be made if a small intestine biopsy has been performed and found to show appropriate abnormalities.

Theresa was a 35-year-old woman who was referred to Ian because her family doctor thought she likely had celiac disease. This was a perfectly reasonable supposition because Theresa had compatible symptoms (including bloating, cramping, weight loss, and diarrhea) and a positive tissue transglutaminase antibody (this antibody is almost always found if someone has celiac disease). Ian advised Theresa that he thought her family doctor was likely correct, but still recommended that an endoscopy and small intestine biopsy be performed to be sure. With some reluctance, Theresa agreed to the procedure. As it turned out, Theresa's small intestine biopsy was normal and further tests revealed that all her symptoms and her positive antibody were actually related to previously undetected liver disease. If Theresa hadn't been biopsied, a wrong diagnosis would have been made, unhelpful therapy (a gluten-free diet) administered, her correct diagnosis delayed, and proper therapy (for her liver disease) given only belatedly.

# Can I Protect My Child from Getting Celiac Disease?

We are often asked by moms and dads who have celiac disease whether they can do anything to lessen the risk that their child will also get celiac disease. This, of course, begs the question as to whether *anybody* can be protected from getting celiac disease.

The quick answer is no. There is no proven way to prevent your loved one — or anyone else for that matter — from getting celiac disease. Medical researchers, however, are exploring several hypotheses about how to reduce the risk of getting celiac disease. One hypothesis, as we discuss in Chapter 14 is that the risk is reduced if you delay exposing an infant to gluten. Another theory, however, is diametrically opposed and suggests that giving infants small amounts of gluten early in infancy is the better thing to do to lower their risk. Geesh, how confusing is that?! Until this debate is resolved, we recommend you follow the current consensus amongst most celiac disease experts that it is best to first introduce gluten to infants who are genetically at risk of celiac disease between 4 and 6 months of age.

There is also research suggesting that breastfeeding an infant reduces a child's risk of developing celiac disease. Perhaps this will become yet another reason to breastfeed. (Not that any more reasons are necessary given the vast number of proven benefits that currently exist.) We recommend that you breastfeed your child for *at least* the first 6 months of life; breastfeeding is particularly important during the period of time that gluten is introduced into the infant's diet.

 If being involved in medical research may interest you and your family, consider contacting a nearby university-based teaching hospital to find out whether that institution is performing any celiac disease prevention studies. If so, you may consider enrolling your child in one of these studies.

# Should I Have My Child Tested for Celiac Disease?

If your child has symptoms of celiac disease (we discuss these in Chapter 6), your child's doctor should test to see whether celiac disease is present, unless there is some other apparent cause. If, on the other hand, your child is perfectly well, he or she doesn't need to be tested for celiac disease unless

some other reason to do so exists. In other words, it is not currently recommended to test all healthy children for this ailment. There are, however, two important circumstances for which you and your child's doctor should *consider* (there are no hard and fast rules here) having your child tested for celiac disease:

- ✔ If your child has a first-degree relative (mother, father, brother, or sister) who has celiac disease. (We discuss this further in the later section "If I Have Celiac Disease, Will My Child or Sibling Also Have It?")

- ✔ If your child is known to have a health condition that puts him or her at increased risk of also having celiac disease. Most commonly, this other condition would be an autoimmune disease such as type 1 diabetes. (Having type 1 diabetes , for example, is associated with a 5 percent lifetime risk of also having celiac disease.) In Chapter 8, we discuss a number of different conditions — including autoimmune diseases — that are associated with celiac disease.

We've worded this FAQ specifically as "should I have my child tested for celiac disease?" because, well, that is the frequently asked question we hear. Nonetheless, our answer would be the same if the question had been asked by *any* person who has *any* first-degree relative with celiac disease. (Assuming, of course, the first-degree relative was a *biological* first degree relative, not an *adopted* relative; the increased risk is due to shared genes, not a shared environment.)

Testing for a disease in the absence of symptoms or other evidence it is present is called *screening*. We discuss this topic in detail in Chapter 4.

## Can You Outgrow Celiac Disease?

You likely recall how much better you felt soon after starting a gluten-free diet. And the odds are darn good that as you continued your diet, all your previous symptoms gradually resolved and you remained well thereafter. It could be — human beings being human after all — that at some point you inadvertently (or maybe even intentionally) resumed consuming gluten. It's likely that in short order your old symptoms came back to haunt you, reminding you that you had not been cured of your celiac disease, but rather, that you still had it and needed to look after it. But what if you had resumed eating gluten and your symptoms, in fact, did not return? Or perhaps you have a child with celiac disease and, after being entirely well for years whilst on a gluten-free diet, you are now wondering whether your child needs to continue it? Could it be that you or your child have "outgrown" celiac disease?

So, then, with that 158-word preamble (yup, we counted) under our belt, can you, in fact, outgrow celiac disease? Alas, although you will outgrow your high chair, your first bike, adolescence (thank goodness), your wedding-day tuxedo (sigh), and a million other things, you will *not* outgrow your celiac disease. Similarly, if you have a child with celiac disease, your child won't outgrow it either.

If you are a middle-aged person and were diagnosed in your youth with celiac disease it is quite possible that you recall long ago being told by a doctor that you could — or would — outgrow your celiac disease. At one time, this possibility was entertained by some health care providers. Nowadays we know this is incorrect.

So what might happen to you if, feeling completely well, you decide to resume eating gluten-containing foods? The answer is, you will develop one or more of the following problems:

✔ Your symptoms (see Chapter 6) will return, possibly becoming severe and exceptionally difficult to settle (see Chapter 12 for information on refractory celiac disease).

✔ You will develop complications of celiac disease (such as iron-deficiency anemia or osteoporosis); see Chapter 7.

✔ You may expose yourself to an increased risk of several types of cancer, as explained in Chapter 9.

The bottom line: As much as we wish it were otherwise, you cannot, in fact, outgrow celiac disease and it is potentially dangerous to resume eating gluten, even if, having done so, you feel perfectly well.

# If I Have Celiac Disease, Will My Child or Sibling Also Have It?

As we discuss in Chapter 2, celiac disease tends to run in families. The reason for this is that members of a family share many genes — including those for celiac disease — in common.

If you have celiac disease, your first-degree relatives (that is, your mother, father, brother, sister, or child) has a risk of somewhere between 4 and 12 percent of also having celiac disease. (The reason for the broad range in numbers is that different scientific studies have found different results.)

Compare this with the much lower risk (about 1 percent) of celiac disease in the general population.

Because the risk of celiac disease is so much higher in first-degree relatives of an affected person, these relatives are often screened for the condition. We discuss this further in Chapter 4.

# How Much Gluten Can I Safely Consume If I Have Celiac Disease?

We begin our answer to this question by being dogmatic: If you have celiac disease, you should consume *no gluten at all*. Celiac disease is an immune system disease, and the immune system can be triggered by even a minute stimulus, so don't play with fire and don't ingest gluten. Period.

Okay, so much for dogma; now let's look at practical realities.

Following a gluten-free diet doesn't mean that you will never ingest a single molecule of gluten. The U.S. Food and Drug Administration (FDA) defines a gluten-free diet as a diet in which no more than 10 milligrams of gluten is ingested per day. In other words, the FDA definition implies that "too much" is anything more than 10 milligrams per day. What would 10 milligrams look like? About the same size as 1/100th of a peanut. In other words, although gluten-free doesn't mean zero gluten, it's so close that it can be considered one and the same.

As we say throughout this book, if you have celiac disease it is not only unwise, it is also unsafe to consume gluten. Having said that, we recognize that even the most conscientious of people is likely to ingest gluten — accidentally or otherwise — at some time. Will this be a disaster-in-the-making, or will you be okay if this happens to you? Well, so long as it seldom happens, and so long as the amount consumed is very small, you will likely be fine.

# Can I Skip the Diet and Just Take an Iron Supplement to Treat My Low Iron?

As we discuss in Chapter 7, many people with celiac disease have no — or virtually no — symptoms and the condition is discovered only after a blood test, typically done for routine purposes, reveals iron deficiency, often with anemia present. Iron deficiency in celiac disease occurs because the damaged first part of the small intestine, the *duodenum*, is unable to properly absorb ingested iron into the body.

Given that a person who has celiac disease discovered in this incidental way typically feels healthy, it's not surprising that he or she may ask whether it's really necessary to follow a gluten-free diet and whether an iron supplement can simply be taken instead. Our reply (which you may predict if you've read this chapter from the beginning) is that, regrettably, taking iron alone is not sufficient, and you must also follow a gluten-free diet.

Here are three important reasons why you can't simply consume iron and forego the gluten-free diet:

✔ Even if you have no gastrointestinal symptoms, your gut is damaged and will remain so if you continue to ingest gluten. This damage prevents you from sufficiently absorbing into your body the iron you are ingesting and, as a result, despite taking iron supplements you'll continue to be iron-deficient.

✔ You may feel fine now, but if you continue to consume gluten, there is a good chance that you will eventually feel ill. Even if you don't, your celiac disease may still be taking a silent toll on your body (for example, by causing osteoporosis, which we discuss in Chapter 7).

✔ Ongoing ingestion of gluten may increase your risk of developing certain types of cancer. See Chapter 9 for more on this risk.

Another question about treating iron deficiency that comes up fairly frequently is whether you can get around the problem of malabsorption of oral iron by taking iron by injection instead. As we discuss in detail in Chapter 7, this can be hazardous and is recommended only for very special circumstances.

# Should My Whole Family Eat Gluten-free If Only One Member Has Celiac Disease?

If a person has celiac disease, there is a significantly increased risk that a close family member will be similarly affected. For this reason, we're often asked whether it is wise — or, at the least, easier or simpler — to put *everyone* in the family on a gluten-free diet. (Following a gluten-free diet is the mainstay of treating celiac disease. We discuss this diet in detail in Chapter 10.) Like most things in the world of medicine, there are some good things about doing this and there are — you guessed it — some bad things about doing this.

Here are some advantages of having the whole family eat gluten-free:

- ✔ The person who is known to have celiac disease won't feel singled out for dietary restriction because everyone in the family is eating similarly.

- ✔ Food shopping becomes more straightforward if everyone in the family is eating the same types of foods.

- ✔ If another family member has — but has not yet been diagnosed with — celiac disease, he or she will be on track with therapy.

- ✔ If a family member has been screened for celiac disease and it wasn't detected, that doesn't guarantee that it won't later develop. Starting a gluten-free diet early in the game introduces a diet that that person is going to end up requiring later anyhow.

And here are some disadvantages to having the whole family eat gluten-free:

- ✔ Family members who needn't follow a gluten-free diet will be eating an unnecessarily restricted diet.

- ✔ Following a gluten-free diet typically entails greater grocery costs than a conventional diet. If you are buying additional gluten-free foods (as you would if your whole family is following this diet), then you'll end up spending more money than you would have otherwise.

- ✔ If a person who is not known to have celiac disease is following a gluten-free diet, when he or she comes to be tested for the condition, it will be more difficult to determine whether he or she does or does not have it. We discuss this further in Chapter 3.

- ✔ The family member with celiac disease may not adjust as well to learning how to deal with staying gluten-free once they leave the home environment as compared to someone who learns to live gluten-free while living at home. (We discuss this in Chapter 14).

Although the final decision always rests with the family dealing with this issue, we advocate great caution before having an entire family follow a gluten-free diet when the whole family doesn't actually have to follow such a diet. Celiac disease is a lifelong and important disorder. We feel it best that one commit to the often-challenging gluten-free diet only if one has been definitively proven to have the ailment.

# Is It All Right for Me to Eat Oats?

Until recently it had been thought that anybody who has celiac disease should not consume oat-based products (including oatmeal). Nowadays, however, it's been determined that this prohibition wasn't sufficiently well-founded to be justified. Indeed, it is now known that the great majority of

people with celiac disease can consume oat-based products so long as "pure" oats are being ingested.

As we discuss in Chapter 2, the misperception about oats triggering celiac disease likely arose because the oats that were typically available (and, therefore, consumed) were mixed in with *other, gluten-containing* products. In other words, the oats weren't triggering the celiac disease; the other products were. *Pure* oats (that is, oats not contaminated by other, gluten-containing products) are now available and are fine for you to consume (see Appendix A). Bon appétit!

As much as we'd love to sound dogmatic here and end the discussion with the preceding paragraph, alas, in the interests of being entirely scientifically accurate, there is one qualifier we need to add to this discussion. There are rare individuals with celiac disease whose condition *is* triggered by oats. (This is the other reason why oats were thought to be a trigger for celiac disease but as it turns out, this is very rare.) So if you eat oats (or oatmeal) and develop gastrointestinal symptoms, it would be wise to discontinue eating them or, at the very least, have yourself checked out by your doctor to see what is causing you to be unwell. (And, of course, either in this circumstance or any other, if you develop persisting GI symptoms, it is imperative you seek medical attention to be checked out.)

# Does Avoiding Gluten Protect Me from Getting Other Autoimmune Diseases?

As we discover in Chapter 8, if you have celiac disease (which is an auto-immune disease, a condition in which the body's immune system mistakenly attacks part of one's own body), you're at increased risk of also having other autoimmune diseases like type 1 diabetes and certain forms of thyroid disease.

A unique feature of celiac disease, in contrast to other autoimmune diseases, is that the trigger (gluten) for this condition is known, whereas for other autoimmune diseases, it remains a mystery. We are often asked if this mystery is not so mysterious after all. Could it be that gluten exposure not only triggers celiac disease, but is also responsible for causing these other auto-immune diseases (at least, in those people who already have celiac disease)?

In case you're wondering, we've saved this FAQ for last for a very good reason: It's the hardest to answer! It is known with absolute certainty that if you have celiac disease, you must not consume gluten because doing so per-petuates injury to your intestine and potentially leads to other celiac disease complications. What is not as clear is whether avoiding gluten — if you have celiac disease — has the additional benefit of reducing your risk of

acquiring other autoimmune diseases or, if they are present, helping to keep these other conditions in check.

This is a very important question for scientists to figure out. If avoiding gluten does actually help protect people with celiac disease from developing other autoimmune diseases, this knowledge will contribute to our understanding not only of the particular disease in question, but also of how the immune system malfunctions in the first place. Regardless of the answer, following a gluten-free diet is an absolute necessity for everyone with celiac disease in order to protect them from complications of this disease. If it also helps prevent other autoimmune diseases from developing, that will be a true blessing. If it doesn't, well, the diet remains essential for maintaining good health anyhow.

# Chapter 18

# Ten Tips for Living Successfully with Celiac Disease

*In This Chapter*

▶ Discussing how one can strive to be healthy

▶ Looking at staying informed

▶ Examining how to eat and seem normal

▶ Reviewing how to handle questions from friends and coworkers

▶ Realizing that gluten isn't plutonium

A s with any other health condition, when it comes to having celiac disease, the goal isn't just to avoid being ill; the goal is to be able to lead a full, active, and healthy existence. In other words, to live successfully.

In this chapter, with the assistance of Sheila's husband Peter (who has lived with celiac disease for 50-plus years), we share ten key tips to help you climb the hills, traverse the valleys, and swim the seas of daily life with celiac disease. Now just before — or just after, if you prefer — you do all that climbing, traversing, and swimming, in this chapter we also share tips about dealing with workmates and friends, eating out, and, well, let the journey begin.

## Strive to Be Healthy

"Living successfully" isn't, of course, being *obliged* to live the same routine day-to-day (although you're perfectly welcome to if that's what you prefer.) For most people, living successfully also involves constantly re-evaluating *how* life is lived: looking at how you eat, what exercise you do (or are hoping to do), what bad habits, if any, you feel you should abandon, what good habits you want to adopt, and so forth.

If you are living with celiac disease, one of the things you've had to re-evaluate is your diet as you've faced the challenges of living gluten-free. But as you have already discovered or, if celiac disease is a new diagnosis to you, will soon discover, striving to be healthy by making the necessary dietary changes involves making *healthy* changes. Disruptive? Sure. Good for you? You bet.

Eating gluten-free is healthy eating because it's a balanced diet based on fresh fruits and vegetables, a variety of carbohydrates, and different sources of protein, fats, minerals, and vitamins. A person lives gluten-free to not only *feel* well but to *be* well, and the necessary dietary changes make this all the more likely to happen.

We suspect that you know many people without celiac disease that are also striving to be healthy by making their own dietary changes. Perhaps they've cut down on their saturated food intake or are trying to eat more vegetables, get more fiber, reduce how often they consume fast food, and so on. These people *without* celiac disease are looking at making many of the healthy eating changes that you *with* celiac disease already have. Bet it feels nice to know that you're ahead of the (healthy eating) curve!

For a detailed discussion on gluten-free eating, see Chapter 10.

# Keep Informed about Your Disease

As physicians (and, in the case of Peter, an immunologist and former veterinarian), we are constantly reading about new research findings, attending medical conferences, and doing our best to ensure we are current in our scientific knowledge. As a health care consumer, you, too, would be well served by ensuring you remain abreast of important aspects of living with your celiac disease.

Keeping informed provides you with ways to help you live successfully. Whether its highly practical information, like what new gluten-free foods have recently made their way onto the shelves of your corner grocery store, or more academic information about new discoveries, knowledge is power.

You can remain informed in a number of ways:

  ✔ Your celiac disease specialist will be able to answer questions specific to you and your celiac disease. He or she is also a source of general information about what's new in the world of celiac disease.

✔ Your dietitian — especially if affiliated with a celiac disease clinic — is an invaluable resource when it comes to providing you with current information regarding gluten-free eating.

✔ Being a member of a support group gives you the opportunity to learn practical tips that others living with celiac disease have discovered (such as what restaurants in your community have the best selection of gluten-free menu items). Support groups also provide a venue to which invited speakers come to share their expertise on how to manage celiac disease and many other relevant topics.

✔ You can avail yourself of up-to-date information provided by a number of very helpful organizations specifically charged with meeting the needs of people living with celiac disease. Here you find both practical information as well as scientific information that is geared toward a lay (but interested) audience. We list a number of these organizations in Appendix B.

✔ Reading informed publications (both print and online) keeps you abreast of what's new in the world of celiac disease. Remember, though, particularly when it comes to virtual (that is, Internet) publications, you need to always consider the source of the information. Anyone with an Internet connection can post materials, however inaccurate, to Web sites. In Appendix A, we list Web sites that have a reputation for reliability and accuracy.

# Discover How Avoiding Gluten Is Sexy

Peter was going to write a ten page, exquisitely detailed essay in this space graphically discussing how living gluten-free has impacted his sex life. Sheila told him he was welcome to do this, but only if she could first draw up the divorce papers. Peter reconsidered and, with his wife's permission, narrowed his thoughts down to one sentence. "Living gluten-free has no impact on one's sex life." And that pretty well ends this discussion. Well, almost. The one thing we'd add is, as we discuss in Chapter 14, medical research from Italy has found that people with celiac disease who follow a gluten-free diet have sex more often — and find it more satisfying — than they do before they start their gluten-free diet.

Moral of the story: If you have celiac disease, you'll be more interested in sexual relations if you feel well. And the key to feeling well is getting on — and staying on — track with your gluten-free diet.

# Prepare for Your Child's Visit to Friends

Being a parent of *any* child has all sorts of challenges. Oh, we'd be the first to say there are many, many, *many* joys. But we'd also volunteer that there are challenges too. And if you are the parent of a child with celiac disease, you likely have already had to deal with some of the extra challenges that are present, including what to do when your child wants to eat "normally, just like the other kids." This perfectly natural and completely understandable desire to want to fit in with friends at school, in the playground, in the home, and so on, can at times be one of the biggest hurdles for both parent and child to surmount.

The most important thing about having your child cope with these situations is to have clear direction from you. And that direction must include a lovingly delivered, but firm stance on the importance of your child not consuming gluten-containing foods. However difficult this may be, you must not yield. You love your child dearly and, born of this love, is your desire for your child to be healthy. And consuming gluten if you have celiac disease is not healthy. Period.

As we discuss in Chapter 14, there are a few ways in which you can make the difficult task of keeping your child gluten-free, whether she's a youngster eating at a friend's birthday party or young adult having meals with friends at college:

- ✔ **Teach your child, as early as is age-appropriate, about what foods contain gluten and the need to avoid them.** Again, as age appropriate, take her shopping with you at the grocery store and teach her how to tell the difference between foods that include gluten and those that don't, including knowing what to look for on food labels. Increase the sophistication of the explanation you provide to her as she gets older.

- ✔ **Teach your child how to cook gluten-free.** Peter, cooking gluten-free, is able to cook with the likes of an executive chef in a five star restaurant. In ten minutes, working from scratch, he can create a six course meal. He can create deserts fit for a king. He can leap tall buildings in a single bound. He can . . . okay, well, we got carried away there and none of that is actually true (except for the tall building leaping, or so he says). But what Peter can do, and has done since he was a kid, is prepare excellent gluten-free meals. His parents taught him that if he wanted to be independent, he'd be best off learning how to shop for and prepare gluten-free dishes. It's been an invaluable strategy for him and one you might consider fostering with your own child with the amount of information you share and the cooking autonomy you allow them being progressively increased as they mature.

✔ **Speak to the parents of your children's friends and explain to them about celiac disease and how it's treated.** You may find them surprisingly willing to do their best to accommodate your child's needs when your child is visiting their house.

✔ **When going to a birthday party or other celebration, have your child take some gluten-free treats with them.** For example, if cupcakes are being served for Johnnie's birthday, send along a few gluten-free cupcakes so your child does not feel left out. If hotdogs or pizza are going to be served, preparing a gluten-free version to drop off with your child at a party or an end-of-the-season sports team celebration will be appreciated by the host or coach.

For more tips, have a look at the section "Growing Up Gluten-Free" in Chapter 14.

# Learn How to Eat Out without Standing Out

Unless you are on the flamboyant side, you likely prefer, when eating out, to not stand out. Oh sure, you want good service and you surely want good food, but you probably don't want the fact of your celiac disease to become an issue (even if it's as much the restaurant's issue as it is your own).

There are a number of ways you can have an enjoyable, stress- and gluten-free dining experience when at a restaurant:

✔ **Call the restaurant before you go and ask if gluten-free foods are on the menu.** If so, ask what ones. If not, feel free to suggest that the restaurant consider revisiting this and in the future including gluten-free items. The restaurant business is the most competitive one out there, and your suggestion may well be appreciated, especially if it helps to draw in more customers.

✔ **Order "off" the menu.** If you're with friends or family at a pizza restaurant (where gluten-free menu items are typically not commonplace), for example, feel free to ask the waiter to have the cook whip together a plate of fresh mozzarella, a couple of tomato slices, some basil, artichokes, and olives all drizzled with a little olive oil for a heartier salad. They'll likely be happy to do this. You might also ask if the owner is around (if it's a small restaurant, your waiter and the owner may be one and the same); small restaurant owners are, intrinsically, hosts and want to please their guests so they are often very accommodating and will likely do their best to accommodate your needs and requests.

✔ **Take some gluten-free snacks with you.** Peter has toted gluten-free bread and other goodies to friends' homes, to the theatre, to parties, to restaurants, to, well, pretty well everywhere he goes where food is going to be served and he's not sure they will have gluten-free choices available. If they do, he packs his snack away for another time; if they don't, well, he's got some food on which to chow down.

✔ **Consider having a light meal or snack at home before you go out.** It is easier to retain your gluten-avoidance willpower if you aren't starving as someone offers you a tasty, but off-limits gluten-containing morsel.

You can find more tips on eating gluten-free when out of the house in Chapter 10.

# Figure Out How to Save On Your Food Purchases

As you probably discovered when you went on your inaugural gluten-free grocery shopping trip, living gluten-free means incurring additional expenses. In a sense, wheat is the "great extender" in that it takes up a significant portion of the volume of many prepared foods. Replacing wheat-based components with alternative products means the manufacturer incurs increased food production costs, which, not surprisingly, are passed on to you. (There are multiple other cost factors also at play here, including the absence of the same economy of scale that is present with regular food production.)

Here are some ways that you can save some money on your gluten-free food grocery purchases:

✔ **Apply for tax rebates that reimburse you for your additional food purchasing costs.** As we discuss in Chapter 10, this is not always straightforward to do.

✔ **Learn how to do your own gluten-free cooking and baking.** In addition to being a great hobby, it also helps you save money because cooking for yourself is typically less expensive than eating out or buying gluten-free prepared foods.

✔ **Fill up your always-hungry teenager by having them eat rice, beans, corn (polenta), and potatoes to complement their other nutritious foods.**

✔ **Find suitable restaurants.** Because the less expensive, fast food types of restaurants typically don't provide much in the way of gluten-free food offerings (and are generally not very nutritious places anyhow), you may feel that you are limited to fancier, more expensive restaurants, which often are more likely to have gluten-free options. Another option is to find small, family-run restaurants where the owners are on-site and typically do the food buying, preparing, and serving themselves. These types of establishments are likely to charge less than the fancy place down the street. More importantly when it comes to you and your celiac disease, although they may not know much about celiac disease, they sure as shootin' know what ingredients are used in their recipes, and you can chat with them to make sure you make appropriate gluten-free selections.

We look in more detail at these and other money saving food purchasing tips in Chapter 10.

# Be Prepared for Blank Looks (Or Worse)

You've likely had experiences where, when you told acquaintances, friends, or workmates that you have celiac disease, you got looks ranging from, at best, a blank stare to, at worst, one that says you may as well have told them you had the plague. Although things are changing, most people still know very little about celiac disease. And in any event, even when they do, discussing the details about a digestive disease hardly seems like a smooth beginning to a "normal" conversation and hardly an effective pickup line (unless, perhaps, you're in the gluten-free food shopping area of the grocery store, but that's a discussion for another place. Mind you, having said that, we *could* refer you to the "Discover how avoiding gluten is sexy" section earlier in this chapter . . .)

Depending on how comfortable you are telling people you have celiac disease, the people to whom you're speaking, the specific situation, and so forth, you may find it helpful to have different comments or responses prepared in the event the topic of your having celiac disease comes up. Most people with celiac disease find the simplest thing to do when chatting to people with whom they're not particularly close is to describe their celiac disease as being a food intolerance or a food allergy. This brief description, even if not quite accurate, is usually effective at dispensing with the subject and moving the conversation on to other subjects.

# Have a Good Answer to the Inevitable Question — "What Happens When You Eat Wheat?"

As we mention in the preceding section, although people may be surprised to hear you have celiac disease, they usually drop the subject once you've explained it in a few words (assuming, that is, you elect to say anything at all) or, conversely, opt to provide a more detailed explanation.

Some people, however, out of either curiosity or caring — or, at times, even prying — may press you for more details than you're comfortable providing. Chief among these is typically a question along the lines of "What happens if you eat wheat?" If you know the person well and want to provide a full answer, then, of course, go for it. On the other hand, if you would rather they would simply stop asking you anything at all, you might try the one answer that Peter has longed to use for decades, but hasn't yet ever had the impudence (rudeness?) to try. Here's how his fantasy vignette goes:

Stranger to Peter in food line-up: "Hey, their bread's great in this place; you gotta try some."

Peter to stranger: "Oh, okay. Thanks."

Stranger: "But you're not taking any."

Peter: "No, not today."

Stranger: "Why not?"

Peter: "I'm allergic to wheat."

Stranger: "Oh, ah, that's weird; what happens if you eat wheat?"

Peter: "My bowels explode."

Stranger: *Suddenly speechless . . .*

It's seldom easy to get into a clinical discussion of one's bowel habits with a perfect stranger.

Assuming you don't want to tell someone that your bowels will explode if you eat wheat (or other gluten-containing products), you may want to have an alternative answer at the ready. Often, keeping it simple works best, and a "If I eat wheat I get an upset stomach" typically suffices.

# Pack Your Bags, We're Going To . . .

Eating is one of the greatest pleasures on a trip, but also one of the biggest challenges or sources of anxiety for someone on a gluten-free diet. Even more daunting is the situation when traveling to a country where you don't speak the language. This is another example of how a little preparation can go a long way to making the trip go more smoothly.

Before you go, try to learn about the foods likely to be available and served in the place to which you'll be traveling. Using the Internet, you can find out what the regional dishes and local recipes are in pretty much any neck of the woods. Also, in many countries, food isn't as mass-produced and processed so often as in North America, so dishes containing gluten aren't as prevalent. In Appendix A, we list a number of Web sites that provide helpful information about traveling while living with celiac disease.

Most countries have some spectacular gluten-free dishes that you may even want to introduce into your regular menu. Can't eat quiche? Try a frittata. Enjoy the Swiss *raclette,* which is melted cheese on potatoes. And fresh berries in *crème fraiche* with a drizzle of excellent balsamic vinegar puts most baking to shame. In Italy, you'll find that there are many alternatives to pasta, including corn-based polenta and risotto. Italy also has many food shops that cater to people who are living gluten-free. In France, try a *charcuterie* (a type of delicatessen specializing in meats and other prepared foods) for many gluten-free options for a great picnic. In Japan, rice is nice. Also, "spring rain" noodles are made from rice. And miso soup is gluten-free. In Scotland, they use a lot of wheat and bread crumbs, so eating gluten-free has some challenges. On the plus side, the whisky is gluten-free (due to the distillation process).

 It's very helpful to learn a few key words of the language local to where you're traveling. Peter has learned how to say he is allergic to wheat and to ask whether something is made with wheat flour in 4 languages (though he still finds communicating in Scotland particularly tough!). Phrase books also work well, as do dining cards (see Chapter 10 and Appendix A). Sometimes, however, nothing works quite as effectively (and succinctly) as pointing to a dish you recognize from your homework as likely to be gluten-free.

Bon voyage!

# Deal with the Slipups

Being aware of the importance of avoiding gluten in order to maintain good health, most people living with celiac disease strive, as they should, to be as careful as they can with their diet. But life happens and the odds are darn good that at one point or another (or multiple points for that matter)

you — and everyone else living with celiac disease — will either intentionally or inadvertently consume gluten-containing food.

If and when this happens, the first thing to do is to take a deep breath and reassure yourself that you've not just swallowed plutonium and you're not about to die! In the next breath tell yourself that your slipup doesn't make you a weak person, it doesn't make you a dumb person, and it certainly doesn't make you a bad person. Following a strict diet of any type for even a few days or weeks can be tough; following a strict diet for the rest of your life can be that much more formidable a challenge.

In the third and with every subsequent breath, do your darndest to never refer to your gluten-consuming misadventure as *cheating*. Cheating is something devious or immoral. Eating gluten isn't those things. Eating gluten represents a break in willpower or an accident or, for children, simply part of growing up and experimentation. The term *cheating* is patronizing at best, insulting at worst, and should never be uttered in the same sentence as the words celiac disease or gluten. Wow, we feel so much better now that we got that off our chest.

So take pride in your usual success following your gluten-free diet, get quickly back on track and, should you feel guilty with your slipup, let the guilt pass quickly for it won't serve you much good in the long run.

# Chapter 19

# Ten Myths, Misperceptions, and Falsehoods about Celiac Disease

## In This Chapter

▶ Looking at misperceptions regarding being overweight and having celiac disease

▶ Discussing myths surrounding gluten-ingestion and celiac disease symptoms

▶ Eliminating the myth of borderline celiac disease

▶ Correcting misperceptions about non-ingested gluten sources

▶ Debunking the idea that celiac disease is always to blame for a return of old symptoms

*I*n some ways, celiac disease is a very straightforward condition: The bowel gets damaged from exposure to gluten, and by avoiding gluten all will likely be well. And in other ways, celiac disease is incredibly complex: Why does one person get celiac disease, yet someone else does not? Why does one person get a whole host of symptoms and someone else no symptoms at all? Why does one person run into other autoimmune diseases and someone else has no other health issues? The questions go on.

We think it's this mixture of the readily explained, and the complex and confusing that leads to so many of the myths, misperceptions and, at times, downright falsehoods that surround this often puzzling condition. In this chapter, we look at the ten most common such issues our patients bring up with us.

## Heavy People Can't Have Celiac Disease

As we discuss in Chapters 6 and 7, celiac disease causes *malabsorption*, meaning that nutrients you ingest are not properly absorbed into your body. These nutrients have to go somewhere, so if they are not being absorbed *into* your body, they then go *out of* your body (with your stool). Also, as the nutrients are lost from your body, so are the calories they contain. It makes sense, therefore, to conclude that losing calories from your body would lead to weight loss. Indeed, this is exactly what happens to many people with active celiac disease.

The thing is, however, when it comes to malabsorption due to celiac disease, it's not an "all or none" issue. The substantial majority of people with active celiac disease successfully absorb into their body most of the nutrients (and thus, calories) they consume. They often *do* have some malabsorption; it's just that it's selective in terms of which nutrients are malabsorbed and limited in the degree to which they malabsorb. So if most nutrients — and the calories they contain — are being absorbed into the body, it comes down to how many calories are being ingested versus how many are being lost. For many people with celiac disease, just like for most people in general, the calories we eat exceed the calories we use up, leaving us with a net surplus of calories which ends up making us overweight.

Here are a couple of other reasons why people with celiac disease can be overweight:

- ✔ Perhaps the person was considerably overweight before he developed celiac disease. When he then acquired this condition, it could be he lost weight, perhaps even substantial weight, but depending on his size before he became ill, he may still carry around extra pounds at the time he was diagnosed.

- ✔ Once you follow a strict gluten-free diet, any problems you previously had with malabsorption will resolve. At that point you will, just the like everyone else, be at the mercy of that notorious and sometimes oh so frustrating balance between calorie intake and calorie expenditure.

# Eat Gluten and You Feel Immediately Ill

If you have celiac disease, you should consume no gluten; it is the consumption of gluten that leads to damage to your gut and the symptoms (see Chapter 6) that then arise. Having said that, it is a myth that all people with celiac disease immediately develop symptoms after ingesting gluten. Here are some important reasons for this:

- ✔ **Not everyone with celiac disease has symptoms.** You may well be one of the many people who were diagnosed either through screening (Chapter 4) or after an unexpected, abnormal test result was found (Chapter 7). So if you felt fine when you were consuming gluten *before* you were diagnosed with celiac disease, it's quite possible that you will continue to feel well when you consume gluten *after* you were diagnosed. (*Note:* This is not a reason to resume ingesting gluten! If you have celiac disease, you should consume no gluten at all! Hmm, we think we've said that before.)

> ✔ **Although ingesting gluten triggers your immune system and leads to damage to your intestine, this isn't instantaneous.** For most people with celiac disease, it takes days, weeks, or even months before the damage becomes severe enough to cause symptoms. This is unlike the immune problem seen if you have a peanut or bee sting allergy, in which case you have an immediate reaction upon exposure to these agents.

After reading the preceding list, you may have come to the conclusion that ingesting gluten will *not* make you feel immediately unwell. Excellent; we're glad we convinced you. But — well, yeah, there's a but — *some* people with celiac disease, for reasons that are unclear, *do*, in fact, start to feel unwell with symptoms of bloating, abdominal discomfort, and indigestion developing within hours of ingesting gluten.

So, is it a myth that if you consume gluten you will feel immediately unwell? For most people, yes, it's a myth. But for some people it is a reality.

# You Can Have Borderline Celiac Disease

We never take exception when a person advises us that they or a loved one has "borderline" celiac disease. Oh, sure, it's a myth, and one can no more have borderline celiac disease than one can be borderline pregnant, but the person with this misperception got it from somewhere and that somewhere is typically a well-meaning but misinformed friend, relative or — more commonly in years gone by — doctor. Like pregnancy, when it comes to celiac disease, you either have it or you don't. And speaking of the myth of borderline celiac disease, as we discuss in Chapter 17, it is also a myth that you can "outgrow" celiac disease.

If ever you have been told you had borderline celiac disease, most likely this happened because you had some other condition (a bowel infection, for example) or were too-quickly labeled as having celiac disease without benefit of a small intestine biopsy; then, when you got better, you were told that you got better because you only have *borderline* celiac disease.

Another possibility is that you do, in fact, have the real deal; that is, you were told you had borderline celiac disease, but you actually do have celiac disease. This is most likely to occur if the type of celiac disease you have is either the *silent,* or *latent,* form of the disease. These types of celiac disease are unassociated with symptoms. We discuss the various types of celiac disease in Chapter 5.

Because celiac disease is so important a condition, with so many health implications, if you've been diagnosed with "borderline celiac disease," we

encourage you to speak to your physician to find out on what basis this determination was made. If you had a small intestine biopsy, ask your physician what it showed and compare these findings to those we discuss in Chapter 3. If you didn't have a biopsy, ask what, if any, antibody studies were done and compare your results to those we also discuss in Chapter 3.

If you were told long ago that you had borderline celiac disease, it may (or may not) be worth your while to be retested for celiac disease beginning with having appropriate antibody or genetic testing done. (Often a genetic test is a particularly good way to start since, as we discuss in Chapter 3, if you don't have certain genes, you almost certainly cannot have had, or ever get, celiac disease.) Be sure to speak to your current doctor about this.

## You Cannot Eat Buckwheat

If you're like us, when you think of buckwheat it's not only the ingredient you think of, but Eddie Murphy's impersonation of the Buckwheat character from the old TV show *The Little Rascals.*

Buckwheat doesn't contain gluten and in fact, it is not even closely related to the wheat family. This grain is a healthy, nutritious addition to your diet, whether or not you have celiac disease. Amongst other uses, buckwheat can be used as an ingredient in pancakes or added to salads and soups.

There is, however, one important precaution: Some products contain both buckwheat *and* other, gluten-containing grains, so read labels carefully to make sure you only purchase pure buckwheat or buckwheat mixed only with other gluten-free ingredients.

## You Must Avoid All Products with Gluten

Sometimes it seems to us that gluten is about as ubiquitous as the air we all breathe. As we discuss in Chapter 9, gluten can be found not only in foods, but also in some shampoos, creams, and lotions. A commonly held myth is that if you have celiac disease or dermatitis herpetiformis (DH), using such gluten-containing products can trigger your celiac disease or your DH. In a word (well, two actually), it can't.

The only way that your celiac disease will be triggered is by you ingesting gluten. So long as your shampoo, cream, lotion, and so forth stay on your skin and out of your mouth (as if!), they won't come in contact with your

small intestine and thus, will be unable to cause your disease to flare. This is also true of DH which, as we discuss in detail in Chapter 8, is a skin disease very closely linked with celiac disease. If you have DH, it is safe for you to use gluten-containing topical products.

Lipstick may also contain gluten, but so long as your lipstick does as its name says it should — that is, *stick* to your *lips* — your insides will remain a stranger to your lipstick's gluten and thus, your use of lipstick won't pose a risk.

 For the sake of completeness, we'll add one qualifier here: Albeit very rare, it is possible that some speck of gluten-containing lipstick will, indeed, find its way into your insides and lead to problems. So if you're strictly avoiding gluten yet you continue to have gastrointestinal symptoms, make sure your lipstick is gluten-free. You'll need to contact the lipstick manufacturer to find this out.

# Vinegar Is Forbidden

As an impressionable youngster, Ian recalls being seated at a not-yet-cleaned table at a famous delicatessen in Montreal. The waiter came by, took the vinegar bottle off the table, turned it upside down, and sprinkled its contents over the table. He then grabbed a cloth and wiped off the dirty table. Hmm, vinegar as a cleaning solution? Guess so. (But, Ian wondered, did he now really want to put a cleaning solution on his French fries?) One commonly held myth about celiac disease is that if you have this condition, the only acceptable use for vinegar is as a cleaning solution. Well, if you, too, have this understanding, then we're pleased to say it ain't so. As it turns out, apart from malt vinegar, vinegar is perfectly fine for you to consume if you have celiac disease.

The reason for the exclusion of malt vinegar from the "vinegar is safe" policy is because it is made by malting barley and, as we discuss in Chapter 2, barley contains gluten. For this reason, if you have celiac disease, you should not consume malt vinegar.

# Feeling Fine Means No Celiac Disease

People with celiac disease can have nausea, vomiting, bloating, abdominal cramps, diarrhea, weight loss and, as we look at in Chapter 6, many other symptoms. And people with celiac disease can have no symptoms at all. When we tell someone in the former group the news that we've discovered

the cause of their problem (celiac disease), this is typically greeted with mixed emotions: relief at knowing that a cause has been found and that treatment will relieve their symptoms; and upset at finding out they have a chronic disease to contend with.

On the other hand, when we determine — such as at the time of screening a relative of a person with celiac disease — that a person who is entirely free of symptoms nonetheless has celiac disease, we are frequently greeted with disbelief. "How can I have celiac disease? Celiac disease makes you feel lousy, and I feel fine," we often hear.

As it is, however, you can feel perfectly well yet not only have celiac disease, but actually have or later develop complications from it such as osteoporosis and anemia. Although in some ways, that you may feel perfectly well yet have celiac disease is good — who wants to feel unwell after all? — it can actually be bad because it understandably makes it harder for many people to accept the diagnosis and to follow a gluten-free diet.

If your celiac disease was discovered during investigations to find out why you had some other health problem such as iron deficiency or osteoporosis, but, because you have no symptoms, you don't believe you actually have the condition and therefore haven't adopted a gluten-free diet, we strongly recommend you speak to your celiac disease specialist (or primary care provider) and share your thoughts with them. She can then review with you on what basis the diagnosis was made and, if it turns out the diagnosis is uncertain, further evaluation would be in order. Otherwise, if the evidence is incontrovertible, we hope you come to accept that you have celiac disease and follow a gluten-free diet. It's your health after all, and you need to protect it.

If, however, you have silent or latent celiac disease (see Chapter 5) and therefore have no apparent health problems, you and your physician need to decide together whether you should be treated.

# You Are More Likely to Have Food Allergies and Food Intolerance

One common misunderstanding surrounding celiac disease is the impression that having this particular food-related condition makes you more likely to have *other* food-related conditions such as food allergies or intolerance. We can certainly see where this concern arises since all these conditions are related to the ingestion of food, but, in fact, with the exception of lactose intolerance (which we discuss in detail in Chapter 11) that's pretty well where the similarities end.

As we discuss in Chapter 2, there are major differences between celiac disease, food allergies, and food intolerance, including the time between when you eat something and when you start to react to it, the symptoms that occur, and the underling immune problem, if any. Given the disparate nature to these conditions, discussing them in the same breath is, in keeping with our food theme, like comparing apples to oranges.

# You Can't Share Cooking Implements

As we mention repeatedly in this book, having celiac disease means you must avoid any and all gluten. So you might reasonably conclude that would mean you should not share a toaster or cooking utensils with family members who are not on a gluten-free diet, lest these items become "contaminated" with gluten which might then be ingested.

Well, as it turns out, when it comes to sharing a toaster this isn't quite as black and white as it might at first appear. It depends on the type of toaster you use:

  ✔ **Toasters with removable racks:** If you use a toaster with racks, so long as you clean the racks (soap and water will do) before you use them, you'll be fine and you don't require a separate toaster.

  ✔ **Upright toasters:** If your family shares an *upright* toaster (which typically does not have removable racks), then it's very difficult to avoid having your bread pick up someone else's crumbs. Therefore, you may be better off using your own toaster.

As for sharing cooking utensils, again, so long as you thoroughly wash them before you use them to prepare your own, gluten-free foods, you'll be fine.

For more information on these and other issues about cross-contamination have a look at Chapter 10.

# If Your Old Symptoms Return, It's Likely Due to Celiac Disease

If you have celiac disease and you're meticulously following a gluten-free diet, you probably feel just fine. But, perhaps you can recall a time prior to your diagnosis, a time when — if you're like many people with celiac disease — you had gastrointestinal (GI) symptoms such as nausea or cramps or bloating or diarrhea or one of the many other celiac disease symptoms that

we describe in detail in Chapter 6. Having this recollection, it would be perfectly understandable, should you happen to redevelop these symptoms, if you were to say to yourself "before I was diagnosed with celiac disease, I had these symptoms, and now they're back, so my celiac disease is likely responsible."

Well, although we agree that this line of thought would be perfectly reasonable, it may not actually be right. Indeed, if you're being really careful with your gluten-free diet, there's a darn good chance that your recurrent symptoms are unrelated to your celiac disease and may be due to something else altogether. In other words, having excellently controlled celiac disease doesn't protect you from getting the same, other health problems that anyone else can get. Also, as we discuss in Chapter 8, having celiac disease does increase your risk of developing certain other ailments.

Here are just a few examples of symptoms that may mislead you (and, by the way, your health care provider) into prematurely concluding your celiac disease is flaring:

- ✔ **Abdominal cramps and diarrhea.** Sure, these symptoms could reflect a flare of your celiac disease. On the other hand, they could actually mean you've come down with a gastrointestinal infection (like stomach flu or food poisoning for example).

- ✔ **Nausea.** Perhaps this is due not to your celiac disease, but has occurred as a side effect from a new medication you're taking.

- ✔ **Fatigue.** Type "fatigue" into an Internet search engine and you'll get millions of hits. Type "fatigue" and "celiac disease" into that same search engine and you'll get several hundred thousand hits. In other words, there are tons of causes of fatigue unrelated to celiac disease.

- ✔ **Weight loss.** Although active celiac disease causes malabsorption and this in turn can lead to weight loss, many other conditions also cause weight loss, including hyperthyroidism (thyroid over-functioning) which occurs with increased frequency amongst people with celiac disease — regardless whether the celiac disease is under control.

Having said all this, you shouldn't discount the possibility that your symptoms are indeed indicative of your celiac disease flaring. What to do? We recommend, if you redevelop GI problems or other of your previous symptoms and they don't promptly settle, that you check carefully to see whether you are inadvertently ingesting gluten (see Chapter 10 for a discussion on what foods contain gluten and on hidden sources of gluten).

If you are accidentally consuming gluten, of course you need to eliminate this. If you're not, then, as we discuss in detail in Chapter 12, there remain a number of other possible causes that may account for your symptoms and for which you and your health care provider can explore.

# Part VI
# Appendixes

The 5th Wave                    By Rich Tennant

"I think you're overreacting, but yes, I'll find out if your opponent's boxing gloves are gluten-free."

# In this part . . .

Here are two appendixes you won't want to remove. In this part, we share Web sites worth visiting and we look at organizations that are available to assist people living with celiac disease.

# Appendix A

# Web Sites Worth Visiting

*W*e love the Internet. It's a treasure-trove of useful information that can help a person stay informed, stay current, and stay healthy.

*We hate the Internet.* It's a storehouse of useless tripe that can mislead, misguide, and cause misadventure.

Geesh, so what is a person with celiac disease to do? Well, you can continue reading this appendix, because here we list a whole bunch of Web sites that have a reputation for providing accurate and useful information.

The information you'll find on these sites will likely be of value not only to you, but also to your family and friends, and, depending on your particular situation, perhaps workmates or classmates with whom you spend time (and to whom you're hesitant to lend out this book lest you never see it again! Just kidding of course. Sort of.).

In this appendix, you discover Web sites ranging from those devoted to gluten-free cooking to where to get dining cards (these, as we discuss in Chapter 10, are cards that contain celiac disease information that you would give to wait staff in restaurants) to allied health issues and everything in between. (We don't, however, include Web sites that focus on gluten sensitivity. Gluten sensitivity, as we discuss in Chapter 12, is, at least at the present time, an ill-defined entity without solid scientific studies from which to make recommendations about diagnosis or treatment.)

The list of sites in this appendix is by no means all inclusive and, given the rate new celiac disease related businesses and organizations are popping up and given the inherently dynamic nature of the Web, it's guaranteed that there will always be new sites regularly making an appearance on the Internet. Therefore, if your favorite Web site is not listed here, please realize that we did not omit good sources of information intentionally. (Have a site you particularly like? We'd love to hear about it. You can reach us at celiac disease@ianblumer.com.)

Four footnotes before we get to our list:

- ✔ If you're looking for university-based celiac disease centers, celiac disease support groups, or celiac disease foundations, you can find these listed in Appendix B.

- ✔ If you're wondering whether you should trust a site that you come across as you surf the Web and that isn't listed in this Appendix, have a look at Chapter 1 where we discuss helpful ways to determine the likely worth of a Web site.

- ✔ If you follow one of the URLs (that is, Web addresses) that we provide and get a message along the likes of "this page is no longer available" or "this page has been removed" or some other similar (frustrating) message, instead try going to the home page of the site and look for a new link to the page you're searching for. (Often the easiest way to get to the home page of a Web site is to delete everything in the address bar of your browser after `.com` or `.org` and so on then press Enter.)

- ✔ Last, and most importantly, always first speak to your health care providers before you make any change to your celiac disease (or other health) management based on what you've read on a Web site.

Oh, okay, we can't help ourselves; we've got one other footnote to mention before we move on. Some of the sites we list here are commercial and have products such as gluten-free cookbooks for sale. These cookbooks can be very helpful and that's why we mention the sites in the first place. For the record, though, we want to note that we have no affiliation whatsoever with any of these sites and in particular no financial interest.

# General Celiac Disease Web Sites

If you're looking for general information on celiac disease, in addition to checking out those organizations and support groups we list in Appendix B, you can surf over to the sites we list here.

## The National Institutes of Health (NIH) Celiac Disease Awareness Campaign

`www.celiac.nih.gov`

This excellent site, run by the National Digestive Diseases Information Clearinghouse (which is a service of the National Institute of Diabetes and Digestive and Kidney Diseases), and a result of the combined efforts of

professional, voluntary, and governmental organizations, has as its goal to "heighten awareness of celiac disease among health care professionals and the public." It does this by presenting information in a concise, straightforward and very readable way.

## Children's Digestive Health and Nutrition Foundation (CDHNF)

www.celiachealth.org

This site, run by the North American Society for Pediatric Gastroenterology, Hepatology and Nutrition (NASPGHAN), is intended to "provide a vital resource for medical professionals, parents and patients." A highlight of the site is its excellent series of PDFs on various important celiac disease topics.

# Determining Whether Your Child Is Growing Properly

A child with celiac disease is at risk of not growing at a normal rate. (We discuss this issue in Chapter 14.) Therefore, tracking the child's growth as they get older is important. The Centers for Disease Control and Prevention has a series of charts at www.cdc.gov/growthcharts to help you calculate whether your child's growth is progressing as it should.

# Determining Whether You or Your Child Are at a Healthy Weight

www.cdc.gov/healthyweight/assessing/bmi

The Centers for Disease Control and Prevention Web site, designed to be "your online source for credible health information," provides interactive forms to calculate body mass index (BMI) for both adults and children. Knowing your BMI provides an indicator if one is at a healthy weight, overweight, or underweight. (We discuss BMI and its implications in Chapter 15.)

# General Nutrition, Vitamins, and Minerals

In Chapter 10, we focus on the nutritional needs of one's diet. Here are some sites that provide helpful information on healthy eating.

## The Center for Nutrition Policy of the United States Department of Agriculture

www.mypyramid.gov

This branch of government has created MyPyramid.gov to provide "steps to a healthier you." On this site you'll find lots of information on healthy eating and, in a clear sign of this digital era, podcasts for download.

## The National Institutes of Health Office of Dietary Supplements

www.ods.od.nih.gov

This site provides detailed information on the use of dietary supplements.

## Health Canada

www.hc-sc.gc.ca/fn-an/food-guide-aliment/index-eng.php

Health Canada's highly respected Eating Well With Canada's Food Guide is available at this site. Sure, it's got a long Web site address, but it's well worth the effort of typing it into your favorite Web browser.

## The National Dairy Council

www.nationaldairycouncil.org

The National Dairy Council site has, as you might expect, information on dairy nutrition. Here you will find information on vitamin D and calcium, and there are also helpful materials on lactose intolerance.

# Gluten-Free Cooking and Eating

In Chapter 10, we discuss the ins and outs of a gluten-free diet. The sites we list in this section provide you with additional information on eating gluten-free. (Also, see Appendix B for a listing of other celiac disease support groups and organizations that provide a wealth of information on eating gluten-free.). Many of these sites also have free online recipes and some have gluten-free cookbooks for sale. One thing pretty well all the sites listed below share in common is having a very creative name.

- **The Celiac Scene** (www.theceliacscene.com) has an excellent search tool to help you find restaurants that make a point of having gluten-free menu options.

- **The Gluten Free Dietitian** (aka: Tricia Thompson, MS, RD) created her site (http://glutenfreedietitian.com) to "help you or someone you love successfully follow a nutritious gluten-free diet." Tricia's site advises she will do her best to respond to emails sent to her.

- **Glutenfreeda** (www.glutenfreeda.com) is designed to "help people with dietary restrictions return to a normal life of eating, cooking and entertaining." They state they provide "the largest collection of gluten free recipes in the world" with over 3,000 recipes. We're drooling already!

- **Celiac Central** (www.celiaccentral.org) is the Web site of the National Foundation for Celiac Awareness, an organization "dedicated to raising awareness and funding for celiac disease that will advance research, education and screening amongst medical professionals, children, and adults on a gluten free diet."

- **Carol Fenster's Savory Palate** (www.savorypalate.com) offers a selection of gluten-free recipes.

- **Gluten-Free Girl** (www.glutenfreegirl.com) is the Web site of Shauna James Ahern and has stunning pictures of (and recipes for) gluten-free foods.

- **Gluten-Free Diet** (www.glutenfreediet.ca) is the online presence of the well known Canadian dietitian, Shelley Case. Shelley specializes in gluten-free nutrition.

- **Hey That Tastes Good** (www.heythattastesgood.com) is aptly subtitled "How I learned that gluten-free doesn't mean taste-free."

- **La Tartine Gourmande** (www.latartinegourmande.com) has a large inventory of recipes, but note that not all of them are gluten-free so make sure you follow the appropriate link to get to the site's gluten-free section.

## n-Free Foods Online

nore Web sites where you can purchase gluten-free
dix B we list some celiac disease organizations and
ave information on this topic.) Here are a few Web sites
ye and our taste buds:

(www.againstthegraingourmet.com), in addition
...ery clever name, has as its goal to "bring dietary normalcy to
those requiring a gluten-free diet, and distinctive, great tasting bread for
everyone else." One of their offerings, their "Original Gluten-free Baguettes,"
is a favorite of Peter, Sheila's husband who lives with celiac disease.

- ✔ **'Cause You're Special** (www.causeyourespecial.com) offers "gourmet gluten-free foods." Their Hearty Biscuit Mix has received rave reviews from members of Sheila's local celiac disease support group.

- ✔ **Olive Nation** (www.olivenation.com) features Italian food including gluten-free pasta. Le Veneziane Corn Pasta is 100 percent corn and very good!

- ✔ **Da Luciano** (www.dalucianos.com) features gluten-free pizza and pasta.

# Where to Buy Pure Oats

As we discuss in Chapter 10, consuming oats if you have celiac disease is almost always perfectly safe so long as it *pure* oats (that is, oats not contaminated with some other grain) you are eating. Here are sites where you can order pure oats:

- ✔ Gifts of Nature Oats (www.giftsofnature.net)
- ✔ Gluten-Free Oats (www.glutenfreeoats.com)
- ✔ Chateau Cream Hill Estates (www.creamhillestates.com)
- ✔ FarmPure Foods (www.onlyoats.ca)
- ✔ Great Northern Growers (www.greatnortherngrowers.com)

# Choosing a Gluten-Free Beer

Beer is brewed from grains that contain gluten so there is always concern whether beer may contain gluten. The process of making most beers gets rid of the gluten but to be safe a number of breweries in North America are selling gluten-free beer made from sorghum, millet, buckwheat, rice, honey, and hops. Here are some breweries and the name(s) of their gluten-free beer(s):

- **Anheuser-Busch** (www.anheuser-busch.com) makes Redbridge lager (brewed from sorghum).

- **Bard's** (www.bardsbeer.com) makes Bard's Tale Golden Dragon lager (made from sorghum).

- **Lakefront Brewery** (www.lakefrontBrewery.com) makes New Grist beer (from sorghum, hops, water, rice, and gluten-free yeast grown on molasses).

- **Microbrasserie Nouvelle France** (www.lesbieresnouvellefrance.com) makes La Messagère (brewed from rice and buckwheat).

- **Ramapo Valley Brewery** (www.rvbrewery.com) makes Honey Lager.

- **Sprecher Brewery** (www.sprecherbrewery.com) makes Mbege Ale and Shakparo Ale (both are African-style beers brewed with sorghum and millet).

# Eating Out Gluten-Free

The following Web sites provide information that can assist in your quest to remain gluten-free when you're eating outside of your home:

- **The Gluten-Free Restaurant Awareness Program** (www.gluten freerestaurants.org) has a listing of restaurants that make a point of having gluten-free offerings. This is a program of the Gluten Intolerance Group (see Appendix B).

- **Kinnikinnick Foods Inc** (www.kinnikinnick.com/media/pdfs/restcard.pdf) provides dining card information which you can download and print.

- **Celiac Travel** (www.celiactravel.com) is a site devoted to, as you might have guessed from its name, traveling if you have celiac disease.

- **The Celiac Disease Center at Columbia University** (www.celiac diseasecenter.columbia.edu/inforeg.htm) sells a "handy guide" providing "accurate and helpful information" on a variety of topics including dining out and traveling.

- **The Celiac Sprue Association** (www.csaceliacs.org) has information on celiac disease including dining cards for purchase. (To find the specific link for these cards, from the home page, click on "Shop" then "Online Store" then "Pamphlets.")

- **Living Without Magazine** (www.livingwithout.com) offers gluten-free dining cards amongst other helpful resources.

✔ **Triumph Dining** (www.triumphdining.com) sells dining cards, a gluten-free restaurant guide, and a gluten-free grocery guide. (The recently released third edition has an iPhone app!)

✔ **Gluten-Free Passport** (www.glutenfreepassport.com) offers wide-ranging products to assist the person living with celiac disease as they trek around the globe.

# Dietary Restrictions Apart from Living Gluten-Free

As we discuss in Chapter 11, individuals with celiac disease may have additional dietary restrictions. These add to the challenge of maintaining adequate nutritional intake whilst remaining gluten-free. Here are some Web sites to assist you if you have lactose intolerance, are a vegetarian, or have food allergies:

## Lactose intolerance

The National Digestive Diseases Information Clearinghouse (http://digestive.niddk.nih.gov/ddiseases/pubs/lactoseintolerance/index.htm) is an excellent resource to learn more about living with lactose intolerance.

## Following a vegetarian diet

Here are some Web sites designed to help people follow a vegetarian diet:

✔ **The Vegetarian Resource Group** (www.vrg.org) is a non-profit organization that has, as part of its stated mandate, a goal of "educating the public on vegetarianism."

✔ **The American Dietetic Association** (www.eatright.org) has very detailed and helpful information on vegetarian diets.

✔ **The Vegetarian Nutrition Dietetic Practice Group** (www.vegetariannutrition.net) has as its mission to "serve as the leading authority on evidence-based vegetarian nutrition for health professionals and the public."

# Food allergies

The Food Allergy & Anaphylaxis Network (www.foodallergy.org) is a very helpful site for information about food allergies.

# Gluten-free medications

Medications can be a source of hidden gluten which we review in Chapter 10. Here are some on-line sites to find information to keep you and your family member with celiac disease from exposure to gluten in prescription and over-the-counter medications.

- **Physicians Desktop References** (www.pdrhealth.com/drug_info/index.html)
- **Gluten-Free Drugs** (www.glutenfreedrugs.com)
- **About.com** (http://celiacdisease.about.com)
- **American Society of Health-System Pharmacists** (www.ashp.org)
- **Celiac Central** (www.celiaccentral.org)
- **The Medical Letter** (www.gluten.net/downloads/print/gluten%20free%20Drugs.pdf)

# Advocating for those on gluten-free diets

The following sites can provide information and assistance in getting the help you or your loved one need whether it is keeping gluten-free while residing in a nursing home or assisting with the financial costs of living gluten-free:

- **The Celiac Sprue Association** (www.csaceliacs.org/documents/THENURSINGHOMECHALLENGE.pdf) discusses nursing home challenges faced by people living with celiac disease.
- **The National Citizens' Coalition for Nursing Home Reform** (www.nccnhr.org) is an organization that looks at the standard of care provided in nursing homes.
- **The Celiac Disease Foundation** (www.celiac.org/resources/tax-deductions.php) provides information to assist with possible eligible tax deductions incurred by having celiac disease.

# Other Gastrointestinal Conditions

As we discuss in Chapter 12, if you have celiac disease and you continue to have gastrointestinal (GI) symptoms despite following a gluten-free diet, it could be that you have some other, coexisting GI condition. Here are some Web sites where you can find more information on some of these conditions.

## Inflammatory bowel disease

The Crohn's & Colitis Foundation of America (www.ccfa.org) and the Crohn's & Colitis Foundation Canada (www.ccfc.ca) Web sites contain very helpful information about Crohn disease and ulcerative colitis.

## Functional gastrointestinal disorders

Useful information about the many forms of functional GI disorders including irritable bowel syndrome and functional dyspepsia can be found on the Web sites of the International Foundation for Functional Gastrointestinal Disorders (www.iffgd.org) and the Rome Foundation (www.therome foundation.org).

# Appendix B

# Organizations for People with Celiac Disease

. . . . . . . . . . . . . . . . . . . . . . . . . . . . . . . . . . . . . . . . . . . . . . . . . . . . . . . . . . .

*I*n the past decade, there has been a relative explosion in the number of societies, centers, foundations, and support groups for and about celiac disease. We list these in this appendix. Although this list is comprehensive, new celiac disease bodies are born all the time, so there will invariably be some organizations not captured here. If yours isn't listed, heavens, we mean no disrespect.

## Celiac Disease Societies and Support Groups

As we discuss in Chapter 1, if you have celiac disease you may find belonging to a support group helpful, as you can become acquainted with others who share your condition, who know its challenges, and who have insights into — and tips on — dealing with and ultimately mastering it. You will be able to derive support and knowledge through the group's social and educational programs.

In this section, we list the major national societies and support organizations. There are also many smaller, excellent, support groups such as the one based out of Sheila's university medical center which, because of space constraints, we unfortunately can't include here.

The organizations we discuss in this appendix have many chapters; you can find them listed on the main Web sites that we provide.

# The Canadian Celiac Association (CCA)

www.celiac.ca

905-507-6208

The Canadian Celiac Association (CCA) is the longest running celiac disease support organization in North America. It was founded in 1972 by two women, both of whom had family members with celiac disease. Sheila's mother-in-law, Kay Ernst, was one of these co-founders.

# The Celiac Sprue Association (CSA)

www.csaceliacs.org

877-272-4272

The Celiac Sprue Association is one of the largest of the U.S. support groups and has roots dating back to1978. It is a non-profit organization with a current membership of 10,000 individuals.

# The Gluten Intolerance Group of North America (GIG)

www.gluten.net

253-833-6655

The Gluten Intolerance Group of North America is a large, national, non-profit organization founded in 1974 and based in Washington state. Its mission is to "provide support to persons with gluten intolerances, including celiac disease, dermatitis herpetiformis, and other gluten sensitivities, in order to live healthy lives."

# La Fondation Québécoise de la Maladie Coeliaque

www.fqmc.org

514-529-8806

La Fondation Québécoise de la Maladie Coeliaque is a celiac disease patient support association in Quebec that offers information and support in French.

# Foundations and Organizations

Over the past few years a number of foundations and organizations have been created to provide a broad and unified voice for people living with celiac disease.

## The American Celiac Disease Alliance

www.americanceliac.org

703-622-3331

The American Celiac Disease Alliance is a non-profit alliance of individuals and groups interested in advocacy and action for celiac disease.

## The Celiac Disease Foundation

www.celiac.org

818-990-2354

The Celiac Disease Foundation is a national non-profit group established in 1990 "dedicated to providing services and support regarding celiac disease and dermatitis herpetiformis through programs of awareness, education advocacy and research."

## The National Foundation for Celiac Awareness

www.celiaccentral.org

215-325-1306

The National Foundation for Celiac Awareness is non-profit foundation created in 2003 by Alice Bast to "raise awareness of celiac disease among the general public and the healthcare community, and to facilitate research to better understand the causes, mechanisms, and treatment of celiac disease."

# Celiac Disease Centers at University-based Medical Institutions

Many university-based (academic) institutions have centers that specialize in — and have resources devoted to — celiac disease. Here are some of these institutions, organized by region and listed alphabetically by city. The Web address for most of these centers is overwhelmingly long (and defies even the most deft keyboarder to transcribe correctly) so in most cases we've written the institution's main address from where you can use their search engine or links to find their celiac disease clinic.

## Eastern U.S.

Here are some university-based celiac disease centers located in the eastern U.S.:

- ✔ **Baltimore, MD:** The University of Maryland Center for Celiac Research (www.celiaccenter.org; 800-492-5538).

- ✔ **Boston, MA:** Celiac Center at Beth Israel Deaconess Medical Center (www.bidmc.org/celiaccenter; 617-667-1272) is affiliated with Harvard Medical School.

- ✔ **Charlottesville, VA:** University of Virginia Digestive Health Center of Excellence — Celiac Disease (www.hsc.virginia.edu; 800-251-3627). This is Sheila's center.

- ✔ **New York, NY:** Celiac Disease Center at Columbia University (www.celiacdiseasecenter.columbia.edu; 212-342-4529).

- ✔ **Philadelphia, PA:** The Center for Celiac Disease at The Children's Hospital of Philadelphia (www.chop.edu; 215-590-1000) is affiliated with The University of Pennsylvania.

## Central U.S.

Here are some university based celiac disease centers located in the central U.S.:

- ✔ **Chicago, IL:** Adult Celiac Disease Program at Rush University Medical Center (www.rush.edu; 312-942-5861).

- ✔ **The University of Chicago Celiac Disease Center** (www.celiacdisease.net; 773-702-7593).

- **Denver, CO:** Celiac Disease Clinic at University of Colorado (www.uch.edu; 800-621-7621).

- **Iowa City, IA:** University of Iowa Hospitals and Clinics Center for Digestive Diseases, Inflammatory Bowel and Celiac Diseases Center (www.uihealthcare.com; 319-356-4060).

- **Rochester, MN:** Celiac Disease Clinic at Mayo Clinic (www.mayoclinic. org/celiac-disease; 507-538-3270).

## West Coast U.S.

Here are some university based celiac disease centers located in the western U.S.:

- **La Jolla, CA:** University of California at San Diego William K. Warren Medical Research Center for Celiac Disease (http://celiaccenter. ucsd.edu; 858-822-1022).

- **Los Angeles, CA:** Celiac Center at Children's Hospital Los Angeles (www.childrenshospitalla.org; 323-361-2181).

- **Stanford, CA:** Stanford University Medical Center Celiac Sprue Clinic (http://stanfordhospital.org; 650-723-6961).

# Index

## • A •

A vitamin, 112–113
abdomen
  abdominal symptoms, 98–99, 119
  physical examination, 48
absolute risk, 160
acid, stomach
  diagnostic complications, 67
  digestion process, 40
  heartburn, 99, 100
actin, 51
active celiac disease
  associated weight loss, 102
  defined, 2
  infertility, 240–242
  response to gluten-free diet, 213
Addison's disease, 103, 108
adenocarcinoma, 167
ADHD (Attention-Deficit/Hyperactivity
    Disorder), 106, 141–142
adrenal gland, 103, 147–148
advertising, online, 17
advocacy, patient, 276–279, 288, 337
AGA (antigliadin antibody), 51, 264
age, of sufferer
  calcium intake, 199
  cancer risk, 161
  diagnosis, 30
  frequently asked questions, 302–303
  iron-deficiency anemia, 122–123
  screening, 75
  types of celiac disease, 80
  vitamin D deficiency, 115
air travel, 187
alcohol, 170, 334–335
allergic reaction, 37, 120
allergy. See food allergy
American Celiac Disease Alliance, 341
American Diabetes Association, 144
amino acid, 40
androgen, 242

anemia
  atypical celiac disease, 84
  B vitamin deficiency, 124
  causes, 121
  children's diagnosis, 248
  defined, 121
  described, 107, 121
  folate deficiency, 113, 124
  iron deficiency, 84, 107, 118, 121–124
  pregnancy preparation, 244
  response to gluten-free diet, 211, 212
  symptoms, 110
  vitamin E deficiency, 116
anger, 14–15
angular stomatitis, 129
antacid, 100, 101, 119
antibody. See also specific types
  autoimmune disease, 49
  children's diagnosis, 248, 250
  defined, 27, 49
  dermatitis herpetiformis, 134, 135
  diagnostic tests, 49–53
  disease management, 263–264
  gluten challenge, 66
  neurological problems, 139
  response to gluten-free diet, 211, 212
  screening methods, 76, 77
  types of celiac disease, 80
  vitiligo, 136
anticoagulant, 57–59
antigen, 27, 28, 135
antigliadin antibody (AGA), 51, 264
anti-inflammatory drug, 58
antioxidant, 207
aphthous ulcer, 110, 129
appetite, 102
aspirin, 57–58, 218
associated disorder. See also specific disorders
  atypical celiac disease, 83–87
  common types, 219–221
  defined, 72, 131, 132
  gluten-free diet, 131
  listing of, 74

associated disorder *(continued)*
  pregnancy preparation, 244
  screening criteria, 72, 75
  symptoms, 105
  treatment, 105
  weight loss, 103
asymptomatic person, 77–78, 87
ataxia, 106, 140–141
atherosclerosis, 113
atopic dermatitis, 137
atrophy, 62
Attention-Deficit/Hyperactivity Disorder
    (ADHD), 106, 141–142
atypical celiac disease
  associated disorder, 83–87
  children, 245
  defined, 82
  described, 82
  main features, 80
  nutritional deficiencies, 197
  symptoms, 80, 83, 94, 102
aura, 140
author, Web site, 18
autism, 107, 142
autoimmune disease. *See also specific diseases*
  cause of celiac disease, 24, 26
  described, 49
  effects of, 36
  frequently asked questions, 307–308
  hepatitis, 155

• *B* •

B cell, 27, 165
B vitamin
  anemia, 84, 124
  ataxia, 141
  deficiency, 113–114, 124, 140
  vegetarian diet, 208
bacteria overgrowth, 104, 216
baked goods
  children's meals, 251
  cooking tips, 183–184
  restaurant dining, 177
  shopping tips, 175
baker's yeast, 181
bakery, 193
bariatric surgery, 32
barium x-ray, 165

barley, 34, 181
basophil, 27, 37
beans, 118, 201, 270
beer, 334–335
behavior, abnormal, 248, 249
Benefiber (supplement), 271
beta blocker, 140
Betty Crocker (food manufacturer), 183
bile acid, 153
bile duct, 153, 154–156, 167
bile salt, 40
Biocard (blood dot test), 63
biopsy, intestinal
  children's diagnosis, 248, 249
  defined, 61
  described, 61
  diagnostic challenges, 68
  diagnostic steps, 46
  disease management, 264–266
  endoscopy, 60
  enteropathy-associated T cell lymphoma, 165
  features of celiac disease, 80
  frequently asked questions, 299–300
  latent celiac disease, 80, 89, 90
  microscopic colitis, 218
  response to gluten-free diet, 212–213
  silent celiac disease, 80, 88
biopsy, skin, 134–135
bisphosphonate, 126
blister-like sore, 133
bloating, 98
blood
  cell formation, 121
  clotting process, 116
  flow, 153
  glucose level, 87, 103, 143–145
  loss, 122–123
  thinners, 57–58
blood pressure, 48, 148
blood test
  children's diagnosis, 248
  classical celiac disease, 81
  dermatitis herpetiformis, 134
  diagnostic challenges, 68
  diagnostic steps, 46, 48–55, 63
  disease management, 263–264
  folate deficiency, 113
  iron-deficiency anemia, 121
  latent celiac disease, 89

managing the disease, 50
response to gluten-free diet, 211–212
silent celiac disease, 88
bloody stool, 96, 166
body mass index (BMI), 47–48, 267
bone
marrow, 121, 169
mineral density test, 85, 125
mineralization, 127–128
bone development
calcium deficiency, 117, 118
folate deficiency, 113
malabsorption, 125–128
borderline celiac disease, 321–322
bow legs, 127
boxed food, 180
brain chemistry, 138, 237
bran, 271
bread
cooking tips, 182, 183, 184
grain contents, 34
meal plan, 183
restaurant dining, 185
breast
cancer, 168
milk, 204, 245
breath
shortness of, 121
test, 205–206
brewer's yeast, 181
brush border, 203
buckwheat, 322
bulk fiber, 270–271
bulk flower laxative, 272
bulk food bin, 190
butterfly rash, 151

● **C** ●

C vitamin, 119, 199
cafeteria, 255
cake, 182, 183
calcium
deficiency, 115, 117–118, 126, 139, 199
disease management, 263
epilepsy, 141
osteomalacia, 128
osteoporosis, 84–85, 126
calcium channel blocker, 153

calorie, 266–267, 268
camp, children's, 253
Canadian Celiac Association, 22, 183, 340
cancer
celiac-related types, 109, 162–168
prevention, 169–170
refractory celiac disease, 223
risk factors, 159–162, 169
screening, 168–169
weight loss, 104
candidiasis, 150
canned food, 180
capsule endoscopy (CE), 69–70, 165, 266
car travel, 188
carbohydrate
complementary treatment, 231–232
diabetes, 143
digestion process, 40, 145
flatulence, 97
nutritional deficiency, 196
carotenoid, 207
case finding, 75
Case, Shelley *(Gluten-Free Diet)*, 182
CE (capsule endoscopy), 69–70, 165, 266
celiac disease. *See also specific types*
causes, 10, 24–32, 31
complications, 12, 44, 49
defined, 9–10
effects of, 9–10, 11–13, 23
versus food allergy/intolerance, 36–37, 176
incidence of, 23, 26
myths, 319–326
past knowledge of, 1, 10, 11
spelling variations, 10
types of, 79–80
Celiac Disease Foundation, 22, 341
Celiac Sprue Association, 340
celiac-related disorder. *See* associated disorder
central nervous system, 140
cereal. *See* grain
CharlottesVILLI (support group), 288–289
chat group, 18
chemotherapy, 165
chewing food, 149
children. *See also* infant
Attention-Deficit/Hyperactivity Disorder,
141–142
atypical celiac disease, 82
autism, 142

children *(continued)*
  calcium intake, 199
  cancer risk, 161
  chromosome disorders, 156–157
  classical celiac disease, 81
  developmental delay, 139
  diabetes, 144
  diagnosis, 245–249
  frequently asked questions, 301–304
  gluten exposure, 288
  gluten-free challenges, 178, 251
  gluten-free lifestyle, 252–256, 312–313
  healthy habits, 312–313
  rickets, 126–127
  screening, 249–250
  shopping and cooking tips, 251, 252,
    254–256, 312
  vitamin A deficiency, 113
  weight loss, 81, 104, 144
chromedoscopy, 60
chromosome defect
  described, 156
  example of, 110
  types of, 156–157
cirrhosis, 154–155
Citrucel (supplement), 271
cladribine, 295
classical celiac disease
  children, 245
  diagnosis, 81
  main features, 80
  nutritional deficiencies, 197
  symptoms, 79, 80–81, 94, 102
clinical trial, 281
coated tablet, 119
coeliac disease. *See* celiac disease
coffee, 100, 199
Colace (stool softener), 272
colitis, 69
collagenous colitis, 217
college student, 254–256
colon, 42, 69, 168
colonoscopy
  colon cancer, 168
  described, 57, 69
  occult blood loss, 122–123
Communion wafer, 193
complaining people, 20

complementary and alternative medicine
  carbohydrate diet, 231–232
  described, 227
  digestive enzymes, 231
  gluten-free diet, 232–237
  herbal supplement, 230
  pre- and probiotics, 229
  safety information, 228–229
  vitamin supplements, 230–231
complete protein, 208
connective tissue disorder, 149–152
conspiracy thinking, 18
constipation, 95, 119, 269–272
cooking
  baked food, 183–184
  children with celiac disease, 252, 312
  Internet resources, 333
  meal plans, 184
  myths, 325
  support group activities, 21
  tips for success, 182–183
coping strategies, 16–17
cornea, 150
cornstarch, 181
cortical atrophy, 142
corticosteroid, 136, 137, 147, 223
cortisol, 148
cramp, abdominal, 99, 326
Crohn disease, 283
cross-contaminated food, 186, 190–191
crouton, 182
crypt, 43
crypt hyperplasia, 43
CT scan, 164, 165
cure, lack of, 15
cutting board, 190, 191
cytokine, 28, 29, 287

• *D* •

D vitamin
  deficiency, 115, 211
  disease management, 263
  osteomalacia, 128
  osteoporosis, 126
dairy product
  calcium deficiency, 117, 199, 200
  Internet resources, 332

lactose intolerance, 203–204, 206
  vegan diet, 207
  vitamin deficiency, 114, 115, 116
dapsone, 136
deamidated gliadin peptide (DGP), 51, 52, 264, 284
deamidation, 28, 29
defecation, 42
defective bone mineralization, 127–128
dehydration, 48, 55
denial, 14, 15
dental problems
  cancer, 166
  common types, 128–129
  rickets, 127
  Sjogren's syndrome, 149–150, 151
depression, 103, 107, 138
dermatitis herpetiformis (DH)
  children's diagnosis, 248
  described, 106
  symptoms, 133–136
  treatment, 137
dermatologist, 132
developmental delay, 139, 248, 331
dextran, 181
dextrose, 181
DGP (deamidated gliadin peptide), 51, 52, 264, 284
DH. *See* dermatitis herpetiformis
diabetes
  atypical celiac disease, 87
  causes, 42, 108
  celiac screening, 144–145
  children's diagnosis, 249
  described, 143
  endoscopy procedures, 57
  symptoms, 108
  treatment, 143–144
  weight loss, 103
diagnosis. *See also specific diagnostic tests*
  accuracy of, 67–70
  Addison's disease, 148
  age of sufferer, 30
  children, 245–249
  classical celiac disease, 81
  colitis, 69
  dermatitis herpetiformis, 134–135
  described, 10–11

emotional response, 9, 14–17, 138
enteropathy-associated T cell lymphoma, 164–165
folate deficiency, 113
frequently asked questions, 299–300
future research, 293
gastroparesis, 219
gluten sensitivity, 236
hyperthyroidism, 146
hypothyroidism, 147
importance of symptoms, 46–47
insurance issues, 277
iron-deficiency anemia, 121–123
lactose intolerance, 205–206
latent celiac disease, 89
liver disease, 154
medical improvements, 284
misdiagnosis, 15–16, 45, 99
osteoporosis, 85, 125
pancreatic insufficiency, 217
refractory celiac disease, 222
silent celiac disease, 88
small intestine bacterial overgrowth, 216
sufferer on gluten-free diet, 55, 64–66
typical diagnostic steps, 46, 54
diarrhea
  complications, 96
  described, 95–96
  iron supplement side effects, 119
  lactose intolerance, 204
  myths, 326
  treatment, 97
Dicke, Willem-Karel (doctor), 11
diet. *See* gluten-free diet
dietitian
  gluten-free diet tips, 126, 179
  insurance coverage, 277
  response to gluten-free diet, 221
  role of, 2
  visits to, 258–266
  vitamin requirements, 112
diffuse large B cell lymphoma, 165
digestion
  body system, 37–38
  capsule endoscopy, 69–70
  celiac disease process, 43–44
  complex functions, 38
  defined, 37

digestion *(continued)*
  diabetes, 145
  enzymes, 231
  lactose intolerance, 203
  process, 38–42
dining card, 186–187
dining hall, 255
discussion forum, 18
distention, abdominal, 98
doctor. *See also specific types*
  complementary medicine safety, 229
  dermatitis herpetiformis, 133
  endoscopy procedures, 57–61
  intestinal biopsy procedure, 61–63
  managing the disease, 258–266, 274–276
  preparation for doctor's visit, 274–276
  response to gluten-free diet, 214
  second opinions, 62, 67
docusate, 272
dominating people, 20
double balloon enteroscope, 69
Down syndrome, 156–157
Doxidan (laxative), 272
DQ gene
  children's diagnosis, 250
  described, 25–26
  diagnostic tests, 53–55, 65
  screening methods, 76
dressing, salad, 182, 183, 186
dry cough, 150
dry mouth, 129, 149, 151
Dulcolax (laxative), 272
duodenal bulb, 60, 61
duodenum
  biopsy procedure, 60, 61
  described, 40
  digestion process, 40
  effects of celiac disease, 43
  endoscopy procedure, 60, 61
  illustrated, 41
  iron absorption, 119
  signs of celiac disease, 60–61
dyspareunia, 150
dyspepsia, 101

• *E* •

E vitamin, 116
eczema, 137

eggs, 115, 116, 202
electrolyte, 55, 196
elemental iron content, 119
elementary school children, 253
elimination diet, 233–234
emergency preparedness, 189–190
empirical therapy, 217
enamel, 128
encouragement, 19
endocrine system, 143, 217, 241. *See also
    specific endocrine glands*
endomysial antibody (EMA), 50–51
endoscope, 56, 68
endoscopist, 58–61
endoscopy
  children's diagnosis, 248, 249
  defined, 56
  described, 56–57
  diagnostic challenges, 68
  diagnostic steps, 46
  disease management, 266
  enteropathy-associated T cell lymphoma, 165
  ineffective treatment, 63
  medical advancements, 285
  occult blood loss, 123
  postprocedure actions, 59
  preparation for procedure, 57–58
  procedural steps, 58–59, 59–61
  video images, 69–70
energy level, 210
enterocyte, 30
enteropathy-associated T cell lymphoma
  defined, 109, 162
  described, 163, 224
  diagnosis, 164–165
  prevention, 169
  risk for, 160–161
  symptoms, 163, 224
  treatment, 165
enteroscope, 70
enteroscopy, 70
envelope label, 194
environmental risk factor, 30–32
enzyme
  complementary treatment, 231
  lactase supplement, 206
  liver disease, 154
  supplements, 285–286
eosinophil, 27

epidemiology, 291

epilepsy
  described, 106, 141
  rickets, 127
  vitamin/mineral deficiency, 117, 118, 127

epithelial cell, 29, 43, 166

esophageal cancer, 162, 167

esophagogastroduodenoscopy. *See* endoscopy

esophagus
  cancer, 162, 167
  described, 39
  endoscopy procedure, 59
  illustrated, 38
  reflux, 100, 101

excretion, bodily, 37, 39, 42

Ex-Lax (laxative), 272

exocrine function, 216

eye problem, 149, 150

## • F •

failure to thrive, 81, 104

false negative result, 50, 51

false positive result, 51

family
  children's diagnosis, 249, 250
  depression, 138
  diagnostic complications, 64
  frequently asked questions, 303–304, 305–306
  infant's gluten exposure, 245
  meals, 183, 188–189, 251
  nursing home selection, 279
  response to diagnosis, 16
  risk for disease, 282–283
  screening criteria, 72

fast food, 185

fasting, 58

fatigue
  anemia, 121
  calcium deficiency, 117
  celiac disease, 107–108
  fibromyalgia, 152
  iron deficiency, 118
  lupus, 151
  myths, 326
  primary sclerosing cholangitis, 155

fats
  dairy products, 206
  digestion process, 40, 42

healthy eating tips, 202
  liver disease, 154
  nutritional deficiency, 196
  types of, 202

fat-soluble vitamin, 196

fecal test, 63

feeding tube, 223

femur, 125

fermentable oligosaccharides, disaccharides, monosaccharides, and polyols (FODMAPS), 234

ferritin, 121

ferrous fumarate, 119

ferrous gluconate, 119, 120

ferrous sulfate, 119, 120

fetus, 242–243

fiber, 200–201, 270–271

fibromyalgia, 107, 109, 152, 153

first degree relative, 72

fish, 115, 117, 118

fissure, 60

flatulence, 95, 97, 204

flax, 201

flour, 182, 186, 193

fluid balance, 40, 44, 196

FODMAPS (fermentable oligosaccharides, disaccharides, monosaccharides, and polyols), 234

folate, 84, 113–114, 124

fold, duodenal, 60

food allergy
  versus celiac disease, 36–37, 176
  defined, 37
  effects of, 36
  elimination diet, 233–234
  food labels, 174
  versus food sensitivity, 232
  Internet resources, 337
  myths, 324–325

food intolerance
  versus celiac disease, 36–37
  defined, 232
  elimination diet, 233–234
  versus food allergy, 232
  gluten sensitivity, 235–237
  myths, 324–325

food label, 33, 119, 174, 181

food shopping
  children with celiac disease, 251, 252, 254,
      255–256, 312
  cost-cutting tips, 314–315
  cross-contamination, 190
  food labels, 33, 174, 181
  general guidelines, 180–182
  Internet resources, 334–335
  lack of products, 178, 237
  local support groups, 21
  pure oats, 34, 334
  sources of gluten, 33–35
  tax deductions, 179, 314
fractured bone, 85, 125, 127
fraternity, 255
free radical, 207
friendly gathering, 188–189
friendship, 21
fructan, 234
fructose, 234
fruit
  A vitamin, 112
  B vitamin, 113
  fiber, 270, 271
  healthy eating tips, 201
  K vitamin, 116
frying oil, 190
functional dyspepsia, 219
functional gastrointestinal disorder, 220, 338

## • *G* •

gall bladder, 38
gastric emptying scan, 219
gastric surgery, 32
gastritis, 60
gastroesophageal reflux
  atypical celiac disease diagnosis, 83
  described, 99–100, 219
  treatment, 100–101
gastrointestinal symptoms, 94–102. *See also
      specific symptoms*
gastrointestinal tract
  blood loss, 122–123
  digestion process, 39–42
  endoscopy procedures, 57, 58–60
  illustrated, 38
gastroparesis, 218–219
Gee, Samuel (doctor), 10, 11

gene, 25
genetics
  cause of celiac disease, 24, 25–26
  children's diagnosis, 249, 250
  chromosome defects, 110, 156–157
  depression, 138
  described, 25
  diagnostic tests, 49, 53–55, 65, 66
  environmental triggers, 30
  frequently asked questions, 303–304
  insurance companies, 277
  research, 25–26, 282, 283, 291, 292
  risk for disease, 282–283
  screening criteria, 72, 73–74
  screening methods, 76, 77
genome wide analysis study, 283
geography, 30, 293
gestation, 242, 243
gliadin, 34, 51, 139, 286
glucocorticoid deficiency, 147
glucose, 40, 145, 203
gluten
  causes of celiac disease, 24, 28–30, 31
  challenge, 66
  children's first exposure, 288
  defined, 9, 24, 32
  dermatitis herpetiformis, 135
  described, 32, 174
  food diary, 215
  immune response, 24, 28–29
  increased consumption, 31
  infant's diet, 31, 245
  major triggers of celiac disease, 32
  myths, 322–323
  redevelopment of symptoms, 273
  role in disease process, 10, 13, 24, 28–30, 176
  scientific research, 286, 295
  sensitivity, 235–237, 295
  sources, 33–35, 174, 192–194
  tolerance, 295
Gluten Intolerance Group of North America, 340
gluten-free diet
  associated diseases, 131
  associated weight loss, 103
  atypical celiac disease, 85, 87
  awkward conversations, 315–316
  cancer risk, 161, 169
  children's challenges, 178, 251
  children's lifestyle, 252–256

classical celiac disease, 81
complementary and alternative medicine, 232–237
cross-contaminated foods, 186, 190–191
defined, 24, 173, 175
diagnostic complications, 55, 64–66, 70
diarrhea treatment, 97
dietitian consult, 126, 179
Down syndrome, 156
drawbacks, 177–178
emergency preparedness, 189–190
emotional response to diagnosis, 15, 138
family meals, 188–189
frequently asked questions, 304–308
gluten sensitivity, 235–236
hidden gluten sources, 192–194
hospitalization, 279
importance of, 12–13, 173, 191, 215
indigestion, 101
iron-deficiency anemia, 123–124
lack of products, 178
latent form of disease, 78
long-term plan, 191
misinformation, 289–290
myths, 320–321, 323
nutrition management, 266–272
nutritional challenges, 197–203
off-diet gluten consumption, 273, 317–318
osteoporosis, 125–126
rationale, 24
reasons for failure, 213–221
reliable information, 178–180, 333–337
restaurant dining, 177, 185–187
rickets, 127
sexual intercourse, 241
signs of success, 209–213
silent form of disease, 78, 88–89
sources of gluten, 33–35
strict regimen, 176
support group, 273
travel, 187–188
vegetarians, 207–208
visits to doctor, 262
glutenin, 34, 184
gluten-sensitive enteropathy. *See* celiac disease
gnocchi, 186
goiter, 146, 147

grain
  major triggers of celiac disease, 32
  myths, 322
  sources of fiber, 201, 271
  sources of gluten, 33–35, 174
  vegetarian diet, 208
grand mal seizure, 141
granular IgA antibody, 134
Graves disease, 103, 108, 146
gravy, 186
grilling surface, 191
guilt, 94, 243
gum disease, 149
gynecological problems, 109

## • *H* •

hair loss, 118
Hashimoto's thyroiditis, 146–147
headache, 106, 139–140
health care professional, 20, 22. *See also specific professionals*
heart rate, 48
heartburn, 99–101
height, 47–48
hemoglobin, 55, 211
hepatitis, 155
herb, 181, 230
herpes virus, 133
histamine, 37
history, medical, 46–47
HLA gene. *See* human leukocyte associated gene
hookworm, 287
hordein, 174
hormone
  Addison's disease, 108, 147–148
  diabetes, 108, 143–145
  digestion process, 42
  endocrine system, 143
  infertility, 241, 242
  thyroid malfunctions, 108, 145–147
hospitalization, 278–279
H$_2$ blocker, 100, 101
human leukocyte associated (HLA) gene
  children's diagnosis, 250
  defined, 25
  diagnostic tests, 53–55, 65
  medical advancements, 287
  risk for disease, 282–283

human leukocyte associated (HLA) gene
  *(continued)*
  role in disease process, 25–26
  screening methods, 76
humidifier, 151
hygiene hypothesis, 31
hyperthyroidism, 103, 108, 146
hypocalcemia, 139
hypoglycemia, 145
hyposplenism, 130
hypothyroidism, 108, 146–147

## • *I* •

ice cream, 186
IgA deficiency
  classical celiac disease, 81
  described, 52, 110, 157
  response to gluten-free diet, 211
ileoscopy, 69
ileum, 40, 41, 69
immediate hypersensitivity reaction, 37
immune response
  dermatitis herpetiformis, 134–135
  described, 27–29
  digestion, 43
  food allergies and intolerance, 36, 37
  gluten's role, 24
  hygiene hypothesis, 31
  medical advancements, 287
  risk for disease, 283
  small intestine, 24, 28–29, 31, 43
  triggers, 29
  vitiligo, 136
  white cell types, 27
immune system
  associated diseases, 221
  cancer risk, 162
  cause of celiac disease, 24
  components, 26–27
  defined, 26
  function of, 26
  neurological problems, 139
  role in disease process, 27–29
  vitamin A deficiency, 113
  vitamin D deficiency, 115
immune-modulating cream, 136
immunoglobulin, 49–53, 81, 157
immunology, 291

indigestion, 101
infant. *See also* children
  calcium intake, 199
  gluten exposure, 31, 245
  lactose intolerance, 204
  pregnancy complications, 243
infection
  cause of celiac disease, 31
  response to gluten-free diet, 213
  Sjogren's syndrome, 150
  spleen, 130
infertility
  atypical celiac disease, 86–87
  described, 129, 240
  men versus women, 240–242
  screening for celiac disease, 244
inflammation
  biopsy results, 62
  cancer risk, 162, 169
  connective tissue disorder, 149–153
  depression, 138
  response to gluten-free diet, 213
  skin rash, 106, 133–136
  vitamin B deficiency, 114
inflammatory bowel disease, 220
injection, iron, 120
insoluble fiber, 270–271
insulin
  diabetes, 143
  digestion process, 42, 145
insurance, 277
intercourse, 241, 311
Internet resources
  benefits of, 276
  body mass index calculator, 48, 267
  children with celiac disease, 331
  dairy products, 332
  described, 329
  dietary supplements, 332
  food allergies, 232
  functional gastrointestinal disorders, 220, 338
  general celiac information, 330–331
  genetics research, 283
  gluten-free diet, 333–337
  inflammatory bowel disease, 220, 338
  medicines with gluten, 193
  nutritional information, 332
  public awareness, 289–290
  reliability of sources, 17–18, 289–291

search guidelines, 330
support groups, 18–21, 22
tax information, 179
thyroid disease, 145
intestinal biopsy. *See* biopsy, intestinal
intraepithelial lymphocyte, 43, 163, 213, 218
intrauterine growth restriction, 243
iron deficiency
  anemia, 84, 107, 121–124
  described, 118–120
  dietary strategies, 198–199
  disease management, 263
  frequently asked questions, 304–305
  pregnancy preparation, 244
  response to gluten-free diet, 212
  treatment, 119–120
iron salt, 119
irritable bowel syndrome
  atypical celiac disease diagnosis, 83
  described, 219
  diagnostic complications, 65
  elimination diet, 234
  misdiagnosis, 99
  symptoms, 95–96, 219, 220
itchy skin
  dermatitis herpetiformis, 133–134, 136, 137
  liver disease, 154
  primary sclerosing cholangitis, 155

## • J •

jaundice, 154, 167
jejunum
  digestion process, 40
  effects of celiac disease, 43
  endoscopy, 60
  illustrated, 41
  iron absorption, 119
joints, 149–153
juice, 119, 200
junk food, 103, 268

## • K •

K vitamin, 116–117
killer T cell, 287
knife sharing, 190
knock knees, 127

## • L •

La Fondation Québécoise de la Maladie
    Coeliaque, 340–341
lactase, 203, 204, 206
lactose, 203, 204, 234
lactose intolerance
  affected population, 204
  damaged intestines, 204–205
  defined, 13, 203
  described, 36
  diagnosis, 205–206
  elimination diet, 234
  Internet resources, 336
  response to gluten-free diet, 215–216
  symptoms, 204
  treatment, 206
language issues, 20
large intestine
  biopsy, 218
  cancer, 168
  digestion process, 42
  illustrated, 38
latent celiac disease
  described, 77–78, 89
  diagnosis, 89
  main features, 80, 89
  versus silent celiac disease, 89, 90
  symptoms, 80, 94
laxative, 272
leakiness, 29
legislation, 288–289
letter, from doctor, 278
leukemia, 168
lipstick, 193, 323
liver
  cancer, 167
  diagnostic tests, 55
  digestion process, 40, 42
  disease, 74, 110, 153–155
  enteropathy-associated T cell lymphoma, 164
  illustrated, 38
local support group, 21–22
long-chain triacylglycerol, 206
low impact fracture, 85
lower esophageal sphincter, 100
lumbar spine, 125
lupus, 109, 151–152
lymph node, 26, 164

lymphocyte, 43
lymphocytic colitis, 217
lymphoma, 163–165

# • *M* •

macrophage, 27, 28
magnesium, 126, 141
malabsorption
  atypical celiac disease, 85
  cancer risk, 162
  classical celiac disease, 81
  defined, 96, 111, 196
  dental problems, 129
  described, 44
  diabetes, 145
  diagnostic blood tests, 55
  diagnostic physical examination, 47
  disease management, 264
  effects of, 96
  epilepsy, 141
  infertility, 241, 242
  mineral loss, 117–121
  myths, 319–320
  neurological problems, 139
  osteomalacia, 127–128
  osteoporosis, 85, 126
  peripheral neuropathy, 140
  rickets, 115, 126–127
  vitamin loss, 111–117
  weight loss, 102, 103, 104
malaise, 10
malnutrition, 196–203, 248
malt-based product, 181
maltodextrin, 181
managing celiac disease
  common questions, 13
  coping with emotions, 16–17
  food shopping, 314–315
  healthy habits, 309–310
  informed, keeping, 310–311
  local support groups, 21–22
  medical advocacy, 276–278
  medical improvements, 284–285
  medical tests, 50
  online support groups, 18–21
  refractory celiac disease, 223
  reputable Internet resources, 17–18
  restaurant dining, 313–314

rules for management, 257–258
  visits to doctor, 258–266
mast cells, 27, 37
matzoh, 186
meal plan, 183, 184, 254–255
mean-spirited support group, 20
meat
  cooking tips, 182, 183
  iron sources, 118
  restaurant dining, 185
  vegetarian diet, 207
  vitamin sources, 112
medical expenses, 179
medical history, 46–47, 274
medicine
  dermatitis herpetiformis, 135–136
  endoscopy preparation, 57–58
  fibromyalgia, 153
  gastroesophageal reflux, 100–101
  hidden glutens, 192–193
  Internet resources, 337
  laxatives, 272
  microscopic colitis, 218
  migraine headache, 140
  osteoporosis, 126
  preparation for doctor visit, 274
  psoriasis, 137
  Raynaud's phenomenon, 153
  refractory celiac disease, 223
  safety information, 228
megaloblastic anemia, 124
memory, 114
men, infertile, 241–242
menstrual period, 122, 124, 240
Metamucil (supplement), 271
microbiome, 116
microscopic colitis, 217–218
microvilli, 41, 44
migraine headache, 106, 139–140
milk, 203, 206
milk of magnesium, 272
mineral, dietary. *See also specific minerals*
  bone development, 121
  deficiencies, 196
  effects of celiac disease, 44, 117–121
  Internet resources, 332
  malabsorption, 117–121, 141
mineralocorticoid deficiency, 147–148
miscarriage, 241, 242–243, 244

modified food starch, 181
mood disorder, 106–107, 152, 237
motility, 242
mouth
  cancer, 166
  cracked skin, 129
  diagnostic exam, 48
  digestion process, 39
  guard, 58
  ulcers, 110, 129
mucosa, 61
mucosal immune system, 27
mucosal surface, 27, 60, 61
muscle tissue, 48
musculoskeletal problem, 108–109, 148–153

● *N* ●

NASH (nonalcoholic steatohepatitis), 154
National Foundation for Celiac Awareness, 341
nausea, 326
nerve damage, 114, 116, 140
nerve tissue, 48
neurological disorder, 106–107. *See also specific disorders*
neurotransmitter, 138
neutrophil, 27
night blindness, 113
night sweats, 155
nonalcoholic steatohepatitis (NASH), 154
non-Hodgkin lymphoma, 163
non-responsive celiac disease, 213–220
non-tropical sprue. *See* celiac disease
non-ulcer dyspepsia, 219
numbness, 106, 140
nurse, 58, 279
nursing home, 279
nutrition. *See also specific nutritional deficiencies*
  dietary deficiency, 195–203
  disease management, 266–272
nuts, 201

● *O* ●

oats
  described, 34
  fiber, 270
  frequently asked questions, 306–307

Internet resources, 334
  triggered versus untriggered celiac disease, 35
objective information, 17, 20
obstetrical problems, 109
occult GI blood loss, 122
online advertising, 17
online support group, 18–21
organizations, celiac disease
  listing, 339–343
  misinformation, 289–290
oropharyngeal cancer, 162
osmotic laxative, 272
osteomalacia, 127–128
osteoporosis
  atypical celiac disease, 84–86
  causes, 115, 117
  defined, 108, 125
  disease management, 263
  versus osteomalacia, 128
overeating, 100
ovulation, 240, 241
ovum, 240, 242

● *P* ●

pain
  abdominal symptoms, 98, 99
  cancer, 166
  fibromyalgia, 152
  iron injections, 120
  lupus, 151
  rickets, 127
pancreas
  cancer, 167
  digestion process, 40, 42, 145
  digestive enzymes, 231
  illustrated, 38
  insufficiency, 103, 216–217, 231
  weight loss, 103
partial villous atrophy, 43
party food, 252–253, 313
pasta, 182, 183
patchy skin, 106
pathogenesis, 291, 292
pathologist, 62, 134
PBC (primary biliary cirrhosis), 154–155
PEG (polyethylene glycol), 272
peptic duodenitis, 67

peptide, 40
perforated intestine, 164
peripheral nervous system, 140
peripheral neuropathy, 106, 140
peristalsis, 69
pernicious anemia, 124
petroleum jelly, 137
pharmacist, 192–193
phosphate, 119
phyate, 208
physical examination
  celiac disease diagnosis, 46, 47–48
  children's diagnosis, 248
  defined, 47
  dermatitis herpetiformis, 134
  enteropathy-associated T cell lymphoma, 164
phytate, 198
pimecrolimus, 36
pizza, 183
play dough, 194
pneumococcal vaccine, 130
pneumococcus germ, 130
policy, public, 288–289
polyethylene glycol (PEG), 272
positive thinking, 16
postage stamp, 194
potential celiac disease. *See* latent celiac disease
prebiotic food, 229
precancerous cells, 222
pre-existing health problems, 277
pregnancy
  complications, 129, 242–245
  folate deficiency, 113
  gastroesophageal reflux, 100
  preparation for, 244
preschool children, 252–253
preterm infant, 243
primary biliary cirrhosis (PBC), 154–155
primary sclerosing cholangitis (PSC), 155–156
probiotic food, 229
processed food, 174, 180, 190, 202
prolamin, 32
propranolol, 140
prostate examination, 168
protein, 208
proton pump inhibitor, 101
pruritis. *See* itchy skin
PSC (primary sclerosing cholangitis), 155–156

psoriasis, 106, 137
psyllium, 270, 271
public awareness, 288–291, 296, 315
pure oats, 34, 307, 334
push enteroscope, 69
pylorus, 60

### • *Q* •

questioning doctors, 274, 275
quinoa, 208

### • *R* •

radiation therapy, 165, 166
rash
  children's diagnosis, 248
  consult with doctor, 132
  dermatitis herpetiformis, 106, 248
  lupus, 151
Raynaud's phenomenon, 109, 153
reagent, 63
rectum, 38, 42, 48
reflux. *See* gastroesophageal reflux
refractory celiac disease
  cancer risk, 161
  causes, 273
  described, 222
  disease management, 273
  risk factors, 223
registered dietitian. *See* dietition
relative risk, 160
respiratory system, 150
restaurant dining
  college students, 256
  cost-cutting tips, 315
  drawbacks of gluten-free diet, 177
  healthy habits, 313–314
  Internet resources, 335–336
  tips for success, 185–187
reticulin, 51
rheumatologic problem, 109, 148–153
rheumatologist, 150
rice, 201
rickets, 108, 115, 126–127
roughage, 270–271
rye, 34

## • S •

sadness, 16, 138
salad, 182, 183, 186
sales pitch, 20
saliva
  dental problems, 129
  diagnostic tests, 63
  digestion process, 39
  Sjogren's syndrome, 149–150, 151
salsa, 175
saturated fat, 202
scaly skin, 106, 137
SCD (Specific Carbohydrate Diet), 231–232
scientific research
  Attention-Deficit/Hyperactivity Disorder, 142
  clinical trials, 281
  diagnostic improvements, 284
  digestive enzyme supplements, 286
  disease management, 265, 295
  genetics, 25–26, 282, 283, 292
  misinformation, 290
  needed areas of research, 291–296
  neurological problems, 139
  new technologies in disease management,
    284–285
  reputable Web sites, 17, 18
  rules for managing disease, 258
  silent celiac disease, 89
  uptake of gluten, 286
screening
  asymptomatic disease, 77–78
  cancer, 168–169
  children, 249–250
  criteria, 72, 73
  defined, 55, 71
  diabetes, 144–145
  frequently asked questions, 301–302
  future research, 292–293
  gluten-free diet before diagnosis, 64
  infertility, 244
  methods, 76–77
  risk factors for disease, 72–75
search engine, 18, 20, 22
secalin, 174
secondary amenorrhea, 240
sedative, 58
seeds, 201
seizure. *See* epilepsy

selective screening, 73
Senekot (laxative), 272
serology, 49
serotonin receptor agonist, 140
sex, 241, 311
sharing stories, 19
side dishes, 185
sigmoid colon, 42
silent celiac disease
  described, 77–78, 87–88
  diagnosis, 88
  versus latent celiac disease, 89, 90
  main features, 80
  symptoms, 80, 94
  treatment, 88–89
Sjogren's syndrome, 109, 149–151
skin
  cracked lips, 129
  diagnostic examination, 48
  discoloration, 106, 136
  iron injections, 120
  plaques, 106, 137
  rashes, 106, 132–136, 151
SLE (systemic lupus erythematosis), 109,
    151–152
sleepover, 253
small intestine
  anemia, 84
  bacterial overgrowth, 10, 216
  cancer, 109, 162
  control of permeability, 28, 29–30
  described, 40
  diagnostic tests, 56–63, 69
  digestion process, 40–42
  effects of celiac disease, 43, 44
  endoscopy procedure, 60–61
  hygiene hypothesis, 31
  illustrated, 38, 41
  immune response, 24, 28–29, 31, 43
  infection, 31
  iron absorption, 119
  vitamin deficiency, 114, 116
snack, 184, 187, 253, 256
soluble fiber, 270
sorbitol, 234
sorority, 255, 256
soup, 182
soya sauce, 181, 186
Specific Carbohydrate Diet (SCD), 231–232

sperm, 242
spice, 181
spine, 125
spleen, 130
spontaneous abortion, 242
squamous cell cancer, 167
starch, 181, 182
steatorrhea, 96, 97
stimulant laxative, 272
stomach
   diagnostic examination, 48
   digestion process, 40
   endoscopy procedure, 60
   illustrated, 38
   surgery, 32
stool
   bloody, 96, 166
   children's diagnosis, 248
   diagnostic tests, 63
   digestion process, 39, 42
   softener, 272
storage protein, 32
stress, 32
stricture, 101
subclinical celiac disease. *See* silent celiac
   disease
summer camp, 253
sun exposure, 115, 152
supplement, dietary
   A vitamin, 113
   calcium deficiency, 118, 126
   complementary treatments, 230–231
   D vitamin, 115
   digestive enzymes, 286
   fiber, 271
   important considerations, 112
   Internet resources, 332
   iron deficiency, 119–120, 123–124, 304–305
   osteoporosis, 126
support group
   gluten-free diet, 273
   information about disease, 311
   Internet-based, 18–21
   listing, 339–341
   local groups, 21–22
   public awareness of disease, 288–289
   response to diagnosis, 17
   role of, 19
   teenagers with celiac disease, 254

Surfak (stool softener), 272
sustained-release tablet, 119
swallowing difficulty, 101, 149, 167
symptoms
   Addison's disease, 108, 147–148
   anemia, 110
   associated disorders, 105
   children's diagnosis, 246–247
   dermatitis herpetiformis, 133–134
   enteropathy-associated T cell lymphoma,
      163, 224
   esophageal cancer, 167
   fibromyalgia, 152
   food allergy and intolerance, 36, 37
   gastroparesis, 218
   glucocorticoid deficiency, 147
   gluten sensitivity, 235
   hyperthyroidism, 146
   hypothyroidism, 146–147
   iron supplement side effects, 119–120
   irritable bowel syndrome, 95–96, 219, 220
   lactose intolerance, 204
   liver disease, 154–155
   lupus, 151–152
   lymphoma, 165
   microscopic colitis, 218
   migraine headache, 139–140
   mineralocorticoid deficiency, 147–148
   myths, 320–321, 323–324, 325–326
   osteomalacia, 128
   pancreatic insufficiency, 217
   pregnancy preparation, 244
   primary sclerosing cholangitis, 155
   Raynaud's phenomenon, 153
   refractory celiac disease, 273
   response to gluten-free diet, 210
   rickets, 127
   visits to doctor, 260–262
   vitiligo, 136
symptoms, of celiac disease
   atypical celiac disease, 80, 83, 94, 102
   classical celiac disease, 79, 80–81, 94, 102
   dental problems, 128, 129
   described, 10, 12
   diabetes, 108
   diagnostic complications, 66, 68
   diagnostic steps, 46–47
   gluten challenge, 66
   ignored, 93–94

latent celiac disease, 80, 94
screening criteria, 73, 74–75
silent celiac disease, 80, 94
thyroid problems, 108
undetected disease, 23
systemic immune system, 26
systemic lupus erythematosis (SLE), 109,
    151–152

## • *T* •

T cell lymphocyte
described, 27
immune response, 28
lymphoma, 109
medical advancements, 287
refractory celiac disease, 222
risk for disease, 283
tacrolimus, 136
tax deduction, 179, 314
tears, 150, 151
teenager, 253–255
teeth, 39, 128–129
tender point, 152
terminal ileum, 69, 114, 140
thought disorder, 106–107, 114
thyroid, 55, 103, 108
tight junction, 28, 29–30
tissue transglutaminase (TTG)
antibodies, 50
children's diagnosis, 248, 250
classical celiac disease, 81
defined, 28, 50
dermatitis herpetiformis, 134
described, 50
diagnostic tests, 50, 52, 63
disease management, 263–264
immune response, 28, 29
medical advancements, 287
response to gluten-free diet, 211
screening methods, 77
toaster, 190, 325
tobacco, 166, 167, 170
tofu, 117, 200
tongue, 114, 118, 129
topical medication, 136, 137
tortilla, 186
total villous atrophy, 43

trachea, 145
train travel, 188
transaminase level, 154
travel, 187–189, 317
treatment, medical
associated diseases, 105
atypical celiac disease, 85
basic tenet of, 24
classical celiac disease, 81
constipation, 269–272
dermatitis herpetiformis, 135–136
described, 12–13
diabetes, 143–144
diarrhea, 97
enteropathy-associated T cell lymphoma, 165
fibromyalgia, 153
future research, 294
gastroparesis, 219
gluten-free diet before diagnosis, 64
history of disease, 10
hyperthyroidism, 146
ineffective, 63
iron deficiency, 119–120
iron-deficiency anemia, 121–123
lactose intolerance, 206
latent celiac disease, 78, 90
liver disease, 155
lupus, 152
medical advancements, 285–287
migraine headache, 140
osteoporosis, 125–126
pancreatic insufficiency, 217
psoriasis, 137
Raynaud's phenomenon, 153
reflux, 100–101
refractory celiac disease, 223
reputable Internet resources, 17–18
screening criteria, 75
silent celiac disease, 78, 88–89
Sjogren's syndrome, 150–151
types of celiac disease, 80
vitiligo, 136
triacylglycerol, 206
triglyceride, 40
triticale, 34
TTG. *See* tissue transglutaminase
Turner syndrome, 157
Type I/II diabetes. *See* diabetes

## • U •

ulcer
  mouth, 110, 129
  stomach, 60, 99
ulcerated cornea, 150
universal screening, 73
university-based disease centers, 342–343
unsaturated fat, 202
upright toaster, 325

## • V •

vaccination, 130
vaginal secretion, 150, 151
vegan, 207, 337
vegetables
  A vitamin, 112
  B vitamin, 113
  calcium, 117, 200
  cooking tips, 182
  E vitamin, 116
  fiber, 270, 271
  iron, 118
  K vitamin, 116
  shopping tips, 180
vegetarian, 124, 207–208, 336
verified fact, 18, 20
villi, 41, 43, 44, 62
villous atrophy, 213
vinegar, 323
vitamin. *See also specific vitamins*
  anemia, 84
  bone development, 121
  deficiencies, 111–117, 196, 211–212
  dietitian consult, 112
  digestion process, 40
  disease management, 263
  effects of celiac disease, 44
  Internet resources, 332
  iron supplements, 119
  malabsorption, 111–117
  osteomalacia, 128
  osteoporosis, 84–85, 126
  sources, 112–117
  supplements, 112, 230–231
  types of, 112–117
vitiligo, 106, 136

## • W •

walking problem, 106, 141
water-soluble vitamin, 196
weight, body
  diagnostic examination, 47–48
  gains, 266–268
  Internet resources, 48, 267, 331
  myths, 319–320
  nutritional deficit, 203
weight loss
  atypical celiac disease, 102
  cancer, 164, 166, 167
  causes, 102–104
  children, 81, 104, 144
  classical celiac disease, 81, 102
  described, 102
  disease management, 268–269
  heartburn treatment, 100
  hyperthyroidism, 146
  myths, 326
  response to gluten-free diet, 212
wheat
  conversations about diet, 316
  described, 34
  foods to avoid, 181, 182
  myths, 322
  past knowledge of celiac disease, 11
white blood cells, 27, 43, 168
whole grain, 271
Wijmenga, Cisca (doctor), 283
women, infertile, 240–241
World War II, 11, 32

## • X •

x-ray, 165

## • Y •

Yahoo!Groups (Web site), 20
yeast, cooking, 181, 223
yeast infection, 150
yogurt, 206, 229

## • Z •

zonulin, 28, 286

## EDUCATION, HISTORY & REFERENCE

978-0-470-87855-2    978-0-7645-2498-1

**Also available:**
- Algebra For Dummies
  978-0-470-55964-2
- Art History For Dummies
  978-0-470-09910-0
- ASVAB AFQT For Dummies
  978-0-470-56652-7

- Chemistry For Dummies
  978-1-118-00730-3
- Math Word Problems For Dummies
  978-0-470-14660-6
- Statistics For Dummies
  978-0-470-91108-2
- World War II For Dummies
  978-0-7645-532-3

## FOOD, HOME, GARDEN, & MUSIC

978-1-118-11554-1    978-0-470-17810-2

**Also available:**
- 30-Minute Meals For Dummies
  978-0-7645-2589-6
- Bartending For Dummies
  978-0-470-63312-0
- Home Improvement All-in-One Desk
  Reference For Dummies
  978-0-7645-5680-7

- Music Theory For Dummies
  978-0-7645-7838-0
- Violin For Dummies
  978-0-470-83838-9
- Wine For Dummies
  978-0-470-04579-4

## GREEN/SUSTAINABLE

978-0-470-84098-6    978-0-470-59678-4

**Also available:**
- Alternative Energy For Dummies
  978-0-470-43062-0
- Energy Efficient Homes
  For Dummies 978-0-470-37602-7

- Green Building & Remodeling
  For Dummies 978-0-470-17559-0
- Green Your Home All-in-One
  For Dummies 978-0-470-40778-3
- Sustainable Landscaping
  For Dummies 978-0-470-41149-0

## HEALTH & SELF-HELP

978-0-470-58589-4    978-0-470-15732-9

**Also available:**
- Breast Cancer For Dummies
  978-0-7645-2482-0
- Depression For Dummies
  978-0-7645-3900-8
- Food Allergies For Dummies
  978-0-470-09584-3

- Healthy Aging For Dummies
  978-0-470-14975-1
- Improving Your Memory
  For Dummies 978-0-7645-5435-3
- Neuro-linguistic Programming
  For Dummies 978-0-7645-7028-5
- Understanding Autism
  For Dummies 978-0-7645-2547-6

Available wherever books are sold. For more information or to order direct: U.S. customers visit www.dummies.com or call 1-877-762-2974. U.K. customers visit www.wileyeurope.com or call 0800 243407. Canadian customers visit www.wiley.ca or call 1-800-567-4797.

## HOBBIES & CRAFTS

978-0-470-28747-7    978-0-470-29112-2

**Also available**
- Crochet Patterns For Dummies
  978-0-470-04555-8
- Digital Scrapbooking For Dummies
  978-0-7645-8419-0
- Home Decorating For Dummies
  978-0-7645-4156-8

- Knitting Patterns For Dummies
  978-0-470-04556-5
- Oil Painting For Dummies
  978-0-470-18230-7
- Quilting For Dummies
  978-0-7645-9799-2
- Sewing For Dummies
  978-0-7645-6847-3

## HOME & BUSINESS COMPUTER BASICS

978-0-470-49743-2    978-0-470-11806-1

**Also available:**
- Blogging For Dummies
  978-0-470-56556-8
- Excel 2007 For Dummies
  978-0-470-03737-9

- Office 2007 All-in-One Desk
  Reference For Dummies
  978-0-471-78279-7
- PCs For Dummies 978-0-470-46542-4
- Web Analytics For Dummies
  978-0-470-09824-0

## INTERNET & DIGITAL MEDIA

978-1-118-09203-3    978-0-470-87871-2

**Also available:**
- Facebook For Dummies
  978-0-470-87804-0
- Search Engine Marketing
  For Dummies 978-0-470-26270-2
- The Internet For Dummies
  978-0-470-56095-2

- Twitter For Dummies
  978-0-470-76879-2
- YouTube For Dummies
  978-0-470-14925-6
- WordPress For Dummies
  978-1-118-07342-1

## MACINTOSH

978-0-470-87868-2    978-0-470-43541-0

**Also available:**
- iMac For Dummies
  978-0-470-60737-4
- iMovie '09 & iDVD '09 For Dummies
  978-0-470-50212-9
- iPhone For Dummies
  978-0-470-87870-5

- MacBook For Dummies
  978-0-470-76918-8
- Macs For Seniors For Dummies
  978-0-470-437797-7
- Office 2008 For Mac For Dummies
  978-0-470-27032-5